# By With To & From

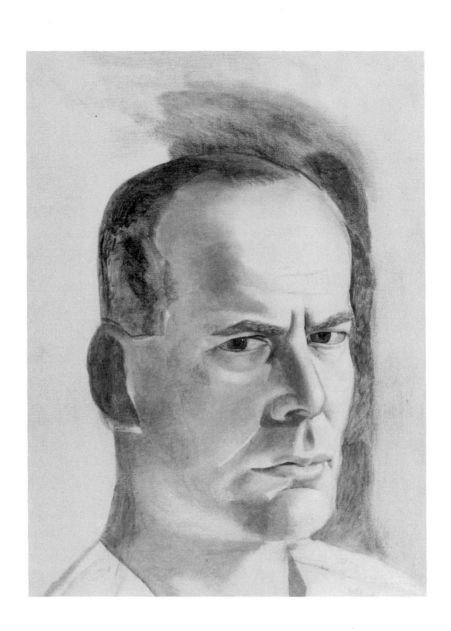

# By With To & From

## A Lincoln Kirstein Reader

### Edited by Nicholas Jenkins

*Farrar, Straus & Giroux*

*New York*

Library of Congress Cataloging-in-Publication Data
Kirstein, Lincoln.
By with to & from : a Lincoln Kirstein reader / edited by Nicholas
Jenkins. — 1st ed.
Includes index.
1. Arts, Modern—20th century.   I. Jenkins, Nicholas.
II. Title.   III. Title: By with to and from.
NX456.K56   1991      700'.9'04—dc20      90-48226

FRONTISPIECE
Lincoln Kirstein (unfinished; 1950) by Lucian Freud; oil on canvas

FOR LESLIE GEORGE KATZ

*Blessed be all metrical rules that forbid automatic responses,*
*force us to have second thoughts, free from the fetters of Self.*

<div align="right">W. H. AUDEN</div>

# Contents

# List of Illustrations

# Introduction

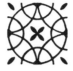

I

A GREEK EPIGRAM about Plato said that "in whatever direction we go, we meet him on his way back." Anyone looking at the history of this century's arts in America may begin to feel something similar about Lincoln Kirstein. A denizen of countless memoirs and chronicles, his name is ubiquitous, and a browse through the pages of his bibliography, or a glance at even the most skeletal chronology, only sharpens the impression of a life of extraordinary diversity and intensity, spent right at the heart of the culture.

Kirstein is, of course, the visionary patrician who brought George Balanchine to the United States (where they formed, *ex nihilo*, the New York City Ballet and the School of American Ballet); but he was also one of the crucial forces in the founding of the Museum of Modern Art in New York (later on, he became one of its most intransigent critics), and he has been an aggressive, highly informed polemicist on behalf of many neglected artists and movements, an art and rare-book collector (whose once unfashionable confidence in artists like Dadd, Gerôme, Saint-Gaudens, and Nadelman now echoes through the lecture hall and auction room), one of the instigators of a national theatrical repertory company, as well as a profound and graceful dance scholar, a cultural ambassador, a historian, a musical patron, a literary editor, an essayist, and a distinguished poet. During 1950, when the New York City Ballet was performing in London, Kirstein and his wife, Fidelma, were guests of the English dance writer Richard Buckle, and one evening their host noted guiltily in his diary: "I have often

gone to sleep to the busy music of his typewriter in the small hours, to be awoken by the same sound at six in the morning." Ballet's ordered flow of energy is paralleled by Kirstein's own almost relentless passion and vigor.

But a person can hide themselves in the limelight. Few, perhaps, have more than a clouded sense of the continuities that underlie all Kirstein's different roles. One of his favorite books when he was a child was George and Weedon Grossmith's now largely forgotten *Diary of a Nobody* (1892), and this fact seems, in retrospect, like an ironic foreshadowing of the importance that selflessness was to have in his adult life and thought. Though many of his achievements are absolutely clear-cut, and though Kirstein himself, with his jagged profile and his immaculately tailored black silk suits, has a commanding physical presence, there remains something mysterious and contained about him.

Partly this stems not from his own attitudes but from the modern craving for labels: we find it easier and more comfortable not to remember that the great impresario is also a historian *and* a poet. In part, however, this mysteriousness does accurately reflect the real paradoxes and contradictions of a dandyish, witty, moralistic, hotheaded man whom the choreographer Jerome Robbins called "as bewildering as anyone I've ever known." And the ambiguity also derives from Kirstein's strategies of behavior, from his carefully worked-out way of insinuating himself into a key position, of cutting past distractions in order to get something essential done. "People have trouble figuring out who I am," he once wryly told John Russell. "They can't make out if I'm a P.R. man for the City Ballet, or if it was all some kind of accident, or if I'm just a rich boy who tagged along."

In the thirties, Kirstein identified with T. E. Lawrence, the Oxford-educated intellectual who, in service to the Arab cause, cultivated "the Briton's imperial gift to pass in deserts" (see pp. 325–29). During World War II, Kirstein was drafted into the military as a private, but with the tacit approval of his officers he removed the stripe from his uniform (the precedent was set by Cocteau's behavior in World War I), becoming, in effect, rankless. Making use of his dignified, Harvard-polished bearing and his familiarity with French and German, Kirstein roved through Europe unfettered by the Army's rigid hierarchy, working as a courier, chauffeur, and interpreter. (When the

war ended, he was one of the very few foot soldiers able to claim that he had had his own jeep.) As a training for his "interstitial activity" as an aesthete in the "desert" populated by politicians, philanthropists, arts bureaucrats, and bankers during the fifties and sixties, when he was struggling to turn the New York City Ballet into a national institution, the war, "the key experience of my time," proved permanently valuable to him.

But there is a further—and more fundamental—reason for this rarefied aura of impersonality. Instead of passing his years sustained by a cushion of family money while he coddled a gift for verse, Kirstein committed himself to action and service. This has meant that so far some of his activities can be glimpsed only intermittently, for he has moved about behind the scenes in the skillfully played role of galvanizer: inspiring, bullying, encouraging, and then moving on. Large amounts of his energy and talent have been put at the disposal of those artists—Balanchine is the most obvious example—in whom he believes; few have equaled the extreme sincerity of his passion for excellence wherever he finds it. The imaginative ambiguities and possibilities of such selfless dedication are, therefore, a concern throughout his writings, and lie at the center of his neoclassical aesthetic.

And yet, self-evidently, Kirstein is a major figure in his own right, an extremely powerful and idiosyncratic writer. From the vantage point of today, it is clear that his enormous output on so many subjects adds up to an oeuvre, something unique and distinctive in itself, with its own stylistic coherence and an elaborately recurring set of ideas. In many cases, what was originally intended as a support for another person's art has turned out to be free-standing, autonomous, permanent. (Even his brusquely learned notes in the City Ballet's programs, although unsigned, stick out like nails.) Certainly his prose never descends into the neutral, dry tone and circumspect manner that we expect from a critic. His forte is the committed, passionate, authoritative note, learned and sometimes deferential, but never ecumenical or facetiously diplomatic. With him, the stakes are always high.

II

Lincoln Kirstein was born (by his count) in the "107th year of the nineteenth century" on May 4, 1907, in Rochester, New York, the second child of Louis Edward Kirstein and Rose Stein Kirstein. Eight days later, he developed a fever and very nearly died. Although Louis Kirstein went through several bankruptcies, he eventually began to prosper as a merchant of eyeglasses and when, in 1912, the Kirstein family moved to Boston, he rapidly became a wealthy man through a partnership in William Filene and Sons, the largest department store in the city. The Kirsteins owned a gray Rolls-Royce, the first in Boston, and Louis Kirstein, a forceful, elegant man, became president of the city's Public Library.

Although by 1912 Boston had absorbed frequent tides of Irish, Canadian, and Italian immigrants, it was still the social fiefdom of the Adamses, Lowells, and Cabots, a city whose Anglo-Saxon origins loomed massively over the polyglot present. Lincoln Kirstein's parents were enthusiastic adherents to the cult of England: as a child, he was often dressed in a miniature Royal Navy uniform and nourished by Dickens, Stevenson, Kipling, and bound volumes of the *Illustrated London News*. He wrote later that "since childhood, my criteria of art, public policy and behavior [have] been British." This Anglophilia did not preclude, though, the transmission of equally ardent feelings of patriotism and mission. Mixing Bostonian pride with an un-Bostonian optimism, Mr. and Mrs. Kirstein were determined that their children would become proper sons of Boston. "I had no dynasty; I had no family," Kirstein has said. "My father gave me the idea that anything was possible—I mean that nothing was possible for him but *anything* would be possible for me."

As a teenager, he formed part of the army of rich Americans who traveled each year to Europe, viewing the Continent as a sort of vast training ground for their future roles in the unfolding epic of American civilization. Several summers were spent in London, touring art galleries with John Maynard Keynes and visiting the Sitwells and the Woolfs. Then in 1926, after attending Phillips Exeter Academy and the Berkshire School, and working—at his father's insistence—as an apprentice in a stained-glass factory, Lincoln Kirstein, at the third attempt, managed to pass the exams for entry to Harvard.

During the late twenties and early thirties his future must have seemed crowded with possibilities, though, looking back, he views it as a time when he was gradually "shedding off incapacities." Kirstein's father, in his son's words, "set me free" by protesting about but always ultimately funding his offspring's artistic interests. At Harvard, passionately interested in almost all aspects of contemporary culture, Kirstein founded with classmate Varian Fry *Hound & Horn* (the title comes from Ezra Pound's "Bid the world's hounds come to horn!"), a quarterly magazine on dance, art, and literature which was to influence a whole generation's taste. From 1927 until 1934, when Kirstein gave up his editorship, there were contributions from, among others, T. S. Eliot, Pound himself, James Agee, Katherine Anne Porter, John Cheever, and Edmund Wilson. Although recently Kirstein has played down the significance of the magazine and of his role in it (pp. 20–30), there is no doubt that its success gave him immediate entree into the upper reaches of social and artistic life in Manhattan and London.

For a while at Harvard, at the same time that he was editing *Hound & Horn* and contemplating a career as a professional horseman, Kirstein was also trying to become a painter, an effort that culminated in his massive Léger-like mural decorations of the university Liberal Club's dining room, a Machine Age allegory which depicted gears and pistons replicating themselves endlessly. In 1928, he and classmates John Walker III, later a director of the National Gallery, and Edward M. M. Warburg founded the Harvard Society for Contemporary Art, one of the forerunners of the Museum of Modern Art in New York. Walker described Kirstein at the time as a "dark, saturnine, shaved-headed, six-foot youth . . . [who had] energy, determination, a streak of genius, and a touch of bravura." The society's exhibitions put work by Matisse and Picasso on public display in Cambridge for the first time, although, as Kirstein himself notes, modernist painting had already entered some private Boston collections. Little of this was received with enthusiasm by Harvard's higher authorities, and the university's provincialism enraged Kirstein as, later on (although his aesthetic views had by then changed considerably), his country's easygoing indifference to the highest achievements in the arts was to appall him. At Harvard, Walker explained, the group felt themselves to be "part of the new movement, discoverers and prophets of a new

beauty." When they tried to get T. S. Eliot appointed the Charles Eliot Norton lecturer at Harvard in 1928, they were turned down point-blank. (The university asked the poet to deliver the Norton lectures in 1932.)

Although on moral grounds his parents had forbidden him to see Nijinsky on his visit to the United States in 1916, Kirstein did attend all five of Pavlova's performances in Boston in 1920. Then, in the summer of 1922, during one of his visits to London, Kirstein saw Diaghilev's Ballets Russes for the first time, and he became enthralled by this flagrantly new, modernist version of the classical dance. In 1927, he saw Balanchine's *La Chatte,* and the following year his *Apollon Musagète,* the work which was, as he later wrote to the composer of the music, Stravinsky, "actually my start in musical education; it was a door through which I passed into the music of the past and out of which I heard the music of the present and the future." In 1929, again in London, he attended another Balanchine ballet, *The Prodigal Son,* and gradually over the next five years—although he continued to edit *Hound & Horn* from New York until 1934—his attentions and money were diverted towards the ballet. In 1932, the same year that he published his first novel, *Flesh Is Heir,* Kirstein studied with Michel Fokine, perhaps not ever with the intention of becoming a dancer himself, but in order to learn what it was like to dance. (Certainly, Fokine had his doubts: "How can Kirstein be a director of a ballet company? He took some ballet lessons from me, and he can't get his feet off the floor.") By the summer of 1933, though, he was in London and Paris, working with Mme Nijinsky on the biography of her husband and trying, at the same time, to persuade George Balanchine to come to the United States to form an American ballet company with American dancers. He first met Balanchine through the painter Pavel Tchelitchev at the Savoy Theatre in London on July 8, and on the eleventh they had the first in a number of long, decisive conversations at the house of Kirk Askew, an American art dealer. After several months of extraordinarily difficult and murky negotiations (partly described in "From an Early Diary," reprinted here on pp. 130–58) Balanchine agreed to gamble. He docked in New York that October.

In January 1934 Balanchine and Kirstein's School of American Ballet opened on Madison Avenue, and in October 1935 they formed

the first of their five dance companies, the American Ballet Company. In the following year, Ballet Caravan, a touring company, was inaugurated. The early years of the Balanchine-Kirstein partnership were, naturally, difficult and insecure. Immediately after he arrived in the States, Balanchine, who was tubercular, became extremely ill, and later, from 1935 until 1938, the American Ballet Company held an uneasy and ultimately disastrous residency at the Metropolitan Opera House in New York. There was virtually no allowance there for ballet independent of the opera, although in 1937 the American Ballet Company did manage to mount its own Stravinsky Festival (see pp. 159–63), the first of three such festivals that Balanchine-Kirstein companies have held.

Perhaps the intensity of Kirstein's involvement with ballet can be gauged by the fact that in 1940, at the age of thirty-four, after Ballet Caravan had collapsed, he donated over five thousand books and documents on dance to the Museum of Modern Art. (This archive was later transferred to the Dance Collection of the New York Public Library.) Though he spent much of his time during the late thirties and early forties trying to ensure that Balanchine had a company to work with and building up his own authority as a scholar and critic of the dance (in 1942 he founded the influential magazine *Dance Index*), he was also extremely active in many other fields, especially art. In 1938, for instance, he organized the first large exhibition of Walker Evans's work for the Museum of Modern Art in New York. Over the next few years, at the instigation of his friend Nelson Rockefeller, who sent the American Ballet to South America in 1941, he also undertook several buying trips in the region on the museum's behalf. (Many of the Latin American pictures now in the permanent collection were purchased by Kirstein during his travels.) In 1941 Lincoln Kirstein married Fidelma Cadmus, the painter Paul Cadmus's sister.

In 1942, while on a trip to South America for the museum, Kirstein also agreed to report secretly to Rockefeller, who was Roosevelt's Co-ordinator of Inter-American Affairs, on the state of U.S. diplomacy there. His letters were intercepted, and he rapidly became a victim of heavy bureaucratic crossfire between the State Department and Rockefeller's agency. As a result, although many in his Harvard class were as a matter of course awarded commissions when the United

States entered World War II, Kirstein was condemned to spend his war in the ranks: in 1943, he was drafted into the U.S. Army as a private first class. After training with the Corps of Engineers at Fort Belvoir, Virginia, and then, for several months, being assigned to guarding a military stove, he went to Europe. The Army absolved him from routine duties, and he served for a while as a driver for General Patton, before being seconded to the Monuments, Fine Arts, and Archives Division of the Third Army, where he was responsible for cataloguing the destruction of works of art and trying to recover stolen artifacts (see pp. 92–97).

In 1946, after an honorable discharge from the Army, Kirstein plunged back into the ballet world. He and Balanchine founded Ballet Society, a small subscription-only company, which was the direct forerunner of the New York City Ballet. At the same time, his involvement with painting and sculpture grew even more time-consuming as his dissatisfaction with the drift of modernist art deepened. In 1946, he published one of the earliest monographs on the nineteenth-century sculptor William Rimmer, and at a time when Elie Nadelman had been almost entirely forgotten, Kirstein began working to revive the sculptor's reputation. In 1948, the Museum of Modern Art mounted a Nadelman retrospective, for which he wrote the catalogue essay.

Ballet Society spent the winter and spring season of 1947–48 at the City Center of Music and Drama, on the verge of financial ruin. However, those few months, which were to be the final and most crucial stage in the establishment of a permanent company for Balanchine, were distinguished by the premiere of one of the choreographer's most stringent and elevated masterpieces, *Orpheus*, first performed at the City Center in April 1948. In May, on the sudden and completely unexpected initiative of Morton Baum, Director of the City Center, a new entity, the New York City Ballet, was incorporated as the City Center's resident dance company, with Kirstein as its General Director and Balanchine as Artistic Director. This was the turning point.

The next few years were a period of consolidation for the new company, as the New York City Ballet undertook its first tours abroad and cultivated an audience at home. By the time that his dancers began to perform in Europe, the basic tenets of Kirstein's aesthetic

had been formulated and the trajectory of his activities had been determined. From then on, his energy was dedicated to amplifying and propagating his views, and to applying these highly personal neoclassical criteria to a series of monographs on individual artists. The New York City Ballet continued to grow in size and reputation as Balanchine created the outstanding body of work produced by a choreographer in this century. All the while, Kirstein, through his writing and personal influence, helped to enlarge the ballet audience throughout the country to an extent that could hardly have been imagined just a decade earlier. The stabilization of the company did not, of course, decrease the need for money to support the performances, and in this respect Kirstein's social connections with wealthy patrons in New York were to be extremely important. During the fifties, the ballet became, like the Metropolitan Museum of Art and the Metropolitan Opera, an institution with social prestige, a factor that, in a world which had not yet invented sponsorship by foundations and corporations, was crucial to its survival.

From 1955 onward, one of Kirstein's major tasks was involvement with the planning and organization of the Lincoln Center for the Performing Arts, a huge and highly contentious project fraught with bitter quarrels. Finally, in April 1964, after an epic struggle with John D. Rockefeller III for the right to control their new quarters, the New York City Ballet moved into the New York State Theater. It had been designed for them by Philip Johnson (a friend of Kirstein's since Harvard), in collaboration with both Kirstein and Balanchine. For the opening night there was a specially composed fanfare by Stravinsky.

While the New York City Ballet was expanding into an internationally recognized company, the incarnation of Balanchine's "contemporary classical" style, and while the School of American Ballet established itself as the leading educational institution for young dancers in the United States, Kirstein continued to be involved in several other fields. During the late fifties, for instance, he was associated with the American Shakespeare Festival Theatre Academy in Connecticut, an attempt to create a national repertory company for classic plays. And in 1964, as well as shepherding his company into the State Theater, he published a large book of poems, *Rhymes of a PFC*, which W. H. Auden described as "by far the most convincing, moving and impressive" picture of World War II that he had come across. Kirstein's

historical and interpretative writing during the sixties and seventies tended to be in book form rather than in the more charged but ephemeral modes of article and pamphlet that he had used so often in earlier decades. At the same time as the New York City Ballet was undertaking a number of ambitious festivals, and as a stream of degrees, honorary memberships, and civilian medals (including the Benjamin Franklin Medal of the Royal Society, the Presidential Medal of Freedom, the Presidential Medal of Arts, and the *Chevalier dans l'Ordre des Arts et des Lettres*) flowed to Kirstein in recognition of his lifetime's work, he poured out major scholarly monographs on Nadelman, Pavel Tchelitchev, his brother-in-law Paul Cadmus, and Nijinsky. His day-to-day involvement with the company he had founded only ended in 1989, when, at the age of eighty-two, he took the title General Director Emeritus and withdrew to concentrate on his prose.

### III

This *Reader* does not attempt to present every aspect of his historical, literary, and critical work, nor to suggest any final definition of his achievements, not least because, at the age of eighty-four, Lincoln Kirstein is still at work and further books seem certain to issue from his typewriter. Five general areas have been staked out here, and within those areas, in close collaboration with Mr. Kirstein himself, selections from across the whole span of his career have been made. First there is a section of personal essays and memoirs. (This is the only case in which the date of composition has been ignored in order to present the pieces according, roughly, to the stage of Kirstein's life to which they refer; in the rest of the *Reader*, within each section, the choices are arranged in chronological order of their writing.) That is followed by a small sample of Kirstein's work on the dance. Given his range and authority, no selection could really be adequate: this is no more than enticement to further reading. Then come sections on Lincoln Kirstein's other lifelong interests: the graphic arts, and literature and the theatre. Finally, there is a collection of pieces that meditate on individual predicaments, particularly those involving people in service to (or trapped by) a cause. A secondary aim of the book as a whole is to present the spectrum of Kirstein's styles, from the punchiest to the gravest and most learned. Nevertheless, the picture that this *Reader*

gives is incomplete, and perhaps not fully consistent. It could hardly be otherwise, and it hardly matters. *By With To & From* has a double focus: it is an anthology of essays on some of the great figures of the century, but it is also intended as an introduction to another, an opening-out.

.    .    .

Two books and two editors gave assistance that was essential to the completion of this *Reader*. *Lincoln Kirstein: The Published Writings 1922–1977: A First Bibliography*, compiled by Harvey Simmonds, Louis H. Silverstein, and Nancy Lassalle (New Haven, 1978), and *Ballet: Bias and Belief: Three Pamphlets Collected and Other Dance Writings of Lincoln Kirstein*, edited by Nancy Reynolds (New York, 1983), proved unfailingly helpful and precise sources of information; while Jonathan Galassi and Rick Moody at Farrar, Straus & Giroux were consistently patient and constructive. As for Mr. Kirstein, I can come up with no better acknowledgment of his tolerance and candor as he was squeezed between these covers than the one that first occurred to me, a heartfelt "Thank you."

*Nicholas Jenkins*

# I

# PERSONAL

# ASIDES

# Boston:
# Frames and Outlines

[*This essay, written during the mid-eighties, has not been published before. Towards the end of it, Kirstein records the sittings for a portrait by Martin Mower. Since then, he has been painted, photographed, or sculpted, by many artists, including Walker Evans, Gaston Lachaise, Isamu Noguchi, Diego Rivera (in his destroyed mural at Rockefeller Center), Pavel Tchelitchev, Lucian Freud, Paul Cadmus, James Wyeth, and David Langfitt.*]

SOCIALLY, my parents sprang from liberal, un-Orthodox Jews of northeastern Teutonic origin, intellectually and morally, from sources in Protestant Reformation, the Enlightenment, and the revolutions of 1848. Neither was a staunch Temple member; my father (usually without my mother) attended synagogue once a year on the Day of Atonement. My religion, such as it is, was bred by his explanation of the day's name: "at-one-ment"—not satisfaction with self, but the self's relative unimportance.

I was sent to Sunday school briefly, but it didn't stick; later I came to credit heterodox metaphysics, which my forefathers would have condemned but my parents tolerated. Although a prince of organized charity, for principles of patriotism more political than religious, my father refused to become an active Zionist.

Spinoza, Goethe, Schiller, Heine, possibly Marx supplied my grandparents' ethic. Carlyle's *Sartor Resartus* was by way of becoming their son's breviary; this boy, though, turned into no tailor but instead a master of merchandising. "The Tailor Retailored" might have fitted

better my mother's tribe. Her fortune came from emigrants to Geneva, New York, who cut and sewed uniforms (about which there were complaints) for the Union Army. Father's father was a lens grinder from Jena who, after 1848, exiled himself to Rochester, New York, and found work in the great optical factory of Bausch and Lomb. So, as one for whom the visible world is supremely important, I came by avid eyeing honestly.

Ancestral strains, aesthetic genes switched. A lens grinder's son had little visual curiosity save for the appearance of fine craftsmanship in men's clothing and haberdashery. A tailor's daughter looked at painting, listened to music (Wagner mostly), fascinated by domestic decoration, high couture, and lace. Thus, early on, I became sensitive half-consciously to what was well cut, well sewn, accustomed to standards of excellence in facture long before I had any notion of historical sequence, rarity, price, or need of ownership.

The poor boy, my father, managed to marry a rich girl, canceling her family's pretensions towards a worthier match. My parents shared approximate poverty for a decade, although in their Boston apartment, my mother set up a small "Turkish corner." My father joined an old firm of Scottish opticians, after owning a bush-league baseball team and enduring a couple of bankruptcies. Wisdom gained in rigorous experience eventually landed him a partnership in William Filene's Sons Company, a retail emporium inherited by Edward and Lincoln Filene. The name is not common; it derives from an emigration officer who translated the given name "Katz" by misspelling "feline." My ability to fondle and collect cats must have been preordained. As for names, it was often assumed I was called after "Uncle" Lincoln Filene, although no blood kin, a dear friend, rather than after the Abraham who was my father's idol. My father was instrumental in choosing the architect for a palatial new department store designed in the office of Daniel Burnham, Chicago's great city planner and engineer. Luxuriously planned for its period, it was hailed as innovative, even beautiful. Its "bargain basement," in due time, let me "collect."

After 1914, my father gained security, by which he could please himself. Nevertheless, he would keep a lean appetite for material possessions. He never owned real estate; the houses we lived in were always rentals. As far as personal "collecting" went, for him it was

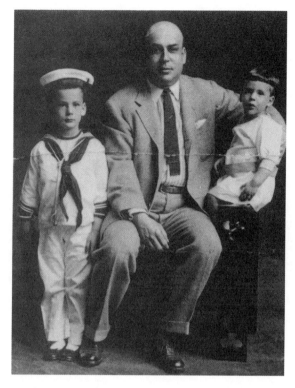

*Lincoln Kirstein (left) in his midshipman's uniform from Rowe of Gosport with his father, Louis Kirstein, and his brother George. Rochester, New York, 1910*

English suits, French shirts, cravats, and good golf clubs. There was a 1914 Rolls-Royce touring car which, with its faithful chauffeur, lasted twenty years. In the year war was declared in Europe, we moved to 506 Commonwealth Avenue, on the farthest domestic reaches of a thoroughfare which proper Bostonians of the late 1870s had laid out on a filled-in Back Bay, imitating Baron Haussmann's renovation of Paris by arterial boulevards.

I was seven when we moved to "506." For three years we had lived at "373" (Commonwealth), in a darksome railroad flat. It faced a shy statue of Leif Eriksson, discoverer of Vinland, made by a prudish spinster who modeled his figure on a woman; this was my first intimation of sculpture and its problems of verisimilitude. Our apartment house was "The Ericson," dim but comfortable. On its walls were

sepia photo-enlargements of the Parthenon, the Forum Romanum, Raphael's *Sistine Madonna*, Dresden (my mother's favorite), Abraham Lincoln, and Louis D. Brandeis, father's friend and lawyer.

Commonwealth Avenue from Public Garden to Massachusetts Avenue still boasts a number of fine Federal-revival or neoclassic homes and private clubs by the firm of McKim, Mead & White, but neither Charles Follen McKim nor Stanford White had planned the house we would inhabit. This was in a reduced version of their style, set opposite the Kenmore trolley station, at which cars emerged from the nation's first subway system. 506 Commonwealth was an address which might read as prestigious; the actual site was less so.

Its façade followed a restrained limestone solidity, without adornment except for a blunt cornice and generous bay-windows. It had half the space of an adjoining château, rich in memories of Chambord and Blois. In comparison, 506 was modest enough; today it might be considered a mansion. There was a big basement; the kitchen, with its massive coal range, linked by a dumbwaiter to the dining room above: laundry, furnace, storeroom; three floors for living, with a miserable fourth cubicled in raw pine for two maids, cook, and a laundress.

From the street, granite steps mounted to a small vestibule's mosaic pavement. Polished maple marched up to a foyer, at the side of which an oak staircase climbed three flights. It was owned by an absentee landlord, unseen forever: "Mr. Whitney," a bachelor who, after building it, shortly disappeared, depositing furnishings of choice and taste. Abandoning to lawyers their further disposition, his remnants became foundation for my fancy, or at least its frame.

Our absent landlord, "Mr. Whitney," must have known Spain. On stair walls, up to a second-floor broad landing, shone small oil paintings, copies of details from famous compositions by Diego Rodríguez de Silva y Velázquez, signed "José Villegas y Pacheco," all framed in blistered gilt. From a volume of my mother's (*Klassiker der Kunst*), I came to recognize each picture as a reduced portion of some larger work, achieved by brushes loaded with pigment. Parts of skirted infantas, grandees, dwarves, sleepy hounds stared back at my curiosity and wonder.

"Whitney," whoever and wherever he may have been, had preferred the genteel taste of his youth. Affluent as he probably was, he

owned little enough of the "right, real thing." In the corridor of what could have counted as his *piano nobile*, there was indeed a fine knobby late-Florentine *cassone*, over which hung, suspended by fat red tasseled cords, a life-size, coffee-colored copy of Titian's *"Bacchus and Ariadne (National Gallery, London)."* Gracing a bent flight of slippery stairs grazed a full dozen identically framed oblong views of cattle. Grim gray tree trunks, brown lank grass, chocolate and mustard cows were anonymously charmless but hand-painted. Above the dining-room sideboard hung an ample, beautiful, and luxurious homage to fruit, flowers, vegetables, fish, conch shells, and a dead rabbit, signed Melchior Hondecoeter. It was an original. Dry, flaking colors exposed fine-grained, pale, dusty linen beneath. Its condition was troubling. After all the labor in presenting an industrious vision of delight, no one seemed to have loved it recently. Pictures, one gathered, were neither impervious nor eternal, despite massive frames, rarity or cost.

My father's future now in fair promise, my mother decided to transform borrowed lodgings into her own. Whitney's lawyers didn't seem to care. She had her dream of what befitted a merchant-prince, while he was content to leave her free for whim, outlandish as this might prove. However, despite determination and energy, she allowed one single space, the first-floor foyer, to remain as found. This salvaged site, twenty-five feet square, led on its right to a parlor facing the street; to the left, the dining room. This room became fixed for me as the peak of domestic architecture.

Perhaps Whitney in Paris had encountered M. Marmottan, a famous collector of Napoleonic memorabilia, who founded a small but comprehensive museum later donated to his city. Napoleon's tactics, strategy, ingenuity, and taste made him master of Europe. Whitney had sampled his period's enormous mass production, and brought back a smattering of its output to post-colonial, late-Victorian, upper Back Bay Boston.

His foyer was *green*. Walls were hung with olive-green corded silk, tautly stretched from baseboard to cornice, bound in heavy galloon. The fireplace was paneled in fat, flat slabs of sea-green serpentine, its firedogs confronting bronze sphinxes. The mantel focused on the stiff smile of some marshal's mistress by a follower of Isabey or Baron Gros. Flanking the portrait were monumental Winged Victories bearing seven-branched candelabra of formidable authority from Thomire's

imperial foundry. A chandelier of similar character hung from chains which did not conceal the electric wiring. A verdant, plushy rug, edged by a Greek key, when stepped on left footprints as on crushed moss. Platoons of wall brackets and hardware had the sharp chasing and clean finish of sidearms, all evoking the stoic regimentation of forms by which Jacques-Louis David and the early Ingres summoned the spirit of Homer, Virgil, and Ossian.

Today, in comparison to the tidy restitution of "period" rooms in contemporary interior-decorator taste, Whitney's foyer might seem coarse. But to me, now as then, its knife-edge clarity still commands an alert chill, a metaphorical stand-to-attention. Firm, sharp, fixed, three-dimensional gilt-bronze ornaments, their vegetal tendrils crisp as celery, sculpted wreath, torch, shield, sword, and arrow, studding an ensemble in which strong plasticity echoed a lyric iconology. Ostentation was disciplined and puritanical, lean echoes of a Caesar and a soldier.

My visual appetite was quickened more by three-dimensional plasticity than by the spectra of color. Sculpture was firmly responsive to touch; for me the ultimate effect of craft was the immediate suggestion of form in space. Upstairs, in what had served as Mr. Whitney's "library," now our own living room, were set a range of glazed vitrines, which my father filled with his own books. Above glass-fronted cabinets containing complete sets of Plato, Dickens, Thackeray, Stevenson, Kipling, and Mark Twain there were centered electrotype reproductions of Pompeian bronzes, the *Seated Youth* (on a granite rock) extracting a thorn from his foot, the *Dancing Faun,* heads of Zeus and Homer, patinated sea-green. Parents were skittish about sex; their hired help were not. With appropriate gestures, our laundress noted the kinds of protuberance.

My mother transformed Whitney's master bedroom into a connubial pavilion. The fantasy effecting this mutation was so peculiar that it could hardly have been achieved through her notions alone. She was bewitched by a decorator assigned her by the firm of Irving Casson and A. H. Davenport, purveyors of perfect taste to a rising generation of Back Bay householders. It would have been logical to have replaced Whitney's huge double bed by twin singles, but quite unforeseen that she might transfigure the chamber with such unwonted abandon. Why this was countenanced or endured by her husband

remained one of several mysteries attached to a predominantly viable union. He could, in any case, afford her fun.

The room was not large. Ceiling was high, with two tall windows and a fair-sized fireplace, the whole some twenty feet square. The gentleman-decorator in charge resembled an Edwardian dandy cast as an aging juvenile in a stock company surviving on Wilde or Pinero. A seductive courtier; his hairline mustache, glazed wig, lips, and cheeks shone with thin waxen veneer.

This site finally filled seemed to explode as if hydroponic tomatoes had been hurled at stiff yards of scarlet slipper satin, drenching walls and furniture in crimson. Windows draped in lengths of heavy flat silk were crowned by pelmets snipped from a mandarin's embroidered coat. Encarnadined shock was further ensanguined by its contrast with black lacquered bedsteads and night table. A chaise longue was trussed so tightly in polished silk that one reclining might slide off it, despite an anchorage of heavy pillows with their plethora of fringed tassels interspersed by jade balls and ivory buttons. Exaggeration defied embarrassment. The total impression was awesome. Here was really nowhere at all to dress, undress, or sleep in. Fortunately, my father dressed, slept, and lived in it unperturbed. It was first, and last, my mother's "Chinese Room."

This did not exhaust her fancies, but her more sober whims served as decorating schemes for my sister's bedroom. These drew from Northern Italian farmhouses, rough-plaster "wumpsed" walls, coarse linen upholstery, burnt-umber painted woodwork. Where my brother and I slept stood commodious wardrobes, painted black, stenciled with birds, fruit, and flowers, recalling Bavarian hope chests. Not our choice, had we had any, but pretty and bright to wake up to.

I had no way of guessing it then, since I took my mother's taste as inspirational, but in fact she was, at one remove, adept and victim of a potent local sorceress and her lair. This was Isabella Stewart Gardner's Fenway Court, the Venetian palazzo that charged a number of Beacon Hill and Back Bay householders with glamorous dreams of domestic beautification, however dilute their pretensions to her valid glory.

To relegate "Mrs. Jack," as she would be known to those who never knew her, to the status of a dubious legend was easy but unjustified. Of those who have in this country "collected," she was surely queen. Her beautifully maintained house is her superb memorial. My

mother, like most Bostonians, was never invited inside during its *doyenne's* life. Mrs. Jack might be glimpsed Friday afternoons at Symphony Hall, or reported in her box at the opera with a lion cub on her lap. Once a year, on hands and knees, she scrubbed the Church of the Advent's pavement. Annually, Mass was said in her private chapel under a great painted window (from Chartres?) for repose of the soul of her ancestor, Charles Stuart, king and martyr.

As for her collection, it ranks with those of Morgan, Frick, Huntington, Mellon, and Widener, a jewel in the gilded age of tycoon acquisition. As distinct from, and in some ways surpassing, the personal ambiance of the richer amassments, her house itself was a wondrous mosaic of Gothic and Renaissance ceilings, fireplaces, floors, furniture, forged into space which was the perfect, if unlit, frame for miraculous paintings. This residue, left legally as immovable as a mastaba, still has the late-afternoon atmosphere of Henry James's and John Sargent's Venetian situations. Their letters to her lie enshrined in the vitrines of her tiled corridors. She had gathered around her a cozy circle of musicians and painters, native and international, whose careers were promoted, talents paid for, while it was common gossip that her feasts largely consisted of canned sardines and soda biscuits. Her famous portrait by Sargent in a uniform of severe black velvet, head haloed in brocade, pearls big as birds' eggs knotted around her middle, is still censed daily with bunches of Parma violets, just as when she plucked them herself.

Long before she began to buy in earnest, she'd encouraged a handsome young Lithuanian emigrant, just graduated from Harvard, who wished to study European museums, to make himself expert. In due time, Bernard Berenson would find her capital work by Fra Angelico, the circle of Botticelli, Piero della Francesca, and Titian, that hung so comfortably next to her Raphael, Rembrandt, Vermeer, and Velázquez, against random yardage of cut Genoese velvet. Her wit and spirit were magnetic. She loved chamber music and its makers. Streamers of orange-yellow nasturtiums hung three floors down from window frames salvaged from the Ca' d'Oro. Orchids, lilies, tulips, cinerarias filled the center court, brought from her Brookline greenhouses in season. She knew she was no beauty, but liked to watch what painters would make of her face and figure. Anders Zorn saw her caught abruptly in a doorway, smiling sunlight slashing across her

dress. Towards the end, her old friend John Sargent stopped by to make a dashing watercolor of her swathed in veils, casual, loving, all trace of wrinkles fused under transparent washes of dove-gray. She died at eighty-four in 1924, leaving her house open to the public.

During those years when I was first looking around, Mrs. Gardner's person and renown would be a summit of reference, although I never saw her, nor, until years later, saw what she had collected. Like many other magnets, she stayed at one remove, but still a powerful influence.

Even before I was sent to boarding school, I fussed with crayons and Higgins's India inks. Then I decorated class-book annuals and muddled with watercolors. However, it was not until I was a freshman at Harvard that I gained much sense of the rational process by which painted pictures were worthy of their frames. Here I met a teacher and person who coincided completely with what I wanted and needed. This was Martin Mower.

He was no "great artist"; I doubt whether he would have classed himself even as a "minor" master. But he was a well-equipped professional, combining the qualities of excellent artisan with sympathy, analytical intelligence, and high responsibility towards stewardship in his craft. For those who might have wanted to partake of what he knew and taught, he was their capacious invigorator. Only evidence of some student's chance flair triggered much more than his passive attention. It was perhaps odd that he cared to continue classes or that a college granted him tenure. Possibly it was because an academic faculty more attached to nominal attribution and historic theory rather than the actual production of paintings had lurking respect for one who, after all, knew something of digital procedure and mastery. Apart from the lasting gratitude of a few young men, hardly any of whom would pursue his path past graduation, there are relics from his hand still visible. A friend of Mrs. Jack Gardner's, he gave her gentle pictures; she must have bought a few. These were in return for music and conversation, access and closeness to work of masters who were his idols. She may have found him lovable in his intense, specific, but modest passion, for there was much discreetly heroic in his devotion to the basic materials of painterly tradition.

For me, he breathed an air of amiable wizardry. When I came to be adopted as more than a casual student, he could not have been

far from mandatory retirement. It was in his own studio rather than at slide lectures in art history at the Fogg Museum that I came to absorb what Harvard had to give. Recalled from the perspective of sixty years, he evokes a presence of silvery grays with soft accents of dull maroon. His square-cut head crowned *en brosse* with a full cap of pepper-and-salt, gray mustache, Shetland-gray jacket, gray suede slippers with small silver buckles, and a burgundy scarf secured by a big garnet, advanced an unapologetic though reticent elegance.

His worldliness was manifest in chill judgments, more acid than prim, told with an edged, low-voiced wit devoid of any tinge of self-conceit. Every so often some odd locution from an antique lexicon, set next to our vernacular, would astonish one into realizing he was alive to a shared present. "In fine," "in sooth," "betimes," "quip," "ilk," "ept," "girt," "fret," "pert," natural enough in print, on his tongue had a ruddy italic glow. Some pictures were "saucy"; some painters "couth," "tetchy," or "awry." This gave a quaint, questioning reversal to my riddles about modern art and its innovative character, which, at the time, possessed me. Most responses were a dialectical ambiguity. Exact answers were left to that future when decent data might with further viewing eliminate need for elementary definition.

Mr. Mower had seen so many jolly pictures and jaunty people that, while unwearied, he discounted what had become useless to his peace of mind. By succinct and aphoristic phrasing, he stopped careless attack, and his curt response would stay to broil in an innocent's amorphous mentation. How dared Martin Mower question the prestige of Manet or Maillol? Was, as he murmured, Cézanne all-thumbs clumsy or Derain awkward and dull? What licensed him to name Hals flashy or Rubens beefy? He put to test flocks of received ideas I'd been only too eager to make my own. Part of this was Socratic goading. I also heard him defend Cézanne watercolors as possessing the rugged virtue of Romanesque voluminous plasticity.

He dwelt in a charming house in an anonymous passage off Brattle Street. Its large skylit studio floor was tiled in red; light was controlled by overhead linen shutters. Two sturdy easels of oak, each with its glass-topped easel table, recommended that it was canny to have more than one project in hand at a time; dogged, doltish industry welcomed his only enemy: ennui. His aesthetic was prompted by an oft-repeated principle of pleasure. If what you painted did not delight yourself and

your patron—and the twain were always linked in professionally symbiotic balance—there was no point to a project. This insistence on "pleasing" sounded disturbingly unethical. Was not "pain" or "suffering" that which produced all "major" art? Mower was never daunted by self-doubt or dismay; he knew what was truly grand too clearly to be daunted by working in its shadow.

His own canvases were stacked slant against the walls. He did not stop me when I peeked to uncover decorative ovals scheduled to be installed as supraportes. Portraits of jolly children with pert pets or toys rested against landscapes which might have located actual sites but were really modeled on small arrangements of rock, sponge, and feathers (like Gainsborough's). The room was happy with boxed orange trees, potted orchids, climbing bougainvillea, and blue plumbago. There was an absolute absence of pinned-up reproductions or art books. He had a horror of photographic reproductions, which he claimed were the worst kind of betrayal, pretending that what one saw was a fact when it was but a demeaning echo. There were, however, some objects of oiled wood: square blocks, cones, pyramids, and globes. Half life-size, an antique mahogany lay-figure collapsed in a corner. A fine small armillary sphere, inherited from his late wife's astronomer-grandfather, was the single thing furnishing his space with any reflection of sunstruck brilliance. There were no shadows. Always freshly turned out, he painted without a smock in a quilted corduroy jacket with brass buttons. I had heard that Sargent attacked his dukes and duchesses in formal morning dress, ascot tie, tailcoat, and spats. Thomas Eakins was apparently a grubby worker, but he depicted a great surgeon operating in full civil regalia, ignoring his scalpel's enameling of ruby gore soiling starched cuffs.

Mower was a late-nineteenth-century admirer of John Ruskin, a splendid "amateur," and yet he himself was a professional filling the diminished demands of the twentieth. Crisp and unfaltering, he corresponded to requirements, however diminutive their necessity, without fuss, mussiness, or waste motion. There was no hint of what, incidentally or accidentally, might have been "felt." Feeling for him was de-selfed observation. Reticence was a feline nimbus; he had the house cat's placid glee in its independent satisfactions, its tongue a tender instrument, caressing form, fur, and tail.

So I asked him to paint my portrait. To mention price was a

hurdle for shyness. He needed no pay. Guessing my chagrin: "Oh, we'll tend to all that later. But, ah, what if you won't cherish it?" He grinned. "Well, well . . . so. For what ilk of icon do you itch?" His question was a further instance of instruction, involving psychology or morality beyond "taste" or "technique." He put me into a position of serving myself. What he could provide would be my choice of stance or style. Apart from the spread of pigment, his picture was to be my image of me. It might have been more flattering if he had simply taken over, assuming he had any clear opinion of a personality over its appearance. But no. He reduced his engagement to a minimum, forcing me to choose from an anthology of prototypes.

One among many uppermost in my memory was Sargent's smashing *Graham Robertson*, a slight youth in a long morning coat fondling a slim jade-handled cane, his dog with its creamy ruff licking sleek patent-leather slippers. A trophy of London's Tate Gallery, it is a consummate report on Edwardian dash and polish. Particularly fascinating was a flash of green on the ebony stick's translucent jade handle, brushed on in one full sweep with firm economy. An epitome of high fashion in high Bohemia, ironically embodied in an immature man-of-the-world, this presumptive dandy was the kind of man a boy like me longed to become.

Photographs were taken in several disguises, so Mower might tell me which was most appropriate. These were rather theatrical, a figure posing for Raeburn, Romney, Sir Thomas Lawrence, or indeed Sargent. Oscar Wilde said that youth may be forgiven its affectations; it's only trying on masks to see which might fit. Mower's portrait did not result in quite what was hoped for or expected. He continued my technical education by a further lesson in techniques used by Titian, Tintoretto, and Veronese. The full-length body was brushed in *grisaille*, a gray-green monochromatic underpainting, then glazed in a restricted gamut of pinks, reds, and brown. The finished body, face, and riding boots (it was an equestrian portrait minus a mount) shone in wan but ruddy health, not exactly vacuous, but any close facial likeness summarily sketched. Even more sobering was his decision, since the canvas seemed to get too big (as he said) for my boots, to slash it to a rectangle framing only the head. I was forced to concede this didn't show much character. There was little more than neat reminiscence of previous portraiture, rather than much identification

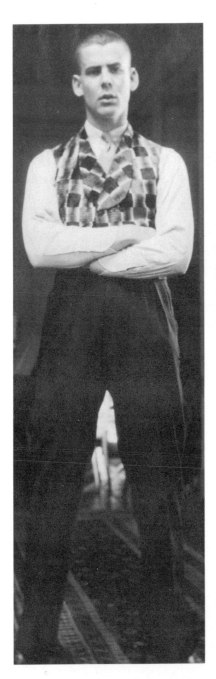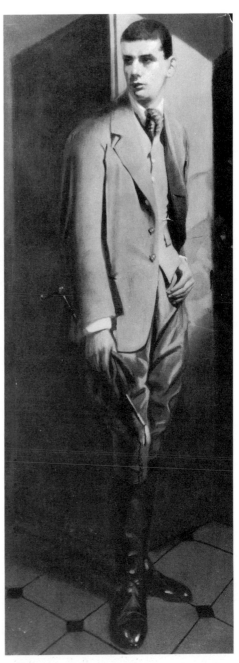

*(Left) Cambridge, 1927. Preparatory photograph for the portrait by Martin Mower. (Right) The original full-length version of* Lincoln Kirstein *(1927; partially destroyed) by Martin Mower; oil on canvas*

with my facial particulars. I paid him with a fine antique carved oak frame which I thought might redeem the varnished face. As for style, it was far too elaborate for the head. So Mr. Mower accepted it gratefully with delight and later filled it with his own superabundance of fruit and flowers, with all the charm, candor, and bravura he'd failed to find in me.

However, this first commission had its uses. Later, when I came to sit for sculptors and painters I abdicated from any preconception. It was not that Mr. Mower had failed; he had succeeded in developing my judgment to the point of my being able to realize the little there was in his subject. I learned some of the worries attendant on obtaining a "likeness" more than the fractious crux in verisimilitude. Was it not Sargent (or Whistler, or every professional portraitist) who said: "A portrait is a picture with something wrong with the nose (or eyes, or mouth)"? Was it not Michelangelo who teased a Medici by telling him he need not trouble how little his carven head resembled the patron's; after death, which would be remembered?

# A B C

[*In the foreword to* The Poems of Lincoln Kirstein *(New York: Atheneum, 1987) the author explains: "I never aimed 'to be a poet.' I liked to write verse; this was always play with no pretension. . . . I was attached to history in its passage and as I passed through it. Failing as dramatist or screenwriter, light verse served instead, with its game enhanced by rhythm, rhyme and metric." Functioning as a kind of diary, many of Kirstein's poems ponder significant, and otherwise unrecorded, events in his life.*]

War leaves some half-shot young men
Who wage it, get wounded, and then
Take long aimless walks through the night.

I learned this, if I recall right,
Somewhere between twelve and thirteen,
When, precociously keen,
My family all safely asleep,
I dreamed up appointments to keep,
Got up and got dressed in the dark
To walk down that broad strip of park
On Commonwealth Avenue,
Block after block through light dew.

Elms fanned above the wide mall
Giving scale to their big and my small;
Street names spelled an odd alphabet
Whose rubric I'll never forget:
Arlington, Berkeley, Clarendon,
Dartmouth, Exeter, Fairfield, on
Past Gloucester to Hereford, where
I picked up a well-deserved scare.

A trench-coated man tapped a cane—
Canadian ex-soldier in pain
Inhaled the dank airs of the night.
Like me, he couldn't sleep tight.

My prowls in a tom-kitten youth
Pursued some vague personal truth,
Though often my daddy warned me
Against living dangerously:
I was not to risk the fierce morn
Nor discover how or why I was born.

Yet here I was early, and met
A sleepwalking loony. You bet
He was bats: a classical case
Since he lacked a third of his face.
His folks owned that château and tree
This side Fairfield at Newbury.

I shadowed him mutely around,
Out of sight but not out of sound,
Though he was too far gone to care
For some curious kid staring there—
Shy me playing sly Sherlock Holmes,
Protecting the health of our homes
From a typical type of shell shock.
If only two fellows could talk.

But he was oblivious of me
Envious of maturity;
Me drawn, hot, aching, and wild,
Half a man, to him, half a child—
Me plotting great war books on where
"Over the Top" 's "Over There,"
Though I'd been nowhere but here,
Damp in teenage erotics of fear.

I stole strength from his adult shell shock
Past each alphabetical block.
A-B-C spells L-O-V-E:
Mayn't I magic his blindness to see?
I wasn't his dad nor his son;
My own epic had barely begun.
Hence I was content me to stalk
My wounded stag rock over rock:

Exeter, Dartmouth, Clarendon,
By Berkeley to Arlington,
While he led the perilous way
Past Arras, Bapaume, and Cambrai.

# Forty-eight Years After: Hound & Horn

[*This memoir was first published as the Introduction to* The Hound & Horn Letters, *ed. Mitzi Berger Hamovitch (Athens, Georgia: University of Georgia Press, 1982).*]

I GRADUATED from Harvard College in 1930. I'd lived in Boston, Massachusetts, since 1912. It is perhaps hard to understand the feeling that I still have about Boston—and Cambridge. When I went to school, the nineteenth century was only terminating its cultural and intellectual hegemony. I felt and feel I am a man of the nineteenth century. Although Harvard was in few ways comparable to Oxford or Cambridge of the same epoch, I consider I had a "classical" education—of a kind—and so did the young men with whom I came to be associated in several thoughtful pursuits. Most of us took our formation from Harvard as it existed before the "House System" was instituted in 1931, when I was leaving Cambridge. But when I was a freshman, and for some four years after, the minds I most admired were still under the influence of Charles William Eliot, Charles Eliot Norton, George Santayana, John Livingston Lowes, Alfred North Whitehead, Charles Grandgent, and Irving Babbitt. Reading Ms. Hamovitch's kindly words documenting some of our efforts, I find myself brought face to face with a character I have trouble in recognizing: myself. The casual reader may be brought to believe that one of the founders of the magazine under survey was one of a corps of intellectuals. In a very real sense, I personally never had intellectual pretensions. I started the magazine as a "Harvard Miscellany," intending it to be a kind of

historical or archaeological survey of a site, its buildings, traditions, and the men who made them. That it developed more broadly was not, at first, foreseen by me. I abandoned the magazine after seven years, not entirely because my interests had altered and I was otherwise magnetized (by the ballet). The real reason I did not fight to continue *Hound & Horn* and made only feeble efforts to have several interested groups pick it up was that I didn't give a damn for politico-philosophical tendencies which I felt were devouring the magazine's space, and I was neither equipped to deal nor interested in dealing with them. I felt inadequate, and still do, with those delighted by ratiocination, with energies that mentate as sport.

I was an adventurer; *Hound & Horn* was my passport. If the truth were known, and, at a time when burgeoning "modernism" was a mandatory stance, my idiosyncratic models were Balzac's Lucien de Rubempré, Bulwer-Lytton's Pelham, and Benjamin Disraeli's Coningsby. I wrote an (unpublished) romance entitled *Choice of Weapons*, which portrayed the luxurious perplexities of a contemporary young dandy, a provincial who would conquer the great city. This character couldn't decide who or what he wanted to be or do; the fun was in the choice. Should he become a diplomat (like Harold Nicolson, whom I knew and admired), or a painter (like John Singer Sargent, with whom my father had contact), or a poet and/or critic (like Conrad Aiken and John Brooks Wheelwright, who were advisors). Wheelwright was my strongest mentor; an architectural critic, a Brahmin of Boston's best, an Anglican Trotskyite, and a most interesting theological poet, he knocked a lot of ambitious nonsense out of my head and told me life was not a career but a service.

In 1926, my freshman class was addressed by Harvard's president emeritus and editor of the famous five-foot bookcase of the World's Best Books. He was very old, very eminent, very tottering. His advice to the rich and clean young gentlemen already tenderized by St. Paul's, St. Mark's, St. George's, Phillips Exeter, and Phillips Andover (with a few from the Boston Latin School) was *"Flee introspection."* I wasn't listening with great attention. At first I thought he said "Free introspection." No—he reiterated: "Flee introspection." Over the years I mused on that accumulation of sagacity which prompted such drastic advice and tried, on and off, to arrive at what he intended. Advising a crop of rich youths to avoid self-examination, if that's what he meant,

was barely necessary. The boys I knew didn't take drugs, at that time, but they certainly drank, like fish. I would, in the next four years, meet few undergraduates who could be tormented by self-examination. Most were on impalpable launching pads, which Harvard has never been slow to provide, that would propel them with minimal deviation into their destined and ultimate operations. They would be occupied by business, the law, medicine; a few might teach. The very notion of introspection was almost as alien to the majority as political, visual, or musical curiosity. They were (the ones I knew and liked) physically brilliant, self-assured, charming, mannerly, gentle, good-natured, and kind. They had absolutely no idea of, or interest in, *Hound & Horn*. My occupation with the magazine, which took about half my time (at the expense of decent academic grades), was in a world apart. It was diverting to pass from one world to another. I imagined the other world resembled the Harvard class of 1859, whose members included the friends of Henry Adams and Roonie Lee, in those halcyon days when a Bostonian and a Virginian were still friends just before war. Not that war, or even the Wall Street crash or the Great Depression, ever impinged on our conscience or consciousness. But the boys, who in my time knew one another as "The Lads," belonged to a Hamiltonian dynasty of the rich, wellborn, and able. As for their ability, I never knew what happened to them; when I played with them, their charm seemed a kind of genius which spelt unlimited possibility. As for what they thought of me—they didn't think of me, or anything else. But I should say that they, as a class or representative group, were neither stupid nor snobbish; they were, according to those who would make *Hound & Horn* whatever it became, mindless. Not only had they fled introspection; their innocence, animal spirits, instincts, and endowment lacked any mechanism with which to manipulate abstract notions, for they saw no reason to occupy themselves with anything unnecessary to their satisfactory and circumscribed physicality.

My co-founder and co-editor, Varian Fry, held "The Lads" in high contempt. To him, they were the enemy. He was an excellent Greek and Latin scholar, a formidable pianist with a good background in elementary philosophy. This was before the age of Wittgenstein and Popper. When I told him I was auditing Professor Whitehead's course in metaphysics, Varian said that contemporary philosophy was nothing but epistemology, and I shouldn't try to put my abstractions in order

since I was as incapable of rational analysis as the dumbest of "The Lads." He was quite right; when *Hound & Horn* began to fill itself up with quasi-political or proto-Marxist exegesis, I became increasingly uncomfortable. It would, of course, be an inverse sort of vanity to insist on one's being feebleminded. But I could only feel myself attracted to what I personally could use. Later, when through Jack Wheelwright, Eliot, and others I became interested in Christian theology, it was poetry rather than the dogmatics which inspired faith. Reviewing Kierkegaard's *Either/Or*, Wystan Auden wrote: "In contrast to those philosophers who begin by considering the *objects* of human knowledge, essences and relations, the existential philosopher begins with man's immediate experience as a *subject*, i.e., as a being in *need*, an *interested* being whose existence is at stake."

As for visual taste and the interest *Hound & Horn* manifested in painting, sculpture, and architecture, as far as I was concerned it came from an intimacy with the magnificent palace of the Boston Public Library, of which my father was, for many years, president. The splendor of design and craftsmanship in one of the greatest of many great buildings by Charles Follen McKim and Stanford White still shared, fifty years ago, in the brilliance of its original conception. My father was responsible for the cleaning of Puvis de Chavannes's murals, and he spoke with John Singer Sargent over the completion of his wonderful vault depicting comparative religion, now shamefully ill-used and defaced. While the library had been planned in the old century, it represented to me the apex of concrete perfection in a rational material plan, on the highest level of imaginative competence, from Edwin Austin Abbey's series of Arthurian murals in the Delivery Room to Louis Saint-Gaudens's golden marble memorial lions on the grand staircase, the inlaid brass zodiac in the entrance hall, and the richness of the mahogany paneling in the Directors' Room. While McKim and White looked back to Leon Battista Alberti and Giacomo da Vignola, so Professor Grandgent made Dante a contemporary voice, and while Sargent was the antithesis of painting that our Harvard Society of Contemporary Art fostered in an effort parallel and comparable to the magazine, it was neither Pablo Picasso nor Henri Matisse who was my model, but rather Hans Holbein, Corneille de Lyon, and Jean-Auguste-Dominique Ingres.

As an adventurer, on a small scale, I embraced the advance-guard

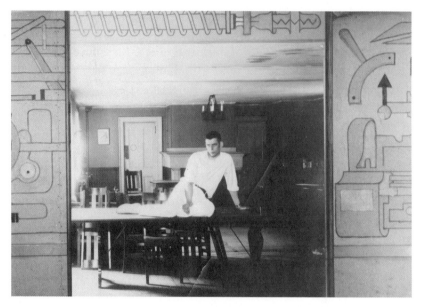

*Lincoln Kirstein in the dining room of the Harvard Liberal Club
in 1928, surrounded by elements of his final mural, a vision of
machinery reproducing itself*

taste of Alfred Stieglitz and progressive Manhattan galleries. Essentially
this was opportunism. The fun was in the energy expended in a cru-
sade, and the opportunities this afforded to have contact with movers
and shakers. I curried favor with Ezra Pound, although apart from his
oft-quoted passages, I could never make head nor tale of the *Cantos*.
As for the Southern Agrarians, their economics seemed childish, their
regionalism stubborn and perverse, but I was daft about the ambiance
of the Civil War and was deeply in love with both General J. E. B.
Stuart and his tragic young aide, Major John Pelham. I had toured
the principal Virginia battlefields and extravagantly admired Allen
Tate's "Ode to the Confederate Dead." In fact, my natural bent towards
historicity, my consciousness of a living past, was reinforced
by a very active and beautiful familial society which extended from
Beacon Hill in Boston to Shady Hill (C. E. Norton's old home),
Cameron Forbes's estate in Milton, and the lovely houses of Shaws,
Lowells, and Ameses in Concord. In our late twenties, my nineteenth
century was indeed alive. Identification with a society of living and
thinking New England dynastic actors gave a security and assurance

prompting freedom of action, a sense of inevitability of possibility achieved which I do not think any other locus in America then offered.

Wheelwright was also a poet, although a very eccentric metrist. His architectural training, his residency in Florence, his assumption of authority as a man of the world as well as being heir of Adams, Brooks, and Chardon, kin to half of old Boston, and his attachment to the odd orthodoxy of the Cowley Fathers, brought me closer, at least in thought, to T. S. Eliot, who, more than any one person, was responsible in my mind for the pattern of what a magazine might be— when I came to be conscious of what that was. His magazine, *The Criterion*, was indeed, for me and many of my generation, "a standard of judging; a rule or test by which anything is tried in forming a correct judgement respecting it." I was fifteen years old, in boarding school, when an older friend, a senior on his way to Yale, gave me a copy, Volume I, Number I, of a new magazine. It had no pictures. Its contents included an essay on "Dullness" by George Saintsbury, a sketch of a novel by F. M. Dostoevsky, an essay on Tristram and Isolt by T. Sturge Moore, and a longish poem entitled *The Waste Land* by the magazine's editor, T. S. Eliot. It is impossible to recapture the effect this work had on me and my friend. We had no education in *The Golden Bough* or *From Ritual to Romance*; the poem then bore neither notes nor the dedication to Ezra Pound; it was quite unexplained and inexplicable. But it was magic; it seemed to fuse past and present, to make certain assertions about renewal or repetition of seasons and epochs. It became a text from which we quoted at increasingly frequent and inappropriate moments.

In school I had written a certain amount, but I had had no real desire to be an "editor." *The Criterion*, later *The Dial*, were models of what magazines might be; both seemed so elevated and comprehensive in their spectra that, at the start, *Hound & Horn* aimed to have been, modestly enough, a mere "Harvard Miscellany." But we printed a trial issue and secretly hoped that somehow it would please Eliot. Five years after I first read *The Waste Land* I was taken to a *Criterion* luncheon in London by the scholar and critic Bonamy Dobrée. Mr. Eliot was charming; he did not need to frighten me; I was already scared—but he promised help. I imagine that Dobrée eased my way. In any case, Eliot seemed to me, at the time, the most important authority in the world for anything and everything that could

occupy me, and strangely enough this included theatre. Those who read his essay on Marie Lloyd and the English music hall will recognize the scope of his theatrical appreciation, while this was years before his own plays. Varian Fry and I manfully campaigned to get Eliot appointed to give the Charles Eliot Norton lectures; we were tolerantly laughed off; not until years later did he come to Harvard for exactly this purpose.

It must appear that I had little contact with "life," or rather that *Hound & Horn* at its start was a rich boy's dilettante toy more than a genuine literary assemblage or an aspirant to academic experiment. My father felt I should not enter college without some knowledge of "life" as he had lived it in his youth. He was a poor boy who lived by his wits; his father had been a lens grinder from Jena who had emigrated to Rochester, New York, after the troubles of 1848. Father and son had a large sense of craft; lens grinding is something of a jeweler's trade. I wanted to be a painter, preferably a portrait painter (like Sargent or Holbein), but I found myself in a stained-glass factory which turned out windows for the National Cathedral in Washington and St. John the Divine in New York. I designed some roundels with figures of jazz-band players. They were conceived after the renderings of Viollet-le-Duc, but I had been given *Mont St. Michel and Chartres* by my sister, who as a graduate student at Radcliffe had finished a dissertation on Henry Adams; I felt comfortable combining the thirteenth and twentieth centuries. More important, I became involved with the craftsmen and manual laborers responsible for making stained-glass windows. Situations arose which led towards the unpleasant eventuality of a strike. Although I was an unpaid apprentice, nevertheless I could not help taking sides, identifying myself with a man who had befriended me and who was the leader of the labor action. I had assumed that beauty was imagined, invented, or created in "beautiful" surroundings or under "beautiful" conditions. We know the Hans Christian Andersen story of the flower pot and the flower, the furnace that fires the clay, as well as the dunghill that breeds the blossom. I had some sleepless nights trying to decide how, or what, to risk in the dispute over wages and conditions. I found, of course, I had nothing to gain or lose and it made absolutely no difference how I acted about what I felt. Anything I suffered or agonized over was sheer luxury. And yet the atmosphere in the shop was ugly, my presence embar-

rassing (to me), the issues obscure. However, I did get inklings of human extremity, degrees of despair. These, then, I found, as well as words well arranged, also contributed to "literature." So, in a way, my education started before I was a freshman, and a certain confidence in being able to talk with and feel for more than one class of person was useful.

I mention this in order to explain my degree of interest in the nature of Marxism, articles about which began to get themselves printed in the later years of *Hound & Horn.* As for the philosophical or economic basis of Marxist theory, or the position of its various factions or political stratagems, I never gave a damn. But I did become involved with some individuals actually in the field, who interested me personally. There was a Southern boy, an organizer of sharecroppers, of whom I saw a great deal. He seemed to me an updated representative of confederacy of the same ilk as Stuart or Pelham. I was more interested in people than notions, and hence it was almost a relief when the magazine was terminated. However, if serving no other purpose, it was educational. It did provide a passport of a kind which was to be used on less flabby material. It also left me highly critical of similar ventures, for I note in them the tendency to which we also were susceptible, mutual self-service and support of coterie predilections.

I recall very little of individual editorial conferences. I remember, in the first years, driving up to Portland, Maine, to read proof at the Southworth Press, under the direction of Fred Anthoensen, a printer of taste and sympathy for our not very lucrative contract. I spent a considerable amount of care on format and decorations. The Widener Library's rare-book room, which encased the fine collection of young Harry Widener, and the course in book design led by George Parker Winship made us conscious of the importance of the looks of a page of print. Eliot's *Criterion* was designed (and published) by an eminent English printer, R. Cobden-Sanderson, although his presentation was far chaster than ours. Rockwell Kent, whom I then admired as a latter-day William Blake, made decorations for us at what he called "children's prices"; later, W. A. Dwiggins drew some printer's "flowers," which I thought very pretty and other editors felt very silly. My own silliness increased in mathematical proportion to the emphasis on Humanism, Agrarianism, and Marxism. Varian Fry was tacitly ex-

cluded early on as being "impossible," and he left. I really had little
to do with the magazine in its last years, except to fulfill ordinary
obligations and to pursue the inertia of habit. There is a good short
essay (about as long as its subject is justifiable) in the Yale University
*Gazette* for January 1965 which anatomizes the intellectual skeleton
that projected our tables of contents. It was by Leonard Greenbaum,
then an assistant professor of English at the College of Engineering at
the University of Michigan at Ann Arbor. This was the first historico-
critical piece about the magazine that had an impersonal stamp; he
called *Hound & Horn* "an adventure in ideas." I have called myself
an adventurer, but with myself the adventuring was more with people
than notions, although the people may have been characterized by
congeries of ideas entangling them.

I remember several hideous scenes involving refusals of contri-
butions, misplaced and unacknowledged manuscripts, unpaid bills,
and disagreements about payments to needy or politically important
contributors. The concluding article in a series by Adrian Stokes, a
writer on the Italian Renaissance promoted by Ezra Pound and sub-
sequently an art historian of note, was killed by me, for no other reason
than that I felt it unreadable. After the magazine accumulated a fragile
reputation of its own and began to be taken seriously (up to a point),
I withdrew, both out of a sense of inadequacy facing the dominant
interests, however divergent, of Bernard Bandler, Richard Blackmur,
and the contributors they preferred, and because they bored me. I was
not very responsible; I felt that the pieces, reviews, or verse that I wrote
myself, which essentially interested neither of them, must seem friv-
olous. I have described elsewhere how Bandler aspired to be (after
college) a new Aristotle. Actually, he turned out to be a distinguished
psychiatrist, but his intellectual ambition was daunting. Dick Blackmur
worked in Maurice Firuski's excellent Dunster House Bookshop and
conducted informal seminars with undergraduates who came to find
the latest books recommended by *The Criterion, The Little Review,* or
*transition.* Firuski loved fine printing and published limited editions,
beautifully presented, of texts he admired, older ones by George San-
tayana and new ones by the promising Archibald MacLeish. Blackmur
had the day-to-day burden of keeping shop. The Dunster House Book-
shop was of the same rare quality as Heywood Hill's on Curzon Street,
Basil Blackwell's in Oxford, and Terence Holliday's on Forty-ninth

Street in New York. Such shops, which were also gathering places of men interested in ideas, seem hardly to exist today, even on the university level. These were less "advance-guard" than a place where the best of the academic energy was available as lively amenities.

Dick Blackmur wrote lucubrations on smallish white paper pads, in a hand that was not crabbed but miniaturized, square and clear. There was no crossing out or emendations; his notes always stood ready for the printer. One day, he protested when I said he was the best-educated man I'd ever met, and the reason for this was that he'd never been able to go to Harvard. Nevertheless, this was a deprivation that troubled him through his life, and my flattery, and that of others later, was small consolation. He rejected the compliment bitterly, saying he could not teach himself Sanskrit. At the time, I had no notion of why Sanskrit was important; to me the whole subject of semantics or linguistics was about as germane to my idea of fun as Thomist philosophy. I loved the persona of Eliot but rarely knew what he was talking about. Blackmur ended up at Princeton; I prized his poetry more than his prose and am happy his poems are now published. They are poignant and precise, concentrated and elegant. He was a great influence in our minuscule world, and his handwriting—cramped, delicate, and precise—perfectly reflected this influence.

In writing this note, I have found it necessary to make a distinction between what I personally felt about *Hound & Horn* and whatever intrinsic or objective value the collective activity of seven years at a certain juncture in a particular place may have had. Ms. Hamovitch's selection of documents is probably as representative a reliquary as can be managed. For myself, it seems mostly juvenilia; what I prize most in recollection is the encouragement, advice, and friendship of half a dozen collaborators. The magazine helped me clear my mind and decide on several things I finally found that I did not want to do. It provided a series of heady flirtations with current fashions in thinking; more important, it gave one a sense of the vitality of a few working intelligences who were interested enough in general principles to apply these to particulars. The magazine, which at its start called itself a "Harvard Miscellany" and dropped this title later as jejeune, was indeed exactly that. Without Cambridge it could not have happened. At least nothing like it was to appear in New Haven, Princeton, Chicago, or Ann Arbor. The magazine could never compare in quality to *The*

*Criterion* under Eliot, *The Dial* under Marianne Moore, *The Little Review* under Jane Heap, or *transition* under Eugene Jolas. It borrowed elements from all of these, whose editors were senior to ourselves. Looking back, I most regret our rejection of Hart Crane's "The Tunnel" section from *The Bridge*. Perhaps I learned most, at least whatever good I may have done in writing verse, from Yvor Winters. My most constant stimulation and awareness of discovery came from A. Hyatt Mayor. The single piece prompted by myself which I feel does me most credit was a translation of some of the great *sura* of the Koran, done by an anonymous scholar whose heavy effect on me determined the structure of my subsequent development. *

---

* [See "Twelve Surat of the Holy Quran," tr. Abu-Ali George Khairallah and Payson Loomis in *Hound & Horn* (July/September 1934). —Ed.]

# Carl Van Vechten: 1880–1964

[*First published in the* Yale University Library Gazette 39.4 (April 1965).]

I MET CARL first in the spring of 1927, at one of Muriel Draper's famous Thursday evenings, in her loft over an old coach house on East Fortieth Street. He looked like a large, blond, faintly Churchillian baby, and he wore a red fireman's shirt. I was a freshman at Harvard, so I assumed he must be a fireman. I had only just been introduced into New York's High Bohemia, and it seemed entirely natural that at Muriel Draper's one might encounter, along with Mr. Gurdjieff, Langston Hughes, Edmund Wilson, Gilbert Seldes, Paul Robeson, Mary Garden, Mabel Dodge Luhan, and Richmond Barthé, an angelic (real) fireman. I had been in love with the idea of the Russian ballet since 1916, when my parents thought I was too young to see Nijinsky. Carl was the first person who told me how Nijinsky danced, in such a manner and with such intensity that I often used his description later as a personal lie, pretending to have experienced this dancer, who, in real life, I had never seen. Yet, somehow, I never, at least to myself, felt myself a liar. I had merely used Carl's eyes.

Carl Van Vechten told me and taught me many things, the most important being a sense of the individual, idiosyncratic authority of elegance as style. Dictionaries define elegance as a refined gracefulness, propriety, a stoic expression of fastidious taste, especially when richness and refinement combine. We recall the twenty cravats Beau Brummell spoiled in a morning before he tied one that suited him; Brummell

introduced the daily bath to the British gentleman, although he was not born one, and he imposed on modern fashion the supreme authority of black-and-white civil dress. Carl was a dandy. He will be by no means the last of the American dandies—today we have Cassius Clay—but he understood elegance in a way few Americans have conceived it. Alone, before Carl, one might cite Edgar Allan Poe, or perhaps rather Poe, the American, as translated by Baudelaire. Carl had been educated by Paris far more than the University of Chicago. Cedar Rapids plus the Champs-Élysées makes a bubbling mixture. His description of the first night of Stravinsky's *Le Sacre du Printemps* (May 29, 1913) [see pp. 106–7 ] is a classic of on-the-spot reportage.

Cocteau, whom Carl resembled in so many ways, once called the entire process of art "the rehabilitation of the commonplace." Carl, disguised as a fireman at Muriel Draper's, now introduced me to a young Negro vaudeville dancer. He was the first Negro with whom I had ever had a personal conversation. I was unable, raised in Boston, insulated by Cambridge, to imagine that there was in the world this day, not to say in Manhattan alone, a magical jungle called Harlem. The dancer, whom Carl had helped with lessons and cash, was as odd, attractive, and exotic to me as a black unicorn. He was a mysterious animal from the lands above 125th Street, where dancers of the gift, passion, and ability of Nijinsky were born and grew up, even though they lacked opportunities of imperial patronage and proper academic instruction. Carl was my Dr. Livingstone. He helped me explore the marvelous dark continent where shone those magnificent palaces, the Savoy Dance Hall and the Apollo Theatre. It was a Harlem then oddly unresentful, open and welcoming to the Prince of Wales, to Miguel Covarrubias, to Muriel Draper, and to all writers and artists who recognized in its shadows the only authentic elegance in America.

Now that we have the horrible conflicts of racism on our hands and shoulders, it is well to remember those pioneers of the color E. M. Forster calls (in *A Passage to India*) "pinko-grey," who early in the history of a national movement sparked the present tremendous crusade. Carl was, when one analyzes it in terms of cultural history, perhaps the most important figure in the movement since Booker T. Washington, who, at the invitation of Theodore Roosevelt, was the first of his color to be dined officially at the White House. Recently I was in Boston, and again looked with amazement and tears at the

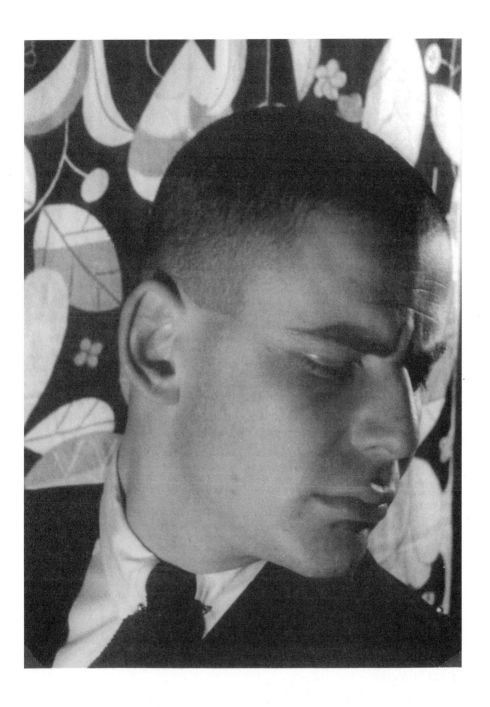

*Lincoln Kirstein photographed in Harlem by Carl Van Vechten,*
*May 8, 1933*

magnificent memorial erected by the State of Massachusetts to Colonel Robert Gould Shaw, the young New England aristocrat who at his own expense recruited the first volunteer regiment of ex-slaves for the War between the States, who sustained his regiment for long months when the federal government denied them pay, and who was buried in the common ditch with three hundred of his men after the terrible assault on Fort Wagner [see pp. 356 ff.]. Carl Van Vechten was too old to march to Mississippi last summer, but many who marched, even if they never could have suspected it, were surely spiritually reinforced by Carl's long labor and delight in the preservation, revitalization, and promulgation of everything that is splendid in the depth, grandeur, tragedy, and brilliance of the Afro-American tradition.

Carl made Harlem real to me; it was not the tragic Harlem we know now. It was a Harlem far more parochial, private, remote, less dangerous. To us, Harlem was far more an *arrondissement* of Paris than a battleground of Greater New York. It was the Harlem of Josephine Baker, of the *Blackbirds of 1926*, and of Ronald Firbank's *Prancing Nigger*. E. M. Forster, who from his experience of an imperialist civil service in India knows more about race relations than many politicians and sociologists, called Ronald Firbank "that iron butterfly." Carl adored Firbank, and in *The Tattooed Countess*, in *Nigger Heaven*, and in *Parties*, one finds that same deceptive understatement of the fantastic, ironic, and outrageous, which in its irony holds a certain pathos, and whose brilliant flashes have black shadows. Firbank and Van Vechten are far more "serious" writers than more ponderous contemporaries, and their social comment cuts far deeper than the doctrinaire compassion and protest of the thirties and sixties.

In so many ways, Carl was responsible for the early recognition and triumph of American jazz and jazz dancing in France, and then throughout Europe and the world. His early studies of Stravinsky (whose interest in "ragtime" dates from before 1916), his expositions of Debussy's *Jeux* and Erik Satie's piano pieces gave American critics a courage to face new sounds, which although they heard them on their own doorsteps they did not recognize as art, but only as "folk" or "primitive" expression.

I remember coming home quite late one night in Paris. It was 1929, the last season of the ballets of Diaghilev. I was stopped by an English lady, slightly squiffed on champagne, who asked me gaily:

"*Où est la rue Josephine Baker?*" I said I didn't think there was one. She affirmed, pointing a positively insisting finger in the general direction of the Pantheon: "There will be. There will be." New Yorkers should borrow the Gallic custom of naming streets for persons rather than numerals. Someday there should be a Van Vechten Plaza in Harlem, and placed on a marble shaft, Gaston Lachaise's superb bust of him (which is in the Chicago Art Institute—one of the many munificent gifts which Carl made, during his own lifetime, of his personal treasures). Lachaise told me once, after a session with Carl: "*Comme il est magnifique; comme un empereur romain!*" Carl saw the surprising in the ordinary; he found, perhaps first in any articulate degree, the natural flair, the talent for rhythm and expressiveness, the joy, the fire, the murder, and the verbal accuracy in the vernacular in the day-to-day life of Harlem. He made it his own, and ours. Like everything else that interested him, he understood its essence, he analyzed its sequence, its influence by documents. Carl was a child of the nineties, who became The Man of the twenties, and a sage in the sixties. He was of the tribe of Beckford and Horace Walpole, who not only made taste by their own but left an inheritance of real objects, and but for their love of possession, or rather their stewardship, the National Gallery in London, the New York Public Library, and the Beinecke Library would be the less rich.

From Carl I learned the elegance in the ordinary. I first through him saw that an American had far more to do with baseball and jazz than grand dukes and ballerinas. The fact that George Balanchine's first professional work in the United States was not with a ballet company but with the last edition of the *Ziegfeld Follies* and with the marvelous musical comedies of Lorenz Hart and Dick Rodgers was due in some part to Carl. Balanchine had been Americanized long before he left Russia in 1924. He, like Stravinsky, had a passion for American popular music. That Gertrude Stein prized Carl so highly was natural and logical; the American domesticity which, so magnificently cooked up in her Paris kitchen, resulted in the two veritable masterpieces of American opera which will hold a permanent place in our lyric theatre, Virgil Thomson's *Four Saints in Three Acts*, a ritual valentine of grace, faith, bliss, and order in Harlem, and *The Mother of Us All*, the tragedy of the failure of the American suffragette.

All of us know of his public, and some few of his private, gen-

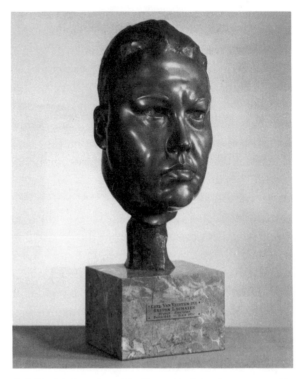

Carl Van Vechten (1931) *by Gaston Lachaise; bronze on marble base*

erosities. His qualities are so alive, we feel little diminishment in his extravagancies. He adored the preposterous, and shrank pomposity to a just perspective by the authority of his scholarship and the huge range of his personal observation. He was, if you will, anti-heroic. His scale was big, but it was domestic, to be assimilated; a transmuted domesticity, like the fire in a hearth, the small proscenium where magic pictures glow. He never subscribed to the usual judgments of the vogue. In his time he imposed fashion. He could be deliberately unfashionable. As time passed, he became what the oldish young post-adolescent advance guard calls "old-fashioned." But theirs is a ritual novelty, based on heroic precedents; they are mere vulgarizers and showmen. Old-fashioned as his novels may now be reputed, since they are not in print, we may confidently expect the complete paperback Van Vechten, with introductions by Osbert Sitwell and Wystan Auden,

and a slew of doctoral dissertations on "Peter Whiffle as a Prototype of the American Hero."

Carl adored cats. To me, he always seemed to be an enormous, fair-haired, white kitty. Sometimes he purred. He could also scratch. Sometimes he would only blink, like a cat whose mysteries, opinions, and pleasures are secretly wise. Like any cat, he preferred the cream of life, not thin milk. He knew his own worth, as a cat is conscious of its own softness and beauty. He had the complacency, serenity, and amusement of an inherent security. He did not mind being stroked, but he was too preoccupied with art, life, and people to care much whether or not he was called an artist or a journalist or an amateur or a collector. He was, anyway, important, and history will admit it.

# Carlsen, Crane

[*Published in* Raritan 1.3 (*Winter* 1982).]

DICK BLACKMUR, and later Bernard Bandler II, a student of Aristotle who eventually became a very distinguished psychiatrist, took care of *Hound & Horn*'s Big Ideas. While I was in awe of their analytical mentation, I never considered myself an "intellectual." I had received an ignominious D+ in Whitehead's lectures on metaphysics; Varian Fry relieved my guilt by telling me that philosophy, all of it, was only vain epistemology, and that took care of my curiosity until I found Nietzsche.

Indeed, all through this period I was very much preoccupied with the social life of Shady Hill, Charles Eliot Norton's beautiful old estate, where Paul Sachs ruled his roost, and Gerry's Landing, where his partner, Edward Emerson Forbes, gave splendid parties. More glamorous was a house on Beacon Hill where the heirs of Henry Adams and Mrs. Jack Gardner continued their elevated taste and life of the mind. It was the ghost of Henry Adams that presided over *Hound & Horn* due to Dick Blackmur's infatuation with the triumphant failure of Adams's *Education*, and over my own attachment to a vanished Boston.

It may seem farfetched to blame this atmosphere for certain editorial strictures which governed the taste and tone of *Hound & Horn*. It may explain, and in part apologize for, its editors, in refusing to print Hart Crane's "The Tunnel," seventh and penultimate canto of

*The Bridge*, his masterwork. We did accept a mass of inevitably mediocre and much more forgettable verse, among a small amount of distinguished poetry by well-known names.

How could ostensibly sensitive young men with notions "advanced" (for their time), with some acquaintance with advance-guard French, English, and American poetry, reject Crane's evocation of the power and grandeur of Manhattan's mystical bridge and mysterious subway? It was not refused out of hand, but after discussion, led by Blackmur the purist, Varian Fry the Latinist, and myself, who was entranced by the poem's epigraph:

> *To Find the Western path*
> *Right thro' the Gates of Wrath.*

I had had as my Freshman Advisor S. Foster Damon, who had just published the first important American explication of William Blake's symbols and story. To Harvard's everlasting shame, he was denied tenure and was let go to Brown; Providence then was considered provincial exile, and it was this proprietary attitude of Harvard's Department of English that *Hound & Horn* sought to contest. Blake's beautiful painting of *Glad Day*, a brilliant nude youth seen against the dazzling spectrum of a full rainbow, was my personification of Melville's Jack Chase and Billy Budd, and Walt Whitman's comrade. In arguments over the acceptance or rejection of Crane's poem, I felt he had not lived up to the oracular in Blake's lines. I was a victim of Blackmur's compensatory stringency and my own snobbery derived from my recently earned arcane knowledge of Blake's true cosmology, derived from Foster Damon. This was an early example of the academic deformation we thought we were trying to avoid—competitive vanity based on subjective attachment.

In 1927, the more energetic Americans were writing books which would provide capital for future Departments of English Literature— mainly in London and Paris. Harvard's imaginative aura lingered in a prior generation, with veterans of the recent war (Cummings, Virgil Thomson, Dos Passos) providing the exuberant foundations of our future hegemony. London seemed closer to Cambridge, Mass., than Paris, because T. S. Eliot's own teachers were still ours. Irving Babbitt lectured on Rousseau, Chateaubriand, the sources of French Roman-

ticism, and his own brand of humanism. Still in residence was J. L. Lowes, whose *The Road to Xanadu* became a bible, and there was Grandgent for Dante, A. N. Whitehead for Plato and Pythagoras, A. Kingsley Porter for the Romanesque. We had French and some German, but compared to Christ Church or King's, small Latin and less Greek. For us, at our stage of development, Baudelaire tended to be primarily a Roman Catholic, Rimbaud an anarchist, Joyce a lapsed Jesuit, and Valéry Larbaud more "modern" than Corbière or Laforgue. The Germans were Rilke and Thomas Mann; Goethe and Heine were largely ignored.

I had met Dick Blackmur the year before I entered college. He advised me on what most recent books I should buy and what I should think of them. He regretted that he knew no Sanskrit (yet). His reading was enormous in fields I had no notion were even available, from symbolic logic to the *Nicomachean Ethics*, from Origen to Gerard Manley Hopkins, Crashaw, Hegel, Jeans, and Eddington. When he married I asked what he wanted as a wedding present: it was a pretty new four-volume edition of Herrick. He had contempt for many of my limited roster of masters. I would race down to his shop, comfortably housed in what was once an eighteenth-century tavern, eager not to miss the latest arrival from Faber & Gwyer or the Nonesuch Press. He asked me what I had "learned." Maybe I told him that Professor Babbitt had said something astonishing about Sainte-Beuve; Dick's thin lips would curl: "Oh, that. It's just his usual inane reply to M. Tel-et-tel's theory in the May number of *La Nouvelle Revue Française* (or *Le Mercure de France*)." This goes some way to define the attitude or atmosphere in which we felt free to refuse an important poem by Hart Crane.

Perhaps I might have felt less guilty if I had known sooner that there were other more eminent rejectors of Crane—Harriet Monroe of *Poetry: A Magazine of Verse*, Marianne Moore at *The Dial*; Edmund Wilson at *The New Republic*. And in reviewing the published *The Bridge* in *Poetry* (June 1930), Yvor Winters, with Allen Tate, Crane's most useful literary correspondent, turned on his entire achievement. I might mitigate my own responsibility, evoking the authority of our editorial board, which indeed exerted a common authority. Yet I was much involved with verse, daring to print some of my own. I had no interest in politics or social theory. *Hound & Horn* would increasingly

be taken over by Southern Agrarians under the captaincy of Tate, and finally by a mixture of Anglican Marxists(!), Trotskyites, and "humanists." When poetic contributions came into the office I chose "the best" for Blackmur's severity. Unlike myself, he was not chastened by seeing his own verse in print, which was far more professional and justified than mine. He thought Crane's "The Tunnel" was "promising, confused, self-indulgent, inchoate, etc." It had some "good lines"; Crane would be better next time around, doubtless after a long letter from Dick, written on his thick six-by-four-inch blocks in his small, square, immaculate orthography. Perhaps a script exists; it was my duty to abstract refusals from his too extensive text.

In *Hound & Horn*'s summer issue of 1931, the excellent poet and discerning critic Yvor Winters reviewed a French study of the influence of *symbolisme* on American verse, analyzing Crane's presumed debt to Rimbaud, which was then discounted since Crane could only read him in translation. The first writing of Crane's I happened to have read, mainly for its subject matter, was dedicated to Stanislav Portapovich, a dancer in Diaghilev's Ballets Russes, who elected to stay in the United States after its disastrous 1917 season. In this poem Crane used as a rhyme "Chloe" (from "*Daphnis et Chloë*") as a monosyllable. This was enough to demonstrate how shockingly ill-lettered and pretentious was Crane. And Yvor Winters's analysis of Crane's beautiful "For the Marriage of Faustus and Helen" complained that

the vocabulary of Mr. Crane's work suggests somehow the vocabulary of Rimbaud's prose and of a very little of verse, in its quality of intellectual violence and of almost perverse energy.

"Perversity" and "violence" indeed. If there were any two elements lodged in my head to justify the rejection of unworthy or uncomfortable material, unorthodox or unfamiliar, in spite of our ostensibly pro-"modern" bias, they would have been violence and perversity. We were "educated" (in a strict sense, as editors); we were sustaining humane values, traditional though progressive, against mindlessness, anarchy, and chaos. We were mandated by Eliot ("Tradition and the Individual Talent") and Pound ("Make It New"). Blackmur, severely traumatized by his permanent lack of a *summa cum laude*, used overkill. I had taken received ideas as scripture and wasn't to be budged

against instruction I'd absorbed with awe. Later, listing errors of commission and omission, one could be partly consoled by the names of those who got, and didn't get, the Nobel Prize for Literature. Pearl Buck, John Steinbeck did. Marcel Proust, W. H. Auden didn't. As historic compensation, up to a point, Allen Tate reviewed *The Bridge* (*Hound & Horn*: summer 1930) under the heading "A Distinguished Poet." (For those curious about Crane's worried if deeply appreciative, yet far too troubled reaction, it is fully covered in John Unterecker's monumental biography, *Voyager*.)

I was also at this time a companion of John Brooks Wheelwright, who helped us with his very professional if eccentric analyses of architectural styles. A properly improper Bostonian, an authentic Puritan combining extremes of High Episcopal liturgy, proto-Trotskyite metaphysic, and post-Ruskinian taste, he was both monk and dandy. An important, now ignored writer of verse, he was kin to Henry and Brooks Adams: he wrote a beautiful threnody on Crane's death after a tense confrontation, entitled "Fish Food," which I came to wish I had been able to write myself as my particular personal apology. I was also a friend of Walker Evans, the photographer; with Wheelwright, we found a hundred fine nineteenth-century houses in the Greater Boston area and published photographs of some in *Hound & Horn*. Evans was living in quarters near Crane alongside the Brooklyn Bridge, and he had contributed photographic illustrations to the deluxe first edition of Hart Crane's poems published in Paris and reproduced, I never knew why, in the format of postage stamps. A little later I shared a house with Archibald MacLeish, then writing for *Fortune*, who had the happy and generous idea of commissioning Crane, who badly needed a job, to describe the construction of the George Washington Bridge. I also knew Estlin Cummings; he and MacLeish had not met, and I brought them together. They spoke of Crane's difficulties. "eec" said flatly that Crane was incapable of finishing anything; Archie should be warned.

I never knew Crane personally. I bumped into him a few times when I came down from Cambridge to New York. He never failed to frighten me. His reputation, of course, preceded him, a negative fame of lurid pyrotechnics, at once alluring and repulsive. He surely could have had small use for a supercilious college kid, some ten years younger, with firm poetic prejudices.

On March 28, 1931, I went to a party thrown by the editors of *The New Republic,* in a big penthouse above Fifth Avenue. Present were Edmund Wilson, Paul Rosenfeld, C. D. Jackson, Dwight Macdonald, and Walker Evans, among others. e. e. cummings's second wife, a termagant, baited me, deservedly, for being gratuitously rude to Crane at another party at the MacLeishes' a few weeks earlier. Cummings said that Crane's mind was no bigger than a pin, but that it didn't matter; he was a born poet. The one person present I knew at all well was Walker Evans, then about to embark on a South Seas voyage to make a film on a yacht chartered by Oliver Jennings. It was through Walker that I encountered Crane's friend Carl Carlsen, who was signed on as an able-bodied seaman.

*The New Republic*'s party sticks in a befogged memory, illuminated by a brief thunderclap. The air was subdued, with the usual self-enclosed groups in a haze of cigarette smoke and alcohol. Abruptly, in a far corner of the high, big room, angry voices and motion. I had not noticed the spark of the fracas; now there were fisticuffs. Two men traded punches. The taller seemed in control; he held the other at arm's length and hit him, hard. Someone had called somebody else something. Whatever the source of the rumpus, music-under swelled into gathering general irritation. "Chuck the son of a bitch out!" A door onto the elevator outside opened as of itself, and Crane, slight, with rumpled shock of pepper-and-salt hair, helped by hands other than his own, was chucked out. Quiet resumed, drinks were drunk; nobody paid much mind to an interruption which scarcely had had time enough to come to serious trouble.

About half an hour later there were blunt bangings on the door. Kicks, knocks, yells; it was opened. Crane bounced back into an unastonished assembly pursued by a small but furious taxi driver. Crane had hailed him for a run to a Sands Street sailors' bar under the Brooklyn Bridge. Having arrived, Crane had no cash. Driver had pushed him into the gutter, but was persuaded to drive back to the party, where friends would take up a collection and pay for three trips. Crane, filthy, sodden, and desperate, was remorseful but morose. Cabbie, given a couple of drinks, was mollified. Crane proclaimed what a marvelous character he was; he would hire his taxi to take him to Mexico on his recently awarded Guggenheim. They left, quietly enough, together.

This eruption, which probably seemed abnormal mainly to me, was no great event for those foregathered. To others, on similar, more or less familiar occasions, this was not rousing behavior. For those who lived by the lyric imagination, whose craft and career was the play of words and imagery, Crane was not overly distressing or disagreeable—except possibly to himself, when he sobered up. When he came back with the cabdriver I was struck and humbled by his patient penitence, muffled apologies, a small boy's pathetic, instinctive good manners. At first I was inclined to be, or tried to be, surprised, horrified, and outraged. Actually, I longed to have had the guts to get drunk and pick up a character who much resembled Jimmy Cagney in *Taxi*, a brilliant Warner Brothers film. I idolized Cagney and studied his films assiduously as they appeared, seeing each one half a dozen times—from *Public Enemy, Smart Money, Blonde Crazy, The Crowd Roars*, and *Here Comes the Navy* to Max Reinhardt's beautiful *A Midsummer Night's Dream*, in which he starred as a marvelously inventive Warwickshire Bottom. Cagney, for me, provided a postgraduate course in heroic lyric realism in opposition to Harvard good taste. (Cagney liked an article I wrote about him and we were intermittent friends for fifty years.) I aimed to delete the conditioning of my schools and class, costumed myself from cut-rate Army-Navy stores, and was not wildly successful as a male impersonator. In Brooklyn bars Walker Evans taught me to keep my mouth shut, and so I penetrated the safer areas of some jungles where there was no real threat or risk except of an exotic landscape. I deceived no one; denizens of such urban areas can spot a stranger on sight. I smelled different, but I was kindly tolerated for my curiosity and adulation. It was not exactly cross-pollination, but there was some exchange in encounters between mutually bizarre tribes. In this ambiance I met Carlsen.

If he had any professional calling it was the sea, but his real ambition was to be a writer, with the sea as his subject. Walker Evans had met him through Crane's great friend Emil Opffer, a merchant seaman, and Evans had told Carl to send some of his stories to me, an editor of *Hound & Horn*. Three duly arrived, each neatly typed in its own spring binder. None of them made much of an impression. Walker pressed me concerning them. I found it hard to say anything definite. Although we were small fry compared to big-circulation magazines, we printed the first or early stories by Katherine Anne Porter,

John Cheever, Erskine Caldwell, Kay Boyle, Stephen Spender, and others during seven years of publication. I read the greater part of the fiction contributions, and what I deemed best was passed on to Dick Blackmur and Bernard Bandler for final judgment. As for Carl Carlsen's quite unmemorable pieces, they had passed without comment, or at the most gained an impersonal rejection slip.

Then, one day when I was lunching at the greasy spoon near Time-Life with Walker Evans and Jim Agee, Evans brought me a scruffy bundle of typewritten yellow sheets, the rough draft of another story by Carlsen. I think its raw presentation and obvious travail attracted me, since it was so unlike the shipshape typescripts previously sent. It concerned the stoker in a boiler room of a merchant freighter. An important piece of a machine—perhaps a piston—overheated or lacking lubrication, had split and snapped. The stoker or other mechanic immediately substituted his forearm for the broken part. For some minutes the man's flesh and bone were a working replacement for steel and oil. The tragedy, while not convincing as written, obviously derived from vivid memory. The prose was by someone who knew more about metal and machinery than short-story composition. However, I could not be entirely disdainful of its stiff primitive energy, small as its wick might glow. Its strained rhetoric was influenced by Melville and his masters; it was overwritten, rhapsodic, and rhetorical. Yet somehow pretentious it was not, nor even synthetic. There was too much detailed observation to betray contrivance. The narration could not read as exactly naïve; there was the taint of absorption in Melville and Conrad. The notion was powerful, but the prose was without practice; we couldn't bring ourselves to accept so primitive a piece. I wrote its author the kindest rejection note I could manage and sent him a volume of Rudyard Kipling's riveting short stories, including "The Ship That Found Itself," in which the intransigent components of a newly commissioned steamer, after an agonizing launch run, grew to have its stubborn separate parts finally work together. It was this that brought Carlsen to our office at 10 East Forty-third Street (we were newly transplanted from Cambridge to Manhattan). He did not come in person; I was thanked by a letter slipped under the door. Carlsen found the Kipling tale unreal; its author obviously had been no merchant seaman. Fame did not forgive the fable, but his strictures made their point.

Who was Carlsen? I never discovered as much as I wished to know. Walker Evans could or would not elucidate: only "a chum of Emil and Ivan Opffer's, Gene O'Neill's and Hart's." In 1930, Crane wrote Caresse Crosby in Paris that Carl was "a former sailor who has got tired of office-work and expects to hit the deck again for a while." Crane drowned before I had real contact with Carl. Eventually, after some timorous urging, Walker took me around to Carlsen's home. This was an oversized doll's house, a picturesque miniature semisecret habitat awarded him by the guardian angels of Walt Whitman and Herman Melville. One passed through an all but unmarked gap in a row of mid-nineteenth-century brownstones in the middle of a block somewhere between far West Sixteenth and Twentieth Streets; I can't now say exactly where, since I've not been there in fifty years. Between the two blocks survived three tidy two-storied unpainted clapboard buildings with a joined narrow porch and pairs of gabled dormers. Built by 1840, these were freshly shingled, old, but without decay. In the middle house dwelt Carlsen. The single downstairs room was bare, spotless, shipshape-tidy. It might have been comfortable as a whaler's cabin anchored in Nantucket, New Bedford, or Sag Harbor. The only intrusion from the twentieth century was a small shiny upright piano with stacks of music on top. A narrow stair with a rope banister led above. Later, I would find a common lavatory in a back courtyard which served the three buildings, and there was a hand pump. Gas was laid on, but there was a total lack of heat and hot shaving water.

Evans introduced me as the man from *Hound & Horn* who had judged his offerings. Carl was a stocky, thick-trunked man, thirty-five to forty, clean-shaven, leathery, no extra flesh, and apparently hard-bitten. He had coarse, untrimmed bushy eyebrows fairer than his ash-blond, close-cropped hair. The piano obviously belonged to a stolid, self-contained woman, maybe ten years older than Carlsen. Her hair was in a stiff orange pompadour. She nodded to Walker and me without enthusiasm and abruptly disappeared up the stairs, as one might say, in a marked manner. This didn't seem to bother her companion. He wore well-worn, crisply laundered, old regulation U.S. Navy bell-bottoms, with a drop fly and thirteen buttons, in honor of the thirteen original colonies. Next to the small gas range was a wooden icebox, maple, with nicely turned legs, unpainted—perhaps a recent addition. In the icebox were cream and lemon; on the stove water, boiling. Tea

was made; the master of the house took rum from a cupboard and set the full bottle before me. The—to me—exotic purity or clarity of the local weather bemused me. Speech was slow in coming. Soon enough, Walker made desultory politenesses. I studied the room. On the mantel above the wood-framed fireplace were three brass candlesticks, all different. Next to them was a portrait of Crane by Walker in an old cork mat. Inside a foot-long green bottle was the model of a full-rigged sailing vessel. I asked how it managed to get inside the bottle, which couldn't have been blown around it. Carlsen explained that the mast and rigging had been laid flat; the hull was thin enough to slip by, and a thread pulled the masts upright.

From upstairs came grunts of furniture being moved; something slammed. Carl rose from the tea table to investigate. I tried to signify to Walker in Carlsen's absence how abjectly fascinated I was by this quaint home; there was hardly enough time. Some manner of abrupt exchange was heard from the top of the stairs. Walker winked. Carl came down; there were no apologies; we were dismissed, leaving warm tea in mugs and rum untasted. He smiled without embarrassment; hoped he'd see me again "some time"; slapped Walker on the back, firmly shook my hand, and we were out in the courtyard. There had been not a word about his manuscripts.

I was loath to leave, troubled, as if, somehow, I'd done the wrong thing, for I had been enchanted. Here was a human situation, a concentrated mystery of class behavior which I might have read about or suspected, but never touched. I was torn as to what further contact I might seek. How could I warp a half-uttered invitation into some story *Hound & Horn* might print? Walker was no help. On the walk back I bombarded him with questions, but his thin answers told more of Crane than Carlsen, whom he claimed to have met only in passing. Evans had a collector's passion for ephemeral American artifacts: matchboxes, baseball and cigarette cards, old valentines, tobacco boxes, trademarked paperbags, and twine. Somehow, Carlsen and his ambiance were connected with such collecting.

In my idiosyncratic mythology, those whose fortunes followed the sea had solemn significance. The first dress-up clothes I'd been given to wear were those my father brought me (aged four), the midget uniform of a Royal Navy rating (from Rowe of Gosport), complete with a silver bosun's rope and whistle, in which I was duly photo-

graphed. At bedtimes, he read to my brother and me Dana's *Two Years Before the Mast*. His steady affairs in Britain supplied the *Illustrated London News*, with their splendid extra-colored souvenir editions celebrating the coronations of Edward VII and George V. Portraits of Princes of Wales disguised as midshipmen were linked in my mind with Mark Twain's *The Prince and the Pauper*. The rôle of sailor, ordinary and extraordinary, seemed to be that of a classless, or declassed prince. When I was a freshman at Harvard, Foster Damon, my tutor, gave me *White-Jacket* and *Israel Potter* to read. The reputation of *Moby-Dick* was at the crest of its recognition. The manuscript of *Billy Budd* lay in Widener Library. I paid a classmate to transcribe Melville's virtually illegible handwriting, since Damon told me that the recently published Constable "complete" edition was full of errors. I had been on my brother's small boat in Marblehead Harbor, but never on the open sea. In 1925, in London, I had fallen in love with the Russian ballet. Léonide Massine's *Les Matelots*, with Georges Auric's early jazz, had among its three sailors an American, borrowed from Jean Cocteau's memories of the U.S. Mediterranean cruises with gobs ashore in the bars of Toulon and Villefranche. The jolly sailors Massine choreographed for Diaghilev's Russian dancers-in-exile were domesticated acrobats, hardly sailors at sea but players ashore. Like Carlsen.

My image of him, presumably fictive, had little enough to do with any essential self; but for me, he incarnated legends. The fact that he was approachable, on the beach, and hence both estranged from his proper province and yet accessible, made his vague presence all the more exhilarating, for surely "he knew the name Hercules was called among the women and held the secrets of the sea." Perhaps he only existed between voyages, likely to ship out at any moment. How would I ever find him again unless I were able to conceive a stratagem which, so far, I had not the slyness to imagine? Here, again, Walker Evans was no help; he had gone as far as he could pushing Carl towards "literature"; he wasn't particularly generous, or amused by my fascination. If I wanted to see the guy again, no big deal. Drop in on him, just as we had today. After all, as yet there had been no mention of his ambitious writing, nor my dubious thwarting of it.

So, breathless and in some dread, I did risk it. On my second visit, he was alone. Now my self asserted its typecasting as college

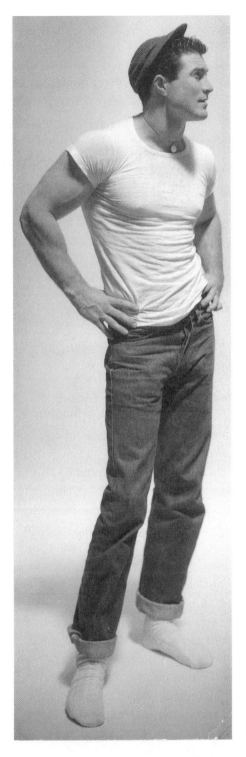

*Carl Carlsen, photographed by*
*George Platt Lynes,* 1932

critic; my sincerity was clear even if suggestions were limp. But perhaps I was almost the first to take him seriously as more than a mechanic, and thus I advanced slowly, solemnly into a hesitant friendship. Steps from cautious contact to relative intimacy were propelled by the abrupt arrival of his brother, a second officer on a coastal freighter on regular runs from San Diego, through the Panama Canal up to Portland, Maine. Every three or four months Nils Carlsen enjoyed a few days' liberty from Hoboken. Carl took me over to explore his command. When we first climbed aboard, there seemed to be no one anywhere. It was deserted. One custodian tended pilot fires in the furnace room. Here was surely the site of the split piston rod and the stoker's shattered arm. Carl drew no special attention to any single piece of machinery. I was about to ask the function of every obvious object, but realized this was his private time and sacred place, not to be profaned by idle or overeager curiosity. If I, indeed, had the wit to feel awe, then let this jungle of polished brass bandings, glistening serpentine coils, and tigerine furnaces purr its hot breath. My cautious questions were answered by his ready brother. The latent power in the engines seemed to swell, filling Carl's fixed, riveted silence, in which his complete comprehension of mineral potency was haloed in a scent of oil, the slumbering, acrid fragrance of coal fire; an incandescent bluish gloom through thick-glazed furnace doors. A brutal but delicate mechanism was alive, grossly asleep, lovingly tended, waiting to be ignited into full flame. An unfired weapon, immaculately maintained, called for its own ration of love, and love is what burnished it through Nils Carlsen's professional concern. He apologized for the inadequacy of active operation. Here was power at one remove; his ship slept, not to be aroused until it met open sea. As we left, Carl astonished me by saying evenly that if we ever should ship out together, then he would let me learn what hot metal meant as the measure of energy in motion.

Initiation in the boiler room was revelation, but this abrupt personal inference or interpolation, tossed out so lightly, exploded that vein of incendiary excitement which is the rapacious flare of first love. While I realized only too well I could never bet on any specific date for a joint voyage, the fact that he had uttered so vague a proposal diffused small logic. After all, his brother was bound to this boat and could probably arrange everything easily. Why shouldn't we, some

time in what glorious future, ship out together? I would teach Carl how to write as he taught me how to live.

For two good reasons, among tides of unanswerable others. First, Carl was in retirement from the sea, by will or chance. He was fixing to be "a writer." He took writing seriously; he wrote mornings, he said, every day: eight to eleven. What he wrote, Bertha, the piano teacher, his consort, typed afternoons. I could imagine that while she typed, he wandered around, did chores. She was the real hindrance for me. I never knew whether or not they "slept" together. It would have been impossible to have guessed otherwise, yet in public there was little contact. Carlsen never talked dirty, or made the exciting, outrageous, or forbidden raw jokes or references which might have been expected, and for which I knew men of his class were famous. This further distanced me from a full unveiling of the many secrets he seemed to hold. Bertha cooked; she kept their house in its pale immaculate rigor. As I ventured to drop in more often and stay longer, she made fairly polite efforts to speak, but sooner or later she retired upstairs. She even tried to make it appear that she knew Carl and I had serious things to say by which his career might be furthered. Perhaps she somehow knew his "writing" was more or less of a fantasy, but at least it was an alternative to his going back to sea, which certainly she did not want. She kept him on a loose chain; he had his "freedom." I hoped he was free enough to include me somewhere in it. He seldom spoke of her. I might have made the silly speech of setting myself up against her, but his perfect manners precluded such folly.

However, eventually I felt close enough to Carl to risk mentioning that I sensed that "Bertha didn't like me." I dared this presumption, risking a connection to which I had precarious right. All he admitted was: "You don't bother her." This was no resolution, but I knew enough not to press it. At the time when one is breaking out of post-adolescence, fright, insecurity, apprehension encourage an appetite for adventure dared. Everything I had previously experienced or felt about people seemed now on the other side of a glass wall, and my "education," *pace* well-beloved Henry Adams, was a half-conscious attempt to eliminate the self-protection from a "real world." Carlsen was my real world, and his isolation was at once nearer and farther than anyone or anything. Unfleshed imagination flickers, a vast amorphous void, filled with rainbow possibilities and doubt. Carl exploded

in my life, bringing to the exercise of heart and mind the chance for a three-dimensional existence, released from the prison of prior habit. While he strove to make art out of a half-life, I tried to make come alive what heretofore I had only read of in books, which were now the models which stopped him dead.

As for any actual contact with Hart Crane, the poet, heir of Poe, Whitman, and Hopkins, this was tenuous in the extreme. Encounters with Crane were negligible; yet I depended on Crane's immediacy to certify my contact with Carl. I knew Crane would not have recognized my face. But I was rather close to those who did know him very well: Evans, Allen Tate, Katherine Anne Porter. I was not really drawn to his gift; I barely connected the man with his poetry. Both seemed outrageous and unmannerly, although I was not ready to face the blame for fearing its obscurity. After all, there was Modern Art, and what a success that was becoming! And I was forced to feel, in spite of prejudice, that there was some irreducible courage, both in art and life, a defiance, however gross or unseemly, of which I could not help being envious. Carl was slow to speak of him; if they had been drunk and disorderly together often enough, he volunteered little that was revelatory or proprietary. He shied away from mention of violence or perversity. For these there were no apologies; he inferred such was the fiber of genius that Crane was licensed to play as he pleased. Crane was above praise or calumny. As for Carlsen's own preference or promiscuity, he let me hear nothing; when he dealt out rum, it was the classic brace at the capstan. I was forced to assume his deliberate moderation was the result of some possible earlier excess now monitored by a lady piano teacher. Yet I was eager to bring Carl into "my" world, to exhibit him to Muriel Draper and Carl Van Vechten. But he disdained entrance into alien areas, and was not eager to be exhibited as a picturesque trophy.

On April 28, 1932, I was invited to Muriel Draper's for cocktails. I wrote in a diary:

I learned of Hart Crane's drowning. A sickening feeling, but I never really cared for him or his work, except for "Hurricane," which I thought magnificent.

*Rock sockets, levin-lathered!*
*Nor, Lord, may worm outdeep*

*Thy drum's gambade, its plunge abscond!*
*Lord God, while summits crashing*

*Whip sea-kelp screaming on blond*
*Sky-seethe, dense heaven dashing—*

*Thou ridest to the door, Lord!*
*Thou bidest wall nor floor, Lord!*

After this, I began to hesitate in asking Carl to show more of his writing, since my early response had been so unwelcoming. With the removal of much compulsion to connect the two of us through "literature," he grew less shy, and our relations went from friendliness to something approaching friendship. One of the impersonations requiring considerable craft is that of feigning enthusiasm about the disappointing labors of one liked or loved. Carl was never going to be much of a literary man; if his attempts had been high-school student work by a sixteen-year-old, it might have proved promising. Apt phrasing, careful observation, genuine emotion, and brief bursts of oddly personal intonation there may have been, but since he had read so little, and what he had found on his own to read—Marlowe and Melville in particular—were such monstrous models, and since his own vital experience was both so very deep and narrow, one could not hope for much quality beyond the primitive. There was yet a further, more profound impediment. From inherent shyness, good manners, or instinctive discretion he excluded from his narrative much approaching vivid personal comment. He wrote about the sea and its mariners in terms of popular magazine illustration confused by "literary" rhetoric, avoiding psychological insight, as if such realism might dull a "beauty" in expression. Carl, like Crane, his idol, was a rhapsodist not a precise analyst. The exalted rhetoric of Marlowe and Melville derived in great part from traditions of the spoken word—drama or pulpit, the heightened accents of vocal utterance. Carl's prose, like Crane's verse, was written to be read aloud, but I have yet

to hear any speaker give voice to Crane as satisfactorily as one mouths
it in the mind with closed lips. Carl's opacity and stumbling richness
were hard enough to read and would never be printed.

He came to the world of books late in his development, receiving
the key to his furnished library from a poet who canonized four over-
whelming masters: Marlowe, Melville, Whitman, Rimbaud. Before
almost anyone in the United States, through Yvor Winters, Crane
came upon Gerard Manley Hopkins, and strove earnestly without
much effect to make him better known. Crane's power was more verbal
than metrical; Hopkins's shackled ferocity combined word, measure,
and music with far more discipline, despite the short-circuits and elided
metaphors of which both were masters. Just as Hopkins adored and
was terrified of Whitman's bare-faced carnality, so Crane concealed
the immediacy of his sentiment in an almost hysterical chromatics of
language and compressed imagery. The alchemy of the word was a
hazardous science; Carlsen, with his slight talent and less familiarity
with his betters, was doomed as a writer. His awe of the potential in
the English language betrayed him. Carl's longing to make literature
was a means of touching magic he couldn't make. Crane came into
his life as some Prospero, transforming Manhattan and Brooklyn into
enchanted islands. Did Carl have much notion of what Crane was
trying to say? We had once been reading, together, from *The Bridge*:

> *Whose head is swinging from the swollen strap?*
> *Whose body smokes along the bitten rails,*
> *Bursts from a smouldering bundle far behind*
> *In back forks of the chasms of the brain—*
> *Puffs from a riven stump far out behind*
> *In interborough fissures of the mind . . . ?*

Carl stuck on "swollen strap." Why swollen? Now "interborough"; he
could see the subway connection, but he asked: "Why in hell can't
he say what he means?" In the summer of 1926, Crane had written
to Waldo Frank, one of his first professional enthusiasts:

. . . work continues. The Tunnel now. I shall have it done very shortly. It's
rather ghastly, almost surgery—and oddly, almost all from the notes and

stitches I have written while swinging on the strap at late midnight hours going home.

In 1932, writing after the suicide, introducing the first American edition of *The Bridge*, Waldo Frank explained:

"The Tunnel" gives us man in his industrial hell which the machine—his hand and heart—has made; now let the machine be his godlike Hand to uplift him! The plunging subway shall merge with the vaulting bridge. Whitman gives the vision; Poe, however vaguely, the method.

Now, fifty years later, Carl's innocent objection irritates like a stubborn hangnail. Here as elsewhere Crane said something less than what he hoped to mean. Rather, he relied on Rimbaud's *alchimie du verbe* to make magic more than morality or meaning. "The Tunnel," with its random mosaic of subway-mob vernacular quotations, could too easily be read as a gloss on Eliot's "A Game of Chess." To the editors of *Hound & Horn*, hypnotized by that poem and its author, any similarity would have seemed more weakening then than it does now. Perhaps it was this very likeness, or homage, which prompted Eliot to print it in his *Criterion*, for August 1927.

But, partly as a devil's advocate, partly in my rôle as professor of Modern Poetry, I tried to particularize for Carl what I conceived Crane's method proposed. I had been struck hard by an arresting image in "For the Marriage of Faustus and Helen" (Part III), which mentions "Anchises' navel, dripping of the sea—" wherein I saw some ancestral demigod striding towards a surfbound Tyrrhenian shore, Giovanni da Bologna rather than Praxiteles, an ancient marine divinity, model for a Baroque fountain, one of Bernini's gigantic epitomes. Carl asked: "Who the hell's Anchises?" Making it easy, I might have said Anchises was another name for Neptune, the sea god Poseidon, brother to Zeus, enemy of Ulysses, author of his misfortunes—or possibly merely a trisyllable Crane happened to have come across, which like so many fortuitous findings fired his prosody. There seem to be two mentions only of Anchises in the *Iliad*; he was father to Aeneas, lover to Aphrodite born of sea foam, second cousin to Priam, King of Troy. In Book III of the *Aeneid*,

*When old Anchises summoned all to sea:*
*The crew, my father and the Fates obey.*
                 Dryden

Years later, a young Harvard scholar told me that in the Homeric "Hymn to Aphrodite" Anchises mates with the goddess, who bears his child in secret. Later, he is punished for presuming to couple with divinity. Mortals suffer who dare touch the immeasurable. Crane could have had something concrete in mind by naming Anchises—an autodidact; he read widely. But with Carlsen it was useless for me to pursue all this; it reduced a marvel to the academic. I did my best by trying to suggest the taut muscular belly of an ancient athlete brimming with saline, not very wine-dark liquor, chill and glistening, as from some celestial shower bath.

Meditating on Hart Crane's life, death, and residue is sobering exercise. Now enshrined, he has his niche in the mortuary of dazzling self-slayers. He's been well served by friends and students whose sympathy and industry have restored what failed ambition must certainly have granted. Before crisis framed him, his was the treasure of a small, closed audience of passionate if troubled admirers. Now widely available in paperback, griefs forgiven or forgotten, he is redeemed in posthumous sovereignty. This came without any compulsion as the inevitable slow but logical recognition of genius. To regret or complain that there are not more relics to worship, or that his legacy might be other or superior, begs the question. Crane handled, mishandled, and manipulated words, warping heard speech into an electric recalcitrance as no American has done before or since, and which few Englishmen have equaled since Father Hopkins. Nevertheless, Allen Tate, one of his closest friends, wrote in the obituary for *Hound & Horn* (July–September 1932) a judgment of "The Tunnel," which he saw as Crane's attempt to write his *Inferno,* and which is still hard to refute:

At one moment Crane faces his predicament of blindness to any rational order of value, and knows that he is damned; but he cannot face it, and he tries to rest secure upon the mere intensity of sensation. . . . It [*The Bridge*] is probably the final word of romanticism in this century. When Crane saw that his leading symbol would not cover all the material of his poem, he

could not sustain it ironically in the classic manner. Alternately he asserts it and abandons it because fundamentally he does not understand it. The idea of bridgeship is an elaborate metaphor, a sentimental conceit leaving the structure of the poem confused.

Pondering the brief span of Crane's performance, one risks deciphering roots of dysfunction, tension, torment, terror, and hysteria. There are masterful studies of his times and temperament, notably Unterecker's huge *Voyager*. Crane's catastrophe can be reduced, perhaps simplistically, to two afflictions: Cleveland and Christian Science. This middle-American town early in the century stands for the basic provincial Philistine criterion, the Protestant work ethic of crippling but mandatory somnambulistic success as the guarantee and habit of salvation. C. R. Crane's candy business cannot be assigned the worst level of hell, but purgatory of the paralyzed imagination, particularly when genius is at stake, is as sad. Attempts benevolently to straitjacket his only son and heir into the patterns of industrial health were wounding and drained Hart's energy at the very moment it asserted itself towards invention. C.R. was no villain, neither ungenerous nor entirely insensitive. He loved his boy, wished him well, even when wife and mother did her damned best to kill any mutual contact.

She was and is, alas, by no means an unfamiliar American darling. "Science," for her, was true magic. And as too many others had proved, material suffering, physical and mental, was wholly imaginary; *it did not exist*. Mary Baker Eddy stated: "Nothing is real and eternal; nothing is spirit, but God and His ideal; evil has no reality." Since God is pure Good, He cannot have created, or have been responsible for aught that is not Good. Man is God's personal notion, and belongs by essence to an order in which there may be no disease, ugliness, hate, sin, sorrow, or death. Such are mere errors of Man's mortal mentation, without "reality" save as man's mortal mind admits them. Disdain them! *They do not exist!* There is only True or False, with neither degree nor choice. To the neurotic, this banishes neurosis; what we do not wish to credit, asks no credence. But this denial precipitates a terrible burden on the vulnerable lyric mechanism through the solipsism of unmeasured fantasy. The constricted, stoic self tries to force free association into passive courage, but creatures

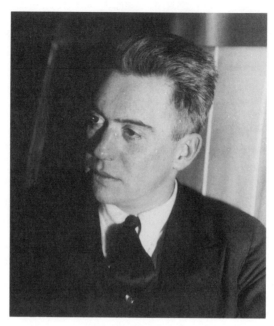

*Hart Crane, photographed by Walker Evans, 1929*

of Crane's temperament, torn between the duel of his parents' feuding, rushed roaring through the barriers of genuine suffering to drown in the only harbor he could imagine: oblivion. As Crane's wise counselor, Yvor Winters, wrote of Hart as Orpheus:

> *Till the shade his music won*
> *Shuddered, by a pause undone—*
> *Silence would not let her stay.*
> *He could go one only way;*
> *By the river, strong with grief,*
> *Gave his flesh beyond belief.*
>
> *Yet the fingers on his lyre*
> *Spread like an avenging fire.*
> *Crying loud, the immortal tongue,*
> *From the empty body wrung,*
> *Broken in a bloody dream,*
> *Sang unmeaning down the stream.*

As a gesture of filial devotion to Grace Crane, now divorced and in lonely anguish, Crane himself tried to "practice" Christian Science, but with little confidence. He recommended his mother be more assiduous in her own practice—the amateur psychologist suggesting placebos. But she was infected, corrupting both herself and him. If human disease does not exist, there is no need to seek the means to face it, endure, handle, or use it. However, since suffering does indeed exist in omnivorous constancy, deliberate ignorance of its presence is an error majestic in consequence. Crane suffered more than most, in the depth, delicacy, and intensity of his sensibility. The pain that sprang from it, the energy taken to resist it and at the same time to bury it, somehow justified it, and absolved him from it. His short life was drained on two incompatible levels: Chagrin Falls, a well-to-do Cleveland suburb, and Sands Street, Brooklyn, a nirvana of sailor bars. Alcohol was a benison; it was as if Mrs. Eddy had handed him her witches' brew. Alcohol obliterated and at once inspired—a distillation of alchemical ink. Unraveling accommodation with his furious progenitors, patched up by his want of and need for love, plus sheer poverty, took more of a toll than bathtub gin or harbor adventures. Random encounters were seldom successful as enduring affection and became hateful payment to his "curse of sundered parentage." One-night stands are for a single night; love of one's mother, however torn, is lifelong, endless, stoked by an overkill of anguish. Physical absence may split son from father, but the tie binds. Maleness is the criterion, and Crane took sides against his own. Only the wavering is constant and consistent; wild nights are blessedly discontinuous; to make small matters better or worse, there's always tomorrow with its luckier midnight. To solve the dreadful problem—freedom, talent, genius—one can embrace a stupendous falsity: Cleveland, Chagrin Falls, according to Christian Science, don't exist.

But psychic energy nurtured by self-deceit only accelerates the false and irrelevant. The old heresy which proclaims Resurrection without Crucifixion as a material fact consoles generations of fairly affluent middle-class vulnerability in its competitive mass. While there may be unemployed Scientists, there are few born and bred as working-class folk. Carl Carlsen could never have been a practicing Christian Scientist, but I was to discover that Bertha, his piano teacher friend, was, on the side, yet importantly for her, a Christian Science healer.

My short connection with Carlsen was through Crane alone, and this was a weak link. Carl spoke little about the person, whom he knew well, but always with awe about the poet, whose lines he could barely grasp. To him, they were disparate identities, never twins. They seemed to have seen less of each other than formerly. Friends that lasted— Tate, Malcolm Cowley, Waldo Frank—were those to whom, finally, Crane could speak of ideas, the matter of his primary labor. But in some deep way for Carl, Crane was faultless; his behavior, his aberrations, were simply routes to a level of fame or feeling which was destiny.

Nevertheless, in meetings with Carl, Crane was an invisible third, spectral but manifest. I could understand well enough what he meant to Carl, but what did I mean—to him, or anyone? I was a rich college kid, twenty-three years old, whose surfeit of "education" had misprized Crane's Pindaric ode to the tunnel beneath the bridge:

> *O caught like pennies beneath soot and steam,*
> *Kiss of our agony thou gatherest;*
> *Condensed, thou takest all—shrill ganglia*
> *Impassioned with some song we fail to keep.*
> *And yet, like Lazarus, to feel the slope,*
> *The sod and billow breaking—lifting ground,*
> *—A sound of waters bending astride the sky*
> *Unceasing with some Word that will not die . . . !*

Perhaps this fixation on one of Crane's buddies was an attempt to compensate for my stupidity, my wickedness. But the truth was, Carl didn't connect me with either Harvard, *Hound & Horn*, or Crane. By then the magazine had been taken over by Dick Blackmur, Allen Tate and his Agrarians, and other intellectuals with political or metaphysical preoccupations. My postgraduate studies were centered in Manhattan. Carl was amused that I was in love with him.

It wasn't easy to find him. He had his work, which I had to assume was dogged, daily typewriting—moonlighting sometimes as handyman, janitor; certainly he didn't type all day and all night. Money never seemed a problem. Maybe piano lessons paid for his drinks, because he was scrupulous about paying for them. But he was not

someone I might feel free to drop in on any old time, particularly if Bertha was likely to be at home. Possibly I made more of her as a problem than she actually was. Most days, having learned to estimate his working habits, I would go over with the excuse of asking if he'd want to go for a walk. If he didn't feel like it, and if she were in, she promptly vanished upstairs. Her presence was pervasive. Some nights Carl might even walk me home to my own room on Minetta Lane, where I made him tea and a drink. I was then sharing the place with Tom Wood, an ex-cowboy who, having been trained as a blacksmith, turned into a craftsman of forged iron. He made handsome firescreens with carefully cut-out silhouettes of animals, stubby andirons, and pleasant shop signs. Carl and he shared the experience of handling metal; there were also the unspoken bonds of class and manual labor. Their immediate cool rapport made me objectively happy and subjectively sad.

One night, a clear September evening in 1932, I went around hoping to catch Carl in, and on the way bet myself he'd be out—insurance against disappointment. The city street sounds were diminished and clarified, the darkening air all the more transparent from the thin punctuation of fragmentary voices. The courtyard in front of his house was swept clean; three garbage pails were in a neat triangle, coverless and empty. Carl was alone. I expected Bertha to return shortly and spoil my fun. He was wearing a crisp pair of regulation white Navy ducks. Rum was on his table-desk; typewriter on the piano. It was almost as if he had been expecting me. Bertha had gone to Chicago to care for a sick sister (through prayer?). How long would she be gone? Don't know; you want tea or grog?

The abrupt luxury of freedom felt then I can still feel. It's a shrunken residue, and although the intensity of the explosion was a once-in-a-lifetime thrust of luck which can only erupt in youth, it was a real joy by which others would later be judged and found wanting. For the first time, I had Carl to myself, in his place, his tavern, forecastle, island. Now I could discover everything—how he felt, what he thought, who he was. It didn't turn out like that. We drank quietly for some time, in a rather oppressive silence, speaking of nothing in particular. What I wished to say rushed far and fast ahead of what I could actually say. Inside, my curiosity boiled, but he seemed perhaps even more self-centered than usual. My first wild manic propulsion

subsided into apotropaic depression. I asked what he'd been up to.
Writing. Evening was leaking away with each sip of rum-and-water.
It would have been ordinary for him to have been drinking alone. I
was an intrusion, whatever his placid courtesy; yet I couldn't bring
myself to quit. Talk unraveled. Finally, I had to say: "Carl, you're
bushed. I'd better go," and pushed my chair back to stand up. So did
he. He put a hand on my shoulder: "Stay here, kid, if you like."

We had nightcaps. I stayed. Thus commenced a brief domestic
interlude in which I played substitute housekeeper, enjoying the close-
ness and coolness of a creature whose mythical image was then for
me no less mysterious than a unicorn or a manticore. Carl's quest for
quiet, his spareness in motion, his quizzical softness, which was also
a tender firmness, his nicety in consideration, his dispassionate atten-
tion or friendliness, could easily be translated into terms of love. In
him, and not far below the surface, were layers of reserve that denied
me any very profound exchange. He was not concealing himself; his
nature, either from its poverty, discipline, or good manners, secreted
some unchallenged dignity, possibly fear, but of what? Such with-
holding or denial was of course for me an accumulative provocation.
He was not teasing; he was just Carlsen. When I too earnestly discussed
all this with Walker Evans, he said only, "Oh, that Carl. He's just
another one of Crane's characters; a sphinx without a secret."

Despite cold water and intermittent doubt, he remained an en-
thralling riddle, never more so than when he got up early, made his
kettle of shaving water, washed from a wooden bucket, and set out
breakfast. I stayed in bed, partly to seem to let him have his house to
himself for a little; partly to observe and enjoy his singularity. I don't
know whether he wandered about bare-assed when Bertha was there.
With me, he never dressed until he was ready to go into the street.
This wasn't "narcissism." He never drew attention to himself, nor
was he particularly graced in the flesh. He might have been any age,
twenty-five to forty-five, a sleek, hard, almost hairless male; easy, self-
confident, and deliberate. Nakedness was this creature's kind of
clothing.

Questions intruded. I couldn't accept my situation for whatever
it was on his part. I must worry it, "make sense" of it. Where, and
who, after all, was I? Soon, Bertha must be back; she might walk in
at any moment—tomorrow morning, tonight; now . . . Each time I

noticed her stubby upright piano with its sparkling black-and-white keys, its pile of music stacked neatly on top, I felt a looming adversary. Yet why should her pervasive if fragile absence cloud my present, since it in no way seemed to disturb Carlsen? How greedy can you get? We both knew she was inevitably expected; ours was no marriage, nor was it a one-night stand. If I strained trying to make myself useful, to justify proximity by offering some "contribution," Carl didn't notice. This was my business. He wouldn't have asked me to stay if he hadn't felt some need. Guilt was nowhere near, as far as I was concerned; only delight. I had hoped to have helped him with his "work," his writing, but he never seemed to have finished a story to the degree he thought it ready or worthy of being criticized. He kept his papers-in-progress in manila binders. Sometimes when I was in his house alone, I was moved to glance at a page or so, but this was a disloyalty for which I might be mortally punished. Then about a week after I'd moved in, something prompted me to start reading one of the folders straight through. There were some ten or a dozen pages, a few typed, others handwritten. Then, halfway down a page, words stopped in the middle of a sentence. This was true of all of his stuff. Nothing was finished; the fact that every one stopped seemed an odd coincidence. I suddenly realized that Carl longed to be "a writer," but couldn't write. Perhaps this was due, in some way, to the refusal from the editors of *Hound & Horn*. I guessed that he knew I knew his secret, but mutual convenience prevented it from being betrayed. He had a rare reserve of emotional energy, without any sentimental taint, and I recognized him as a classic stoic. Perhaps this is why Crane chose him. In an untidy universe, here was order, magic, however miniature, a clipper ship in a bottle.

Quiet consciousness of self, a centered, unexpressed self, trying to comprehend what is done while doing it. For myself, at the age of nineteen, I had by chance begun to engage in similar self-instruction, through the means of one system of analytical method. Hart Crane himself only touched on his astonished impression of a dramatic, then much-publicized demonstration of the corporal manifestation of this same discipline. On February 2, 1924, he had written his mother back in Ohio that he had witnessed a performance of dancing organized by George Gurdjieff, which although executed by amateurs "would stump

the Russian ballet." In 1917, when Crane had first come to New York, aged eighteen, he had seen Diaghilev's company at the old Metropolitan Opera House, and later became friends with Stanislav Portapovich, to whom he dedicated an early poem:

> *Vault on the opal carpet of the sun,*
> *Barbaric Prince Igor:—or, blind Pierrot,*
> *Despair until the moon by tears be won;—*
> *Or, Daphnis, move among the bees with Chloe.*
>
> *Release,—dismiss the passion from your arms.*
> *More than real life, the gestures you have spun*
> *Haunt the blank stage with lingering alarms,*
> *Though silent as your sandals, danced undone.*

Crane came to know a number of people who had been close to A. R. Orage, whom T. S. Eliot called the best editor of his generation. Orage was designated by Gurdjieff as his first American representative. Some twenty-five students performed movements derived from Near Eastern and Central Asian sources in Manhattan, Chicago, and Boston. These drew considerable attention and had some issue. On May 29, 1927, Crane wrote from Patterson, New York, to Yvor Winters in California about his total disagreement with Gurdjieff's proposals, which claimed to impose instruction towards a "harmonious development of man" in its trinity of physical, mental, and moral capacities. He told Winters the aim was

. . . a good idealistic antidote for the hysteria for specialization that inhabits the modern world. And I strongly second your wish for some definite ethical order. [Gorham] Munson, however, and a number of my other friends, not so long ago, being stricken with the same urge, and feeling that something must be done about it—rushed into the portals of the famous Gurdjieff institute and have since put themselves through all sorts of Hindu antics, songs, dances, incantations, psychic sessions, etc. so that now, presumably, the left lobes of their brains respectively function (M's favorite word) in perfect unison. I spent hours at the typewriter trying to explain to certain of these urgent people why I could not enthuse about their methods; it was all to no avail, as I was told that the "complete man" had a different logic than mine,

and further that there was no way of gaining or understanding this logic without first submitting yourself to the necessary training. . . . Some of them, having found a good substitute for their former interest in writing by means of more complete formulas of expression, have ceased writing now altogether, which is probably just as well.

On December 21, 1923, Crane wrote from Woodstock, New York, to his mother in Cleveland a letter replete with patient sympathy for her maddening complaints, her self-martyrizing, her distaste for his way of life.

I, too, have had to fight a great deal just to *be myself* and *know myself* at all, and I think I have been doing and am doing a great deal in following out certain natural and innate directions in myself. . . . Suffering is a real purification, and the worst thing I have always had to say against Christian Science is that it willfully avoided suffering without a certain measure of which any true happiness cannot be fully realized.

Crane might have been paraphrasing Gurdjieff himself. Ultimately, the essence of his teaching proposed means to utilize that suffering which is the common lot, not by avoidance, but by its positive and negative energy. Certain temperaments or "personalities" have found themselves predisposed to the magnetism of the recension of esoteric and exoteric exercises in the residue of post-Pythagorean notions. Like Crane, not a few have been moved by the apparent magic in the organization of corporal action in the Gurdjieff exercises, but have been put off by the ensuing demands of his metaphysical lucubrations. My good fortune, for I consider it the greatest luck that ever hit me, was that I encountered this cosmology when emotionally I was an adolescent, without any essential experience, and hence lacking prejudice but not appetite. I was hardly more than a child, with few "ideas" good or bad. Crane, early on, had ceased being a child. His physique, gifts, affective life were forced into prematurity. Due to over-aroused psychic activity, the furious problems of domestic tension stoked raw habits of antagonism and escape long before the boy had any capacity to diffuse them. The anguish in his prepotency withered him. He quickly became an old youth in an unresisting body and settled for a hysterical persona, laminated to his true center—brilliant,

irascible, corruscating, and electric—a rocket launched towards a magnetic relief in extinction.

When, in the summer of 1927, I was in Fontainebleau for a short stay at Mr. Gurdjieff's priory, I met a Scandinavian-American ex-farmer who might be placed (or rather, I chose to place him later) in a category similar to Carlsen's. I revered him for his undemanding straightforwardness, his unblinking devotion to the feckless jobs which Gurdjieff assigned as muscular extremities of conscious coordination or self-discipline. I had barely reached that limit where I could distinguish between positive and negative energy, but I was able, instinctively, to realize that in the superficially boring, chaotic, but exhausting games that we played there was, somewhere, somehow, a key for conduct to a life I hoped to lead. Hauling big rocks from one pile in the garden to another hole a hundred yards away for no purpose I could decipher was not the most enchanting way to inherit wisdom from the ancients, but due to my proximity in this "work" (rockpiles) to Swede, the sweat (his and mine) was more than tolerable. He took orders unsmiling but uncomplaining. His lack of visible protest or question somehow bespoke genuine need. If he wanted something so clearly undefined, I could borrow whatever it must be. Mr. Gurdjieff, marking our companionship, grinned and said, "So. You and Swede." I was delighted at such attention. He said evenly, "Swede. Honest workman."

*Honest workman.* This phrase had a stubborn resonance. When I was posing for Gaston Lachaise, the sculptor, some five years later, he instructed me in his personal criteria for "modern art," in which, at that time, I was obsessively interested. I mentioned Aristide Maillol, who in the twenties had that mandatory ubiquity now enjoyed by Henry Moore. Lachaise said, "Maillol; not great *artiste*; honest workman." Hart Crane had been friends with Lachaise and his wife since 1923 and owned a fine alabaster dove. On March 5, 1924, Crane wrote to his old friends, the Rychtariks, whom he had left behind in Cleveland: "This afternoon I went around to an exhibition of sculpture by Maillol (who is an honest workman, but not very creative)."

Perhaps Gurdjieff's nomination had been transmitted through Orage, Gorham Munson, Caesar Zwaska, Wim Nylan, or others in G.'s first New York "Group." As I received it, the appellation "honest workman" did not imply peasant, day laborer, or mechanic. It was a

judgment not only of a particular artisan but also of the condition and quality of art and craft in general. Here a basic integrity is not always foremost, whatever the currently accepted reputation for excellence may be. I feel certain that Crane borrowed this from Lachaise; the identity with Gurdjieff's epithet was fortuitous. There were other odd linkages to Crane in my remote contact with him. Years later I came across two "irrelevant" facts which further diminished my superstitions concerning chance. The first artwork I collected (given me by a favorite cousin) was a Maxfield Parrish color print of Cleopatra. It portrayed a flapperish serpent of old Nile in her barge, lounging on what appeared to be an American "colonial" four-poster bed, bowered in dogwood and attended by three high-school athletes. It had been commissioned as the first of a series by C. R. Crane to adorn his five-dollar *de luxe* gift chocolate boxes. This was in 1917; I was ten years old. In 1923, Crane moved into 6 Minetta Lane with his friend Slater Brown. In 1933, I moved in there with Tom Wood, with no notion of what was a meaningless coincidence.

Crane's appreciation of art, for which his parents had prepared him, though primarily in the interests of commerce, was real. His admiration for William Sommer's undistinguished painting was inspired by his first encounter with a working artist. He adopted and adapted opinion, as also in his verse. But as to "honest workman," the simpler it sounded, the more recalcitrant the inference. Merely, honest. Only, a workman. As for the Swede, his absolute health, sanity, sense, and sweat that I imagined smelled of raw wheat—his massive softness and ready acceptance of whatever had to be practically done—were these the normal attributes merely of honest workmen? And why should such try to be any more than that—why also "creative," like Ezra Pound or T. S. Eliot, who then governed the lending library I fancied as my "mind"? Why should unadulterated animal magnetism or sweetness of spirit be allied necessarily with the capacity to paint tremendous pictures or write extraordinary poetry? What is the pay potential on a humane level? Honest work was to be judged on what range of imagination, lyric fantasy, or the responsibility which kindles the heroes and martyrs, makers or failures?

Carl Carlsen had strayed into an adventurous and dangerous area of electrical transformation which has come to be called "creativity." He had stumbled unequipped and unendowed into the field of

imaginative play. His will to write, to become "a writer," licensed desire and gave it an illusion of spirit and ability which was little more than echoed promise. This honest workman had been lent a vision of unlimited possibility. He might have pursued a more profitable existence by schooling himself in physics, chemistry, or navigation, and ensured an alternate future, but the words, the fearsome sorcery of words fixed him in a situation which held only the recognition of ultimate weakness. Crane launched himself on an inevitable trajectory, only to be arrested at its peak. Carlsen never got within sight of a start.

I lost sight of Carlsen; perhaps he went back to sea as a purser, or shipped out with his brother. Maybe he married Bertha. Walker Evans didn't know. When I went around to call after I came back from abroad in 1933, there was a FOR RENT sign tacked to his front door. My conscience was assuaged somewhat by printing in the twenty-eighth and final number of *Hound & Horn* two letters of Hart Crane to his patron, Otto H. Kahn, telling him of the progress of *The Bridge*, with a letter of Kahn's to Grace Crane thanking her for a photograph of David Alfaro Siqueiros's portrait of her son, the original of which he had razored to ruin some days before he sailed from Veracruz. In the same issue we printed three large, evocative photographs by Walker Evans of downtown Havana, Crane's last port of call.

I don't think that the academic or literary renown that was beginning to collect around Crane meant much to Carlsen. To him, Hart was buddy and model, beyond any question of worldly status. Yet the ferocity of suicide must temper earlier memories, a sequence studded by signs, big or little, of ambiguous destiny. After the fact of threats, rehearsals, and the big event itself, was there, could there have been much doubt that he would have ultimately put an end to his agony? Were there no other alternatives here than with Ralph Barton, Harry Crosby, Randall Jarrell, Hemingway, John Berryman, Sylvia Plath—or even Dylan Thomas, Robert Lowell, or Ted Roethke? (And while Thomas and Lowell do not strictly fit into the coroner's casebook as self-slain, they were as much destined, self-centered victims as Delmore Schwartz or Scott Fitzgerald.) Is it only rationalizing to believe that Crane, like others, enriched language, enhanced its rhetoric, while the magnitude of negation was an exact equivalent to the intensity of talent? As to why there was not more positive energy, why

suffering could not have been bridled or used, or why there was not enough spirit to exist while being consumed, perhaps the answers lie in the nature of romantic solipsism. One might wish that the dynamics of affection and revulsion that tore his parents apart, and him in the bargain, might have blessed Crane with Walt Whitman's patience, benevolence, or detachment. Whitman, whose family situation was even more disastrous (with the exception of an ignorant but loving and loyal mother), survived extreme illness, madness, and poverty into his seventies. Crane's residue was achieved in a term of some fifteen years; yet it had its own febrile harvest. His synapsis, "the conjugation of homologous chromosomes, of maternal and paternal origins respectively," exploded into electrical short-circuits which kindled magnificent verbal sparks, flares, and ever-burning torches in their positive bursts and, on the negative coil, brawls, despair, self-pity, and self-loathing. There was never to be

> *My hand*
> *in yours,*
> *Walt Whitman—*
>
> *so—*

It does not take much special pleading to propose Whitman as an "honest workman." He cast himself in a role of which the mature image was a grandiose version amplified from an impersonation of a youthful original. Cocteau said that another bard, Victor Hugo, was a madman who imagined he was Victor Hugo. Whitman invented the "Good Gray Poet," complete with a photograph of a paper butterfly wired to his fingers. He had begun as plain Walter Whitman, journeyman typesetter, printer, schoolteacher, Free Soil editor. One has no feeling that Crane ever cared or plotted to be or impersonate anyone other than his haphazardly given self. As far as his work went, he felt himself one of a band of brothers which included Poe, Rimbaud, Whitman, and even Gerard Hopkins, hoping his voice was a vatic conduit rather than a conscious and governable identity. His legitimate claims to join the company of Marlowe and Melville are his sensational elisions and impacted fireworks, so tightly compressed that the shock of their implosion lasts longer than the time it takes to scan his pages.

His is a high style, an extension of the grandest rhetoric, and could only have been achieved by the most abject expenditure of sense, sentiment, and skill. Whitman's easygoing, lounging prosody betrays few hints of rewriting or emendation; he constantly altered his texts from edition to edition, but this was almost careless correction. It is hard to think of Whitman drunk or Crane sober. Crane failed as apprentice candy salesman, journalist, and professional literary man. Whitman lived as a civil servant, reporter, and lecturer: a career by pittance, but he survived.

While I was living in Carl's house, he took good care that I had my own towel, tumbler, and tar soap; he didn't like to share his old-fashioned straight bare-blade razor, and anyway, I would have cut myself. Everything was shipshape, and the days passed without memorable event. Sooner or later I would leave. Either there would be a letter or telegram from Chicago announcing Bertha's return or she might surprise us. Carl didn't think so; she had her own sort of consideration, which is why they got on so well. The delicacy that linked them need not be broken by resentment on her part, although she of course had no notion I was temporarily taking her place.

So, her special-delivery letter arrived: Bertha's mission in Chicago was a complete success. The sister was entirely recovered, although she made no boast of her "Scientific" ministrations. She planned to take such and such a train, and could be expected at such a day and hour. There was no big deal about goodbyes; in the few days of grace left we pursued our amiable routine without apprehension.

The best place to call it a day was in bed. I loved sleeping with Carl; this was no euphemism. We learned to sleep like spoons; if either had to get up in the night it was no problem to reverse positions and sleep more soundly. Vulnerability transcended? Something like that. Alone, together; cozy and quiet. What I felt most was the gravity or power of his light treatment of my fascination with him. He knew I loved him. As for him—he liked me; I was a pet or mascot.

To make a neat end to this story I could say, "You smell so good." Tar soap? Any less oppressive farewell would have been unseemly. "Yeah: that's vinegar water—but not from vinegar. Crane liked that stuff." I told him how much I had enjoyed this vacation. Abruptly, and for the first time, there was an edge to his ease. "Why didn't you like Hart?" I'd hardly known him; he scared me; I wasn't up to him.

His disorder; my envy. Guilt. "Funny. You didn't like him, but you like me." I heard myself say, "Carl, why the hell do you always have to bring Crane into it?"

"Why, you silly son of a bitch. If it wasn't for Crane I wouldn't have given you the sweat off my ass."

# *From* Rhymes of a PFC

[*Although Kirstein had been writing poems steadily for some years (a garnering, Low Ceiling, came out in 1935), what he produced after joining the U.S. Army in 1943 was markedly different from his earlier manner. Licensed by the examples of Whitman, Kipling, and, perhaps, T. E. Lawrence's The Mint, Kirstein's new poems were vivid, sardonic reports on the confusions and ambiguities of life within the gigantic American wartime machine. As if to gauge the ironies he found there, his style became a pungent blend of the "high" and the low-down colloquial, the archaically lyrical and the brutally matter-of-fact. Today, the results can still seem, in W. H. Auden's words, "defiantly unfashionable," but their accuracy and truthfulness are guaranteed by this rugged, uncompromising quality. These poems, written either on active service or soon afterwards, were collected only in* Rhymes of a PFC *(New York: New Directions, 1964).*]

## Basic Training

Belvoir! What's war to someone who's never known war before?
    Our Civil War—
Splendid in springtime, a sprightly gift sent us from worlds away;
    Under rubbery clay,
Popping out of Virginia hills, coral-pink bushes bud; thrushes sing,
Stirring our fuzzy green fresh clean wildly promising
    Tender marvelous May.

Eighty years gone, more or less, all these roads ran to Bull Run,
  But now our fun
Apes a miniature shadow of such vast disaster to spot
  A few snapshots of what
We've come to suspect has little to do with wars we ever shall see
Fought on land or sea: tanks; planes. No horse cavalry,
  Minié ball, nor grapeshot.

Yet my civil war's nearer than that war over the blue:
  World War II,
Which means zero to me save for drab facts which inspire me to fear;
  I'm absurdly quite here
Trying hard to pretend our crack halfback lieutenant, Bill Beady Eye,
Risks a charge under raking cross-fire to fly
  Carbines and a thin cheer.

This weak dull pun on battles our schoolbook creates
  Between the States;
Where First Massachusetts and Third Tennessee pitched scarecrow
  tents,
  They've hewn stone monuments.
Better than Brady in albums, a leap towards historical fact
Is fooling with live ammunition, trying to re-enact
  Real warlike sentiments.

What sort of an officer's Bill Beady Eye? He's all right—
  By a damn sight
No West Point paladin, Stonewall, Stuart, or Lee. Full of zest,
  Does his beady-eyed best
To haul our poor amateur ranks up a knoll he insists we must take.
Victory! It's took. He awards us a ten-minute break.
  I relax with the rest

And try to recall Dick Hales, a boy I'd known since a child:
  Meek was, and mild.
His dad, a drunk, tossed him his cavalry saber; quit home for worse.
  Dick, a sissy of course,

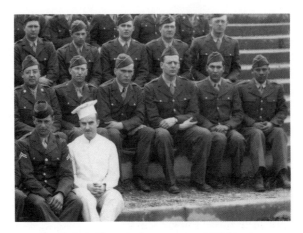

*Fort Belvoir, Virginia, January 1943. PFC Kirstein*
*is third from the right in the middle row*

Tacked the sword to his wall, whimpered for Mummy to come and
    be kissed;
Never won games nor a girl; to Canada crossed to enlist
      In their Royal Air Force.

Yesterday, in some clippings from home I chanced to have read
      Dick Hales is dead.
Slid his flakked plane sidewise low over Sussex to spare a girls' school;
      No trick for coward or fool.
He had the presence of heart or head to make his enormous bet.
Now is he hero, haloed and holy. His mummy can get
      Used to life being cruel.

Dick: what is left of you now, with my civil war please coincide.
      Kidding aside,
Accept sprig of apple or plum which pitiless April has brought,
      The meager tribute I've got;
First to fall among men I have known, always sure to get hit—
Or, after the fact, seems so—your crash links history a bit:
      Minié ball, flak, grapeshot.

## *Tudoresque*

One adores the glory of England. When I was a scamp at school,
　　　The poet James Agee
And I listed the names of English kings, dates of their ev'ry rule—
　　　(Exeter's library);
Sketched coats of arms with sable bend and even a sinister bar,
　　　Baron or baronet;
We savored the fame of Tower jewel, Kohinoor and India's Star.
　　　Late afternoons we met
To devour the epic of England in ancient magazine views
　　　(Periodical stacks),
From leather-backed rusty volumes of the *Illustrated London News*.
　　　My first Shakespeare contacts
Were Jim's reading parts from the Histories aloud, fresh as current
　　　events.
　　　　　Favorite rôles were those
Of Bolingbroke, Hal, and Hotspur in bloody fine incidents
　　　Where bled the Tudor rose
Within the bosom of lover and friend: Prince Hamlet, Horatio.

　　　Often Hamlet was Jim;
We got drunk on Shakespeare's iambics and Britain's dynastic rainbow.
　　　I most remember him
Flipping the pages of portraits vignetted for the *London News*—
　　　The First War's English dead,
Glorious young men all, each a university graduate.
　　　Fate haloed every head,
All officers, baron or baronet, not one a mere private;
　　　History was alive.
Jim had such charm as Hamlet, I was happy Horatio, his friend,
　　　On four days out of five,
Though always I deem myself Denmark and shall play him to the
　　　end.
　　　　　At Harvard before long,
The casting is switched by Agee. He prepares the high comic schools,
　　　Sings us another song:

The chilly end of *Love's Labour's Lost* and *Twelfth Night's* solemn
    fools,
        And Jim, setting forth strong,
Read me his own sug'red sonnets, which made noises like poetry
        Back then as they still do,
And Agee will dwell in English verse whilst, as for merely me,
        In footnotes I'll dwell too
For having first printed his verses in the quarterly *Hound & Horn*
        (A quote from Ezra Pound
Deeply revered in '26 before most Young Poets were born).
        Long since I've turned around;
I've had my fill of Fair Harvard, her Twentieth-Century Men;
        Theodore Spencer's dead
Who taught us the Age of Shakespeare, and his polymath Shakespeare
    then
        Was less of heart than head;
Our tutor was friend to Eliot, a nineteenth-century man
        From the seventeenth century,
So when he rewrote us our poems, the stanzas were wont to scan.

        What meant England to me
Apart from bards on Widener's shelves and Jim Agee's brandied voice?

        Britain: its earth, as well.
My people gave me a pilgrim's scrip, bade me make a scholar's choice:
        Tintagel's drear hotel—
Its Table Round of Morris fumed oak besprent with thumbed Debrett's;
        Cathedral Close at Wells,
Where paddled a white-marble pride of swans with invisible coronets,
        Tugged at the moat-house bells.
And I scaled the heights of Bloomsbury; I took rooms in Gordon
    Square.
        I found some English friends.
At dazzling soirées Lytton, Maynard, Clive, and Virginia were there.
        Lydia superintends
Our *pas de deux*. Lopokova and I perform a world *première*
        When I'm but sweet sixteen,
For the London seasons *entre les guerres* were Heaven and Vanity Fair,

The like since seldom seen.
At the head of St. James's Street, silence. Crowds hush at brisk rattling
    brass:
    The Household Cavalry.
An open coach thrones George the Fifth. From Paul's I see him pass:
    "God bless Your Majesty!"
His mask salvaged from mortal ill, very model of some carved king.
    He also is *my* king.

So here am I back in the ole U.K., endeavoring for to bring
    Whatever decent thing
I can to repay my bad Yankee debts to English poesie.
    It isn't hard at all.
England encourages allies with hearts and hearth, and I
    Have billets within call
Of Third Army Headquarters, leased from a kind P.O. employee—
    A Manchester suburb.
It's a tiny Tudoresque villa, but he's cleared a room for me;
    The service is superb.
From Invasion Exercises I drag in bushed. Always, there he waits,
    Tea on his hob, and toast.
We prattle of the state of England and my own United States;
    We make our Allied boast
Of our present Grand Alliance and those futures we're fighting for.
    I tote him PX gum
For the brats of his son, at sea, who's actually winning this war;
    Splicing a brace of rum,
Since his boy's been absent from home five years, we drink deep to
    his luck—
    An *officer*, no less—
A tall fair youth with starry eyes, like Raleigh or Rupert Brooke
    (His snapshots show me this).
The *Illustrated London News* taught me that specific look
    From World War No. 1,
And declares my P.O. employee: Old England's come very far;
    Now, often things are done
Unthinkable thirty years ago when he'd fought a private's war:
    "Officer? Me? My eye!"

Yet look at his own Bertie now. And Bert's mother, at the door:
    "Daad, coöm ta baid." Hence I
Apologize for keeping him up. It's not that she hates us Yanks;
    She wishes we'd go home,
Though courteous as can be and decently renders her thanks,
    Yet I lack the aplomb
To make her love me for me myself or for my Amediken style:
    Intruder, and too fat.
She thinks I think this war's a lark and her suffering not worthwhile.
    Still, what she's getting at
Is part of a complex problem of country and class and taste
    Useless to ponder on.
'Er 'usband disagrees. We're buddies, though our friendship be a waste,
    For soon it will be dawn,
Nearer that day I fare for France, where wars are actually faced.

    We smother a sheepish yawn,
Ole Limey and young GI, hands-across-the-sea.
                         I quit my foster home
    Shelved full of PX food,
To bivouac nights in a circus ground from the which I may not roam
    Unless I plan it good.
Our circus ground is guarded by fairly reliable MPs
    With itchy tommy guns.
Often almost courageous, I've irrational fears of these
    Amongst some other ones
Mainly about a prepaid tour in a rational modern war
    Beyond this circus ground:
What lurks for Third (censored-dash-censored) Army, on foreign shore.
    Joe Sentry on his round
Lets nary a whisper drop on when we ship out or how we sail,
    But I'm not wholly lost.
I read in a week-old journal, th'invaluable *Daily Mail*,
    Snuck in here at some cost:
John Gielgud opens *Hamlet* in Manchester, right this selfsame week—
    Perchance this very night!
I start to charge batteries, low voltage of the terrible meek;
    Whether it's wrong or right,

John Gielgud I intend to view, granted Official Permission or not.
  Of course it's bad to go;
Deserters from imminent invasions all deserve to be shot,
  But I will see this show,
So I trickle out of our circus ground, nab a fast tram into town
  As quick as you'd say "knife,"
And it *is* the Opening Night! My ticket costs me arf-a-crown—
  The best night in my life
(In a theatre). The house is packed; stuffed in a balcony sit
  I, tight against a wall,
But knowing the words and the music and how the plot will fit,
  I miss nothing at all
Of this greatest Hamlet of an epoch that saw Jack Barrymore.
  My father, years ago,
Graded me all his Hamlets; awarded *grand prix* of princes for
  Black Edwin Booth, although
He conceded Sir Henry Irving possessed the more argent voice.
  Johnston Forbes-Robertson
(At least from photographs) had, until tonight, been my personal
  choice.

  Soon is our drama done:
Ophelia (Peggy Ashcroft) was sideswiped by a flying bomb
  Only two days before.
She goes daft with a bandaged wrist; her performance gains pow'r
  therefrom:
  That's what Theatre's *for*.
Gielgud beggars description; if its begetter could only have seen
  His Hamlet to the life.
Our hearts are cleft in twain. He cradles, he cozens his mother-
  queen—
  Minx, sister, mistress, wife.
No sweet prince ever drew breath, dowered by dynasty or demesne,
  Peer to his taffeta air,
His consonant hysteria, his generous insane
  Cool canny candid stare
When he transfixes his schoolday chums, snapped links with a charmed
  lost youth—

Rosencrantz, Guildenstern.
But now this production assumes a superfetation of truth.
    In my mind's eye still burn
That sunset end, that music at the close, that final scene of all,
    That feast of corpses strewn:
(*Enter Fortinbras & British Ambassadors* . . .) We bite on breath:
    Bright midnight on black noon.
(*Drums, colours, attendants* . . .): "This quarry cries on havoc. O
    proud Death . . ."
    What did those English find?
An empty throne (*stage center*). Loyal Horatio at post, on guard,
    Nor has he lost his mind—
Snatches the crown from his bleeding prince, ill-starred and starry-
    eyed.
    He sets that hollow crown
Upon its siege imperial. Hail! The king lives nor ever has died.
    Then kneels Fortinbras down,
And this piece is no longer Gielgud's nor is it Shakespeare's either,
    Though both make all come true.
It blazons the armour of England in every sort of weather:
    Treason or buzz bomb too.
England shares actor and poet with soldier, civilian, and all
    Allies, of whom I'm one.
*England, what thou wert, thou art.* Bang hands. Roar throats. Teary
    curtain-call.
    Thus all her wars are won.

## Hijack

We drive all day from mildly picturesque Coumbes-sur-Seine
Through Impressionist landscape it's nice to be seeing again;
My colonel, no companion of choice, uncorks his private pint of pain.

I've driven for this old pre–World War I crock before.
He doesn't like me for stink; I deem him a snobby old bore;
But we're inextricably linked by certain tensions ingrained in this war.

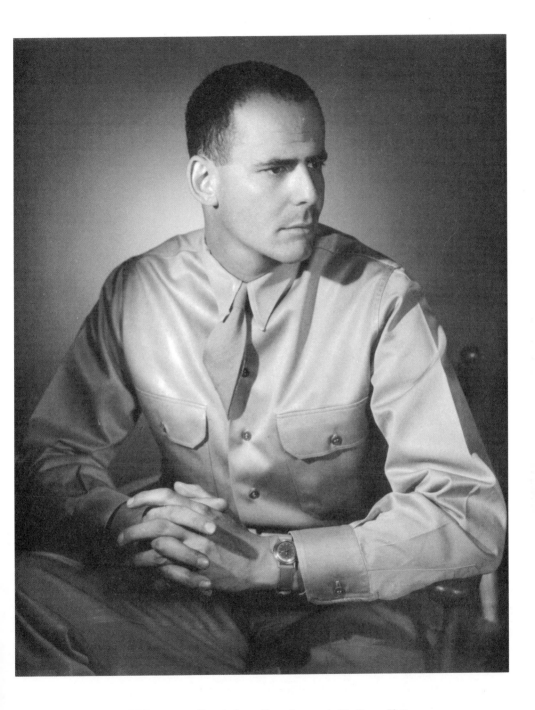

*PFC Kirstein in his stripeless uniform photographed by George Platt Lynes in April 1943, shortly before he was shipped to Europe*

His grief derives from a grandson he's crazy about
Who he's learned was captured two days ago in a censored rout
Of U.S. troops. Now we ride up front fast trying to find something
    out.

North, ever north; then northeast. Disturbing tableaux abound—
Relics of men and machinery, busted husks tossed around.
As we roll through sinister buzzings, nervous-making mysterious sound

Upsets us and—bang—we stall in a small market square—
But how best to describe it? A pitched battle takes place right there
While the parties engaged wear one uniform: ours. Interpret this scare

As some insane gag, but now a big gasoline truck
Overturns. Jerry-cans bounce on fierce combatants striking or struck
By fist, gun butt, monkey wrench. If we have only average luck

Things won't pop, someone get hurt: us. I watch Colonel stand
In our dead jeep shouting orders, though none obeys his command
Sensible as it sounds: "Stop, boys; stop right now," and then his good
    right hand

Reaches for sidearms. I yank him down, jerk our jeep back.
Bodies swivel around the vehicle and dusk dyes to deep black
While it all gets more unreal although staying real enough. Absolute
    lack

Of discipline or authority. Colonel slumps down
Sulking through this crazy vague riot in a French border town
Where American soldiers sock one another for some obscure renown.

Hence: construe this authentic hilarious scene,
Melodramatic yet stereoscopic. What has just been
Logical chaos stems from hysteria mainly about gasoline.

Our motorized units forged so wildly far ahead
Many imagined they'd seized victory but were then stopped dead.
Whichever eager beaver planned this mad push should have stood in
    bed.

Hence we hijack gas from whom gas has to hijack;
There's nowhere near enough to make up our present serious lack,
Not alone to sustain an advance but to stop being shoved way back.

Colonel and I, in sort of a bad spot, are safe enough.
I still have, thank Christ, my own tank half full of the sacred stuff,
Which brings us back to base though driving blackout routes by night
    is rough.

My pre–World War I officer sweats in the dirt
Clinging to a great American Army losing its lousy shirt—
His adored grandson captured by the enemy; lost, maybe hurt. . . .

*Rows of empty American gas cans outside La Falaise, fall 1944*

## *Patton*

Skirting a scrub-pine forest there's a scent of snow in air;
Scattered sentries in smart combat dress accord us their sharp stare;
My chaplain for the first time now allows as where we are:
      At the core of this campaign.

Detroit's vast ingenuity subsumes our plans for doom,
Commandeers an auto-trailer to serve as a map-room;
Hermetic and impersonal, one may reasonably assume
      This is Third Army's brain.

I spy a female nurse pass by, baiting a white bull pup,
Official pet of General's and a humane cover-up
For isolated living or affection's leaky cup
      At secret headquarters.

Nurse accepts my chaplain's solemn amateur salute;
He lets the pup lick and sniff his shiny combat boot,
Shoots her a semiprecious smile, which all agree is cute—
      Raps on that map-room door.

Should I from sloppy jeep jump out and to attention snap?
Patton's informal entrance seems some sort of booby trap,
But his easy stoic manner is devoid of any crap,
      So I stick right in my car.

Measuring our morality or elegance in war,
I marked our nurse compose herself. Starch-white, she primly wore
A gold-filled heart-shaped locket on her chest, and this was for
      Second, minute, hour.

Time's analysis is portable and only time can tell
What's in the works for all of us—nurse, chaplain, general.
Syllables in separate hour, minute, second, simply spell
      Military power.

Our brass cut short their conference, and Patton turns to me:
"Well, Soldier, how about a cup of hot, delicious tea?
Unless I am mistaken, Nurse may even add whisky."
          "Oh, thank you, sir," I said.

"Chaplain says you come from Boston. Then you know it is my home;
Now both of us are many miles from Bulfinch's golden dome.
By springtime it is where I hope the both of us may come
          Provided we ain't dead."

Nurse's watch ticked its temporal tune. Chaplain and I returned
To our base of operations whilst vict'ries blazed and burned.
Reckless Patton's vehicle one year later overturned:
          I see him as a saint.

Angels who flanked his final fling to martial glory's niche
Named Lucifer as honor guard, for that son of a bitch
My immortal captain's mortal, and also he touched pitch;
          His stars tarnished from taint.

In *Stars & Stripes* we read it when he slapped that soldier down
Cringing in a psycho ward to play the coward clown,
Presuming to a state of shock (he'd smashed a stubborn town),
          But Patton blew his stack.

For me and my companions whom slap and shock stung too
Though minimal responsible find other factors true:
The pathos in enlisted men's not special to the few;
          It is the generals' lack.

Inspecting cots of amputees, unshaken obviously,
Approves the stitch above the wrist, the slice below the knee;
Hides in th' enlisted men's latrine so he can quietly
          Have one good hearty cry.

This soldier has to take a leak, finds someone sobbing there.
To my horror it's an officer; his stars make this quite clear.

I gasp: "Oh, sir; are you all right?" Patton grumbles: "Fair.
        Something's in my eye."

With vict'ry's brittle climax pity's never far away;
Patton feels only wounds should hurt which help him win the day.
But wounds have casual exits and it's often hard to say
        If blood flows in or out.

When endowed as a fine artist you can fling the paint around;
Or, called to seek salvation, you can make a solemn sound.
But crafty priestlike soldiers keep one premise as their ground:
        Loose fright ends up as rout.

Patton's a combat artist; hence his palette runs to red;
Makes superior generals anxious he's prone to lose his head,
Spoil pretty Rhenish landscapes with an April coat of lead:
        Our man may go too far.

The British and Canadians are ordered to push through;
Patton learns he's just their anchor with nothing much to do
But cultivate impatience, curse and sweat or curse and stew—
        Not his concept of war.

He vows: "Now you go fuck yourselves. I'm taking off from here."
He vanishes, nor hide nor hair. At SHAEF there is grave fear.
They bid him halt; he wires 'em straight: "I HAVE JUST TAKEN
        TRIER,
        SO SHALL I GIVE IT BACK?"

Military governor, Bavaria's shattered state,
He had a naïve notion which was not so all-fired great;
Hired him all former Nazis who'd nicely cooperate.
        For this he gets the sack.

And yet—it's not entirely fair. Since war is done and won,
Patton fears peace as idleness, peacetime as seldom fun;
Idleness is devil's business, and for the devil's son
        Good Nazis don't rank least.

This old pro was an innocent. Thank Christ for simple souls,
Pearl-pistol-packin' poppa, prince of polo's thousand goals,
And I'm not fooling you, my friend: he starred three major rôles:
     Warrior, craftsman, priest.

We were rained right out of Nancy. Firm Metz we could not free.
Floods muddied fields; his bogged-down tanks less use than cavalry;
Came his orders: ALL PERSONNEL WILL PRAY THAT THESE
UNSEA-
SONABLE RAINS SHALL CEASE.

George Patton through proper channels forwards his request.
There comes logical reply to logistical behest;
Who am I to testify it's some joker's sorry jest?
     Rains cease. His tanks make peace.

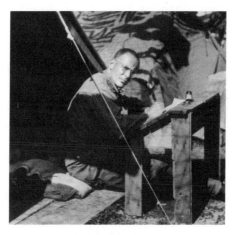

*Lincoln Kirstein at the writing desk he made*
*for himself. Normandy, 1944*

## Rank

Differences between rich and poor, king and queen,
Cat and dog, hot and cold, day and night, now and then,
Are less clearly distinct than all those between
Officers and us: enlisted men.

Not by brass may you guess nor their private latrine
Since distinctions obtain in any real well-run war;
It's when off duty, drunk, one acts nice or mean
In a sawdust-strewn bistro-type bar.

Ours was on a short street near the small market square;
Farmers dropped by for some beer or oftener to tease
The Gargantuan bartender Jean-Pierre
About his sweet wife, Marie-Louise.

GIs got the habit who liked French movies or books,
Tried to talk French or were happy to be left alone;
It was our kinda club; we played chess in nooks
With the farmers. We made it our own.

To this haven one night came an officer bold;
Crocked and ugly, he'd had it in five bars before.
A lurid luster glazed his eye which foretold
He'd better stay out of our shut door,

But did not. He barged in, slung his cap on the zinc:
"Dewbelle veesky," knowing well there was little but beer.
Jean-Pierre showed the list of what one could drink:
"What sorta jerk joint you running here?"

Jean-Pierre had wine but no whisky to sell.
Wine loves the soul. Hard liquor hots up bloody fun,
And it's our rule noncommissioned personnel
Must keep by them their piece called a gun.

As well we are taught, enlisted soldiers may never
Ever surrender this piece—M1, carbine, or rifle—
With which no mere officer whosoever
May freely or foolishly trifle.

A porcelain stove glowed in its niche, white and warm.
Jean-Pierre made jokes with us French-speaking boys.

Marie-Louise lay warm in bed far from harm;
Upstairs, snored through the ensuing noise.

This captain swilled beer with minimal grace. He began:
"Shit. What you-all are drinkin's not liquor. It's piss."
Two privates (first class) now consider some plan
To avoid what may result from this.

Captain Stearnes is an Old Army joe. Eighteen years
In the ranks, man and boy; bad luck, small promotion;
Without brains or cash, not the cream of careers.
Frustration makes plenty emotion.

"Now, Mac," Stearnes grins (Buster's name is not Mac; it is Jack),
"Toss me your gun an' I'll show you an old Army trick;
At forty feet, with one hand, I'll crack that stove, smack."
"Let's not," drawls Jack back, scared of this prick.

"You young punk," Stearnes now storms, growing moody but mean,
"Do you dream I daren't pull my superior rank?"
His hand snatches Jack's light clean bright carbine.
What riddles the roof is no blank.

The rifle is loaded as combat zones ever require.
His arm kicks back without hurt to a porcelain stove.
Steel drilling plaster and plank, thin paths of fire
Plug Marie-Louise sleeping above.

Formal inquiry subsequent to this shootin'
Had truth and justice separately demanded.
Was Stearnes found guilty? You are darned tootin':
Fined, demoted. More: reprimanded.

The charge was not murder, mayhem, mischief malicious,
Yet something worse, and this they brought out time and again:
Clearly criminal and caddishly vicious
Was his: Drinking with Enlisted Men.

I'm serious. It's what the Judge Advocate said:
Strict maintenance of rank or our system is sunk.
Stearnes saluted. Jean-Pierre wept his dead.
Jack and I got see-double drunk.

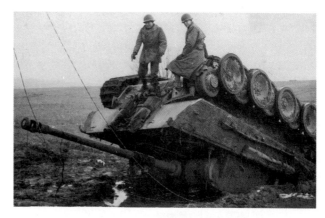

*Captain Robert Posey and PFC Kirstein (right) on a
wrecked tank near Thionville, February 1945*

## Guts

In its seat 'twixt bowel and bladder
Sits the nerve that insists he must dance.
Now he's tense, but what surly disaster
Might mar him a clean pair of pants?
No sense in anticipation;
When it comes, the man says, it sure comes.
This world holds small harvest of heroes
In its gross annual crop of sly crumbs.
Louse he is, but sustains the slim notion
Salvaging him even from fear,
Like curiosity, subtle emotion,
More selfless than first might appear.

When he was a big boy in britches
He got a girl in his daddy's sedan.
It was also the first time for her and

Almost over before it began.
Before he undid she was bloody;
What happened before he was in?
She was only paying her monthly
Wage to original sin.

He should have stopped there but he did not.
Was it courage compelled him to crime?
He was new, hot, hard; and he wanted
To savor the treasure of time.
Bathed in lamb's blood, dried on lamb's wool,
Baptized Buster becomes him a man.
The spunk to buck distaste or habit
Learns you more than a good high-school can.

In a farmer's field five miles from Nancy,
On a dark winter morn, '44.
I drove back alone from Thionville
To Third Army Headquarters Corps.
This here field plowed with raw furrows
In swipes of wide violent earth:
Two medium tanks held disputation
On the essence of death and rebirth.
On its slung treads one tank was flipped over,
The other a crushed can of beer—
Two beetles squashed on their cat-tracks,
Me the one live thing anywhere near.
I parked my vehicle by the roadside,
Pursued tank tracks o'er the spoiled snow;
Implored my morale to quit stalling
Till I'd probed the fierce fate of a foe.

It was rather richer in bloodshed
Than the lass in my daddy's sedan.
You can feature what can't help but happen
When fire grills a thin-armored can,
Such container containing live persons
Who'd climbed in as enlisted men.

If you think this pageant smelled holy
Then you can say that again.

One question, one answer, acquits us;
Caught cheating, we only confess:
"Who the hell do you think you are, man?"
"No worse than that bloody mess."
They're dead and I'm living: it's nonsense.
They're shattered; I'm whole: it's a lie.
Between us, identification:
I am you, men; and, men, you are I.
Tests of failure, dishonor can hardly
Be matters of all-out degree.
Fresh earth will smother you sweetly;
A warm bath can take care of me.
Gruesome glimpses we stare down, maintain us,
Sin and squalor partly appeased.
Such scale bravery may even sustain us,
Our psyches released or increased.

We've endured the Worst That Can Happen.
Hallelujah! There can't be much more,
But the ghastly surprises of history
Hide their inexhaustible store,
And exams in a peace that we pray for
Make dunces of scholars at war.

## Arts & Monuments

We woke up early one morning. My! what a gorgeous day!
We'd crossed Germany's borders to capture a German May;
    Strawberries-in-wine was the weather. All outdoors smelled of fresh
        heather,
    And my puffy captain had a lousy toothache.

"Get me a dentist; it's an order. This pain's just got to stop."
As dentists, we know the Germans rank at the absolute top,

But this town was banged all to hell. I didn't speak German too
    well,
    And where does a good dentist hide out anyway?

Believe it or not, Captain's toothache led to our pulling first prize:
In the street strayed a blond kid with bangs willing to fraternize.
    I puff out my cheeks and I make dumb show like I got a toothache;
    Flirting, I proffer him three sticks of Pep-O-Mint.

With glee he snatched *Kaugummi,* the enemy infants' treat;
He grabbed my hand in both his paws. In step, we chewed down the
    street.
    O'er a door of Gothic design hung a tooth as gilt ensign.
    The dentist inside spoke quite good Rhenish Englisch.

Captain's wisdom tooth was impacted. Dentist was tops at his trade;
He gabbled more than a barber but his tedious small talk paid—
    Much of it rumor or hot air, but somehow he'd been everywhere
    In the vicinity and really knew plenty.

He was swift to uncover our personal specialized part
In these dubious battles. We protected objects of art
    And here the coincidence was extraordinary because
    His own soldier son was in the same business.

No longer a soldier, he'd resigned from the Wehrmacht as such.
His uniform hung in his garderobe; his Lüger he would not touch.
    From his intellectual looks and high shelves of standard art books,
    Big ones, with pictures, he seemed a bona-fide expert.

It took tea and twenty minutes to learn what he had been.
He sent his French wife and child from the room. She brought cognac
    in.
    So: our war had not taken place. I tried to decipher his face:
    Kind? Dangerous? Servile? Clever? Or quite hopeless?

He'd done his whole duty in Paris, charged with Enemy Art—
Location, salvage, seizure, and sale, all from the very start.

He'd records of everything done since the project had been begun
To loot Europe in honor of Hitler's mother.

His price was safe conduct for himself, his child, and winsome wife—
How should I know this requirement determined a family's life?—
  In return for which he would tell which Jews had been forced to
      sell
    What, for how much, and where it all was presently.

We couldn't ensure his protection. Why had he need of the same?
Urgency clouded his liquor as if some shadow of blame
  Disturbed this anxious charming chap. He explained it as mere
      mishap:
    Five years he'd been an officer in the SS.

Him! An attractive Prusso-Balt, yet major of dread SS!
Sentiments evinced by confession we'd just better suppress.
  His Courvoisier made us warm. There seemed to be minuscule
      harm
    Sharing first-rate brandy with such an opponent.

He did not conceal his status, conceding he might be shot;
Not by us: by the Germans. Beloved the SS were not.
  He felt we would understand, whereupon extended his hand;
    Captain lit a cigarette; I nursed my snifter.

We disdained all bargaining. Safe conducts weren't mentioned again.
He turned over his records with the data copied out plain:
  Title, size, and the exchange rate; metal and marble, their gross
      weight;
    Catalogues of paintings, manuscripts, ceramics.

I was impressed by this scholar, who seemed familiar to me—
Bonn-trained, took graduate work at Harvard University
  Under wise old Kingsley Porter; loved Queensley, his wife. He
      thought her
    The cleverest madwoman he had ever met.

His thesis had been research on the Abbey of St. Denis;
Professor Porter taught him to parse the stones of Vieux Paris,
   Which all came handily in when he led Göring's museum men
      In heisting everything they could clamp their claws on.

At first you might think it theft, but later it merely became
Conservation as acquisition, if there's some choice in the name.
   Victory turned much bad into good. In all conscience we almost
         could
      Forgive his foresight as selfish convenience.

Interrogation ended on a brisk businesslike tone;
I felt free to venture a couple of questions on my own
   Since I wanted to understand how the SS program was manned,
      This type of temperament operated.

"When did you first start to wonder would Germany never win?
When you did what you had to do, did it never seem like sin?"
   In all hypocritical jerks, the query certainly lurks:
      Under just what pressures would I have behaved likewise?

At our first Norman landings he knew they were doomed to lose.
His answers sounded candid; 'twas horrid about the Jews.
   Of these, some had been his best friends; some few met depressing
         ends;
      At his club he found himself served off Rothschild plate.

We thanked him as we thought apropos, then bade our brief goodbye.
He recalled his wife and child, both beautiful, frightened, and shy.
   He even remembered some more photos he'd forgotten before;
      I loaded our jeep while he checked maps with Captain.

Was that the last of our major? Until about the first of June.
We'd been ordered forward May ninth and had to leave much too
         soon
   To get the safe conducts required. Besides, we were much too tired
      To think of anything but important problems.

We'd all but forgot this Nazi who'd helped as much as he could.
His romance ended more or less as one might have guessed it would.
  Despair at our lax ingrate haste propelled a predictable waste:
    He shot his wife, child, and himself in a panic.

However, and all thanks to him, we tracked straight to a mine,
Masses of art inside tons of salt, near the Austrian line—
  An upper-class health resort for Tyrolean winter sport;
    It was now held by a committee of miners.

Lines direct to Hitler's chancery were laid to Altaussee
Warning to blow it to Kingdom Come should he be brought to bay.
  These miners were Austrian-born, held Germans in consummate
      scorn,
    And weren't blasting their own livelihoods foolishly.

Mad orders phoned from bunkers of flaming Volsung gods,
But workers in Salzkammergut were betting on different odds.
  They snipped all the dynamite wires and lit tall victory fires
    Hailing the next army here to liberate them.

We prised open crates at random: contents not to be believed—
Supreme constructs of hand and eye that Western man has achieved.
  Objects like these are sacrosanct, for which the SS may be thanked;
    Everything promised is here for the asking.

In cases swaddled in cotton, Van Eyck's Ghent altarpiece:
The Lamb of God sung by All Saints, its glint our Golden Fleece.
  Count Czernin's veristic Vermeer scintillates expensively here—
    He painting Dame Fame's portrait; we, in his studio.

From Bruges in Belgium one huge box cradled a Mother and Child,
Michelangelo's august notion of the massively mild
  Carved in petrified clotted cream, a gently frosted marble dream.
    The edge of the Virgin's robe was chipped in two places.

The worst of it was when we brought out the Van Eyck for close view,
Over his hair shirt St. John's green gown was crisply split in two.
  We studied it under our glass. Now, how could this have come to
        pass,
    And not for the first time? Weak old glue feeds strong young
        worms.

How often through the centuries has Ghent's altarpiece been cracked?
Obverse of its tempera panels showed which had been rebacked.
  Survival is luck or care. Excellence is canonized where
    It takes a miracle to ensure miracles.

Time nicks St. Mary's mantle hem. It rips John Baptist's dress.
Science restores these losses. Art History mops up the mess
  While treasures get shipped home again to hang on the same hooks
        as when
    They were stolen by Hitler or Napoleon.

Presupposing virtuoso vision—scratched, fragmented, or hacked,
Art's intention is barely marred. The residual artifact
  Glimmers steady through years or blood, enduring rough treatment
        or good
    Or the suicidal carryings-on of humans.

How marble molds itself into flesh, paint kindles gold in shafts
Makes me witness salvation first in comely handicrafts.
  It's been often observed before: objects we choose to adore
    Don't prevent war but survive it and us.

## Here Lies

        "I who am now but a thought
          Once was a fanciful man;
      Blood in my nerve, skin on my bone;
          My cheek took a coppery tan.
      While I was breathing I feared
          The nothing I soon might be;

The summer of 1945. Lincoln Kirstein interviews the guardian of
a castle near the Salzkammergut mines in Austria, where Hitler
had buried the art works described in "Arts & Monuments"

Fun, like my fright, was fantasy,
   Sturdiest part of me.
Mirror grinned: 'Don't worry, Joe.
   Others may possibly die,
But boys with flax hair and green eyes,
   Fast workers like you and I,
Are so firm in fanciful pride
   The elegance crammed in our youth
Is helmet enough to keep us whole,'
   Which we knew was hardly the truth."

I'm thinking of three friends of mine,
   None of them selfless nor strong,
Who loved themselves far more than me,
   And fashion, excitement, and song,
Who now are deader than I,
   Who never fancifully lied:
"We lived for somebody else;
   For somebody else we died."
Fair Harry, red Caleb, dark Fred
   Were lavish in other ways,
And when it came time to be killed
   The flush of their holiday days
Spilled its fancy exuberant light
   On a shadow-long late afternoon;
Flared into dusk like song, and sang
   Ends to a fanciful tune.

# II

# DANCE

# The Diaghilev Period

[*This is Kirstein's first major article on the dance, and it begins with his account of what now seems like a symbolic transference of power: the day in 1929 when he unknowingly stepped into the middle of Serge Diaghilev's funeral. In 1934, many of the senior members of Balanchine and Kirstein's School of American Ballet and American Ballet Company were to be recruited from the exiled veterans of Diaghilev's Ballets Russes. This essay was published in* Hound & Horn *3.4 (July/September 1930).*]

## I

AN AMERICAN TOURIST was hunting the back alleys of Venice, one hot morning in the middle of last August, for a church in which Domenico Theotokopoulos must have worshipped. He saw its tower from afar, on the edge of a small canal, and, passing under an arch, found a barge of black and gold moored to the church steps. Beadles in cocked hats, holding brass rods, bore wreaths into the church and he followed into the cool noon dusk. When his eyes were accustomed to the gloom, he saw opposite him a great Byzantine ikonostasis. The Baptism, the Last Supper, their gesso and gilding turned bronze, glowed above a bier, blanketed with heaped-up flowers. Suddenly he became aware of mourners, and the fact that this was, indeed, a funeral. Faces, somehow familiar, ignored him as he passed out into the sunlight, and leaving, he heard the first words of the Greek Orthodox service for the dead. Not until three days later, reading *The*

(London) *Times*, did he learn that he had unwittingly attended, in San Giorgio dei Greici, the obsequies of a great Russian.

Serge Diaghilev was born in the district of Novgorod on March 19, 1872. His early career was varied, and he studied, if he did not practice, all the arts. While reading law in St. Petersburg, he turned his attention to music but took to journalism in 1897, and more especially to the criticism of art. He organized the first great exhibition of Russian art in Western Europe, founded an important journal of art (*Mir Iskousstvo*) which lasted from 1899 to 1905, and in 1903 he was in Paris and producing *Boris Godunov* with a company that included Chaliapin. Thus he began his services to Russian art which he was later to extend to that of most European countries.

Serge Diaghilev, more than any other single person, was responsible for the growth and maintenance of a tradition in contemporary painting, music, and dancing. Picasso is not the gold mine of Fifty-seventh Street and the rue de la Boëtie wholly because he invented Cubism, but in a great measure because Diaghilev commissioned him to decorate Satie's *Parade* and de Falla's *Three-Cornered Hat*, and in a succession of ballets furnished this great decorator with the chance to display himself on a grand scale. Stravinsky Diaghilev found in a class in harmony, and, irritated because his old master Liadov was slow in scoring some Russian fairy tales, ordered *The Firebird*. Then followed *The Rite of Spring, Petrouchka, Pulcinella, Les Noces, Renard, King Oedipus*, and *Apollo, Leader of the Muses*: the works by which the composer is known. Without Diaghilev the great tradition of classical ballet dancing might have died of dry rot, or disuse. Instead, first with Fokine, Nijinsky, Pavlova, later with Massine, Dolin, and Lifar, he made it greater and more popular than ever before. Diaghilev was a synthesizer, a catalyst, who could image in three dimensions the perfect combination of the right dances, for the right music, in the right decor; and by right we must read inevitable.

II

The skeletal structure of classical ballet dancing was developed in France and Italy throughout the seventeenth and eighteenth centuries. Stretching back to the dances before the ark, the tradition of folk

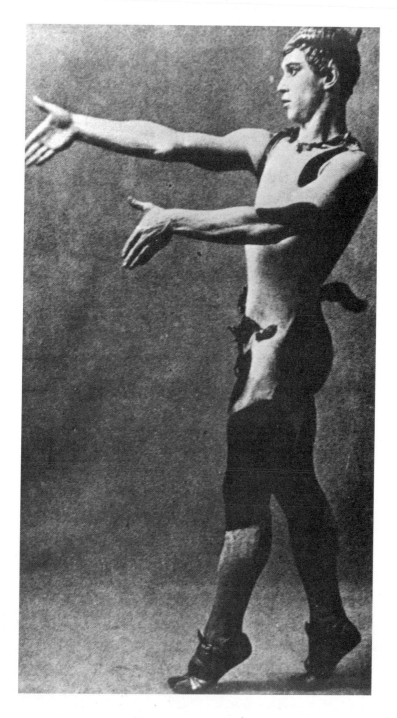

*Vaslav Nijinsky in* L'Après-Midi d'un Faune. *London, 1912*

dancing became stylized with usage, finally achieving a mechanical technique which allowed exact repetition. Toe dancing was codified into a rigid system of five positions, in which the arms, accented by hieratic arrangements of hands and fingers, the legs by linear conformities of feet and toes, were made capable of weaving countless ingenious variations upon a strong formal foundation. During the nineteenth century the technique was intensified into a sterile formula. Dancing masters who had gone from Marseilles and Milan to St. Petersburg were impressed by what they saw of indigenous folk dancing and incorporated parts of its attractive gaucherie into their curriculum. The technical excellence displayed was phenomenal. Girls were kept exercising at the barre, pointing, bending, taking their attitudes and little else for a year or two, until the master saw a hundred legs tap the same line on the floor at the same instant with an accuracy which was as sterile as it was precise. But when this amazing control of muscular perfection was put to a worthy use, in a setting which had not been stylized out of any common emotional reference, it served as a rigid framework for the ingenious variations and surprising floutings of itself, which depended on its initial strictness and strength.

Twenty-two years ago Serge Diaghilev started as the impresario of the Russian Ballet. His previous technical training in law, in aesthetics, in music, his inherent gifts of taste, his consciousness of the chic, his appreciation of social snobbery and his passion for the beauty of surprise and of youth—these in a combination of brilliant energies and practical qualifications made him the isolated genius that he was. The ballet in St. Petersburg had almost petrified between the onslaughts of Italian opera and the strictures of such great classical choreographers as Petipa and Cecchetti. With Fokine as producer and Nijinsky as choreographer and *premier danseur*, Diaghilev instituted a Romantic revolution culminating in the first night of *The Rite of Spring*, no less full of implications than the debut of *Hernani*—one of those revolutions which seem to save art from its crippling ideas of perfection once in a hundred years.* The dances now invented were based partly upon the old tradition and partly on an archaeological interest in Russian

* In Carl Van Vechten's *Music After the Great War*, there is an adequate description of the premiere of *Le Sacre du Printemps*, more valuable as suggesting the atmosphere of aggressive experiment which Diaghilev always managed to stir up than as a factual description. "A certain

folk dancing, as echoed in the music not of Tchaikovsky, but of Rim-
sky, Moussorgsky, and Borodin. The ballets were *Prince Igor, Sché-
hérazade, Thamar, Firebird,* and *The Rite of Spring.* Léon Bakst, with
his brushstrokes of Oriental illusion, turned everything behind the
proscenium into a conflagration of impressionistic palettes, a riot of
the sensualism of stuffs and smoldering colors which must still signify
to many Americans the spirit of the Russian ballet. To us, wrapped
purely in the eclectic classicism of the 1930s, the dances of fifteen
years ago seem, perhaps, inflated, boisterous, and, in spirit, as creased
and dusty as the old scenery in front of which they were, until last
year, still danced. It is true that they were very much in their own
epoch. Their effectiveness was based not wholly on the inherent beauty
of a perfect synthesis but on the physical attraction, the almost animal
appetite of their audience for color—tomato reds, sunflower yellows,
grass greens, and not the monochromatic, neatly indicated decors of
the years before and after. Their attraction was also partly due to the
amazing physical violence of the dancers as people, in orgiastic si-
mulacra.* Nijinsky leaped into the air like a sword flashed from its
scabbard. The brass and clangor of Tartar emperors, arming from
Kazan, bronze thighs through slashed silver pantaloons, in a tempes-

---

part of the audience, thrilled by what it considered a blasphemous attempt to destroy music as
an art, and swept away with wrath, began very soon after the rise of the curtain to whistle, to
make catcalls, and to offer audible suggestions as to how the performers should proceed. Others
of us, who liked the music and felt that the principles of free speech were at stake, bellowed
defiance. . . . The figures on the stage danced in time to music they had to imagine they heard
and beautifully out of rhythm with the uproar in the auditorium. The intense excitement of a
young man behind me, under which he was laboring, thanks to the potent force of the music,
betrayed itself presently when he began to beat rhythmically on the top of my head with his
fists. My emotion was so great that I did not feel the blows for some time. They were perfectly
synchronized with the beat of the music. When I did, I turned around. His apology was sincere.
We had both been carried beyond ourselves."

    * In A. E. Johnson's book on the ballet [*The Russian Ballet,* 1913] there is a detailed
narrative of *Schéhérazade,* the most generally successful of the first ballets. His powers in prose
capture at least something of the essential feeling of the piece: "The fires of passion smouldering
in the heart of Zobeide leap forth on the instant. A woman scorned or a woman denied—her
fury is a thing few men, and least of all an emasculate poltroon, can face. A frightful paroxysm
shakes the panting queen. Like a tigress baulked of her prey, etc., etc. . . .

    "Palpitating with the vehemence of her expectant desires, Zobeide stands before the open
portal, clutching her breasts with eyes glued to the dim recesses beyond. There is a pause, which
adds a new delicious torture to her thirsty cravings; then with agile bound, light footed, there
comes leaping towards her a young Negro [Nijinsky]."

tuous rout across the stage, evoked a fairyland which was a thousand times more satisfactory than the thin puppets of heretofore, for these heroes sweated from their labors, their blood pouring out upon the white breasts of prostrate princesses in a palpable, tangible vision, separated from an audience only by music and lights.

The great star of Diaghilev's first nights was Nijinsky. Those who saw him retain an imperishable memory of sinewy vitality, a fountainous energy, and a quality of physical presence, a mysterious personal charm which has never been approximated. Whether he raped a veil as in *The Afternoon of a Faun* ("elusive being, midway between the human and the animal, he has consciousness of nothing beyond his figs, his grapes and his flute," said Cocteau. "As he smooths with his tongue his jaw, piebald like a horse-chestnut, his quaintly fascinating face seems to resent the weight of the horns upon his head. Could we hear him, one imagines he would laugh and bleat almost in the same breath and all the while his wrinkled brow attests his yearning to cross the border that separates instinct from intelligence") or bounded through an open window, so high that it took six strong pairs of hands with a mattress to break his fall,* or threaded the almost inextricable maze of the original partition of *The Rite of Spring,* he was an unforgettable artist, and it is useless for one who never saw him to attempt a further evocation of his image. His febrile brilliance spent itself like a rocket and in the tragedy of his insanity; and in the great insanity of the war, Diaghilev's ballet rounded out its first chapter. †

---

* From Jean Cocteau's *Igor Stravinsky and the Russian Ballet.* "It was in 1910. Nijinsky was dancing the *Spectre de la Rose.* Instead of going to see the piece, I went to wait for him in the wings. *There it was really very good.* After embracing the young girl the spectre of the rose hurls himself out of the window . . . and comes to earth amongst the stage-hands who throw water in his face and rub him down like a boxer. What a combination of grace and brutality! I shall always hear that thunder of applause, I shall always see that young man, smeared with grease-paint, gasping and sweating, pressing his heart with one hand and holding on with the other to the scenery, or else fainting in a chair. Afterwards, having been smacked and douched and shaken he would return to the stage, and smile his acknowledgments."

† In *transition,* Vol. I, no. 3, there is a story called "The Silent House" by Philippe Soupault in which there is developed a tragic description of Nijinsky "dressed in a long, dark-grey coat, a light straw hat with a black band, and thick yellow boots, very pale like those worn by hunters or chronic invalids," walking in a closed garden, guarded by his intern, or else in the room above pacing the floor to the cracked gramophone record of "Invitation to the Waltz" (the music of *Le Spectre de la Rose*).

III

The saga of the ballet is really fit subject for an epic. Only with a poet's license may we obtain even the palest echo of the spirit and essence of the ballet as a company. A heroic adventure, its protagonists were tragedians of the first rank. As W. A. Propert says in his valuable book *The Russian Ballet in Western Europe*:

That Diaghilev's enterprise should have survived the war is astonishing, and the record of his journeys between 1914 and 1918 is a convincing proof of his courage and determination. The thunderbolt fell within a week of the termination of that memorable Drury Lane season, and many of the more important members of his company hurried back to Russia. He carried his company over to America, fulfilled his engagements there and was back in Europe by the autumn of 1915. There was a wonderful little season in Paris in December, when he produced *The Midnight Sun*, and earned no less than £4000 for the Red Cross. Then away again to America in January, 1916, for three months, and after a summer spent in Spain another long season opened at New York in the autumn. Between the 16th of October and the end of February, 1917, the company danced in over fifty towns through the length and breadth of the United States. Then again back in Europe, April was spent in Italy, May in Paris and June in Spain. Between July and September they were in South America and returned finally to Europe in November, 1917, spending their time in Spain until they could get through to England, where they landed in August, 1918.

It was a tremendous Odyssey, carried through under conditions that might have daunted the old Greek himself, and it involved no less than eight Atlantic crossings through all the perilous times of the submarine warfare.

After the war Diaghilev turned his back on Russia and on its legacy. The empire of the Romanovs was his chief link with the East; the Renascent proletariat, replacing the romance he had made so much of, banished him to an indefinite exile. For of course the ballet's is an aristocratic realm. It depends on autocracy, absolutism, the projection of individuals against an anonymous mass. Logically enough when Diaghilev and Prokofiev produced their ballet inspired by the U.S.S.R., *The Beat of Steel* [*Le Pas d'Acier*], it was rather an empty gesture; the superficial patterns of human pistons and dynamos were

surprising only on first sight—and besides, Diaghilev had well exhausted any possible exploitation of the near Orient. Those who at first regretted the passing of *Sadko, Prince Igor,* and *Schéhérazade* came to realize they were, after all, mainly necessary for their epoch and that the epoch had fulfilled itself. *

The impresario ranged about him for such attendant talents as fitted his hands. He went from the East to the heart and brain of the West and, with his unerring chemistry, dissolved Derain into Rossini: behold *La Boutique Fantasque;* Matisse in Stravinsky: *The Nightingale;* Picasso in Manuel de Falla's *The Three-Cornered Hat.* I must rely again on W. A. Propert, whose words, so much fairer than mine, may hint at the essential qualities of the first mentioned, which was typical of Diaghilev's important change in the direction of his second period:

. . . Derain's *La Boutique Fantasque* (1919), and a gayer more exhilarating entertainment it would be difficult to imagine. His company had certainly de-Russianized themselves, and *Paris 1870* was glitteringly stamped over the whole production. . . . Here was to be the first example of the far reaching change that had come over the ballet—the work of a man who, with the zeal of a primitive, combined the science and sensibility of the twentieth century; who had come fresh to his work unspoilt by any acquaintance with stage conventions. . . . It was like the work of a ten-year-old schoolgirl, and yet the simplicity of its design was so transparently sincere, there was such a feeling of air and space everywhere—the color of the background was so clear and cool as seen through the brown screen, and above all there were such enchanting arrangements of fruits and flowers painted on the wings, that one forgave all those yards of ugly colour and the impossible furniture.

---

* At the time of Bakst's death Paul Morand reviewed his achievement in the light of the later non-Bakstian ballets. "It is true that his art is too often vulgar, barbaric, effective only as a blow between the eyes; but such as it is, it has now become an historical phenomenon with its fifteen years of influence upon manners, the theatre, the city, books, and music. . . . It has been said that it was a Jewish art, with its emphasis upon raw tones, its passion for gold and precious metals, its dearth of line, its nomadic origins, its Oriental sensuality, its contempt for architectural construction. Bakst was, in fact, a Jew; and it was the great Israelite audiences that established the success of the Russian Ballet, that first great international success, marked by the boldness of the audience's dress, its immodesties, extravagant coiffures, depilated bodies, cosmetics; by that mixture of all modes to the point where one could not always distinguish between the house and the stage."

The curtain rises on Derain's toy shop, with a huge clerk's desk; the blue shades are drawn to discover a stiff painted paddle-wheel steamer on the backdrop. The fat storekeeper has his assistant, a bounding imp of a black-haired boy, with eyes like shoe buttons, hair like a mop, and a mustache *à la Charlot*, and they dust up the shop. Ladies and gentlemen of 1870 with their fantastic children come in to buy. Demonstration of performing poodles, Russian toys, tin soldiers, and a pair of cancan dancers. These last unfortunates are each bought by different families and are wrapped up to be taken away in the morning. During the night, the animals and toys come to life, assist the lovers to escape; in the morning the irate families return to discover they have been tricked, attack the storekeeper with bottle-green parapluies, and are routed by the resurrected denizens of the shop—exultation of the shock-headed assistant—*grands jeux; ronde; coda; rideau*—and while the large outline of the plotted action comes first to the mind there are those unforgettable details: the horrified gestures of spoiled American children, the kick of the ladies to get their bustles right, the pitiful smirking swagger of the cancan dancer, the distracted tossing abandon of the storekeeper's assistant, all engendered a deliciously conscious overtone that this is all very ridiculous, but here, in its frame, very true.

The milieu, the setting of 1870, the introduction of the cancan dancers—each has its own significance in the development of the Diaghilev ballet. Part of its charm was its constant sense of the re-creation of a mood, as exemplified by a historical epoch, with an ultimate preoccupation with the present. For it was not 1870 that one saw through the enameled lorgnons of the *Boutique Fantasque* but a Lanvin lady of 1920 rustling her grandmother's ball dresses. Up to this time the ballet had used a subject matter that was overtly aristocratic: king, slaves, and emperors, all the panoplies of princes, or at least the illuminated fairy books of princelings. Now it assumed a higher aristocracy, the remote and special aristocracy of the chic, the familiar texts of the commonplace, seized out of their context, transported to the plane of selection in re-creation, and thus rehabilitated.

## IV

The development of the ballet is the development of choreography, however much painting and music may contribute to its atmospheric

presentation, and by a summary reconsideration of the principal cho-
reographers of the Diaghilev dynasty one can gain an approximate idea
of their ultimate achievement. Michel Fokine directly inherited the
classical dance. Says André Levinson, that invaluable well of infor-
mation on such matters: "The classical dance can be succinctly char-
acterized by the use of beats on the points and beats of *élévation*. It
contains the traditional symmetrical forms of the *pas de deux*, a cho-
reographical poem in three verses, in a rigid framework: the *adagio*,
which is a chain of movements and pirouettes by the ballerina sup-
ported by the dancer; the two *variations*, that of the ballerina and that
of the dancer, whose more restricted art is confined to leaps, the
*entrechat* and series of pirouettes; lastly the *coda*, in which the dancer
alternates with the ballerina a succession of accelerated measures that
mount up to the *presto* and end in a whirlwind of movements and
dizzy complicated turns, crossing the stage diagonally." This of course
may have the background of the *corps de ballet*, whose evolutions are
foil and background for the principal dancers. Fokine invented *Les
Sylphides* (Romantic Reverie in one act), one of the most beautiful of
classic ballets in this formal idiom. One remembers swans swimming
in late twilight—only the thunder of their wings is muted to swishings
of long *tutus*, as paired ladies revolve in an inexpressible gravity of
consecutive action in the midst of a shadowy park. But Fokine, with
the customary violence of one who so well appreciates the tiresome
tradition of his education, became a most passionate *révolté* against it.
He embraced the gospel of Isadora with all his body and mind and
did his best to inculcate this freedom into the Royal [Imperial] Ballet
School. Propert again: "The *Ballet d'Action* in Russia up to 1900 still
retained its old form, the story being told by gesture and the dances
being treated as interludes, more or less illustrative. By judiciously
complicating the plot and multiplying the auxiliary characters, by
adding a procession here and there, and, if possible, an apotheosis, it
was not difficult to spin it out to the regulation four or five acts."
Came the Duncan: "She told of the ecstasy of the opening flower and
of spirits attuned to the music of the spheres, and in the end her Greek
draperies acquired all the significance of a prophet's mantle. . . . While
Fokine disapproved of her indifference to technique, he equally dis-
approved of the others for the misuse they made of it. So he set about
to create his own ideals. He imagined a ballet whose romance should

go hand in hand with high accomplishment and where the unity of aim of the single dancer should inform the movements of the whole company." Fokine as a reformer was invaluable. As an artist he gave us *Petrouchka* and *Les Sylphides*, but it rested with his followers to rid the ballet of its ingenious tedium, its lack of integration between acted episodes and those danced, and the overemphasis on an elaboration of purely decorative action.

To Vaslav Nijinsky is really due the credit for that specialized quality of dancing which was the eventual contribution of Diaghilev's ballet. First in his own dances in *Petrouchka* and *Jeux*, later in *The Afternoon of a Faun* and *Le Sacre du Printemps* he created an intensity of abstracted intellectual physicality* which the rest have developed, modified into something less than its original purity. In addition to the contribution of a great individual technician and the gift of his quality as a person, Nijinsky incorporated Fokine's knowledge of the classical ballet with his subsequent revolt from it and in addition something of Jaques-Dalcroze's eurhythmic dancing. If I seem to lean too heavily on Mr. Propert's admirable book, I can only say that it is better to quote him frankly than to do him the injustice of a restatement. "In the *Sacre*† we see for the first time the polyrhythmic dancing that Dalcroze had suggested. Nijinsky illustrated it by his setting one group of dancers to beat out softly the contrapuntal accompaniment of a theme which was being directly and more forcibly danced by another set.

---

* From Cocteau's "Notes on the Ballets" in the *Decorative Art of Léon Bakst* by Arsène Alexandre, London, 1913: "[Nijinsky in *Carnaval*] half Hermes, half harlequin, cat and acrobat by turns, now frankly lascivious, now slyly indifferent, and all the time the school boy up to every trick the turned-down collar of his dress suggests, as emancipated from the control of the laws of gravity as he is mathematically exact in the elaboration of his antic graces. The embodiment of mischief and desire, arrogance and self-satisfaction and a hundred things besides, with the drollest little nods of his head and strange side-long glances from the shelter of his lids, one shoulder held higher than the other and the cheek bent to meet it, his left hand on his hip, his right palm outstretched. Nijinsky danced his way through *Carnaval* to a din of uninterrupted applause."

† From Muriel Draper's *Music at Midnight*, description of the first London performance: "The sight of human beings moving in an abstract geometric design that became a symbol of eternal emotions, beyond-human in its effect, increased the force with which the music invaded you. When it ceased, people broke and ran, sat motionless and unapproachable, cried with rage and assaulted sensibilities. (You call that *art* do you? You call it *music*? 'My God' rushed to the bar for a drink or tried to laugh it away.)"

"Technically the ballet was of extreme interest. It required great courage on the part of Nijinsky to discard every traditional grace that we had learned to expect. . . . Instead of arms moving in rippling curves we saw them strained rigidly downwards or as rigidly bent at the elbow, and instead of the silence of feet that had seemed scarcely to touch the ground they flew over, we heard the stamping and shuffling of insistent shoes."

Nijinsky lived to originate the idea of the ballet as an organism broken up into interacting members, dancing in relation each to itself and to each other, keeping the time of its unit in relation to the great pulse of the whole. Contrary to what might be expected, this does not present the effect of confusion, disordered patches of irrelevant and overactive limbs, but rather a subtle shifting of an ever-changing pattern which weaves triply a rhythm, movement, and color into a human tapestry of ordered and profound complexity. His feverish activity in the invention of three ballets in a year and a half at the age of twenty-three besides his insistent appearances on the stage finally cracked him, but it provided Massine, Balanchine, and Lifar with a contribution of combinations and an idiom no less important than the original five positions.

<p style="text-align:center">V</p>

Fokine freed the ballet from the chains of a sterile academism; Nijinsky gave it the language of an intellectual complexity; it was left to Léonide Massine then at the age of eighteen to integrate the gifts of his predecessors. Massine's first great contribution was in *Parade*, a ballet in one act by Jean Cocteau; music by Erik Satie; scenery and costumes by Pablo Picasso; produced in 1917. The literary and philosophical background of the ballet is sufficiently complicated to justify a quotation from Cocteau's own description of it.* For *Parade* was the *Sacre* of the middle Diaghilev period—the period of the Parisian *dadas*, the heirs of Guillaume Apollinaire—which resulted eventually in such more pretentious ballets as Nabokov's *Ode*. Cocteau is perennially occupied with the alchemy of the familiar, the rehabilitation of the commonplace. The consciousness of one's own epoch, so amazingly

---

* "The Collaboration of 'Parade' " from *Cock and Harlequin*, by Jean Cocteau.

acute in the twentieth century, reaches its apogee in him. With Satie and Picasso he wished to present to us a poem of ordinaries, of such usual types that only by their isolation and caricature are they surprised out of banality, and in their escape lies our interest. The mood of *Parade* is that of the exterior of a provincial fair; the platform outside sideshow booths before the exhibition starts. It is the mood of the commencement of all harangues, specious, but tacitly specious, and the audience as well as the actors are painfully conscious of the deception.

"*For Reality Alone, even when well concealed, has power to arouse emotion.*

"The Chinaman pulls out an egg from his pigtail, eats and digests it, finds it again in the toe of his shoe, spits fire, burns himself, stamps to put out the sparks, etc. . . .

"The little girl mounts a race-horse, rides a bicycle, quivers like pictures on the screen, imitates Charlie Chaplin, chases a thief with a revolver, boxes, dances a rag-time, goes to sleep, is shipwrecked, rolls on the grass on an April morning, buys a kodak, etc.

"As for the acrobats . . . the poor stupid agile acrobats—we tried to invest them with the melancholy of a Sunday evening after the circus when the sounding of *Lights Out* obliges the children to put on their overcoats again, while casting a last glance at the 'ring.'

"Erik Satie's orchestra abjures the vague and the indistinct. It yields all their grace, without pedals. It is like an inspired village band.

"I composed, said Satie modestly, a background for certain noises which Cocteau considers indispensable in order to fix the atmosphere of his characters."

Here indeed was something else again. Suggestive and atmospheric, *Parade* had perhaps more to do with poetry and philosophy than dancing, but it was the seed from which the full-blown flower of the ballet would at last blossom and die. Here was no quaintness of such a work as *La Boutique Fantasque*. The quality of the strangeness here, its peculiar "quaintness," was a provincial nostalgia, a love and a loathing for the contemporary moment, the epoch of the daily paper and the telegraph, in itself sufficiently diffuse as to be generally incomprehensible—but in its effect extremely powerful. Much of the dancing here was allowed to disintegrate into ponderous shufflings, the painting into chaos and the music into a series of negligible noises;

but in its exquisite snobbery, in its ecstasy of precious eclectism, it presupposed the culmination of whole traditions of all the arts, to give point and pathos to their perversion here. And about this time, in spite of its *succès d'estime*, its comparative financial success, and its crowded houses, the professional wiseacres started prophesying the ultimate downfall of the ballet or announcing its death as a *fait accompli*. But Diaghilev was usually cleverer than his critics. His excursions into the eccentric were guided by a prescience of style that was uncanny. Perhaps he created the ensuing style. It surely followed his wake with extraordinary alacrity. Diaghilev still kept *Igor* and *Sylphides* in his repertory, he still had his troupe dance *Carnaval* and *Petrouchka*, *The Afternoon of a Faun*, and *Le Sacre*. But the public, to make up for their original antagonisms, clutched their hard-earned preferences all the tighter to their habitual taste and were reluctant to accept any further innovation. The lesson of the past in relation to experiment seems never to be learned. Perhaps the initial antagonism provides the spring of release for the new work. At any rate, Diaghilev followed *Parade* with such ballets as *Romeo and Juliet*, the rehearsal of a ballet in itself; with *Pastorale*, the filming of a moving picture, in which the *premier danseur* entered on a clever bicycle as a telegraph messenger. His excursions into native iconography in England were perhaps less fortunate but surely as elaborate. In *The Triumph of Neptune*, Diaghilev, the Sitwells, and the scenery of Pollock's passementerie theatres of the early Victoria evolved a ballet lacking the distinction of similar French creations. Perhaps the English legend itself wanted the kind of raciness to which Diaghilev was accustomed. This, only to show that he was by no means unerring or always successful. His England is the usual decorative England of the Continental—stuffy, suggestive of wet tweeds and foggy afternoons, bound volumes of *Punch*, Dickens; later of du Maurier. "*Le Romantisme puéril d'un peuple des grands enfants rieurs, querelleurs et crédules est admirablement rendu*," says M. André Levinson, "*par les décors, coloriages ombrés à la plume, imagerie naïve agrandie à l'échelle de la scène.*" But in passing it is only fair to say that it was England and not France which supported the ballet in the last days of its existence, and it was England and not France that had talked of a national home for the ballet had Diaghilev lived.

Massine was also responsible for two ballets which combined a

felicity of dramatic action with a grace of choreography that had not been seen before. *The Good-Humored Ladies* retained the wit of Goldoni but never resorted to the archaeology of a mere *commedia dell'arte*, and *The Three-Cornered Hat* more than recalls Alarcón, but it is a dramatic dance rather than a mimed play. For many these combinations of continuous coherent action marked the height of invention in the ballet. It was surely a comprehensible, beautiful, and intelligent expression in itself, and these ballets never tired in repetition, but the quality of invention they expounded was shown so exhaustively and inevitably in these two ballets that it was immediately obvious that the development of choreography lay in other directions.

Massine's most fortunate invention was, perhaps, *Les Matelots*, music by Auric, decor by Pruna; as originally danced with Lopokova, Danilova, Slavinsky, and Woizikovsky it is—with *Apollo, The House Party, The Cat,* and *Les Sylphides*—in the top hierarchy of the later Diaghilev repertoire. The stage had simple curtains of dull red, brown, blue, and side strips of white. A large cube like an enormous toy block had its four sides painted with cupids, lovers, a ship, a lonesome lass, which, turning, accentuated the incident, giving the narrative key as the action progressed. It was danced by six people alone. The young girl, her girl friend, sailors, and a musician who lead the final triumphant dancing march with a tin fork and spoon. The Matelots are Parisian blue-jackets; blue-and-white barred shirts, blue cap with the red pom-pom, and tight, revealing trousers. The girl is a Catholic maiden of passive charm and haughty receptivity; her confidante an eager wench, a matter-of-fact shopfront lass. Its simple plot—of betrothal, farewell, reappearance in disguise (three attachable beads and a pipe)—the test of devotion and the triumph of love, is the basis for the action. All the otherwise inexpressible, romantic charm attendant on seafaring men from Ulysses and Sinbad to Ishmael and any common seamen on Riverside Drive of a Sunday afternoon, their looseleggedness, bravado, their talent for gaming, the breadth and gesture of their leer, thumb back, low grin, legs out, find a frame, a defining stylization here. The movements are abrupt, surprising, yet always bear some implication or reference to natural gestures, whether the sailors dance with real chairs, or slap imaginary cards on the ground, or hitch their pants, or support their girls with that ghostly echo of a posture which betrays the rigidity of the classic regimen beneath it all.

Massine had taken the greatest pains in the episodic transitions, the hint of comedy, the suspicion of sadness, the nostalgia of expectancy, so that the dramatic unit is a symphony of the poetry in human situation.

Massine at present designs the dances for Roxy's ballet in New York. In this position of considerable importance, it is a pity he has not more power to exercise his amazing ingenuity and his splendid talents as a great original dancer. At least he has been given the chance to arrange the dances for the League of Composers' production of *The Rite of Spring* this April. Massine was the first of the "clever" choreographers.* A perfect classical dancer, he took an almost pedantic delight in perverting or satirizing the old formal steps. He introduced a kind of stylish rigidity, a conscious gaucherie, which his followers were often to transmute into an ingenious pattern of meaningless surprises as empty as the original academic formula on which it was based.

## VI

And then there was Diaghilev himself, a personality of the utmost distinction, combining in his fantastic character elements of practical facility, capacity for action, and an exuberant invention which made the ballet possible. M. Henri Prunières described him thus in his memorial written at the time of his death: "Those who did not know him cannot imagine the extraordinary attraction of this big, snub-nosed man, with the enormous head, the black hair parted with a large white lock, heavy jaws, sensual lips, fine eyes of velvet darkness.

---

* A typical example of the more outrageous Massine, the Massine at whose door some laid the decadence of the ballet, was the production of *Mercure* at Beaumont's Soirées de Paris described in *The Criterion* by W. H. Shaw: "*Mercure* left one uncertain. The effect produced on the first night audience was indicative. The younger generation led by Louis Aragon became so excited that they leapt from their seats, running through the theatre to the loge of the Comte de Beaumont, screaming in menacing tones, 'Vive Picasso! Vive Picasso,' as if uncertain whether to thank or damn him for presenting anything so thrilling. . . . The curtain rose on a tableau representing night in a manner entirely new to Picasso, an abstract composition made of canvas and wire. The three graces were done by three mechanical figures which were many times as large as the dancers who carried them across the stage. The dance of Chaos was executed by a group of dancers entirely covered by different colored tights, reaching even over their faces, crawling across the stage, supporting other dancers on their heads and backs."

He wore a monocle and had a slouching walk like the Monsieur de Charlus portrayed by Marcel Proust." It was inevitable that legend should have grown up about him in his life, and of necessity it was on a grand scale parallel to his creations. He was reputed to be at once the wickedest and kindest man in Europe, both the stupidest, the most vulgar, the shrewdest, and the most smart. Perhaps by quoting Lydia Lopokova, who knew him better than most, one can realize some segment of his mercurial temperament: "Then there was his cunning with which he knew how to combine the excellent with the fashionable, the beautiful with the *chic*, and revolutionary art with the atmosphere of the old regime. Perhaps this corresponded to something in his own nature. In spite of his love for the *dernier cri* and the emancipation of his taste, no one could ever have called Diaghilev a 'highbrow.' He was an orthodox believer and devoted slave of Emperors and Kings. Indeed, he was a convinced snob, and it was not only thoughts of the box office which made him so spry and contented when the King of Spain, the Duke of Connaught or even the Aga Khan was in the theatre! He was superstitious; charms, potions, love-philtres were not entirely outside his mentality." He indulged himself equally in his passion for puppies, for Machiavellian intrigue, and for four-handed arrangements of Glinka and Cimarosa. In trying to recollect those qualities which made his success possible Lopokova first cites his extraordinary authority, as ruthless as the traditional Romanov, whose blood was supposed to flow in his veins. As she says, it was no easy task to get such a three-ring circus as Rimsky, Stravinsky, Prokofiev, Debussy, Ravel, Poulenc, Auric, Milhaud, de Falla, Respighi, Strauss, and Matisse, Braque, Derain, Laurencin, Utrillo, Gris, Rouault, Picasso, Bakst, de Chirico, and Pavlova, Karsavina, Bolm, Nijinsky, Mordkin, Dolin, and Lifar to work together. The difficulties in the way of savage professional jealousies, procrastination from both musical and artistic supports, and recurrent and insistent bankruptcy which Diaghilev surmounted are heroic chapters in his saga, which, so vital to his success, will of necessity be forgotten. Naturally he made enemies. His increasing power had become dictatorial. He could make the reputation of a painter, a musician, or a dancer in a single night. "And lastly," wrote Lopokova, "as the force without which, I think, the rest could not have been enough, there was the personal motive of his successive attachments to Nijinsky, Massine, and Lifar. It was

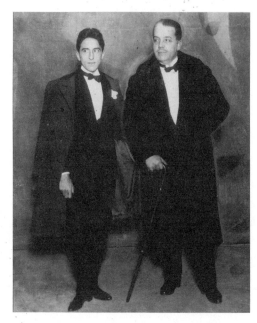

*Serge Diaghilev and Jean Cocteau at the première of*
*Bronislava Nijinska's* Les Biches. *Paris, January 6, 1924*

his unceasing preoccupation to educate, inspire, and develop the nat-
ural talents of these dancers and choreographers to the utmost limit
of their possibilities. It would be half true to say that all this energy
was exercised, the great Opera Houses of the world rented, and the
most famous musicians and artists commissioned in order that a splen-
did *ensemble* might be created for their setting off, that glory should
surround their triumphs and the most perfect opportunities be offered
for their self-expression." Muriel Draper in regretting the passing of
the ballet gives an unforgettable picture of Diaghilev at a rehearsal:
"Abortive democratic principles, the socialization of the arts for the
standardized benefit of the prolific 'brotherhood' of man, the lack of
one great figure to dominate so many interrelated parts of the world
as have been thrown pell-mell together, all these currents have ac-
celerated the temporary eclipse of the grand scale. . . . They are losing
the code, and with a universal increase of intelligence and technical
virtuosity that is in almost exact inverse ratio to standards of value,
there is little left that can be presented on the grand scale. What there
is of it Diaghilev captured and salvaged. I have sat with him in almost

empty theatres during rehearsal and heard him say to the *chef d'or-
chestre* very politely—

" 'Non, non, non maître. Pas tout à fait ça. . . . Pas tout à fait
ça. Est-ce que je me trompe, ou est-ce que ce n'est pas un tout petit
trop. . . . trop lent? En tout cas, essayons-le un to-o-out petit peu plus
vite. C'est bien possible que j'ai tort.' Or to a dancing figure on the
stage, 'Non, Non, Non ma chère petite. Non. L'estomac n'est pas fait
de bois—attendez, attendez, écoutez-moi—ni de caoutchouc. Non,
chère, non. L'estomac est fait de la chair, après tout, de la bonne chair.'*
And so on and so on until by a series of almost chemical emanations
rather than actual directions, he had changed the atomic structure of
bodies, scenes and sounds.

"I once asked him if he could express in words the exact thing
of which he was possessed that brought about this subtle synthesis of
flesh and light and tone vibration.

" 'Je ne sais pas, je ne sais pas, ma chère Muriel, je ne sais pas.
Un toouout petit peu de la connaissance, peut-être, et beaucoup de
l'amour. . . . Je ne sais pas.' "

Diaghilev had his court and for twenty years at least he was king
of the European arts. The power of his unified and isolated authority,
with the exception of the Bavarian king's Wagnerian interlude, has
parallels only in the eighteenth century and before, when Boucher
and Le Brun created an academy and a taste. It is something to have
re-created the art of dancing, to have given painting practically its only
escape from easel painting, to have provided music with the proper
channels to exploit its polyphonic dissonances and return to melodic
line. Diaghilev did more. He created a taste in and of his own period,
he set up the only referable standards of aesthetic excellence in the
first quarter of the twentieth century, and provided the only great
market for a unified creative endeavor. Two things he loved to idolatry:
the physical aura of youth in action; the intellectual brilliance of
surprise. He was a king who created not empires but a world, who
defined with a synthesis of men and their arts, with the transitions of
movement in mass, color, and music, a nobility that had no other
way of being demonstrated. Diaghilev's style was more than a modish
fashion, an ephemeral chic. Unique in itself, it expressed the same
aristocracy of perception and intensity, usually with tragic overtones,
that all great artists have known and erected. While watching a ballet

one could say simply, "There lies nobility, grace, perfection." With words this style is definable, but the very symbols that read abstractions traduce its essence. In the grave sobriety, the untiring effortless fountain of Mozart, in the ironic and passionate delicacy of Greco; in such gay and heroic characterizations as Mercutio's and Hotspur's; in the cadences of Racine and Congreve, and in the elegance of Wren and Bernini, there is that living, tremendous exuberance of human divinity which so often the Diaghilev ballet tangibly and triumphantly expressed. In re-creating the past, whether in Russia or Versailles, in seizing from the present its most precious seconds whether at a house party,* a tennis game (Nijinsky and Debussy's *Jeux*), or a factory, Diaghilev chose the best of life's stream, presented it to those living who could best receive it, in the most fitting of all possible forms.

<div align="center">VII</div>

If the choreography of the first Russian ballets was characterized by its massive emphasis on colorful loose dancing, chaotic gesture, a narrative sequence in action, and a romantic reaction from the strictures of the five classical positions, the last Russian ballets were distinguished by the reverse. The ballet's development had run the logical gamut from the intense and reactionary romanticism of Michel Fokine to the intense and reactionary classicism of George Balanchine (Balanchivadze). For it was he and not Massine who determined the indicative line of the last ballets, although he depended on Massine as much as Massine originally on Fokine. In its first years the by-words of ballet were "grace," "beauty of movement," "line," meaning roughly, smooth transitions from one balanced position to another. Under Massine, with his incorporations of various extraneous influ-

---

* *Les Biches*, choreography by Nijinska (sister of the dancer), music by Poulenc, decor by Marie Laurencin, was surely one of the happiest of all ballets, the perfect definition of the charm of contemporaneity in relation to tradition. The music, with its lovely parody of César Franck, the boys in sashed blue bathing suits, the ladies in pink, gray, and black garden-party dresses; the entrance also of Nemchinova so well described by Cocteau—the type of the perfect entrance. "*L'entrée de Nemtchinova est proprement sublime. Lorsque cette petite dame sort de la coulisse, sur ses pointes, avec de longues jambes, un justaucorps trop court, la main droite, gantée en blanc, mise près de la joue comme pour un salut militaire, mon coeur bat plus vite ou s'arrête de battre. Ensuite, un grout sans fléchissement combine les pas classiques et les gestes neufs.*"

ences, such as music hall* and musical-comedy dancing, this grace
was replaced by a certain abruptness, clipped gestures, strained final
positions, so awkward in themselves that they immediately and satir-
ically recalled the smooth attitudes which they burlesqued. Generally
taken to be awkward and gauche, they seemed to many, rather, stylish,
pointed, accentuating, accenting those gestures which in their cus-
tomary slippery sequence had lost any isolated meaning. Massine was
accused of designing ballets with an excess of movement, insomuch
as the eye never was at leisure. His introduction of acrobatics as in
*Mercure* was generally deplored. Such vulgarisms were not only dis-
pleasing to the smoothly trained eye but they *ruined the dancers* for
such delicate work as in the classical *Sylphides*, which is to say that
Schönberg or Satie ruins one's fingers for Chopin or Tchaikovsky. But
Massine's real forte was in his comic scenes, the Italian and Spanish
deceptions, the barbed wit and brilliant personal deceit of Goldoni and
Alarcón.

Balanchine's triumphs were *The Cat, The Prodigal Son, The Ball,*
and *Apollo, Leader of the Muses.* The ballet disintegrated after Dia-
ghilev's death, and perhaps circumstances will not allow the full de-
velopment of this brilliant choreographer, who must certainly have
developed into one of the ablest of all Diaghilev's designers, for not
only was his energy and invention prodigious, but he well understood
the dangers attendant on the unintelligent if entertaining implications
of the "clever," acrobatic Massine dance, and in *The Cat* and *Apollo*
he produced two of the finest of all the ballets since their inception.
His dances had the spareness, the lack of decoration which is by no
means a lack of refinement, the splendid capacity to display individual
gesture against a background of unrhythmical massed gesture. Some-
times his ingenuity ran away with him, as in *The Prodigal Son,* when
four lines of dancers are ranged as on a grandstand and their hands
shoot out like the struck letters of a typewriter in a sequence which is
distinguished only as a surprise. Or as in the same ballet, when the
shaven men pair off back to back, then slide down until they are sitting
against each other on air, and scuttle off sideways like a battalion of

---

* In Cocteau's *Boeuf sur le Toit,* the three Fratellinis, star clowns of the Cirque d'Hiver,
were taken over to mime the leading roles. How admirable an American ballet would be, music
by Cole Porter, with the addition of Clayton, Jackson, and Durante, whose precision, tempo,
and irony approximate the later Russian ballets in essence more than anything else in America.

crabs. These of course were intended as semisatirical accents, but they had the same undesirable effect as an overelaborate image in a poem, which throws off the continuous emphasis of the piece as a whole. It is true he engaged in acrobatics and influences from the music hall as well. But he had an excellent precedent for such borrowings. Did not Nijinsky and Fokine borrow from Dalcroze and Isadora, and Massine from Spanish folk dances, and the cancan of the Moulin de la Galette, and the *Valser* of the Prater? The ballet of Balanchine was more difficult to follow, perhaps, required more of an effort, insomuch as the human eye accepts more readily easy variations, just as the human ear accustoms itself more readily to tones in transitions bounded by the more obvious tonal intervals. Extremely apropos of Balanchine are the words of M. Valerian Svetloff: "I have always maintained that an art fixed immovably in its forms is doomed. I have said that Fokine, by his great talent, has stirred the classicism of Petipa out of its inertia, has given it new life, for classicism is the source of the art of the ballet." The last period of the ballet was and must be considered a period of transition, not of decadence. Balanchine in *The Cat* and in *Apollo* was leading out of mere ingenuity into a revivified, purer, cleaner classicism. He had drawn on his predecessors, and, with the utilization of his own peculiar invention, had created a classical ballet as pure as *Sylphides* or *Swan Lake*, but with more depth of emotional intensity. Who having seen it will ever forget *The Cat*? When the curtain rose on Gabo and Pevsner's construction in mica, steel, and black oilcloth, a group of young men, arranged in tandems of four, bore on their collective backs their leader, Lifar, the new Nijinsky. The music of Henri Sauguet—"*Je ne suis pas de mon époque*," he said—it is indeed rather that of a more acrid Offenbach—crashed out the chords of a prancing entrance and the human chariot deposited its load in the center of the stage. The young man prays Aphrodite, an implacable divinity of isinglass and white, to suffer his beloved, a cat, to come to life. His prayer is granted and thence, Nikitina, her *tutu* covered with a layer of isinglass, floats onto the scene in an entrance of exquisite and indescribable delicacy, gravity, and precision. The dances are of the older sort, combinations of attitude, *entrechat, rond de jambe, pas de basque*, etc., of the strict regime. But with what tragic overtones is this rigid idiom invested, when Aphrodite to test the love of the cat-girl sends a mouse across the stage. She reverts to type, following it

off the floor to assume her white mittens and mask of cat. How desperately the young man is caught by his overwhelming grief, how he shivers his life away, until he falls on his side, head painfully unrelaxed off the ground in rigor mortis. Then his companions file in, bearing skeletons of great shields, whose shifting outlines, more than their own bodies, describe his funeral march, and he is borne off, over their heads, music, setting, dancing, maintaining an atmosphere of pure tragedy, an exaltation of loss which can only be described as Attic.

*Apollo, Leader of the Muses* was even sparer, more remote. The god, with hair of gilt enamel, chitoned in crimson silk, danced with Terpsichore, Polyhymnia, and Calliope, each dressed by Chanel in the most touching of divine chiffons, cinctured by striped Charvet cravats, as perennially fashionable in the Faubourg St.-Germain as on the uplands of Olympus. Here were the old *pas d'action*, variations and combinations ending in the customary apotheosis, when the sun god's harnessed chariot comes out of the sky for him.

There is no plot. The inspiring of the Muses is a sufficient subject for dances in the old style, with all the emphasis on easy formal transition, a delicacy in the extended line of the body that is by no means a reversion to nineteenth-century choreography, for just as Stravinsky's music transcended Delibes and Tchaikovsky, through the *Sacre* or no matter what, so Balanchine has transcended Petipa, by way of *Prince Igor*, *Les Matelots*, and *La Boutique Fantasque*. Always in the last analysis the classical dance is the most satisfactory; its cold multiplication of a thousand embroideries—divested of the personal, if more romantic charm of pantomime—never becomes cloying. One may love a ballet of surprise just as much, perhaps, after the first astonishment at decor or invention wears off, but in ballets like *Apollo*, the slight crassness that accompanies elaborate conceit never detracts from the nobility of the unerring linear architecture. This ballet more than any other indicated the direction of Balanchine's ultimate attack. Lifar, the *premier danseur*, famous for his acrobatics, had proclaimed his decided attraction not to the ingenious complications of *The Ball* and *The Prodigal Son* but to the classical choreography of the masters Petipa, Legat, and Cecchetti. This winter he arranged and danced Beethoven's *Prometheus* at the Opéra in Paris, which gives some glimmer to the future of the dance.

For to many the future of the dance is very black indeed. To be

sure, there is an enormous interest in dancing today; witness the extravagant success of the Denishawns, Kreutzberg, Argentina, and the score of Sunday-evening entertainers foreign and indigenous. The Denishawns have some interest in their reproduction of Eastern dances, but purely the interest of a good copy; Kreutzberg has only the subjective fascination of postwar German painting, of Pierrot Lunaire. Argentina defines the limits of a perfection, which is by nature of itself limited. The rest, such dancers as attempt "reforms" in the classical ballet—Wigman, Bodenwieser, Laban, and their American parallels—lack the two chief necessities of fine dancing—a formal training and a sense of the aristocracy of style. Solo dancers are never as effective as with the background of a ballet, and the aimless emotional vacuity, the appalling facility of loose gesture under the guise of free dancing that we find in most Americans are far less interesting than the precision of Albertina Rasch or a Tiller corps.

As M. Valerian Svetloff says: "Talent is an all-embracing spirit, it is contented with seven notes, seven primary colors and five positions in dancing; with these it will perform marvels in art, such marvels as will remain young when the present generation, and those that follow it, are in their graves." The classical ballet, once its idiom is incorporated in the mind of the dancer, transcends the heavy self-consciousness of naturalistic dancing, which is always intent on translating the postures of "natural" walking and running into the language of the dance. But in walking and running, for example, the feet and hands are blunt ends, to arrest the flow of lines; by a stylized lengthening of them as in ballet, the eye carries the linear transition easily. For classical ballet dancing is at once the most rigid and elastic of bodily expression. It is the Catholic absolute dogma of the dance. To be sure, there are the Calvinists, the Christian Scientists, and lesser creeds without the law; messengers of beauty in batik draperies, bearing paper hydrangeas in a cardboard urn. They lack the hardness, the muscular accuracy, the coordinated precision of those dancers trained at the barre. Their repertoire is always looser, less coherent, less integrated. The world needs a new Diaghilev to reintegrate the arts, but to save dancing in particular from a facile oblivion.

It is, of course, somewhat pointless to attempt the description of the ballet to one who has never seen it, whose only connection with formal dancing is the "prologue" to a moving picture or the interlude

of a musical comedy. It is hard to convey the feeling of loss one has, having seen it, fearing never to see it again. But it is exactly the same as if one were deprived of a literature, a whole language of expression; for instance to wake up one morning and know one could never read Tolstoy or Proust or Shakespeare again, never to see Poussin, Greco, or Cézanne, never again Gabriel's *garde-meuble* on the Place de la Concorde, or Chartres, or San Marco, never hear again the *B Minor Mass* or *Don Giovanni*.

### VIII

And the social reverberations of the ballet were not wholly negligible; in the minds of some at least, there were serious moral implications. If at the first great nights at the Châtelet the audience included Geraldine Farrar, M. Briand, Isadora Duncan, Gabriel Fauré, Grand Duke Pavel, Caillaux, Saint-Saëns, Octave Mirabeau, the last nights in London were beheld by an equivalent aristocracy of art, letters, and politics. During the intermissions, Miss Sitwell held her court on Covent Garden stairs, to block the upward passage of the Poet Laureate. Prince George sits in a corner with an unknown lady elaborately unobserved. The latest meteors down from Oxford and Cambridge swell the large and androgynous cohorts of intelligent enthusiasts, and these have startled the jeremiads of that nervous Savonarola, Mr. Wyndham Lewis. He fulminated against the ballet as the ultimate snobbish and vapid bagatelle of High Bohemia, the vile afterbirth of the purple nineties. But what Mr. Lewis really objected to was the sight of a great many more or less wicked young people enjoying themselves, contrasting (favorably, no doubt) the formal perfection of the ballet with the formal corruption of their own lives. The gossip that buzzed around its corridors was as lively, as professional, as malicious as at Trianon. One can only hope that there were Saint-Simons on both sides of the channel during the last twenty years. For S. (a delightful dancer of some seasons ago) disappeared with a Finnish lady and contracted leprosy—rewards of the narrow path. There is being kept in abeyance a dancer greater than Nijinsky to replace the present favorite. He was found on the top of a steppe and has been educated at Diaghilev's expense for fifteen years. Stravinsky's Orthodox Mass has been refused. Markevitch, the sixteen-year-old musician, will definitely emerge from

his obscurity to replace Stravinsky. The composer in a dudgeon has withdrawn the rights on all his ballets. Diaghilev is bankrupt, only the generosity of Lord Beaverbrook keeps him at Covent Garden; Stravinsky's Mass will be produced in Monte Carlo in the spring. In spite of the antagonistic critical silence in all the Beaverbrook press, the present season is, bless God, a financial success; now X, Y, Z, and so on can be paid. But the extraordinary thing about this gossip was the high degree of technical and personal information it presupposed. The audiences of the ballet had been reared in it. They were as willing to talk about an entrance, a new invention or elision in the choreography as to scandalize about the dancers. There was no necessity of explanatory lectures, program notes. And the intelligence, the quickness to perceive, the willingness to follow wherever adventures of the mind, the ear, the eye led, made possible amazing voyages in invention, and all the explorations of Diaghilev and his ballet. Equally on the stage, the insistence on a hierarchy of social values accomplished marvels. There was the implicitly accepted favorite of Diaghilev. There may or may not have been accompanying rancor behind the scenes, the feeling that not merit alone had accomplished a meteoric rise. But on the stage, when good dancing was to be done, there was an intentness of purpose, a passionate intensity at impersonalized abstract perfection, unalloyed by the intrusion of emotional competition. There was no attempt at outdancing one's partner, as so often on our stage actors outplay their supporting company. All the dancers had an exquisite realization of their place in the time, the dress, the atmosphere of the ballet, and of their place, their tempo, their spiritual attitude in dancing. Merely because when lined up at the time of curtain calls the *premiers danseurs* were so frequently smothered with bouquets of carnations, the ladies were no less gracious or adorable for accepting the young men's flowers, torn from their more tangible tributes. The recognition of the proud filling each, in their way, of their proper place, in every relation personal and artistic, was that religion which was the style of the ballet.

The style the Russian ballet embodied was to be sure a peculiar and restricted kind of style, a style of manners, an aristocracy of charm, a selection of all the noblest and most desirable qualities to despite life's darkness, in an eternal living definition of the qualities which we find great in painting, sculpture, music, and letters. Words fail at

every turn, and one can only rely on such inscribed and immediate beacons to parallel the qualities here to be inferred. The style, the aristocracy of charm the ballet knew so well was known by Poussin in his *Inspiration of the Poet*; Manet in his *Olympia* and Seurat in the *Grande Jatte* felt the style of contemporaneity which had links with all greatness in the past, and the power of such great projection into the future. The graciousness, the swing, the delicacy of such a style were realized by the unknown Attic sculptor of the Berlin goddess bearing a pomegranate; most fittingly in Carpeaux's *Danse*. The grandeur of its kinetic and noble sobriety Monteverdi inscribed in *Orfeo*; its playfulness, its geniality Mozart interlined within *Les Petits Riens*. But describing the ballet is more fatuous than even attempting to paint pictures with words. How can one ever suggest the delicacy of pause, the void in action that gives dance its accent; the vision of arms and legs in exquisite interplay from symmetry to asymmetry, from rest to violence, or to feel the ineffable charm, warming one like friendship—to see men and women moving together in a sympathy of gesture, a prescience of progressive action that is at once complete coordination, ease, the poetry of life. And Cocteau's first impression of the ballet is true of a last look and every look: "Their thrilling dances then gave me a sharp pang of yearning to get a closer view of things immeasurable and unattainable, such as no poem of Heine's, no prose of Poe's, no fever dream has ever given me, and, since, I have invariably had the same sensation, at once sub-conscious and acute, which I attribute to the silent and nebulous precision of all they do."

# From an Early Diary

[*In 1932 in New York, Kirstein encountered Romola Nijinsky, and he began to work with her (as a kind of supervisor cum ghostwriter) on* Nijinsky (London, 1934), *the biography of her husband. During 1933, as well as editing* Hound & Horn *in New York, coping with Mme Nijinsky and her "medium," Ma Garrett, and nurturing his ambition to become a professional painter, Kirstein was planning a biography of T. E. Lawrence (Lawrence of Arabia; see pp. 325–29) and trying to formulate plans for an American ballet company. These diary entries, which date from the decisive summer of 1933, when he met Balanchine, were first published in* Dance Perspectives 54 (Summer 1973).]

June 3, 1933
Paris. Hôtel du Quai Voltaire, mainly to be next to Virgil Thomson's apartment, but also because Wagner stayed here during the first performances of *Tannhäuser* at the Opéra. Numerous automobiles with German license plates; refugees from Hitler. Dinner with Virgil. He says this year's chic is no longer American; it's German (exile), but will doubtless turn American again. Splits in the various ballet factions. Lifar at loose ends. Balanchine and Boris Kochno defect from René Blum's Ballet du Théâtre de Monte Carlo. Ballet must anticipate, direct, control, and continue fashion, like the big dressmakers. Key positions of two powerful women. Coco Chanel has given Balanchine and Kochno a considerable amount of money in secret (as she did Diaghilev). Misia Sert controls the appointment of *maître de ballet* at the Opéra, which Balanchine seems to have but which Lifar wants.

Big mistake if Balanchine takes it. Main progressive line from Diaghilev is with Balanchine rather than Massine. Virgil spoke of possible American lyric repertory; an *opéra documentaire* on the subject of Andrew Johnson, his rise and fall. However, since this subject involves war, impossible to produce such a work here presently, since war is in everyone's thoughts yet no one wants to speak of it. I suggested a possible Yankee Clipper ballet; gave him my transcription of the manuscript of *Billy Budd* from the Widener Library; also *Benito Cereno*. He says these would overlap on Massine's *Matelots*; besides, neither has any ballerina roles. The problem of opera is roles for a soprano; for ballet, roles for a ballerina. Preferred the notion of Pocahontas.

*June 4*
Passy: Musée des Archives de la Danse. Nijinsky's notations for *Faune*. At Virgil's, Eugene Berman, a Russian painter trained as an architect, complaining non-stop; no one will let him design a ballet. Consoles himself by knowing good painters don't take ballet seriously; only bad ones like Bakst, Benois, and Bérard. Good ones, like Degas, had no interest in dancing; treated dancers like *natures mortes*. Diaghilev used painters as poster artists; for fun or prestige on random occasions when he knew his dancing was less fetching than their decor. Berman would like to design big open-air ceremonies; public funerals. Unhappy little man; hates everybody.

*June 7*
Rodin Museum, in search of drawings and/or sculpture of Nijinsky, c. 1911. Masses of uncatalogued sketches. Conservateur vague; thinks nothing exists; perhaps at the Meudon studio? Lunch with Romaine Brooks, the portrait painter, and Mademoiselle Barney; they brought Dolly Wilde, Oscar's niece; fascinating resemblance. Natalie Barney's lack of interest in (contempt for) dressmaking (Chanel) and interior decoration (Misia Sert). Are there no friendships in Paris? I asked. Miss Brooks said Paris is a continent in itself; there are only alliances, no *amitiés*. I recalled what Wilde said on his release from prison: *"Plus des amis, plusque des amants."* Dolly delighted; we did get on. Dinner with Estlin Cummings and Marian Moorhouse; he spoke of attending rehearsals of *Les Noces*; Larionov took him backstage. Extreme professionalism of Russian dancers; they would be talking to you, then dash

onstage to counts of *raz, dva, tri, chetyri*, then dash back, continuing the conversation as if there was no stitch in the seam. Estlin is painting and writing a little every day. His own ideas for some sort of an American ballet subject. To the Théâtre des Champs-Élysées; premieres of *Les Ballets 1933*, sponsored by Edward James, the young English *milord* (as Virgil says), husband of Viennese dancer Tilly Losch. Balanchine and Bérard's *Mozartiana*; marvelous tomato-red forecurtain; Mozart, the child prodigy at a clavichord, like a silhouette by Beardsley. Beautiful presentation of Tamara Toumanova, a child dancer, in a nightmare funeral procession *adagio*; her four *porteurs*, plumed like biped unicorns, carrying her hearse, which was herself alive. *Les Septs Péchés Capitaux*, by two anti-Nazis, Bert Brecht and Kurt Weill. Deliberate German horrors in the line of George Grosz, but brilliant. After it, organized but halfhearted demonstration: anti-Semitic, anti-Boche, anti-Communist. Estlin says that the Champs-Élysées Theatre has required demonstrations at ballet ever since *Le Sacre du Printemps*, but nothing since has deserved it. *Les Songes*: a white cave by Derain; pretty clothes; Alice in Wonderland atmosphere. Too much Balanchine for one evening, but two out of three knockouts, not bad. Dolly Wilde said: "This is where we want to be; nowhere else; Paris is the only place; in Paris there is only Balanchine."

*June 8*
Virgil very much interested in Kurt Weill; he is writing a critique and has discovered his secret. He's a *Jewish* composer: his subject, remorse for the sorrowful history of the race; his theme, the Wailing Wall; general area, family life. Modigliani, Eugene Berman, Soutine, Kurt Weill, Aaron Copland: all brooders. Ernst Bloch and Marc Chagall are Jewish properties, but their attachment is essentially decorative, rhetorical, and affected. Jewish culture is always practical, concerned with action. The Jew, when he sins, apologizes; the Gentile has not only to repent but to send flowers if late for dinner. Gentile subject matter is War, Nationalism, Love. Jewish: the Home—its presence, absence, or loss. Gertrude Stein is an elementary mosaic of domestic detail. Virgil says I resist this separatist definition of Jewish art (I objected to his flowers-being-sent; I always send flowers), because I was brought up in a first generation without persecution, hence want to prove Jews are the same as everyone else. Dinner with Virgil,

Maurice Grosser, and X. I was astonished at X, a miracle of health; the last time I saw him, he was on the point of death. The reason that Bébé Bérard has quarreled with him is not that his recent paintings show no Bérard influence, but that X has given up smoking: only a little coke last week. To the *vernissage* of drawings, costumes, and scenery for *Les Ballets* 1933. Dolly Wilde says Edward James is a natural son of Edward VII. He is small, delicate, elegant; no resemblance whatever to Tum-Tum.

*June 9*

Nine a.m. rehearsal of Pavel Tchelitchev's *Errante* at the Champs-Élysées Theatre. Sat with Bébé Bérard, who made a running commentary of preposterous fun poked at everything; finally I moved away. Maybe it is all bad; but he made me nervous. Balanchine's choreography: activated Tchelitchev drawings; no dancing, but some startling effects *à la* Loie Fuller. Tilly Losch's ten-foot, sea-green-satin train; hard time managing it. Beautiful orchestration of Schubert's piano *Wanderer* fantasy by Charles Koechlin, a very handsome, gray-white bearded *vieux-maître*, kidding with Darius Milhaud. Stage carpenters were hammering in counterpoint to the orchestra; Koechlin to Milhaud: "It's your sort of music." Vicomtesse de Noailles with Edward James. *Le tout Paris*, which Virgil says consists not of 700 but of 70 people. Disappearance of Proust's *gratin*; no longer any real high society. Americans make the taste; Chanel's "poor girl" taste, really American. After the rehearsal, Esther Strachey took me to Mademoiselle Barney's, 20 rue Jacob. *L'Amazone* of Remy de Gourmont's letters, in a (Chanel?) white *tailleur*, showed me her house, once owned by Adrienne Lecouvreur. In the garden, an eighteenth-century *Temple de l'Amitié*; mottoes from La Rochefoucauld embroidered on long white transparent linen curtains; she pointed out one: "Self-love is the greatest flatterer of all," which made me uncomfortable the rest of the afternoon. Conversation about Gloria Swanson in *Queen Kelly*, which has not been seen in the U.S. Mademoiselle Barney said Marian Moorhouse's clothes (by whom?) were like "the guts of a rainbow," and that the detestable Baron de Haussmann had planned a boulevard through her garden, but luckily died before it was done. Dinner with Estlin Cummings and Marian; repeated the guts-of-the-rainbow. Estlin says Miss B. does not like him because he is coarse and a man; story

of his arrest for being a public nuisance, peeing (carefully) through the spokes of a fiacre. The judge: *"Monsieur, quand vous pissez sur Paris, vous pissez sur la France."* To the Châtelet: Monte Carlo ballet; Massine's *Les Présages, Beau Danube, Matelots.* Entire delegation from rival *Ballets 1933*—James, Kochno, Tilly Losch, Bérard—leave ostentatiously after *Présages.* Dickie Ames took us all to Fouquet's, where he always went after the Diaghilev ballets; drank to the immortal memory. Dickie says there should be a national ballet theatre, independent of the Opéra; only way France can ever gain a proper company. Cummings, in the intermission after *Matelots*, started sketches in his program for an *Uncle Tom's Cabin* ballet. (Virgil says under no circumstances would he work with Cummings; his subject matter is boring, romantic, old-fashioned, always the same: the Artist, Love, Death; Cummings's ideal: Edmund Spenser, not Shakespeare.) Dickie Ames says everyone needs Diaghilev; there's no consolidating force around the considerable energy; split in tradition between Massine and Balanchine: Monte Carlo, reactionary; *Ballets 1933*, progressive; neither strong enough. Drove home around three; horse protesting most of the way. Cold. Put my tuxedo coat around Dolly Wilde; *cocher* put his horse blanket around me.

*June 10*
With Dolly Wilde to Mademoiselle Barney's. Delightful young Chinese in colonel's dress uniform with decorations; six years fighting the Japanese; a girl! We shared admiration for Mei-lan Fang. At tea, sat next to Professor Mardrus, translator of the complete *Arabian Nights.* Said he had given Diaghilev the idea for *Schéhérazade* (!?!). Mardrus told the colonel his one great weakness as a scholar: he could not speak Chinese or Japanese, but only the seven (?) Semitic languages; he wore sort of an Arab caftan (?), horn-rimmed spectacles. To the Champs-Élysées Theatre; *Les Sept Péchés Capitaux*, with many details altered; Balanchine has left out the Mammy; considerably speeded up. No demonstration. *Errante*, stupendous climax with the falling chiffon cloud; Virgil says this is the private life of Pavel Tchelitchev: love, revolution, tempestuous love affairs, etc. Tchelitchev, looking like an angry, intelligent horse; with Edith Sitwell swathed in white chiffon, with a white-and-gold mobcap and huge gold plaque. She has just written a book on the English eccentrics; autobiography?

With Dolly Wilde to elaborately simple new bar opened by Madame de Something-or-other, who has lost all her money but is brave and smart. Marvelously made-up, like a tiger lady in a discreet circus tamer evening gown (*not* Chanel). Victor Cunard came from correcting proof of Harold Nicolson's *Peacemaking*. Colonel Lawrence at Versailles; no one knew to whom he belonged, Faisal or Britain. A very old, sweet gentleman, seeing how fascinated I was with Madame de Something, told me in vast detail about the grand cocottes of *la belle époque*, and Emilienne d'Alençon, Chanel's first inspiration, as Liane de Pougy was Mademoiselle Barney's. I asked him about the story of Edward James and Edward VII; he said, *"Oh, bien possible,"* without conviction. James, Tilly Losch, Tchelitchev, Edith Sitwell came in; great applause.

*June 11*

Interrupted Virgil, overpracticing for his concert. He asked how my education was proceeding; said if I spoke French better I'd get further. (I had not known what a *terrine* was on the menu at Michaud's.) With Peter and Nancy Quennell to Versailles; he wanted to know all about Edmund Wilson. Tried to describe the difference between literary inheritance of Harvard and Princeton; failed. Peter said in the early draft of Harold Nicolson's *Peacemaking*, by some strange fluke, the name of Woodrow Wilson never appeared once, although everyone was thinking of nobody else. To a private concert at the home of Henri Cliquet-Pleyel; Virgil said it was like the annual recital of his music teacher in Kansas City. Paul Poiret, the ancient *couturier*, dithering with age and ague, a parrot made up as Henry VIII; recited three fables of La Fontaine, a famous parlor trick. During the music, he slept and shook. Argument with Maurice Grosser; I complained about the sensibility of Tchelitchev and Bérard; I am interested in subject matter, not sensibility. He said I was talking about preference, not taste. Taste was a serious business *dans tous les sens*, particularly in Paris. There was virtue in sensing and directing the mode, not alone in fashion, but in ideas and manners; the French had provided taste for the rest of the world for three centuries. Virgil said this was now over, and the next taste would be provided by America, having learned the trick in France. Maurice says I am simply put off Paris because I have never been part of it, and its social dimensions are beyond me. They are

cutting great hunks out of their Gertrude Stein opera, Maurice imposing some sort of rationale on its action.

*June 13*

With Virgil and Philip Johnson, Deux Magots for lunch. Phil had just come from seeing Le Corbusier's new Swiss Pavilion at the Cité Universitaire; thinks Corbu has gone mad; too great fantasy, revealing he's now bored with real architecture. The real architecture is German, or Dutch (?). What mainly excited him was the graffiti left by the workers. Dinner with Alfred Barr, who showed incredible documents of what the Nazis have done to the arts; he wants to arrange a show of German Romantic painting (Caspar David Friedrich, Kaulbach, etc.) at the Museum of Modern Art, alongside publication of Hitler's taste—without comment.

*June 14*

Lunch with John Peale Bishop; he spoke of his novel, the sense of sin in America (his South); he said vice is appetite without desire. *What Maisie Knew* is a failure, because no child of that age could have conceivably known so much. Difficulties of narrative in the first person over the long haul. E. M. Forster says the novelist's great problem is the position of the narrator. Called for Katherine Anne Porter, 166 Boulevard Montparnasse; big seventh-floor apartment overlooking serene, green convent garden, which might have been miles in the country. She once wrote the libretto of a ballet for Anna Pavlova, *Xochimilco*, with decor by the Mexican painter Adolfo Best-Maugard. She loved the idea for a New England doomsday ballet, a Calvinist hell. Spoke a long time on why it was American artists can't endure being, at one and the same time, men *and* women: Whitman, Melville, Henry James; most recently Hart Crane. She was with Crane his last six months in Mexico; horror; will never tell what happened to a living soul; years from now might compose it as a tragic history. She gave me the manuscript of her Cotton Mather book, of which I will publish at least the first chapter in *Hound & Horn*. To the Opéra: Lifar in *Spectre de la Rose*; perfect archaeological reconstruction of its physical frame; perfunctory performance. If I had not known something of what it had been would not have been interested. As Romola says: unrepeatable, jumps or no jumps.

*June 15*

At lunch, Janet Flanner (Genêt of *The New Yorker*) told me a lot of ballet background. La Comtesse de Polignac (Winaretta Sewing Machine Singer) furious because Igor Markevitch's ballet was refused by the Monte Carlo; gave a huge evening party with 500 invitations the night of Massine's opening, so that *le tout Paris* would be in absence and spoil it. Ballet activity is greater this year than at any time since Diaghilev's death, but there is no restraining or controlling influence; the dancers (choreographers?) are all too social and uppity; Diaghilev would have permitted none of this nonsense. I am undetermined as to whether to go off to Holland and help Romola finish the biography or stay here and somehow insert myself into a situation with Kochno-Balanchine, but there's small chance of even approaching them.

*June 16*

Lunch with Monroe Wheeler, Laurents, Avenue Gabriel. He gave me all the information I most wanted and needed, and tested my own aims. What did I actually want? What could I actually do? How much money did I actually have or could I raise? Kochno is not powerful enough to last as an impresario. Most of the control in the ballet world is bitten by fashion; or society, which is worse, since it has no real economic base. Everything cries out for Diaghilev to knock heads together. The true function of the impresario. Could not tell whether he was suggesting I try for this: "Self-love is the greatest flatterer of all." Self-doubt is the worst demon. What will happen in Paris is what always happens; either commercial exploitation or inconsequential chic; a dilution of dressmaking. With Monroe to the Galerie Pierre Colle; official salon of Sur-Realism. Enormous stuffed pink cotton cocks; a chair leaking into a glass of beer. To Virgil's. Conversation with Genia Berman. Sur-Realism: simply the most recent academy, with André Breton as its pope. A formulated but tedious development from the bankruptcy of Cubism. Picasso, among the older men; Tchelitchev, himself, Bérard among the younger ones, will have nothing to do with Sur-Realism; Salvador Dalí—*Avida Dollars*. At Mademoiselle Barney's collided with Professor Mardrus. I said I had been reading his excellent translation of the Koran. Indeed; why had I taken such trouble? Because I am interested. Indeed; what faith had I? *Israélite*. Oh, well then, of course; the Koran is the last book written by

a Jewish prophet; nothing in it to which the rabbinate might object or deny. To the Châtelet; beautiful *Sylphides*, Baronova, Riabouchinska; marvelous company. Sandy Calder and Isamu Noguchi in the interval. Filled with rage against both; Sandy is to do a ballet with Massine but made great fun of his dancing. Isamu said the whole thing was nothing but an *édition de luxe*, of no interest as stage decoration. Neither looked at the dancing. Ballet is hardly a serious thing; without permanence, an amusement. Agnes de Mille, fresh from her success in London.

*June 17*
Virgil, on French statuary; haste in documenting their past. Monuments at every *carrefour*, street names—a dictionary of national biography, on tap for constant reference; filed for use as the constant basis and reminder of a cohesive national culture. Virgil took me to Bébé Bérard's; lying enormous and rumpled on a chaise-longue with a horse blanket over him; unshaven, grubby, but comfy and nice. No chi-chi. Professionalism; room, a mess; obviously the confusion of work. Jasinsky's beautiful costume in *Mozartiana*, taken from a photo of Serge Legat in a copy of the *Annuals* of the Imperial Theatres which Diaghilev had given Kochno, who is furious because Bérard mucked up the page with paint. Showed them my Nijinsky photos from Romola. She now can't, or won't, come to Paris. I should meet her in Holland. *Ballets 1933* go to London for two weeks. Asked about Balanchine. Bérard says he is entirely mysterious, invisible offstage, unhealthy—TB; nobody seems to know him. He is held captive by a demon called Dimitriev, an ex-croupier, ex-singer, ex-soldier, most sinister type. Balanchine is in love with Tamara Toumanova, whose mother says he is old enough to be her father (at twenty-nine?). He never goes out or accepts invitations; there is simply no point in my trying to see him. He is slightly mad; really cares nothing for the ballet; is only interested in playing the piano; keeps taking music lessons from some old Russian lady, a pupil of Siloti and Rimsky; Virgil would know; he didn't. Dinner with Marian and Estlin Cummings. He cursed the Sur-Realists. Contrivance is the reverse of fantasy; "comes out of the tube, lies flat on the brush." "*Sur mesure et par commande.*" Systematic hysteria; Rimbaud gave all that crap up before he came of age. Fifteenth (?) wedding anniversary of the John Peale Bishops; much toast-drinking to Jeffersonian democracy. One nice old gentleman, a

M. Gervais (?), lost an arm at Verdun; now on the General Staff, sure of imminent war with Germany; if not next year, the year after. He was quite serious; knew all of Robert E. Lee's moves into Pennsylvania before Gettysburg; learned at École Militaire; delighted John Bishop. Louis Bromfield with elaborate false nose and attached mustaches. John Bishop says Cummings holds his head like André Chenier on the guillotine.

*June 18*

Virgil and Maurice launched a broadside attack on me for not becoming a proper painter; the role of entrepreneur too facile; my lack of any real taste shows that I am a "creative," not an "appreciative" character. The one thing linking up my preferences is painting; my interest is technical; I admire Titian the way Maurice admires Sargent; ability to do things one cannot oneself do. Virgil said American letters could very well take care of themselves; I had neither the authority nor desire to make something first-rate out of *Hound & Horn*; I would be much better off as an entrepreneur (if that is what I actually want) at the age of forty-five, if I now settled down to the strict discipline of painting, which obviously I could do if I wanted to, since my facility was more or less apparent. I should paint in no competitive way; simply to instruct or amuse myself. Weakly defending myself, I said the one thing I wanted was to affect people and get things done. Virgil said I was silly; more affected than effective; I had no mind; I mistook myself for an intellectual; was by no means a man of taste (like Philip Johnson, an admirable interior decorator), but was first of all a worker; the "artist" part is incidental. Virgil says he is not a "composer"; he is a worker-at-music. Maurice is not an "artist"; he is a worker-at-painting. Steady professionalism; Balanchine, for example: not a "choreographer" but a worker-at-dancing.

*June 19*

*Vernissage* of Salvador Dalí, Galerie Pierre Colle; John Bishop's contempt; he says Dalí sleeps with breadcrumbs under his foreskin to induce interesting dreams; automatic Hegelian dialectic; what should be hard is soft, and vice versa; despite his formidable technique and accomplished professionalism he will end as a commercial artist doing trick calendars for Detroit. Champs-Élysées Theatre: Balanchine's bril-

liant improvisation, *Les Valses de Beethoven*, done in three days as a novelty to buck up the season. Met Genia Berman in the foyer as I was looking at Bourdelle's designs after Isadora. He hated the ballet, largely because of its fantastic decor by the architect Emilio Terry, a kind of fermented Palladianism. I said I didn't care finally whether scenery was good or bad; this particular scenery was madly stylish; had nothing to do with anything except Terry's taste. It was the body in motion that was so marvelous. He agreed; balletomania is *la vice Russe*, an infectious disease that I seem to have caught. With Caresse Crosby; she hated everything: *Errante* embarrassed her; Tchelitchev is the modern George Frederick Watts; all that shit about Love and Death. With her to Le Bal Tabarin; Le French Can-Can; ghastly. She says: "You see, dancing is a waste of time; expense of spent motion." To Madame Something-or-other's bar again; whole new getup; tonight she exhibited some sort of a nun's habit, but deep décolletage (black and white; Chanel?). Esther Strachey fresh from some sort of royalist gathering; rather *exaltée*, more on history than liquor; analyzed differences in ambition and inheritance between the Duc de Guise, the Comte de Paris, Prince Sixte de Bourbon (presently to be elevated to the throne of Poland whether he wants it or not). This, the Powers want. Her lecture delivered in the tones of a male impersonator who thought she was a grenadier guard. Does she think she's Metternich, or does she invent the whole business? Veritable Surrealism, but she has no interest in the visual arts; just politics. She began to launch into Oswald Mosley, John Strachey, and British Fascism. Finally she was left talking to herself. Grim.

*June 21*
To Pavel Tchelitchev's studio with Noël Murphy, whom he is painting. George Lynes (the photographer), Glenway Wescott (the novelist) already there. Discussion of the great Bérard-Tchelitchev feud; scandal and gossip around the ballet world. The French dancers deliberately stepped on Tilly Losch's ten-foot sea-green train in *Errante*, and she screamed onstage (in German). Tchelitchev's long lecture on the nature of stagehands, without whom nothing can be accomplished in any theatre; how the French ones were either idiots or (obviously) bribed to sabotage him because he was Russian, or because they were helpless idiots; but German and English ones were the best, giving

effortless aid, like clockwork. Tons of beautiful sketches in heaps, rejects from *Errante*; he pressed one on me; like an idiot I was too slow accepting it, so he gave it to George Lynes. "Oh, so it's not good enough for you?"

*June 22*
Gloomy; no letters from anyone. No word from Romola. No one willing to see me or talk about possibilities for ballet. Even if they did, what could I do? Took Virgil to the Louvre, which, though he has lived here for fifteen years, he says he has never entered before. Poussin's *Inspiration of the Poet*; he said now he sees why one carries on so about Poussin. Said he wanted to commence an "Ode to Diaghilev," appealing to men of morals to arm in the name of the arts.

*June 24*
Lunch with Jacques Mauny, the painter whose tiny exquisite pictures of American life I so admired in New York. His beautiful firm sketches of baseball and football players, signboards, city life. I spoke of feeling lost in France. He said Paris has nothing to do with France; it's a kind of sink for a cultural residue, but also one that smells good and stinks alternatively. About general corruption in political and artistic life: "*Ici, la corruption est une fiscalité parallèle.*" Corruption is simply a different form of taxation. In a traditional society, every person has both his place and his price. It is all very well for the American (me?) to vaunt his innocence, but naïveté is no excuse for not getting things done. Purity, in art or in life, is a question of political convenience; one can be "pure" as a priest or a painter, but if one strives for the role of entrepreneur, one must understand the World, of which *le monde* here is a fairly accurate model. No one troubles today to educate himself; no one takes the pains to learn how to draw as well as any inferior eighteenth-century French painter. He took me to the Beaux Arts; exhibition of anonymous drawings in red chalk. Perhaps not one by Watteau, but each one could be sold for an original; high levels of secondary or median art is the real thermometer of a country's cultural quality. Mauny showed me Houdon's wonderful *écorché*; the only academy is the study of gross anatomy from the human figure. To Tchelitchev's studio, 5 rue Jacques Mawas. Says he is tired of working for snobs and amateurs. I tried to describe the marvelous new stage at

Radio City Music Hall, what wonderful things might be done there. He said toe dancing was finished, ridiculous; that Balanchine was on the verge of abandoning classic academic dance (under his influence?), but had a strong instinct for spectacle. He is sick to death of *scandales*, European intrigues, French (Parisian?) society, fashionable dressmakers; New York was obviously the place to be during the present *crise mondiale*. Edward James phoned: The Monte Carlo company is suing him over the defection of Toumanova; he is countersuing for libel, harassment, or something. Tchelitchev says James's passion is for litigation rather than patronage; he thinks real property is a real asset but only the poor understand stock markets. Tchelitchev particularly wanted to know what Janet Flanner thought of his *Errante*. I said she adored it. I did not say she had been unable to see it, and that I had described it to her in great detail for her "Paris Letter," which covered the two rival ballet companies. Julien Levy took me to Brancusi's studio. Magnificent, all-but-finished portrait of Mrs. Eugene Meyer in the hardest black granite. His gramophone with two needle arms, playing jazz, with half a revolution's overtone apart. I asked if he had photos of his *écorché* in the Bucharest Academy. He was delighted that I knew of it; at first, as a student he had thought of simply imitating Houdon, who had constructed his from the skeleton out. But Brancusi's master suggested he take the figure of a Graeco-Roman Antinoüs, and work from the outside in. He dissected more than fifty cadavers before he finished; he began by being nauseated, but conquered disgust. He said there are worse ways of learning to draw. Houdon's pose and concept, humane; his own, heroic. Huge roughed-out cup shapes; goblets he said for the hemlock a Socrates (which he has not yet begun) could sip. Dressed in immaculate white linen coveralls, looked and smelled like fresh-baked bread; white hair, white beard, white shirt, white neckerchief, the smallest pale stain of nicotine in his mustache. Angel-man. My trip to Paris, self-indulgent failure. Unable to meet Jacques-Emile Blanche, Cocteau, Benois for Romola's book; impossible to reach Balanchine.

*June 27*

Lunch with Barbara Sessions, 23 rue Singer, Passy; she is translating a psychoanalytical life of Poe by a Greek Bonaparte princess, one of Freud's best pupils. Told me of Roger's and her lovely life in Berlin;

marvelous musical life there smashed; Hitler—triumph of the medi-
ocre, the disappointed, the vindictive. How horrible it was to see
apparently "sensitive" people collapse; the lack of any real opposition
after he became Chancellor. How every Jew should leave as soon as
he can, but few believe in a real war. To say goodbye to Marian and
Estlin Cummings; he inveighed against the British—a race of masters
and servants; against the Russians—either commissars or serfs; against
the French—either cooks or dressmakers. French painting is nothing
but pastry and (modern?) French poetry is nothing but paper patterns.
I didn't say, You should know. But then why does he prefer to stay
in Europe? Liquor and conversation better than in New York (his
chance as a monologist?). Showed me his new paintings. What was I
supposed to say?

*June 28*
The Hague. Romola has rewritten first five chapters of Vaslav's bi-
ography; hardly inspired, but at least a skeleton. Possibility of arranging
a benefit for him in London. How to enlist the entire Russian ballet
gang without mutually antagonizing Massine, Balanchine, Lifar,
Kochno? Get the help of the English: Karsavina, Lady Keynes (Lo-
pokova), Lady Juliet (Duff), Lady Ottoline (Morrell). This I should
undertake in her name and she would follow me to London. But I
know none of these characters, most of whom were close friends of
Diaghilev and blame her for Vaslav's fate. Letters from her New York
publisher (Dutton) complaining about the first draft of the book (mine).
He wants to re-edit or write it himself. Okay by me; would like to be
well out of it. Question of further advance; should she go to another
publisher? Every second in Holland an added expense. The guilder,
still on the gold standard, threatens to fall off; disastrous effect on the
dollar. Her horrible stepfather keeps her out of Hungary, where she
thought to finish the book in peace. Only England left.

*July 4*
London. Batts Hotel. Brought A. R. Orage my "Homage to Fokine"
for his *New English Weekly*. He said there had been a frightful and
amusing row over Rebecca West's book on St. Augustine. To the
Savoy Theatre to buy tickets for *Les Ballets 1933*; Edward James
arranging photographs of Toumanova, Jasinsky, Tilly Losch in the

outside vitrines. Waited four hours at the station to meet Romola's boat-train; no show. Back at the hotel, telegram: unable to pay her hotel bill; to American Express, sent the necessary in a blind rage. With Arnold Haskell, who says Toumanova is the greatest living dancer at the age of sixteen (seventeen? eighteen?); that Balanchine is absolutely right for having seduced her from the Monte Carlo company. Agreed that Agnes de Mille is an interesting artist despite a limited technique; she should work in the London theatre rather than as a choreographer for her own solos; hard for women in the ballet; only La Nijinska, Marie Rambert, Ninette de Valois. Well, there's *three.* Jim Ede at the Tate; showed me his Gaudier-Brzeska drawings, and MS for *Savage Messiah.* I had missed T. E. Shaw by exactly five minutes; proofs of Eric Kennington's pastel portraits for *Seven Pillars.* Jim took me to a reception at Mrs. Emil Mond's, Lord Melchett's sister (?). Marvelous spectacle of old Cunninghame Graham, wearing a native (Arab?) headdress and horn-rimmed spectacles with afternoon dress, having come from some sort of pan-Islamic (?) conference: "Speaking for the Arabs, I, for one, have no prejudice against assassination." To the Alhambra, with Kirk and Constance Askew, for the opening of the Monte Carlo season. Edward James arranged to give a big fashionable Serenade Concert tonight to ruin the first performance, but I can't see this had much effect. House full. Ovation.

*July 5*
Another cable from Romola; now she needs an extra 35 florins; what in the world does she do with it? With David Garnett; said I was so sorry to have missed T.E.S. at the Tate. David says Lawrence is now stationed either at Felixstowe or on the Isle of Wight; rumors of his imminent retirement from the RAF; he is working on some sort of secret-design speedboat. He is not retiring at all, but the Russians are making trouble, due to some Indian (?), Afghanistani (?) sources. David said he would doubtless be turning up at the ballet one of these nights, and I should just introduce myself; he'd be in uniform and unmistakable. But at which, when? David's memories of Nijinsky at parties before 1912. He took me to a party at Roger Fry's; Virginia Woolf; the Sitwells. David on George Moore's funeral; the decline of his once

glorious reputation; how he was later abused; how no one cares any-
more for the pure artist (writer?).

*July 6*

No word from Romola. Lunch with Arnold Haskell, Tamara Tou-
manova, and her terrifying mother. Endless, infinitely complicated
history of troubles with de Basil, now assuming direction of Monte
Carlo company, replacing René Blum and de Guinzbourg. De Basil
tried to force her to sign a ten-year contract: penal servitude for life.
She has also refused various film offers. She stayed still; Mama did
the talking. Balanchine is planning a new, strictly traditional eigh-
teenth (?)-century ballet for Tamarashka, repudiating all former de-
formation and *"Modernisme."* She (Mama) is not afraid of de Basil,
who is threatening to sue her for daring to quit his company. (Later,
Elizabeth Bowen said none of this is true; de Basil doesn't know the
difference between one dancer and another; as for Balanchine, he has
signed to do a big ballet for Ida Rubinstein at the Opéra [which he
will inherit, despite Misia Sert], to a book by André Gide, based on
the Pythian odes of Pindar, for a choir of sixty boys' voices to Stravinsky
music [in Greek!?].) Tamara was sweet and managed to interrupt
Mama, who seemed unsure whether Balanchine had also evil designs
on her; that Balanchine was actually a brilliant *dancer*, and she has
seen him turn and jump like no one else can, but that he cannot
appear since he has only half a lung and will die within two years.
Jim Ede took me to tea at Lady Ottoline Morrell's: long table in a big
garden, backing onto the block where they are building a new Blooms-
bury College; riveting and power drills driving her mad. Lady O.
heavily powdered and made up, like an early Augustus John or a ghoul
by Gainsborough; Philip Morrell came in late (from Parliament?). She
said the reason that Nijinsky trusted her was that they shared the same
religious ideas, but this was too subtle and serious to talk about in a
crowd and I should return Tuesday next when she would be alone.
In the evening, a party at Kirk and Constance Askew's; Freddie Ashton
described his new (Cochran?) revue number: the love of an orchid for
a cactus. He is hoping to get the contract for dances in *Nymph Errant*.
We spoke of the possibility of a ballet club in New York, along the
lines of the Mercury or the Camargo Society. Conversation with Eliz-

abeth Bowen about Romola's trance-medium, Ma Garrett (Mrs. Aileen G., who worked with Conan Doyle?).

*July 7*
Romola arrived while I was shaving. Reason she needed extra dough was the gold exchange fell; terribly depressed; suicidal; except for me she would not have made the effort to come over. Raced over to Arnold Haskell; explained the entire situation regarding Vaslav's sanitorium; back debts, etc; need for large advance. He phoned Israel Gollancz, the publisher, who asked to see the MS to read over next weekend. I bought a good big black spring binder to put the second (unfinished) part into. Romola bathed and dressed; we three had breakfast; possibility of benefit here for Vaslav. However, Haskell says there are as many factions here as in Paris now; de Basil vs. Edward James; Marie Rambert vs. Ninette de Valois vs. Maynard Keynes and Lopokova; Karsavina, etc., etc. Haskell said at least the Camargo Society had a secretary and an office; it was all very well to talk of charity but somebody had to organize it. He is seeking general rapprochement of all factions. Tonight he is taking Toumanova onstage at the Alhambra (no, after the Thursday matinée), to clear up her "misunderstanding" with de Basil. I talked to him about the chance of inserting an "American" ballet (de Mille?) into the coming Monte Carlo U.S. tour. Arnold is touching, selfless, so full of heart; sometimes the woes of others seem to silence him. When I tried to thank him for all his efforts on behalf of Nijinsky, he turned his face away so I could not see his eyes fill with tears: "It's nothing; it's for the Dance." Suddenly I felt exhausted. Back to the hotel; slept for an hour. With A. R. Orage; his talk of Major Douglas's economic system; the interest of J. M. Keynes and Ezra Pound (!?) in it.

*July 8*
Lunch with Julian Hardy, 75 Tufton Court. Described his morning's work at the Foreign Office: preparation of an "informal" letter from the King of England to Zita, ex-Empress of Austria, refusing the request of Otto, heir and pretender, to visit England. It began "Madam My Cousin," explained how an acceptance might be misinterpreted as an Anglo-Hungarian alliance of some sort; ending, "Madam My Cousin,

Your Majesty's Good Cousin, George R.I." (*Rex Imperator*). Type-written, on exquisite laid paper with silk strands, like banknotes, kept in a special cupboard. Julian says talk of slum clearance is a political fraud. Arnold Haskell took me to Jacob Epstein's studio; beautiful red-headed model on the posing stand, but he had finished. Studio filled with an enormous quantity of work. He has nothing to do now; no building at all in Britain; no chance for architectural sculpture. Only Bloomsbury College, and although its architect has given him jobs before, nothing now. New York—vaguely Cockney accent; very com-pact, strong, muscular, blunt, concentrated man; terrific physical pres-ence; sweat and dust. Says George Grey Barnard the single American sculptor (never heard of Nadelman or Lachaise). Mrs. Epstein sug-gested a show at the Museum of Modern Art. Took Romola to the opening of *Les Ballets* 1933 at the Savoy. Nervous as to what she might think of it all. She said Toumanova was too big and slow and should still be at school; some of Balanchine's *adagio* ideas not bad; the whole evening like a school demonstration, a sort of *salade russe*. During the entr'acte, she left a note next door at the hotel desk for Serge Lifar. She showed me the spot, behind a column, where twenty years ago she used to watch Vaslav pass, going down to dinner with Diaghilev. Afterwards, backstage; Balanchine came out looking hag-gard and tired. Romola said he had actually to make the very theatre dance, since he had no dancers; "old Pa Diaghilev would be pirouetting in his grave." Rather depressed; a letdown.

*July 9*
To Jim Ede's for a sit-down tea. The Welsh woodcut artist and writer David Jones; fascinating about his experiences in Flanders during the war; Foujita-like bangs, odd steel-rimmed glasses; asked why the style of some uniforms froze at a certain moment: nuns' habits; wigs of judges; trousers for men; top hats and bowler hats. To the Askews'; gossip about Edward James's unsuccessful season at the Savoy; he hires charabancs full of tenants from his Sussex estate to fill the empty theatre. Peter Quennell describing Theodora Bosanquet and the death of Henry James. Romola off to a séance; the medium spoke from Vaslav (?). He would recover for a short time and then relapse—again.

*July 10*

Hotel bills; worries about the falling dollar. With Romola to the ballet; Serge Lifar's evening; she says he didn't know *Spectre* well enough, or *Faune* at all; his versions; nothing to do with Vaslav's. As for *Bluebird*, he reminded her of Adolph Bolm's mannerisms, but she was glad that Lifar was dancing and keeping up *something*. His preference for certain repeated gestures, whether suitable or not. He filled in an absence of clear motion or definition by a repeated use of almost grotesque mannerism. Afterwards, backstage, received us in his Bluebird dress; charming to her; promised to do a benefit for Vaslav, only she must promise him that none of the Monte Carlo people will be involved.

*July 11*

Monte Carlo at the Alhambra. Elsa Lanchester, Charles Laughton's wife, making preposterous fun, imitating *Les Présages*, which made me sore; partly because she's right, but only in regard to scenery and costumes; not the dancing, which was beautiful. At the Askews'; Balanchine came in with Diana Gould and Freddie Ashton. Long talk with Balanchine; how difficult it is to make good dancers out of the French; always too much time out for lunch, with *vin rouge*; the French are serious about nothing but food and drink. He is scheduled to do Beethoven's *Créatures de Prométhée* for the Opéra (Lifar?). At first, Serge was a charming boy, wanting to know how to really dance, since he had little training in Russia; now one could tell him nothing. Had Diaghilev lived, this could not have happened. I spoke of ballets I wanted to see again: *Barabau, Fils Prodigue, Apollon Musagète, The Gods Go a-Begging*. He said one must not revive anything, ever; dancing, a breath, a memory; dancers are butterflies; the older ballets served their time; would look hopelessly old-fashioned now. How *Schéhérazade* is now merely a bad joke, and his own *Fils Prodigue* would seem as bad. The language changes from year to year; the idiom of one decade has little to do with the next; must be cleansed repeatedly, like laundry. Conventions and limits of Petipa, intolerable today. Whole academic dance must be restudied from its base. Taglioni would be inferior to any well-trained technicians today (like Doubrovska, Danilova; even Tamara Toumanova). Nineteenth-century dancers most on *demi-pointe* until well into the nineties. Ballet music (Drigo, Minkus, Pugni) just tinkly, monotonous intervals. Fokine can no

longer compose; perhaps he can teach, sitting down (I had described my lessons with him). One cannot compose without moving in one's own body; dancers are rarely choreographers if they still dance; they can think only of themselves, rarely of other dancers in combination. He says no dancer is much use after forty, which gives him another ten years (?). He would like to come to America with twenty girls and five men, in a repertory of classical ballet in his own extended academic "modern" style. American students he has seen in Paris have great potential; very fast on their feet, but often dead from the waist up; they have spirit and can be touched into fire. He asked after Tamara Gevergeyeva, his former wife; I knew little. He said Lifar left out the parts Romola noted in *Spectre*, etc., because he was lazy, not because he could not do them. Cecchetti was a good teacher, but his system is a straitjacket; he never listened to music and made his method into a series of static positions of a wholly limited and arbitrary correctness; the Italians have not produced a good dancer (female) in fifty years, or a male in a century. Balanchine seemed intense, concentrated, disinterested; not desperate exactly, but without any hope. I like to imagine we got on well; he said nothing about meeting again.

*July 12*
To Cyril Beaumont's marvelous ballet bookshop, Charing Cross Road. He told Romola that Serge Grigoriev, de Basil's régisseur, was trying to spoil the proposed benefit for Vaslav, since it would be dominated by Lifar. I've got to get clear of all this Nijinsky business, as I can do nothing effective; scandals and quarrels are too much for an American. Is this a disease that always accompanies ballet mania? Lady Ottoline has put me off for our date for tea "alone"; I gather she doesn't want to be further involved, either. Oddly enough, I bumped into her at Hyde Park Corner; she apologized in mild embarrassment; indicated I might accompany her down Piccadilly, but I thought better not. Let the dead bury the dead. To the Alhambra with Romola, to see *Swan Lake*; in Buenos Aires she danced the double of the Swan Princess; she said Massine's troupe is hardworking but lacks much *joie de vivre*. Perhaps this is because it is composed of *émigré* children who never had the benefit of the old imperial schools. Party with Lopokova, Maynard Keynes. Roger Fry's marvelous stories about his experience at the Metropolitan Museum; his epic quarrel with J. P. Morgan; how

he had recommended a Botticelli (?) for the museum's purchase, and on the basis of this, Morgan acquired it for his personal collection; whereupon Fry resigned and Morgan said he was dismissed; how the tycoon patron understands only one attitude: the subordination of employees. Did the Medici behave this way? He said they had better artists to deal with, but that it's never easy. Duncan Grant's new pictures; Vanessa Bell and Virginia Woolf; formidable subject for an (unpainted) double portrait (by whom?).

*July 13*
British Museum Library: copied out references for Romola from De- bussy, Calvocoressi, Léon Vallas memoirs. Looked at remarkable wa- tercolors by Richard Dadd; marvelous for some sort of mad ballet. My loose ideas for somehow getting Balanchine to New York, founding some sort of small company; slowly, gradually building it up. In the meantime, he could see the country and compose. Absolute impos- sibility of doing anything with the Russians. Felt rather low about money; Romola's prospects for her book, Vaslav's sanitorium, etc. Drinks with Peter Quennell; not exactly helpful; said I should obviously marry Tamara Toumanova if I presumed to any serious role as im- presario. By this I would secure my future in ballet; his unicorn's smile.

*July 14*
Hilton Hall, with David and Rae Garnett; he let me read T.E.S.'s manuscript of *The Mint*, which Lawrence gave his father; small blue- leather-bound notebook, life in the RAF as an ordinary soldier. Spent all night transcribing some of the more staggering passages by a ker- osene lamp. Greater prose than *Seven Pillars*; in the afternoon, Virginia Woolf; I tried to talk to her about T.E.S. but was scared to admit I had read *The Mint*; gathered she had little interest in his prose (as prose). Or in me (as me).

*July 15*
London; note under my door from Romola when I got back: "Lots of interesting dirt I have. Look pictures tomorrow's paper. Am divorcing to marry Serge Lifar. Benefit Gala Performance arranged; Lifar, Kar- savina, Spessivtseva, Woizikovsky, Idzikovsky; all dancing, October.

Patron, the Duke of Connaught." Long talk later; difficulty of obtaining a divorce, since they were married in Argentina. None of this is caprice; it is a means of getting back into the big world; ultimately of supporting Vaslav. She has been seeing de Basil; *bolshoi cabotinage.* He wants Kyra, her daughter, to dance in Vaslav's *Mephisto Valse* (?!) for the October benefit. But who will choreograph it? Balanchine. (No; he will be then in N.Y.) (?!) She has thought or remembered lots to put in the biography after seeing *Les Sylphides* again. Karsavina suggested she go on the stage; in what? In all this wild scheme, would people think she was abandoning Vaslav, when what she was doing was trying to plan for his support into an unforeseeable future?

*July 16*
Met Father's friend Rabbi Stephen Wise in the hotel lobby. He has just spent a week on the boat, crossing with Ambassador Dodd, the new ambassador to Berlin; attempted to indoctrinate him with the pro-Jewish attitude about Germany. Dodd says it is not true that Franklin Roosevelt is uninterested in Europe, only that the U.S. must first recover herself to ensure any world recovery. Romola went to church (for her sins). Now she thinks of coming back to N.Y.; maybe *not* to marry Lifar? Balanchine came to lunch; nightmare of the management of the 1933 season at the Savoy; colossal waste and loss. James has no notion whatever of money or administration. Talked in detail about chances for an "American" ballet; I tried to explain the idea of starting out at Chick Austin's museum in Hartford. He would bring little Tamara and, of course, Mama (!); also Roman Jasinsky, his first dancer. Romola and I could give lecture demonstrations. Balanchine says America has always been his dream, even before he left Russia; he is now willing to risk everything for it. Romola will give us all rights to Vaslav's ballets, notation, ideas, etc. Balanchine left early to try to raise enough money for an extension of the season at the Savoy, together with Lifar, without the aid of Edward James. Explained how he was forced to leave René Blum, de Guinzbourg, and the Monte Carlo company on account of Grigoriev; how they were suing him for disloyalty; how de Basil says he is a thief. Balanchine says he ought to know a lot about thieves; his real name is Voskresensky; he was a policeman in Tiflis, which is his sole claim as Diaghilev's successor. Americans do not understand police psychology; the position of the

professional police in Russia; difference between civil and political agencies. Wrote a 16-page letter to Chick Austin in Hartford, outlining scheme for ballet school and eventual company. Tried to figure out salaries; imagine what Hartford would think of Mama Toumanova, Romola, etc. Nevertheless. Frightfully worked up over all this. Walked to Hyde Park; a gang of British Fascists marching in threes (not fours) down Piccadilly. Tried to isolate Fascist facial type; failed. A lot of fine-looking men and boys. With Romola to her trance-medium, Ma Garrett; picture frames bounced off the mantelpiece. Not a good sign (?).

## July 19

With Arnold Haskell; Gollancz wants Romola's book, but cut severely, which I am dead against. Also Gollancz says, without reason, everything depends on the last two unwritten chapters. Haskell will do rewriting, editing, etc., as he did for Karsavina's *Theatre Street* (which I'd been told was by Sir James Barrie). Later, Tamara and Mama came in, much exercised; James has paid all the English dancers not to appear in the Balanchine-Lifar joint week at the Savoy; the dancers said they were British and must side with James. James refuses to release the Savoy; said he would buy the house out night after night so there would be no audiences. Spent from three until seven with Romola and Balanchine at Batts Hotel, with a big map of the U.S., showing him how far Hartford was from N.Y. He talked about his work in Copenhagen; *Josephslegende* of Strauss; cuts in the score. Impossible to dance. After he left, Romola says he will die within three years; she has it on Ma Garrett's absolute authority from "the other side." However, we should persevere, as much can be done in three years.

## July 20

British Museum. Absolutely stupendous crystal Aztec skull. Romola indulged her taste for mummies: "The Old Egyptians were right; they knew all about it" (i.e., death). She exhorted me to leave two cocktails next to her corpse. Back at Batts Hotel; teatime, waiting for Balanchine. Three young girls from the home counties, dressed for presentation at court (or to have their photographs taken?); white plumes in their hair; like Bérard's ballet costumes for *Cotillon*; three muses; three fates?

Balanchine has some sort of offer from N.Y. to teach for six weeks with a six-month option; he will let me know tomorrow; would rather work on our project if it has any reality, which it hasn't. He badly needs a vacation, after the disaster at the Savoy. Met with Arnold Haskell; committee formed for Vaslav's benefit and perpetual care. Marvelous distinction of Madame Karsavina; her blue-gray coiffure like a silk wig, but her own hair; like a marquise; immaculate presentation of her stance, carriage, speech, dress, jewels—a queen! Letter of appeal drafted for publication in *The Times*, to be signed by her alone, so as not to antagonize any of the several factions. After all, she is the wife of a diplomat, above the battle, and universally respected.

*July 21*

Bad trouble with Romola about money; I know she is not extravagant, just common necessities, but I haven't enough for two; if I had a lot I'd give her half. I was irritated with her at breakfast; she had projected her astral body last night and saw me in a sort of two-seater, driving like hell; so what? She is on the verge of a major discovery that human personality survives on the other side, and has absolute proof. Balanchine will die in two years; she will die in December 1938, so I had better work fast. When I started to bark, she said it made her heart beat too fast, and she could not work on the last two chapters today. She is, in fact, strong as a horse and will outlive us all. She is to go down to the country to Una, Lady Trowbridge's, with Radclyffe Hall; begged her to stay in town and finish her goddamned book. Tears. Lunch with Virgil Thomson; I had W. H. Auden's *Orators* with me; he picked it up; he asked me to tell him what it was, "in one word." Made me furious; the greatest poem in English since *The Waste Land*, so I said nothing, and also nothing about Balanchine. He's so preoccupied with producing *Four Saints* he'd think I was trying to sabotage it with our ballet scheme for Hartford; he'd be right. At Durlacher's, Kirk Askew showed me an amazing Visigothic treasure of massy roped and knotted gold. Also, a magnificent crystal skull like the one in the British Museum, but less splintered in the crystalline structure of its transparent interior; cold fire, firm-fleshed, or rather with a terrible suggestion of skin stripped down to its last intangible denominator. After the ballet tonight, Sacheverell Sitwell suggested Romola might

appeal to the Polish ambassador on behalf of Vaslav, but Romola said Vaslav was not a Pole, that he detested Poland, was a loyal tsarist.

*July 24*
Worked on the biography manuscript with Romola, but kept being interrupted by Nandar Fodor, Lord Rothermere's secretary and editor of *The Psychic Encyclopedia*. Conversation in Hungarian; I couldn't concentrate. Then they went off to a séance with Levani and Adelati, Ma Garrett's controls; scientific (?) proof of love life on the next plane up. They are dictating plans for Vaslav's cure. Lost my temper; yelled. Romola wept. If all this ghastly nonsense cures Vaslav, then I'll believe it. Romola at the end of her rope; me, at the other end; a long rope.

*July 25*
To Arnold Haskell's; Gollancz has accepted the Nijinsky biography; advance, etc. We can have until September 25 to finish it; enormous relief. I had told them it could be done by August 25; impossible. Lunch with Morgan Forster and a charming friend from the Hammersmith Constabulary; funny police stories. Morgan spoke of what he recalled of the Russian seasons before the war; told him a little of my problems about biography; talked of Goldie Lowes Dickinson; important for me to meet him; asked me to Cambridge; a more interesting man than T.E.S. (?). Dined with Ellis Waterhouse at Jim Ede's; had not seen him since the Escorial, 1926, when he curbed my enthusiasm for El Greco; he says the Visigothic treasure is a fake and the crystal skull is Japanese. Still, it's the most beautiful single object I have ever seen, the only thing of the sort I ever wanted for myself. Ellis extremely strict with enthusiasm; the difference between informed taste and casual preference; I should keep my mouth shut; he says enthusiasm is not (necessarily) charming. What *I* like; what "one" likes. Likes? Knows. Quoted Dr. Johnson (?): "If everything is 'divine,' how does one address one's Deity?" Good taste; bad taste; perfect taste. Ellis said I should learn one thing well, as a touchstone.

*July 26*
Romola back from a marvelous revitalizing day in the country with Una Trowbridge and Radclyffe Hall; story of Una following Vaslav around with her clay, trying to get the exact expression of his face for

her portrait bust; for her, he kept making the face for *Faune*, but in his *Spectre* costume and makeup; she, trying to find the form beneath the paint. Thought of the Aztec crystal skulls (Eliot's "Webster was much possessed by death/And saw the skull beneath the skin . . ."). With Stephen Spender and Tony Hyndman, making plans to visit Auden, who is teaching at Malvern. New copy of *Hound & Horn*, with Stephen's poems. Dinner with Romola at the Hungaria, Lower Regent Street; she demanded a steak "like shoe leather." Minute account of Vaslav's future treatment, dictated by the witch Garrett's controls, plus a little (serious?) nonsense about the sex life of spooks. Alhambra: first performance of David Lichine's *Nocturne*, with a wonderful performance by Massine as Oberon. Lichine, as Puck, did his best to be Vaslav in *Faune*. At the hotel, enthusiastic long cable from Chick Austin about Balanchine and Hartford; nice note from Stephen Spender about his enthusiasm having read the MS copy of *Billy Budd*. Not a word from Balanchine in Paris: sick, dead??

*July 27*
Romola off to Birchington-by-the-Sea, to finish the book by herself. Transcribed chapter on "The Break with Diaghilev" all morning so she could take it with her for correction. Lunch with A. R. Orage. He spoke about the English language, its various accents and intonations. The King's English, intelligible at all times everywhere; the so-called Eton gush and Oxford accent, class deformations. As for the servant-master relationship, this was established inextricably within ten years after the Norman conquest. The Normans were a genuinely progressive people; they took and held Britain by brains, skill, and experience. The governing classes, inheriting property and control, have treated the lower classes like natives (Saxons) ever since "Wogs begin at Calais." The General Strike of 1926 was smashed without bloodshed; there will be no revolution now or ever, despite Oswald Mosley's Fascist excitement. Orage said Byron and Shelley should never be forgiven their disgusting patronization of Keats, their superior in every way; how only exceptional people (artists) transcend a class background; Epstein, Augustus John, Sickert have; D. H. Lawrence never did, even though Frieda was a *baronin*. Lord Morley's remark: Britain is paradise for the rich; purgatory for the able; hell for the poor. Asquith: England is safe as long as Oxford and Cambridge instill the

instinctive urge to govern, and the state schools the instinctive urge to be governed. Orage thinks the archetype of "English Gentleman," the most morally degraded creature on earth, responsible, via the Empire, for most grief (?). I said how marvelously I thought Morgan Forster conquered class condescension; he said: In the first place, Forster is a romantic; in the second, he is middle-class; in the third, he is the best living English writer, and artists surmount most prejudice. He said the master-servant relationship might seem charming to a foreigner (like me), but he could assure me this is what precipitated the British character, and in twenty years would lose the Empire and turn Britain into a boring province, like Belgium or Switzerland. Story of Edward VII at Goodwood, when a recent peer (Derby) came in a derby hat rather than a proper gray topper: "Going ratting, George?" Of Stephen Spender: the formula by which publishers force poets to write novels; seldom their métier.

### August 5

To Birchington. Lunch with Romola and the witch family. Brought Romola a flacon of her favorite L'Aimant; a loofah bath glove like the one she's lost; six Venus green pencils. She says Arnold Haskell has butchered her book; left out all the part about Marie Rambert being in love with Vaslav, simply because he happens to be her friend. I advised Romola to take the book to another publisher, but she's already got a big advance. I read the last chapters, epilogue, etc. I could never had done half as well, although she drives me crazy. On the cliffs, difficult conversation with Arnold; he showed me all his cuts. They were just what I might have done. Afterwards, Romola was furious for my siding with Haskell; she knows things we'll never know (from the other side). I wish she'd go there and stay, and let us finish her goddamn book in peace.

### August 6

Telegram from Chick Austin: Paul Cooley, Edward Warburg, Philip Johnson, Jim Soby, promising three thousand dollars, and for me "to hold on another week." Called Paris; Balanchine had left his hotel. Decided to go and find him; impetuosity necessary. Do I have enough cash? Hotel bills? Romola? From now on, I am going to keep a full account of the invention of "The American Ballet," including all

*George Balanchine in class with some early students at
Kirstein and Balanchine's School of American Ballet*

unworthy and disgusting thoughts, because one day, when I need the
money, I can sell it and tide the then-ballet over one of its inevitable
crises. The Lord Chamberlain has forbidden a play on the subject of
Hitler. Wonderful new poem by Wystan Auden on love in the *Twentieth Century*. A note at the hotel desk saying my second cable to
Balanchine was undelivered.

*August 8*
Cable from Hartford: "Go ahead; ironclad contract necessary, beginning October 15. Settle as much as possible now. Bring photos, publicity. Museum willing; can't wait. Chick." Morgan Forster's birthday
(?) party. I said how sad I was not having encountered T.E.S. Morgan
had seen him two days ago, but seemed oddly disinterested; suspects
him of quasi-Fascist leanings; that he, rather than Oswald Mosley
could be tapped to head a British black-shirt army. T.E. is a close
friend of Lord Lloyd and admires Trenchard; bad. In India, he showed
the natives some photos from *The Tatler* of the Queen of Afghanistan
in Parisian clothes; he did not even need to say: "See what a whore
your queen has become." The uprising followed. Joe Ackerley rode

off on a friend's motorbike and didn't fall off; they dared me to try it; I didn't. Fascinating talk with Laurens van der Post about South Africa; he can imitate the Zulu click; he speaks Afrikaans; stories about hawks dropping black mambas on a tin roof in the middle of an electric storm. Hate to leave England. No word from Balanchine. First two days of next week a French holiday; dead time. I'd like to stay with Laurens, but I'd better get on with it if I'm at all serious about any of this.

# Working with Stravinsky

[*Balanchine and Kirstein founded the School of American Ballet in 1934 and the American Ballet Company in 1935. In April 1937 the company mounted a Stravinsky Festival at the Metropolitan Opera, performing* Apollon Musagète, Le Baiser de la Fée, *and* The Card Party. *Music for* The Card Party *was specially commissioned in 1936, and the composer conducted both performances at the festival. Balanchine eventually produced over thirty works to music by Stravinsky, and the New York City Ballet has mounted two more Stravinsky Festivals (in 1972 and 1982). For his part, Stravinsky declared his allegiance to classical, that is Balanchinian, ballet, "which, in its very essence, by the beauty of its* ordonnance *and the aristocratic austerity of its forms, so closely corresponds to my conception of art. For here, in classical dancing, I see the triumph of studied conception over vagueness, of the rule over the haphazard." These notes were published in* Modern Music *14.3 (March/April 1937).*]

WHEN WE DECIDED to ask Stravinsky to write for the American Ballet there was no question of providing the composer with even the suggestion of a subject. And, as a matter of fact, we were ignorant of his choice for six months after the contract was signed.

He had, some time before, already commenced work on an idea of his own. Since Ida Rubinstein's commissions for *Le Baiser de la Fée* in 1928 and *Perséphone* in 1933 he had written no ballets. Another company had more recently made offers for a new work; his *Firebird*, *Petrouchka*, and *Les Noces* were already in their repertory. But Stra-

vinsky objected to the meager orchestral presentation that a traveling company could afford him, and he wanted more favorable treatment for the new work.

The orchestration and piano score of *Jeu de Cartes* (*The Card Party*, Ballet in Three Deals) were finished simultaneously in November 1936, and we received the score on December 2. The title page also credits M. Malaieff, a friend of Stravinsky's painter son, Theodore, with aid in contriving the action. The scene is a card table at a gaming house, and the dancers are members of the pack. The choreography must closely follow the indications of composer and librettist because the action, in numbered paragraphs, refers to equivalents in the score itself.

Three deals of straight poker are demonstrated, played literally according to Hoyle. Sudden apparitions of the Joker, to whom these rules do not apply, destroy the logical suits of the three hands. At the end of each deal, giant fingers of otherwise invisible croupiers remove the rejected cards.

The musical opening of each deal is a short processional (march, polonaise, or valse) which introduces the shuffling of the pack. For the card play—deals, passes, bets—there are group dances, solo variations, and finales according to the familiar usage of classic ballet.

The music is dry, brilliant, melodic, and extremely complex in its rhythmic pattern, a synthesis of purely creative yet evocative passages, balanced by fragments definitely reminiscent of Rossini, Delibes, Johann Strauss, Pugni, Ravel, Stravinsky's *Capriccio*, and jazz in general. The score is so compact, so various, and so willful that either the choreography must be its exact parallel in quality or else it had better be presented as a concert piece, in which form it will of course, like all Stravinsky's music, be heard sooner or later.

Stravinsky, it seems, expended his utmost care on the skeletal choreographic plan and on his music. George Balanchine brought all his theatrical information and the resources of his knowledge of the classic dance into designing the dances, which were about half done when Stravinsky first saw them. (Stravinsky and Balanchine had worked together on previous occasions. In 1924 Balanchine, fresh from Russia, presented *Le Rossignol* as a ballet, and in 1928 he created the Diaghilev premiere of *Apollon Musagète*.)

When Stravinsky saw the first two deals of *Jeu de Cartes*, he

expressed an enthusiasm, an interest, and a criticism which was as courtly as it was terrifying. The ballet, as with so many Russians, is deep in his blood. It is not only a question of childhood memories of interminable performances at the Maryinsky Theatre, or of the famous works he has himself composed or seen. Stravinsky completely understands the vocabulary of classic dancing. He has more than the capacity to criticize individual choreographic fragments, doubled *fouettés* here, a series of *brisés* accelerated or retarded, or points of style as in the elimination of pirouettes from a ballet which is primarily non-plastic but one-dimensional and cardlike. His is the profound stage instinct of an "amateur" of the dance, the "amateur" whose attitude is so professional that it seems merely an accident that he is himself not a dancer.

The creation of *Jeu de Cartes* was a complete collaboration. Stravinsky would appear punctually at rehearsals and stay on for six hours. In the evenings he would take the pianist home with him and work further on the tempi. He always came meticulously appareled in suede shoes, marvelous checked suits, beautiful ties—the small but perfect dandy, an elegant Parisian version of London tailoring. During successive run-throughs of the ballet he would slap his knee like a metronome for the dancers, then suddenly interrupt everything, rise, and, gesticulating rapidly to emphasize his points, suggest a change. This was never offered tentatively but with the considered authority of complete information.

Thus at the end of the first deal, where Balanchine had worked out a display of the dancers in a fanlike pattern to simulate cards held in the hand, Stravinsky decided there was too great a prodigality of choreographic invention. Instead of so much variety in the pictures he preferred a repetition of the most effective groupings.

It is not that he is tyrannical or capricious. But when he writes dance music he literally sees its ultimate visual realization, and when his score is to be achieved in action he is in a position to instruct the choreographer not by suggesting a general atmosphere but with a detailed and exactly plotted plan. For all questions of interpretation within his indicated limits of personal style or private preference, he has a respectful generosity. He is helpful in a wholly practical sense. For example, realizing that when he conducts the performances he may have a tendency to accelerate the indicated metronomic tempi, he

ordered the accompanist to play faster than heretofore for rehearsal, to take up a possible slack when the ballet is danced on the stage itself. On another occasion he composed some additional music to allow for a further development in the choreography.

As with the music and dancing, so with the costumes and scenery. Before his arrival we had been attracted by the idea of using a set of medieval playing cards and adapting them in all their subtle color and odd fancy to the stage. Forty costumes and the complete scenery were designed before he arrived in America. Upon seeing the sketches Stravinsky insisted they would place the work in a definite period and evoke a decorative quality not present in his music. He called for the banal colors of a deck of ordinary cards, forms and details so simple as to be immediately recognizable. Stravinsky's precise delimitation gave Irene Sharaff, the designer, a new orientation, and strangely enough a new freedom for clarity and originality.

Stravinsky has about him the slightly disconcerting concentration of a research professor or a newspaper editor, the serious preoccupation of a smooth running order that he finds it necessary to employ a laconic, if fatherly and final politeness. The effect is all the more odd coming from a man who is at once so small in stature and who, at least from his photographs, appears not to have changed a bit in twenty-five years. When he speaks it seems to be the paternal mouthpiece of a permanent organization or institution rather than a creative individual.

We had difficulties of course in choosing from all his repertory two other ballets to complete the evening on which *Jeu de Cartes* will receive its premiere. A possible restudying of *Petrouchka*, *Firebird*, or the *Sacre* was rejected because of present or imminent productions by other companies. *Pulcinella* was obviously too close in spirit to *The Card Party*. But at length *Apollon* was selected, because both Balanchine and Stravinsky wished to present it in the choreography of its Paris presentation. In his *Chroniques de ma Vie*, Stravinsky wrote that Balanchine "had arranged the dances exactly as I had wished—that is to say, in accordance with the classical school. From that point of view it was a complete success, and it was the first attempt to revive academic dancing in a work actually composed for the purpose."

The third ballet, *Le Baiser de la Fée*, first produced in 1928 for Ida Rubinstein by Nijinska, has never been seen in North America. At a single hearing in concert or on a piano it may seem thin and

*Lew Christensen in Stravinsky and Balanchine's* Apollon Musagète,
*performed by the American Ballet Company in April 1937*

unrewarding. But as music for the traditional theatrical dance it is
both graceful and original. It is less a salad of Tchaikovsky quotations,
as is frequently assumed, than a projection of the method which Tchai-
kovsky created of framing the classic dance as ritual drama. It is less
a recapturing of the epoch of *Giselle* than it is another facet of the
creative attitude of Stravinsky.

Stravinsky is a composer who meets each problem within the
tradition of the theatre, a tradition which he has helped to create, in
which he resides, and onto which he continually builds.

# The Classic Ballet:
# Historical Development

[As the New York City Ballet gained strength, Kirstein was able to refine his expression of the company's aesthetic. This classic statement of its aims and methods, though signed only by Kirstein, was actually produced in collaboration with Balanchine and is a careful synthesis of both founders' ideas. It was first published in The Classic Ballet: Basic Technique and Terminology by Muriel Stuart (New York: Alfred A. Knopf, 1952).]

## I Source and Status

THE MOVEMENT of the human body to rhythmic accompaniment is basic in society. Primitively, it is rooted in the ritual of seasons and sympathetic magic, in which the function of mimicry promises success to hunt or harvest. But the dance must be well danced to ensure victory and food. Dancing around a hero's altar-grave holds the source of our drama, opera, and theatrical dance. At the start, there was no separation between performer and spectator. The focus was central, the ground plan circular. Tribal ancestors were invoked to sustain their heirs.

Today, in the developed classic ballet, elements of ritual survive. Dancers are ordained by impulse and physical endowment into a rigorous regimen, finally coming of age as members of a professional tribe upon the great platform of an opera house, in lay ceremonies whose only surprise is in individual performances on given evenings. All else—plot, music, choreography, decoration—is equally familiar.

What rests in doubt is the successful accomplishment of predesigned movement and gesture, the display of which is not supernatural but superhuman: beyond the physical capacity of those congregated to watch for such signs.

Ballet as an international plastic expression has enjoyed a notable revival in Europe and, more recently, in the United States. This has coincided with an increasing confusion of style and subject, of ends and means, in our drama, prose, painting, and sculpture. Over fifty years ago, Stéphane Mallarmé, critic of the dance through a great poet's eyes, observed "the astonishing but fragmentary extravagance of imagery in the plastic arts, from which the dance, at least, is isolated in its perfection of technique—alone capable by its concise calligraphy of transforming the ephemeral and abrupt into a concrete absolute."*

The most powerful theatrical essence remains, where it began, in the dance. Its capacity to astonish by brilliance or calm by harmony provides a physical frame in which artist-craftsmen may demonstrate the happier chances of the race, symbolized by the dancer's determined conquest of habitual physical limitation.

Good dancing is never blunted by verisimilitude, nor need it cater to production codes even in the fiercest or most tender representations of love. Journalistic observation in novels or plays never convinces for long, despite a desperate verbal accuracy. It only debases writers, readers, actors, and audiences into dullness. From it the dance is immune when cleaving to the transparent logic in the classic style. Here what might have degenerated into monotonous acrobatics or banal pantomime has been elevated to humane significance, organized by music and transformed by the visual ambience.

## II Towards Spectacle

The classic ballet is a highly artificed craft. Its furthest direct ancestor is Greek choral drama, precedent for most Western theatre. The plays of Aeschylus, Sophocles, Euripides, and Aristophanes utilized semi-professional dance groups in addition to trained soloists, performing

---

* *Divagations, "Richard Wagner, Rêverie d'un Poète Français"* (1897). Those critics of ballet whose words last longest are French: Baudelaire, Gautier, Mallarmé, Valéry; as in sculpture, Carpeaux, Degas, Rodin; as in painting, Watteau, Lautrec, Seurat.

patterned movements within a ninety-foot dancing circle or *orchestra*, often around a central altar, but with the seated spectators finally isolated from the performers. However spectacular, annual dramatic festival seasons maintained an official contact with the state religion. Ritual elements are prominent and persistent through the whole repertory; in the last great surviving complete drama, the *Bacchae* of Euripides, a dancing chorus or *corps de ballet* is itself protagonist in a glorious recapitulation of the sacrificial tragic act.

Roman comedy augmented pantomime—a school of manual gesture, wordlessly legible to an imperial polyglot public, adding virtuoso dumb show to the acrobat's trade. Down to the last generation, Italy has often revitalized theatrical dancing by an insistence on technical brilliance and clowning. Under the Republic, the profession was dishonorable for freemen. Cicero thought one must be mad or drunk to dance. Even after the Christian interdict, which came from the bad name got by circus and hippodrome, a craft tradition survived through medieval wandering minstrels who tumbled, juggled, and danced on cords; who sang and mimed ballads—originally, danced songs.

However, what we call "ballet"—a synthesis of human anatomy, solid geometry, and musical composition—commenced in ballrooms during the High Renaissance in north Italy, where social dances acquired intricate floor plans, swelling out *divertissements* for competitive princely feasts. At first, court guests themselves played principals and chorus, but by the time stages were erected at the far ends of big banquet halls, and shortly after, when functioning theatres were built, Milanese dancing masters codified rules for the manner of performing in gallant exhibitions. The twin provinces of professional theatrical dancing were established and analyzed—on the floor and in the air.

Early floor patterns were quadrilateral, as in the social dances of the West until our grandparents' time, designed equally for four sides of a ballroom that held no single stage-focus. Rapidly, with intrusions from livelier folk and popular dances that lifted heels and skirts off the floor, a vocabulary for the next two centuries emerged. By the time the Medici court was at home in Fontainebleau, indicating the future of a Franco-Italian mannerist art that would dominate Europe and the world, ballet also had been given its idiom, terminology, and aristocratic style.

The development of musical notation—for harmony, counterpoint, polyphony, with dance suites moving towards broad symphonies—a complex growth from plain song to tone poem, was accompanied, step after step, by the academic dance. There may be other means of tempering the keyboard than those fixed by Bach or geometries other than Euclid's, yet the West settled for single systems of instruction. This was now true of the *danse d'école*, from the foundation of the Royal Academy of Music and Dancing, under Louis XIV.

The development of means of rendering plastic form by painting on a plane surface to simulate light, shade, and color—from Byzantine frontal silhouette and calligraphy through the triumphs of Venetian aerial and atmospheric perspective—enabled the proscenium-framed theatrical tableaux to give stage dancing its illusion of spatial dignity, accommodated by architecture to a human scale.

The development of European carving, modeling, and bronze casting was brought to its peak in Baroque ornament. The human body, whose gross anatomy had been supremely delineated in the woodcut illustrations to Vesalius, became familiar as a mechanism of bone, muscle, and nerve, with its own limited if flexible logic of function. Standards of plastic legibility and expressiveness appropriate to this machine were fixed by sculptors in the principle of *contrapposto*, a three-quarter-view opposition of limbs, the placement of members as an active spiral, denying any flattening symmetrical frontality. Poses of wrist, fingers, head, and neck were adjusted to the ball-bearing sympathy of the fluid torso as a working whole. The climate of the Franco-Italian Baroque, from Giovanni da Bologna to Jean Goujon, has remained a criterion for the large profiles of the classic style. Although the antique has been evoked by countless choreographers with the images of poets and the eyes of sculptors, the mean vision (until Nijinsky's archaistic *Faune* of 1912) was usually a late Renaissance recutting of Hellenistic torsion and balance.

The development of manners in European society from tournament codes, dual combat, and *Il Cortegiano* through the protocol of the *grande levée* at Versailles to quasi-Byzantine survivals at Tsarsköe-Selo determined the courtesy of performers: how they behaved on stage, bowed before the curtain, took their partner's hands, and gave those

airs of conscious elegance to *danseurs nobles*, whose deliberate hier-archy in court- or state-ballet troupes still reflects, as in armies and empires, pyramidal authority.*

The development of European poetry, metrically and philosoph-ically, in lyric and epic, from the Courts of Love to our ultimate synthesis of classicism and contemporaneity in Baudelaire, Rimbaud, Yeats, Eliot, and Auden, has provided plots, pretexts, and atmosphere. Orpheus's grief and Medea's fury, Don Quixote's confusion and Don Juan's hunger continue to be danced, as they have been for some three hundred years. The poets of each generation have rewoven a net of legend, myth, or fable to which also Aesop and Ovid, Dante and Ariosto, Spenser and Shakespeare, Racine and La Fontaine, Molière and Marivaux, Hoffmann and Heine, Pushkin and Andersen, Cocteau and Claudel have directly contributed.

## III *Style and Limitation*

Ballet, human action designed towards lyric display, determined by the accompaniment of orchestras, framed in opera houses, is performed in repertory to the support of loyal audiences. While classic theatrical dancing may have ancient roots, what we recognize as such is com-paratively recent. As working idiom and established style, it is about two centuries old; as remembered repertory, barely a century. Only after the French Revolution were court theatres replaced by city opera houses with subsidized academies of music and the dance serving them. In the big municipal theatres arose the need to amplify movements whose delicacy and finesse had long been attached to their birth in ballrooms. Increased legibility was demanded, and it broadened the language.

This also evoked an arithmetical increase in acrobatic virtuosity,

---

* "The art of dancing has ever been acknowledged to be one of the most suitable and necessary arts for physical development and for affording the primary and most natural preparation for all bodily exercises, and, among others, those concerning the use of weapons, and conse-quently it is one of the most valuable and useful arts for nobles and others who have the honour to enter our presence not only in time of war in our armies, but even in time of peace in our ballets."

Letters Patent, from Louis XIV, for the establishment at Paris of a Royal Academy of the Dance, 1661. (From *A Miscellany for Dancers*, edited by Cyril W. Beaumont.)

in which succeeding graduating classes of dancers, like athletes, broke all previous records for endurance and capacity. The alliance of opera house and academy was essential, offering a flexible technical apparatus, official municipal or state subsidy, steady collaboration with musicians, and a more or less consecutive economic stability that freed dancers from the continual need to tour, except on guaranteed invitation. Ballet companies became useful tools of cultural diplomacy and interchange, as dancing, unlike poetry or even painting, was, in most cases, immediately exportable, needing no translation and being independent of local taste.

In the opera-house partnership, first dancers, sharing the scene with virtuoso singing actors, also glowed into stardom and by force of individual glamour raised the capacity, popularity, and prestige of their craft. And just as the first viol turned into the *chef d'orchestre*, an experienced controlling performer in his own right of authority, so the *maître de ballet*, or journeyman ballet master, developed into a choreographer who commanded collaboration of dancer, musician, and designer, and yet of whom, as of other true masters, there is never more than a handful to a generation.

With an increase of virtuosity, legibility remained the first concern. What was danced had to be not only well danced but also cleanly seen. It was increasingly difficult to read tiny movements without blurring from the upper reaches of the balconies. Dancers have always known that their most faithful friends are nearer the rafters than the floor. Hence, a frank graciousness and compact brilliance determined the apparent ease in the classic style. But this consciously simple breadth, the distinction in disdain of all difficulty, was intensified by pure physical feats, tempered through sustained muscular control. In solos, duets, and trios of joy, love, or rivalry, a bravura stage courtesy was calculated, by alternate stanzas of noble consideration and exuberant display, to capture the public.

The ground of style and technique resides in the five basic school positions of the body, arms, and feet. Through them, all other flowering movement is strained; to them it all returns. The five positions are an invisible, or rather transparent, sieve, net, or screen, separating filaments of action into a mosaic of units, consecutive, yet at each step clearly defined. Extension of limbs from the hub of trunk offers elaborate profiles and attenuated silhouettes. The use of toe slippers,

with their small, sharp fulcrum, provided (from about 1835 on) a means of almost imperceptible floating locomotion across the floor and an increase in elevation for the *danseuse*. Denial of gravity commanded a whole division of schooling, with small foot beats, air turns, cross leaps, and vertical jumps, proof positive that a dancer can not only rise through space but can also perform movements with less friction there than on the floor itself. Pirouettes made clear that the front and back of a body have a simultaneous plastic significance in addition to the dialectic brilliance of their blur.

While the increase by innovation, analysis, and instruction developed performers past previous norms of competence, there were and are restrictions of taste, intellectual as well as physical, not always self-evident. Some ideas remain better communicated by other means; others are better left unexpressed or are expressed better in dance terms other than those of ballet. Degas, who was something more than an amateur sonneteer, once complained to Mallarmé that poetry was so difficult to make, yet he was full of ideas. The poet explained that poems are made of words, as pictures of paint. Ballet is made primarily of dancing in the classic style, secondarily of other attractive and ornamental theatrical elements.

With its inherent limitations accepted (one cannot, says Balanchine, explain in dancing that one dancer is another dancer's mother-in-law), there are wide categories of dramatic design in which the developed classic style may be more fully and intensely communicable than any other visual medium. Animation, the emergence into action of a static body; revelation, the abrupt appearance of an active body; movements reminiscent of the creatures of Prometheus testing their first steps; Pygmalion releasing Galatea; a doll becoming human; or a human becoming animal—these find actions that speak clearer than any ecstatic idiom but song.

Edwin Denby, that American dance critic whose book deserves a place on the single shelf of useful study (next to Théophile Gautier), gives the best definition:

Classic dancing is our most expressive development of dance rhythm. It builds long continuities (or phrases) of movement that offer the audience variations of bodily impetus clearly set in relation to a fixed space. And these long phrases of movement convey the specific meaning of the ballet—its drama.

As the impetus of successive phrases of music suggests to the hearer a particular quality of emotion and thought, so the successive phrases of a ballet suggest to the observer a particular quality of human action. *

## IV The Dancer

Dancers are craftsmen. Craft in the classic ballet is not mastered by desire alone, nor even by dedication. It also depends on heredity and temperament, a granted constitutional capacity, always enhanced by pleasant proportions and musical instinct. Inherent limitations may be overcome or put to advantage, as in the case of Taglioni's arms, which were too long but were disguised by her choreographer father in ingenious *ports de bras*. Exceptional performers have been handed outstanding machines; a great part of their supremacy derives from endowment: firm arms, fine legs, delicate attachments, and a splendid mask, with the added blessing of a clear sense of rhythmic phrasing. Although attempts have been made to establish canons of perfect proportion, an ideal body is a concept more than a fact; schooling compensates for faults and develops gifts.

With an adequate mechanism presupposed or adapted, there remain psychological or moral qualifications too serious and special to discuss briefly. Am I really a dancer? Will I ever become a dancer? Will I ever become a great dancer? What sort of a dancer am I? What roles do I really want? What roles do I really deserve? Am I as good a dancer as X, who may be more beautiful but who is surely weaker than I? Would I be happier in another company, with a different repertory? Am I getting too old to dance? Am I as good, or as bad, as the critics write? Answers to such troubling questions can be found only by individuals at various crises in long careers. When parents have asked about their children's chances, Balanchine has long replied: "*La danse—c'est une question morale.*"

A childhood vision of the dancer's glory must somehow be cradled and preserved, for the daily duty is onerous and the result slow to appear. The balance of encouragement from parents and realistic criticism from teachers is precarious. Fathers often aid their daughters. The profession is no longer dishonorable for girls. For this we have

* *Looking at the Dance.*

the British to thank, who took to ennobling stage artists late in the last century and who now recognize (after long years of struggle) their state ballet as an exportable national asset.

The problem of the lack in number and quality of male dancers is distressing. Male actors and singers, painters and poets are enfranchised. The popular dancer of stage and screen, providing he is extravagantly paid and publicized for a personality not necessarily connected with his capacity as a dancer, is also legitimized. But that American parent is rare who helps his son absorb the craft of the classic dance; Americans barely deserve the few excellent male dancers who manage to get themselves trained. But, indeed, English and American ballerinas are a comparatively recent discovery, and who are the French, German, or Italian male dancers of the last three generations? The honored French weakness for the soubrette all but killed opera ballet as a serious manifestation, eliminating men except as supports. We have not entirely recovered from the *boulevardier* prejudice. *

Russians maintain their ballet in such esteem that dancers hold the status of civil servants. Their services are recognized as essential and irreplaceable. They are generally exempt from all but emergency military duty. The careers of Western European and American boys who are encouraged to take ballet classes (a rare occurrence) from the age of nine to nineteen, and who then spend two years in work infrequently useful to the Army, may be wrecked. Bernard Shaw, a man almost alone in his position, appealed (naturally in vain) for the exemption of the British male dancer during the last war. Actually it would take more courage for a dancer to accept exemption on terms of art alone than to escape into the Army. It is not the fault of the material that a national ballet lacks impressive men. We have never been poor in Olympic or professional athletes. The Russians, who are neither pacifist nor unrealistic, have raised and maintained the profession of dancer to a deserved prestige, awarding self-respect to working artists which no other success renders entirely secure.

Dancers are committed to hazard. Unless they take all precautions, what they do cannot be well done. Every performance conceals

* The classic Gallic attitude is voiced by Eryximachus, the doctor of Paul Valéry's graceful discourse, *L'Ame et la Danse* (1923). Nine dancing girls are praised at their entrance for grace and beauty—all except Nettarion, "the little boy-dancer, who is so ugly."

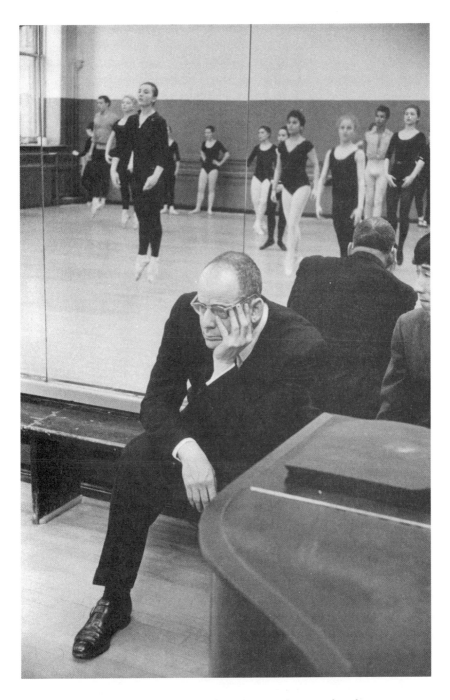

*Lincoln Kirstein, photographed by Henri Cartier-Bresson in the early sixties in a classroom at the School of American Ballet*

the risk of failure—immediate danger from accident, momentary loss of control, or weakness in obeying the proper law. A dancer's role is sacrificial, like a bullfighter's or a trapeze artist's. The physical risk may not be so extreme, but it is serious enough, and few things are sadder than a young girl or boy with a snapped Achilles tendon. Nightly they place themselves in jeopardy for their people, though the aura is more lyric than tragic.

A dancer's manner of projecting the classic style is a helpless reflection of private character, more revealing than handwriting or the quality of a smile. When dancers emerge from the *corps de ballet* to the status of soloist, exposed in naked isolation far from the supports of a classroom, it is only the sum of human nature and digested experience which shapes the muscle tone to direct a future. They are trained from the start to stare at mirrors. Their preoccupation in correcting themselves need never develop into that flagrant narcissism that often deforms other performers, and sometimes dancers as well. * Most students pray that the monster facing them each morning from their mirror will, by application, grow less monstrous, that its all too visible flabbiness and faults will finally be whipped into at least a decent accuracy.

Theatrical presence, awareness, apprehension, immanence, or magic is not self-love but an analytical sense that loves to please by releasing the skilled machine. As for virtuosity, there are few living dancers who need fear that their enormous technique may quite overhaul them—their means becoming their only end, a condition that has harassed some of our ablest painters and pianists. The constant crucifixion of dance training, of submission to new choreography, of risk in performance, which pushes the physique to such sweaty spending, reminds dancers that in great nature there are innumerable elements outside of idiosyncrasy upon which they must depend to ensure the balance of their bodies.

The *danseur noble* and the ballerina are not only idols but also models. Creations of their instructors, they in turn emerge as professors of style, first on stage, later in classrooms. Dancers as stewards of classicism inspire new ballets. More ballets are designed to frame a

* Narcissus, says W. H. Auden, was not a beautiful youth who fell in love with his own image. He was a hydrocephalic idiot who thought: On me, it looks good.

resident soloist than for other reasons. Like piano or violin concertos, choreography may be inspired by the personality of one executant, but soon after a debut, it enters the general repertory for alternative interpretations. And a performance in varieties of studied roles, as well as differing ideas of the same role, may be as instructive to the student or amateur as the daily routine of academic exercises.

## V *Instruction*

Progressive training towards a mastery of body mechanics has been developed over the years into a system of practice exercises based on some absolute premises. The daily lesson, in essence the same for beginners as for accomplished professionals, commences with *adagio* (at ease, slowly) supported by artificial correction from the wooden *barre*. Then students are released into the center of the practice room for a repetition of the identical work, now free from the barre, practicing both to right and to left to gain an easy ambidextrousness contrary to usual conditioning. The lesson terminates with rapid *allegro* combinations, finally launching the body into the air.

At no step in the classic pedagogy is there room for improvisation, experiment, or doubt. The academy is not choreography, any more than finger exercises are music. Without in themselves pretending to art or encouraging premature self-expression, both are stuff from which art derives. But just as there is beauty in a cleanly laid-out palette or a well-played chromatic scale, so the sight of a studio where young aspirants repeat their practice is pleasing.

Training today has advanced, with the dance theatre and choreographic scope as a whole, immeasurably beyond the rudimentary etiquette of Milanese dancing masters or the simple floor rules of the French founding fathers. France has always exercised her hegemony; the language of international dancing, diplomacy, and cooking is phrased in French, just as music speaks Italian, science, law, and the Church, Latin. A terminology has been maintained since the early seventeenth century, but while the nomenclature persists, our usage has frequently pushed past original definitions. When we read descriptions of early ballets or attempt to reconstruct antique works from choreographic notation, it is difficult to arrive at any accuracy because the idiom has been so greatly broadened. The vocabulary (and rep-

ertory) of even one hundred years ago would seem naïve to us today, that of two hundred uninteresting save for the lost charm of a historic style.

The French inseminated Russia, and while there were very important contributions from the Mediterranean, Scandinavia, and Central Europe (often in regard to *demi-caractère*, or theatricalized folk dancing), the standard for delicacy and dispatch remained French. This was true until the first decade of our own century, when the accumulated results of transplanted French, Swedish, and Italian teaching and practice were returned by the Russians to Paris, then far weaker in dancers than St. Petersburg or Moscow. The Russians established in France and then throughout the world a criterion we continue to recognize. The personal standard for the West is still, long after their disappearance from the scene, Pavlova, Karsavina, and Nijinsky.

As teachers, the most progressive French ballet masters found more opportunity under the tsars than in Paris, where the dance suffered (along with the opera) from bureaucratic rigidity, the whims of the gentlemen of the Jockey Club, and a severe impoverishment of male material in the second half of the last century. The male principle, dominant in the seventeenth and eighteenth, pursued by Perrot, Saint-Léon, and Marius Petipa before 1850, evaporated into travesty, girls assuming the dress of boys. Petipa, his able assistant, Lev Ivanov, and their disciple Michel Fokine are directly responsible for our working style. Their repertory (with Coralli's *Giselle*), as transmitted by White Russian agencies exiled to the West, is our immediate background. The French flowered in Russia, where court and a rising middle class were avidly francophile, compensating for a comparatively late emergence from demi-Oriental feudalism. Ballet was taken as a symbol of cultural internationalism. Western stars were not slow to attach themselves to so remote but so rich a province. The splendor of the Russian theatrical and musical apparatus shortly after mid-century was proof that Mother Russia was also a member of the more sophisticated European family.

But those in today's audience who have taken Russian ballet as a fact accomplished for centuries, just like those who accept the present situation in Britain as one of long-standing security, forget the caprice, accident, and agonizing uncertainty that have always dogged the es-

tablishment of this art as a separate feature in a new country. More than once, influential managers and critics have called for the suppression of ballet companies in favor of the more ancient opera, and more than once it has happened that the ballet, with its dynamism and ready novelty, has saved an opera house in desuetude. That the ballet has survived is owing to the devotion of dancers and to the innate excitement in the dance.

In the Russian situation traces of Byzantinism were preserved. The Russians remained imperial in their formal autocracy and spiritual orthodoxy longer than other states. The tsar was autocrat of all the Russias, including French Russia. Dancers were taught to make their *révérence* first in the direction of the sovereign's loge; the ballet was guaranteed by one million gold rubles a year from his privy purse. Ballerinas were awarded to grand dukes as tutors in love and taste. This court retained its absolutism up to the debacle. It never deigned (or was too blind and spoiled) to save itself by transformation into Western county-family gentility. Dancers were members of a royal household, raised in an atmosphere of such paternalistic security from childhood that they would always assume, even in remote exile and quite unconsciously, an absolute authority as their due, by virtue of their own gifts and training to be sure, but also because of an almost blood kinship with the crown.

Pervasive elements from the patristic philosophy of humility, compassion, and personal nihilism (responsible also for the supremacy of Russian character acting) certainly touched academic precincts and must be responsible for some of the constant greatness in anonymous assignments in their stage and film.* In the ballet, the atmosphere of feudal responsibility, aristocratic tenderness without flirtation, ostentation, or affectation—a ritual elevation of human sympathy, subduing but never extinguishing the Tartar violence beneath—contributed incalculably to the dignity, richness, and power of the Slavic style in its Great Russian epitome. And Russians first developed a specialist audience of passionate amateurs with a clinical if conservative, rather than sentimental, connoisseurship.

* In 1915, Diaghilev projected a ceremonial ballet, *Liturgy*, decor by Larionov and Goncharova, based on gestures in icon painting. Dancing would have been unaccompanied by music but linked by Stravinsky's orchestral interludes. The project was not realized, but Stravinsky's later *Symphony of Psalms* and *Mass* recall the planning.

When Diaghilev transported the main elements of the St. Petersburg and Moscow companies to Western Europe in 1909, he was aided by the political climate that made England, France, and Russia establish the Entente Cordiale. But official subsidy was withheld at the last moment, and he was forced to depend at the start (as he was throughout his career until he was kept for a few seasons, and then only in part, by the gaming tables of Monte Carlo) on the support of individual patrons. Diaghilev settled in Paris to pollinate all our fine and applied arts, and this was, in a sense, a homecoming. For French Post-Impressionism was responsible for decor and music, French precedent adapted by Russian, Swedish, and Italian hands for choreography and performance.

And when Diaghilev refused Lunacharsky's invitation to return to head the Soviet State Theatres after the consolidation of the Bolshevik Revolution, modern Russia seems to have shut herself off from progressive dance design, together with the whole early, middle, and late repertory of Igor Stravinsky, the most evocative body of dance music available today, the single inspiration to contemporary choreography comparable to Adam, Delibes, or Tchaikovsky. Diaghilev understood that the new bureaucracy, though revolutionary, remained Russian. Even under tsarist tyranny he had been forced to the West to fulfill his earliest collaborations. He felt he could not pursue them even in the comparative openness of the Soviet twenties. Over a century ago, Chaadayev wrote that "Russia belonged to the number of nations that somehow do not enter into the regular complex of humanity, but exist only to teach the world some important lesson." The lesson she taught in ballet was irreplaceable; it seems to have been learned.

Ballet in Russia may be the strongest in the world today: economically, from generous popular and state support; technically in instruction; in male dancers; and in the prestige of the art and craft as a legitimate and honored expression. But, at least through the evidence of films, the present theatre style, disassociated from French-derived internationalism, has become heavy, overemphatic, and coarse-grained. It is difficult to maintain universal elegance in cases of hermetic intellectual suspension; certainly Russians are now uninterested in accommodating Western notions of good taste. Nevertheless, when international exchange is not permitted full scope, a national manner quickly grows defensively and complacently provincial. Elegance re-

sides in an intensely individual reflection of voluntary behavior; it must still smack of dandyism, and dandyism must always smack of revolt against the ordinary, the level, the average. Elegance is homage to personal rather than national or class distinction. It frames *le côté épique de la vie moderne*, as Baudelaire conceived it, which cannot be imposed by the patriotism of theatrical commissars from artistic supervision by the political police.*

Theatrical dancing persists everywhere as a craft. Academies are reservoirs of information; great teachers are as precious as great dancers. In fact, the authority of instructors may be determined in large part by previous careers as performers. Girls and boys profit by a combination of men and women teachers; a single professor, however able, in one studio, has severe natural limitations. While several excellent male dancers recently prepared in Paris are largely the product of four ex–imperial ballerinas and an ex–first dancer who all maintained separate classes, this amounted to an informal academy-in-exile, for students shifted from one to the other. Men are better teachers for boys (who nevertheless can always learn a great deal from women) simply because they are themselves stronger in legs and arms for leaps and lifting; male specialties do not instinctively suggest themselves to women, any more than males are expert on *pointes*. A varied and balanced faculty, possibly young in years but already mature in stage experience, combined with authoritative and acknowledged personalities, provides the broadest base.

Teachers fall into two categories: instructors by analysis and models by example. It is rare to find a patient analyst and a brilliant stylist combined in one body. While students are temperamentally prone to prefer a single quality that somehow is felt to correspond to their own individual, if as yet undeveloped, character, it is important that they be subjected to as many stylistic and technical facets as are

---

* Working conditions in the Russian state theatres have not changed appreciably. In 1824, Charles Louis Didelot, a French founder of the St. Petersburg academy, was threatened with arrest by Prince Gagarin because ballet intermissions were too long; his resignation was accepted. At the dress rehearsal of *The Sleeping Beauty* in 1890, Alexander II so disparaged the greatest music ever written for the classic dance that Tchaikovsky was convinced of its failure. Diaghilev was in continual difficulty with a bureaucracy largely composed of retired Army officers; the engineering of Nijinsky's dismissal as first dancer to Nicholas II was at least in part a protest at the petrifaction of artistic policy which produced great technicians without a progressive repertory. The suppression of the early Shostakovich ballets continues the story.

Those schools are most efficient which are attached formally to a ballet company (just as the best medical schools are linked to hospitals), for here is continual association with performance from the very start of training. In Russia, children were not (and are not) corrupted by being presented as prodigies before they know what they are doing. They made anonymous debuts as blackamoors in *Aida* or rats in *Casse-Noisette*. From familiarity with makeup, the wearing of wigs and costumes, theatrical emergency, and an opera-house climate, they gradually assumed the quality of professionals, for which there is no other schooling. The virtue of our French-Russian-derived academy is in its unbroken teacher-to-dancer-to-teacher descent. It is the only practical floor for a great national ballet.

## VI Choreography

Dances designed for dramatic presentation as ballets are an extension by combination and ornament of the academic vocabulary, with conscious violations and intensifications. The grammar is first learned in classrooms by individual students. These increase their capacity to assimilate chains of movement by the aid of remembered exercise combinations that, at the same time, have extended and strengthened their muscular memory. The unit is the dancer-student, who has only a single body to manage and one set of motions to master. Choreographers must manipulate many bodies, rarely in unison, working contrapuntally all over the stage surface within the vast cubic space framed by a proscenium. The unit is a large company, broken into groups: soloists, *corps de ballet*, and musicians, fused in a visual orchestra.

The dominant style in classic choreography has shifted over the last twenty-five years towards a purist, or more purely balletic, tone. The traditional academic dance has reasserted itself with startling vigor after certain useful intrusions from extreme idiosyncratic sources, three of the most memorable being Isadora Duncan, Mary Wigman, and Martha Graham. There have always been, and always can be, important contributions from outside the stricter confines of the academy, but personal innovation (extension, inversion, deformation, reformation) usually affects manners in dance composition and individual

styles in movement rather than any basic training in the syntax or vocabulary of ballet practice. It is not difficult for a trained classic dancer to absorb varieties of idiosyncratic idioms; it is impossible for a dancer trained only in a personal method to perform in classic ballet.

In Diaghilev's middle period (1915–25), after his first nationalist or pan-Slav repertory had been exhausted of novelty or shock, the great impresario depended more upon painters and composers of the School of Paris than on new dancers or dancing. He was now separated by nearly a decade from the schools of Great Russia. Western academies had yet to be reanimated by his own dancers' dispersal into teaching a decade thence. His novelties, from the replacement of Nijinsky by Massine to the replacement of Massine by Balanchine, were predominantly in the style of *demi-caractère*, ornamental revivals from historic epochs transformed through contemporary Parisian eyes—such national or period pieces as Massine's *Three-Cornered Hat* or *Good-Humored Ladies*. While the music was often remarkable, the decor delightful, and the individual performance excellent, the dancing itself tended to be decorative and even secondary to the other theatrical elements, with the result that few of the works then invented persist in repertory.

The most recent chapter in the development of classic choreography, that branch of theatre-dance composition which deliberately exploits the expanding possibilities and elastic limitations of the clear academic tradition, commenced in 1928, with Diaghilev's collaboration of Stravinsky and Balanchine in *Apollo, Leader of the Muses*. This remains a neoclassic masterpiece with affinities to the plastic philosophy of Nicolas Poussin.

Diaghilev had become bored by character numbers, atmospheric revivals, and that domesticated and diminutive modernity which Parisian chic breeds with such relaxed and monotonous taste. Before his death in 1929, this animator of all our aural and visual pleasures attempted, as a kind of coda to his career, a return to unaffected nobility. He was no longer in possession of a fine *corps de ballet*, so he determined a veritable novelty employing three ballerinas and a single *danseur noble*, technically the most brilliant executants left to him. For Massine, who had enjoyed little formal academic training, he substituted Balanchine, a product not only of the Imperial and State dancing academy (1914–20), but also of the St. Petersburg Con-

servatory of Music. George Balanchine, of Georgian origin, the son of a well-known musicologist and composer, combined in one person virtuoso capacities as classic dancer, choreographer, and musician. Not yet twenty-five, he invented, to Stravinsky's exalted homage to Handel, Delibes, Tchaikovsky, and Terpsichore herself, a new synthesis of classicism, the first in the repertory since Fokine's *Les Sylphides* of twenty years before.* It was enriched by details that, on its debut, may have seemed astonishing or bizarre, but which long since have become the normal lyric idiom of the subsequent generation of dance designers. Certain tendencies that guardians of the tradition may consider heterodox at one moment are incorporated, sooner than one might imagine, into the catholicity of the flexible idiom. Traces of seeming novelty became imperceptible within a few seasons, having not only expanded the vision of the audience but also extended the capacity of performers.

Those choreographers, like Balanchine, who are most familiar with possibilities inside their tradition are the first to realize when extreme essays at innovation or reversal are no longer needed. One moment in history demands that dullness or overdecoration be shocked by spare elegance; another calls for formal symmetry unshadowed by deformation. It takes a master to lead in either direction against even so-called advance-guard taste. It was Diaghilev's great gift to anticipate such change, offering the next step, which he knew how to make seem at once shocking and inevitable, in the form of a theatrical idea incarnated in a dance.

Today classic choreographers have been given a universal language so specialized, inflected, and unexploited—cleansed and revived by half a century's experiments and research—that they can spend whatever time may remain to them merely filling the repertory with useful works, heedless of any immediate need for greater freedom in

---

* The complete revival of Tchaikovsky-Petipa's *La Belle au Bois Dormant*, magnificently undertaken by Diaghilev, Bakst, and Stravinsky with a great cast in 1921 as an act of pious faith in the classic ballet, failed gloriously, but it was the prototype of the triumph of the Sadler's Wells version of the forties, which consolidated the present position of that company, and of the power of the pure academic dance over all intervening and untraditional intrusions.

For an excellent reconstruction of this production, and a comparison with others, see *The Complete Book of Ballets* by Cyril W. Beaumont.

expression. To invent a useful work is, in itself, a heroic task. Theatrical use is severe. A ballet's survival for even three seasons is unusual.

Choreography is the supreme contribution of the dancer, its invention even more than its execution, for without design there could be no concerted dance. The dancer is to a choreographer what the dancer's own body is to himself. A ballet master is not necessarily a choreographer (even though he may have enough skill to arrange numbers), of whom there have been but a handful to an epoch. Ballet masters remain useful rehearsalists and arrangers. A choreographer is a composing symphonist with personal concepts of movement. He conceives in terms of formal physical activity, as a musician in sound or a painter in line and color.

## VII Contemporary Classicism

The classic style, supported by its academic technique, depends upon rigid criteria and severe discipline for even a modest executant efficiency, like our music, medicine, and architecture, but unlike our prose, poetry, or painting. It has also become true that unless the ordinary run of female dancer is already a budding virtuoso she is unacceptable even for the *corps de ballet.* Virtuosity is almost presupposed, as it is in candidates for a major symphony orchestra. It is beauty and expressiveness that enter the dancer. While good (that is, excellent) performers are not yet quite, as one is sometimes told, a dime a dozen, nevertheless, in America at least, dance training is on about as high a level as the schooling for the best college or professional athletes.

Their classic training as performing artists, however, has removed from them the need of strain towards feverish personal vindication. They husband for extra energy and projection in performance whatever idiosyncrasy survives their schooling. They practice their craft in the same spirit as those nameless guildsmen who made most of the antique artifacts that continue to please us, without themselves ever claiming to be innovators. Even famous dancers or choreographers hesitate to consider themselves "creative," a word few artists of any sort dared use before Romanticism, for Creation was considered a property of the unique Creator, and the fact was in itself historic and irreversible.

Tradition was a living chain that permitted, or rather propelled, inspiration from roots inextricably linked to the past.

In liberal democracy and anxious anarchy, the traditional classic dance, compact of aristocratic authority and absolute freedom in a necessity of order, has never been so promising as an independent expression as it is today. At the moment, when representational art has declined into subjective expressionism, and its chief former subject, the human body in space, has been atomized into rhetorical calligraphy, the academic dance is a fortress of its familiar if forgotten dignity. To it future painters and sculptors may one day return for instruction in its wide plastic use.

Through our twenties and thirties there was still, under the aegis of Diaghilev, contact with advance-guard easel painters. At present, the vanity of dealer- and museum-sponsored decorators tends to overwhelm all classic choreography. Many painters insist that they wish to design for ballet, which usually means they may want to work on cloths larger than those permitted to hang on walls assigned them. There is hardly a handful whom a sensible choreographer could trust to create the illusion of space within which, rather than against which, dancers may be seen to move. As never before, our interest is focused on classic frankness, elegance without ornament.

The repertory of contemporary classicism depends largely upon what survives from the nineteenth century rather than from the initial shocks and glories of the twentieth. Fokine's huge repertory has diminished after its prime historical service into the faint visibility of provincial disrepair. Massine's work is chiefly recalled in a few character numbers; his big symphonic extra-illustrations have proved improbable revivals. Our practical background is that of Petipa, Ivanov (from Sergeyev's memories and adaptations of the Tchaikovsky ballets for the English companies); Coralli's *Giselle*; possibly the Fokine of *Les Sylphides*.

The development of classicism through the centuries, as distinct from character dances that tend to get themselves remembered as solo numbers, has usually depended on one or two choreographers at a time. Today, at least for the West, it is most fully seen in the works of George Balanchine to music from Bach, Mozart, Bizet, Chabrier, and Tchaikovsky, through to Prokofiev, Hindemith, and Stravinsky—

scores whose relentless motor suggestion and support propel his insistent metrical drive. This music is Franco-Russian with Italian and Central European fertilization, as is the technique of the traditional dance itself.

The subject of Balanchine's ballets, apart from love (of music, of the human body, of human beings), is the physical act or presence of the dance itself, not "abstractly," for the sake of detached, desiccated, or decorative motion, but concretely, representing and demonstrating the conscious mechanism in its preparation and animation through mastery of time, space, and gesture.

Balanchine has not transformed the style. He does not classify himself as an innovator or original. He has inherited his language, as Valéry and Yeats inherited theirs. Like a hereditary prince, he has extended its domain through an assumption of its duties and prerogatives, by virtue of his historical position and his innate genius. But he has also defined an intensely personal manner so faceted that it often appears related only to the specific piece of music which is the springboard for the occasion. There are as many Balanchine manners as there are aspects of classic or neoclassic formality and sentiment, which bear no resemblance within his manipulation to anything save his own taste and integrity. His unmistakable signature is in his masterful designs for tenderness, regret of loss, mystery, exuberance, and human consideration.

He has encouraged schools of dancers, a generation of choreographers here and abroad who recognize in his gifts and sensibility the direction in which their own latent invention may be best fulfilled. He has found in the bodies of American-bred dancers, with their professional coolness, resourcefulness stemming from a pioneer heritage of competitive risk and sportive improvisation, answers to his own demands. He seldom considers dancers as personalities according to the Western fashion of stardom, but rather thinks of them in the Byzantine tradition, to which he also adheres, as messengers sent, angelic presences who embody certain capacities for the communication of categories of movement.

Some dancers avoid him. They hold that extra-classic elements, naïvely histrionic or earnestly expressionist, suit the troubled times. Others have turned to him in the midst of successful careers, recog-

nizing that their luck to date depended on dangerously accidental factors that they wish to exchange for the more durable support of the lively academy. For Balanchine has transformed what was once an ephemeral amusement into a continuous amazement. Over the last twenty-five years he has endowed us with a library of models as well as of methods of composition which may be used by his distant heirs.

# Gagaku

*[In 1958, during a tour of the Far East, the New York City Ballet visited Japan. Subsequently, Kirstein made several extended trips to that country, and in 1959, in conjunction with the Secretary-General of the United Nations, Dag Hammarskjöld, he invited Gagaku, the dancers and musicians of the Japanese Imperial Household, to appear in New York. This is his introduction to* Gagaku: The Music and Dances of the Japanese Imperial Household *(New York: Theatre Art Books, 1959).]*

WE PRAY FOR One World, not one world of monolithic unity but of the rich vitality and variety of the many worlds that may, one day, be one in independent diversity. Our two great Worlds of East and West have never before been so interdependent, so linked by tension and by mutual attraction. The fascination of East for West and West for East is the key of our time. The visit of Gagaku, the musicians and dancers of the Japanese Imperial Household, is a symbol of extraordinary depth and importance, of the possibility of bridging culture, time, and place.

Gagaku, founded in A.D. 703, is the oldest institution performing music and dance in the world. Its tradition of imperial support, hereditary personnel, and artistic repertory is uninterrupted. It has had, until recently, an almost secret, almost sacred life. It is possible that more people will see Gagaku in the United States on its epoch-making tour than have ever beheld it in the Imperial Music Pavilion in Tokyo or at one of the great shrines at Ise or Nara.

However, we must school our ears to hear, our eyes to see Gagaku. We are accustomed to sounds and sights arranged quite differently by measures of time and space. In the West, time nervously passes; in the East, man passes through imperturbable time. In America, space is unlimited; our prairies stretch from sea to shining sea. In Japan, the islands are strictly circumscribed; mountains are terraced, foot by foot. Music and dances in their rich accumulation from all Southeast and Central Asia, already a thousand years old in some cases when Gagaku was founded, found a haven and a home in Japan, for there was nowhere else to move on to, save into the Pacific.

So there survived elements from Persia, Mongolia, Thailand, Korea, Japan itself, of an almost unimaginable antiquity. Think for a moment what was happening in Western Europe in A.D. 703; in Nara there was a great court. But what is more, a pre-Buddhist culture that we are only beginning to prize today, along with Etruscan and Cycladic art, had long preceded the Chinese priests and architects who had made Nara a shrine city of unsurpassed splendor. Kyoto itself was not founded until almost a century later. Gagaku performs sacred and secular dances; the ceremonial movement derives sometimes from folk sources, Persian polo, Korean barge poling, Chinese military discipline, but it has been refined, essentialized, formalized, in the atmosphere of the Imperial Court, a precinct, at least, of symbolic serenity; only the all-powerful can be truly serene; calm not rage is the sole sign of authority; one of the most beautiful Gagaku dances is of military origin, but it is known as a dance of peace, for authority has been established and maintained by noble soldiers.

This music, these dances are, to Westerners, slow. That is, they seem so to those eyes which are habituated to divisions of time which are accelerative, unlimited, and, often, undifferentiated. Gagaku dances have a limited vocabulary of movement; we are accustomed to a frenetic brilliance in physical virtuosity. But when the West sees dancing, it is for theatres; Gagaku is not theatrical dancing for a great audience. It is movement designed to be done at court or shrine, for a philosophic, moral, or religious purpose: for the enthronization of emperors, for the marriage of crown princes, for the completion of shrines, for the in-gathering of the first rice. The dancers wear no makeup; sometimes they are masked; they are clad as priests or accoutered as warriors; their arms and armor are not stage properties;

they are the consecrated and personal property of an imperial household.

It is not so much what these dancers and musicians *do*, although what they do is beautiful, hypnotic, absorbing, even after the immediate strangeness has worn away. What is important is what these musicians and dancers *are*. In the West, all is the doing; in the East, all is the being. In Japan, Gagaku, the ceremonial and sacred dance; Noh, the religious drama, and the art of the geisha, the secular craft of refined relaxation, spell Accomplishment; Gagaku, Noh, and the wholly separated skill of private entertainment are institutions of the accomplished.

Our Western dictionary defines accomplishment, first of all, as completion; there is argument among musicologists and historians exactly as to when Gagaku was frozen; few think there has been much change since A.D. 1150. Accomplishment is also "that which completes or equips thoroughly." The visual splendor of Gagaku dress, the perfection of detail in arms and armor, the immaculate presentation of individual performers is unparalleled in the West. Finally, accomplishment is "an element in excellence of mind, or elegance of manners, acquired by education and training." The Western world has long known of the symbolic disciplines of tea ceremony and flower arrangement. Many tourists have testified to the fascination of Kabuki, the popular seventeenth-century classical theatre. Today, more and more Americans are falling under the fascination of Zen philosophy in its multiple aspects; many American soldiers have been conquered by the powerful attraction of ritual wrestling, ritual fencing, and ritual archery.

Gagaku is not a dead art; it is a completed art that is performed within its own limits of perfection; it has meanings for the West, on many levels. It is not easy to grasp completely at first viewing or hearing. Perhaps some Westerners will credit it with as much subtlety, mastery, and depth as the glaze on a pot, or the individual character of calligraphic stroke. New dances are made today for contemporary occasions. The first dance that will be seen at the General Assembly of the United Nations has only just been composed in honor of the recent marriage of Prince Akihito, the imperial heir. Igor Stravinsky, the greatest Western composer and music master for our ballet dancers, first heard Gagaku performed by an amateur group in Los Angeles. In

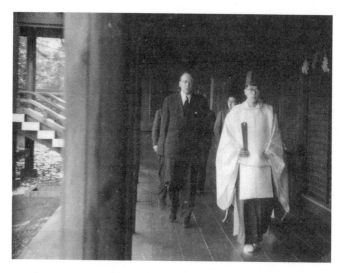

At a ceremony at the Toyokuni shrine in 1959, Lincoln Kirstein is
entrusted with the protection of the dancers and musicians of the
Imperial Japanese household during their journey to the United
States

his *Conversations*, Stravinsky writes: ". . . a new demand for greater
in-depth listening changes time perspective. Perhaps also the operation
of memory in a nontonally developed work (tonal, but not eighteenth-
century-tonal system) is different." Stravinsky, conducting this year in
Japan for the first time, expressed his deep interest in Gagaku, as many
American composers will.

Gagaku is a precious possession of the Japanese Imperial House-
hold, whose symbols are the jewel, the mirror, and the sword. Per-
fection, the face of self, civil authority, have survived their dim origins
in Shinto credence and are living repositories of powerful ideas. It was
the great privilege of this writer to witness Ninjo-mai, perhaps the most
sacred as well as the oldest of all the dances, performed only in the
Imperial Palace and at the Grand Shrine of Ise, at Ise itself. The dance
was done under very modern circumstances. The first team of shrine
dancers and musicians was gone for the day, on duty at a ceremony
of importance some distance away. But the chief priest responsible,
in order not to disappoint honored guests, arranged for this most mov-
ing of dances to be danced to an excellent electronic tape recorder.
The dancer was a young man, neither attached to the Imperial House-

hold nor in any way a hereditary shrine servant. He was only the captain of the local judo team; he was also a magnificent dancer. It was not his expressiveness that moved us, or his personality, or his virtuosity. It was his gravity, the fulfilled correctness of his immaculate presence, the elevation, not alone of his spirit, but of the spirit of what he danced. His being as well as his doing was the praise of God.

American dancers and lovers of dancing will welcome Gagaku, not alone as a magnificent gift from a splendid culture, but as an exemplar of the sources of our theatre, our one-world-theatre, which was, first of all, ordered movement to honor the changing seasons, the survival of life, love, and creation. Gagaku is a wonderful show, but something more. It is an embodiment of truth framed in every splendor human hands and minds have contrived to praise the principle that may, if we can manage to realize it, help us in our own struggle towards perfection.

# Aria of the Aerial

[*First published in* Playbill *(New York State Theater issue, April 27–May 11, 1976).*]

A RECENT WRITER in a counterculture weekly suggests (more in sorrow than in anger) that, for our seventies, dancing as a popular cult overtakes rock music of the sixties. This may or may not be as true of regional as of urban America, but on a grass-roots level, local prolif-eration of holiday *Nutcrackers* on some professional basis is astonish-ing. Parallel to this is the increased presence of "dance" in colleges, with residencies for well-known companies. The number of young people now aspiring to become dancers approaches that of actors, singers, or musicians, a condition unthinkable twenty years ago, while there is a new paying public which hopefully organizes economic support, even state and civic aid.

Dance includes separate families for teaching and performance: "ballet," "ethnic," "social," and "modern." For ballet, there is a single canon of instruction comparable to that which equips pianists, violin-ists, and singers in fingering or voice control. Different emphases obtain, but the alphabet taught is universally legible from long tra-dition, demanding the same criteria. "Ethnic," which includes social styles (more for fun than show), encompasses folk dance, recreation for amateurs and source material for theatre. Formerly "national" dances, stage versions of Spanish, Slav, or "Oriental" were instructed,

but today these, as balance or alternative to academic ballet, are largely replaced by "modern."

During the 'thirties when "modern dance" first asserted itself, an inheritance from Ruth St. Denis and Ted Shawn fragmented into main lines of apostolic succession. Forty years later, energy is lodged in the repertory of Martha Graham, her immediate heirs and theirs. Increasingly, with a use of the ballet *barre* and borrowings from ballet-trained instructors, "modern dance" has lost some of its early antagonism to classic ballet. Stylistic lines blur and fuse. However, important polarities exist, so it may be useful to fix parameters of Ballet and Modern. Cursory definition involves oversimplification; generally it can be stated that ballet training and performance accentuate the area of air, denial of gravity by leg work in beats and jumps; brilliant multiple turns; speed in the stage traverse; *pointe* (toe) shoes; virtuoso acrobatics (attracting large audiences to opera houses) accompanied by orchestras of symphonic dimensions.

"Modern dance" came into being partly as a reaction against such factors, with a basic rationale accentuating the solar plexus as source of contraction and release; a response to earth's gravity and pull; "psychology-through-movement," with ideas from myth and social protest. Stemming from Bennington College, then spreading to state normal schools, where it began to replace "phys. ed" (physical education) as a more aesthetic body building, "modern dance" acquired the fervor of a crusade, vaunting ethical superiority over "mere" (mindless) entertainment.

Along with such protestant policy, there were other determinants. Ballet instruction was then not widely available nor performances visible. Conditions of labor and production costs were prohibitive for unpaid volunteers. A modesty of visual and musical accompaniment made virtues of necessity, fast elevated into articles of faith. It was proclaimed that main differences between "modern" and ballet were between "principles" and "technique," as if one lacked skill, the other morality. Both had both. Rather, difference was and is between accidental idiosyncrasy against tradition, personalism versus collectivity, discontinuity as opposed to an unbroken line. "Modern dance" opted for self-expressive "originality," defined by a few notable heterodoxies. Self-expression triumphed without providing either a cohesive teaching method or a repertory past individual utterance. "Modern dance" lies

among the minor verse of theatre. When one counts how few "major" poets (or anything else) there are, how "major" so many "minor" ones, this seems no aesthetic limitation, although it may prove both a temporal and popular one.

No matter how close "modern dance" approaches widespread acceptance, however flexible or eclectic its expanded idiom, essential contrariety remains. "Modern-dance" choreographers can compose for ballet-trained professionals with few limitations, but "modern dancers" cannot slip from one technique to the other, lacking academic classic training. Few modernists start aged eight or nine, which is mandatory for ballet as for piano or violin virtuosi. Admittance to ballet schooling (at its most responsible) is not licensed by simple ambition but through expert opinion. Severe physical preconditions determine the ultimate chances of a classical professional; such "elitist" limitations need not deter "modern." In ballet, as far as doing-one's-own-thing goes, there is little scope for "originality" or improvisation. "Modern dancers," since they start so much later, with minds more developed, are free to intellectualize impulses which have no bearing on acrobatic efficiency depending on synthetic method. "Modern-dance" training is based on a few isolated concepts tailored first to their unique inventors and restricted by such stylization, then adapted by a more or less liberated succession to their own peculiar needs and possibilities.

Ballet's vocabulary, by which strong executants magnetize big audiences, depends on muscular and nervous control deriving from four centuries' research in a logic combining gross anatomy, plane geometry, and musical counterpoint. Its repertory is comparable to that of opera, symphony, and classical drama. "Modern dance" may be equated with the collected works of contemporary prose or verse writers. It has still to be proven that subsequent performances lacking their originators may long hold the intensity of their originals. "Modern dance" is no longer a vanguard of reform. Far livelier in its current effect on both ballet and "modern" are influences from popular music, jazz and its mutations. Here, its risk lies in the very timeliness of novelty; transient slang fixated on a given epoch.

The root of ballet training in the five academic foot positions established some three centuries ago is not arbitrary. These determine the greatest frontal legibility and launch of the upper body as silhouette framed in a proscenium. Ballet repertory was calculated for opera

*Herbert Bliss of Ballet Society, photographed by George Platt Lynes,*
*in Balanchine and Stravinsky's* Orpheus, *1948*

houses with orchestra pits, and balconies rendering the stage floor a virtual backdrop for half the public. It is not the only form of theatrical dance; it is the most spectacular. Extreme acrobatism entails hazard which, overcome, sparks the most ardent audience detonation. Its filigrain of discrete steps; its speed, suavity, and flagrant tenderness; its metrical syncopation and asymmetry make visual superdrama on the broadest spectrum. In "modern dance," focus is elsewhere. From its start, it was on and in central somatic areas of the body, rather than extension of peripheries. A prime distinction exists between Occidental and Oriental dancing: open against closed, centripetal against centrifugal; kinetic against (dominantly) static; fast against slow. This is oversimplification, but a like parallel might be set for ballet against "modern": aerial versus terrestrial.

From Denishawn down to today, the Orient, both in movement and in morality, strongly influenced "modern dance." From ideas via Emerson, Whitman, and Nietzsche invoked by Isadora Duncan, with Denishawn's experience of Japan and India, first intellectual, then ethical superiority was claimed from religious precedent and temple

practice. Ballet, with its vulgar connotations as frivolous luxury, sexual toy, or musical bagatelle (until Diaghilev), offered a likely target for self-educated amateurs. Isadora was a puritan; she feared seduction of her students by the charms of Russian ballet. In the wake of war and disaster, German and Austrian poets, painters, musicians, and dancers of the twenties and early thirties proposed valid experiment which gained prestige as a passionate vanguard. Serious ballet had been lacking in their countries for nearly a century. American tours by Mary Wigman, Kurt Jooss, Harald Kreutzberg corroborated and encouraged our own modernists. But, as Diaghilev himself said, the Germans had learned how to move as they forgot how to dance.

At the same time, classic ballet received fresh impetus with the arrival in New York of Diaghilev's heirs. America had seen no Russian dancers since 1917. Through paintings by Matisse and Picasso, concerts by Stravinsky and Prokofiev, audiences were eager and prepared for "modern" ballets by Massine, Nijinska, and Balanchine. This repertory was as much novelty as "modern dance" and bore slight kinship to Pavlova's *Dying Swan*. However, the new ballets spoke with a Parisian accent and further spurred an opposition which was not only struggling for progressive form but also a nascent national expression. From such tensions "American Ballet" was born.

It is not too much to claim that its present popularity began in commercial theatre, on Broadway and in Hollywood. The strongest exterior influence on the development of the academic dance has derived (and still does, largely through Stravinsky) from jazz rhythm, beat, the shifting pulse and syncopation of styles and steps from ragtime to rock. "Modern dance" unquestionably extended possibilities. Unorthodox use of the body in ballet, from Nijinsky and his successors, was more an inversion of academic positioning than any radical extension of technique. The rehabilitation of theatrical elegance from commonplace habit came through Kern, Gershwin, and Rodgers. Balanchine's insistence on the then-unknown credit "Choreography by" in thirties musicals gave a new coinage to the classical line, at once sleek, rangy, athletic, and modish, whose prototypes were more Ginger Rogers and Fred Astaire than ex-imperial ballerinas.

That ballet has gained a mass audience is evident. That "modern dance" has its own is plain. What continues to distinguish the two are elements which have always been present and do not change. In ballet

what attracts its public is a sharper focus on the execution of steps, clear components of dance speech, not necessarily at top speed nor unbroken flow, but which proclaim capacity in flexibility, lightness, power, brilliance *off the floor*. Ballet simulates a conquest, against gravity, of aerial space. Grace and elegance are involved but in unwavering control, the convincing wizardry in ease which at once conceals and demonstrates effort. In "modern dance" the torsion of exertion, the moist anguish of psychological contest supplies pathos. The style in its tragic or mythic aspect stays agonized and intimate. Ballet is open, broad, grandiose, courtly, and considerate, not of the exposed self, but of skill in steps and partners in a company. Psychic nuance, the visceral unconscious upon which "modern dance" depended, remains its prime self-limiting material. However, as it has developed through a third or fourth generation, present champions are prompted by pop music as well as Bach and Handel, for satire and comedy, increasingly a reaction from the solemn tyranny of their progenitors. But lacking any absolute acrobatic proficiency, it is doubtful whether continued use of the term "modern" holds much permanent contemporaneity. Its attraction becomes time-bound, a nostalgic mode, like "Art Nouveau," "Art Deco, "modern art."

Dame Marie Rambert proposes that classic ballet offers a service parallel to *bel canto* voice production for trills and roulades. For her, *la bella danza* is not a nineteenth-century stylization or a period fashion but a steadily expandable vocabulary of spectacular action, propelling unique and extreme capacities of the dancer's instrument. For the ballet artist, mastery of steps infers domination of space, as much above the floor as upon it. Limits explored are not those of extreme emotion but of expressive motion. Determined and defined, ballet is a continuous aria of the aerial.

# A Ballet Master's Belief

FOR FATHER ADRIAN

[*George Balanchine died on April 30, 1983. That evening Kirstein appeared in front of the curtain at the State Theater and said, "I don't have to tell you that Mr. B. is with Mozart and Tchaikovsky and Stravinsky . . ." His valedictory appreciation was published in* Portrait of Mr. B: Photographs of George Balanchine *(New York: Viking, 1984).*]

I

WHEN GEORGE BALANCHINE set foot on Manhattan in the autumn of 1933, he and his colleagues were so preoccupied with confusing circumstances, inevitable in founding any ambitious institution, that while formulation of an overall educational morality was not ignored, its expression was delayed. However, after our fledgling School of American Ballet incorporated itself as licensed by the Board of Regents of the State of New York, and opened on January 2, 1934, a policy, latent but dormant, was fermenting. Over the next fifty years it would be distilled, and its taste and temper become clear. This metaphysic, or body of belief, a credence that surpassed concern for mere physical mastery, determined our destiny, as well as the destiny of those ballet companies which eventually came to employ the dancers our school had trained. Only after Balanchine's death does his moral rigor seem definable, although it had long been visible. What he lived, taught, and invented ballets by was a constant employment of traditional guidelines for considerate behavior. While these precepts would

never be codified as curriculum in any catalogue, they determined instruction and practice.

Odd parents, a few very odd, commenced bringing children— mostly girls, too tall, short, or plump—to be auditioned by this young ballet master, who, not yet known to America, had already been interviewed by the dance critic of *The New York Times*. One woman asked him, after he'd inspected her daughter in practice class, "Will she dance?" What she meant was, "Do you think she is beautiful and talented, as a child, and will she be a star?" A middle-class American mother was seeking a prognosis, as from an allergist about her child's rash. The putative ballerina clung to Mummy's skirt, exhibiting filial attachment worthy of a Shirley Temple. Balanchine was unassertive, slim, no longer boyish, and with his grave, alert mannerliness, the more daunting in his authority, instinctive and absolute. He hesitated, perhaps to make sure he would be understood; she repeated her question: "Will my daughter dance?" A Delphic response was the reply she received, sounding more oracular couched in French, although the sound of its meaning was plain enough through its four transparent cognates: *"La danse, madame, c'est une question morale."*

The dance as a moral consideration. The abstractness of the answer, in its hardy phrasing, may have seemed even more puzzling than its pronouncement in French. *"Morale?"* Morals? Morality? Immorality? Ancestral seventeenth-century Puritans in Plymouth, Salem, Boston, Providence, New Haven, founding theological seminaries which would mutate into influential seats of teaching, if less frequently of learning, had provided the mid-twentieth-century American with a curious inversion of the word "morality." John Harvard, Cotton Mather, Elihu Yale, and their ilk denounced "dancing" as devil's business, the fancy of whoredoms, a relic of the Caroline court, of the corruption of divine kingship. Faced with exile, a trackless continent, savage enemies, starvation, an imponderable future, God-fearing pioneers needed every ounce of muscular energy just in order to survive. Jehovah had chastised a tribe frolicking in exile before a golden calf. Waste motion, especially that kindled by animal spirits, was not to be spent ecstatically or mindlessly. Witch-hunters contrived, with self-defensive ferocity, to salvage their irrepressible flock.

As a reaction, or indeed a revolt, against such historical conditioning, our own permissive epoch—thanks to pragmatism, behavior-

ism, Freud, and "freedom"—believes that somatic muscular instinct can, and indeed must, be identified with every born creature's right to "life, liberty, and the pursuit of happiness," but with individual personal choice, no matter what the circumstance of birth or qualification may be, regardless of class or color. Any vast preoccupation with formidable definitions of good or evil, of morality itself, has become an inhibition on that guaranteed liberty. Limits imposed on available satisfaction, however brainless or fashionable, are disdained as a restriction on natural gifts that any or all of God's children (few of whom are taught to believe in Him) may, with promiscuous benevolence, accidentally be granted. Corsets beset Isadora Duncan; she tossed them off: hence any American is free to dance as she or he sees fit, presuming we possess a conscious choice.

After a long, despairing revolutionary war for political independence, a frightful civil rebellion, participation in a first world war, and despite rumbles and ensuing depression from 1929, the United States in 1934 was hypnotized by the illusion of limitless possibility. Animal instinct was manumission. Restrictive rules for the cultivation of modern art, particularly modern dance, were condemned as not only retardative but un-American. Any girl child, given a break, might hope to be—perhaps not yet President, but at least a baby movie star. "Morality" was an attack on optimism, hedonism, a straitjacket on compulsive free will, on the full play of one's instincts, a hindrance from which only backward or exhausted European academies might be withering.

Mother and fidgety daughter lingered irresolutely in the small shabby foyer of the School of American Ballet at Fifty-ninth Street and Madison Avenue—a space that, some thirty years before, Paris Singer had leased for Isadora Duncan. She, a canonized immoralist and freedom fighter, had kept her small Russian students from entering the Bolshoi Opera House, fearful lest their innocence be corrupted by the glory of what was left of an imperial dynastic ballet company. Her own heroic counter-morality had done what it could to exorcise the ghosts of those Pilgrim Fathers who proscribed lewd behavior around the maypole at Merrymount. With the Puritanical triumph, the profession of theatrical dancer was cursed on this continent for the next two and a half centuries.

Isadora gained her personal victory, tragic as it may have been.

Martha Graham, her liberated successor, because of her own feminist morality, won a more fruitful and lasting career. In 1934, modern dance was exulting in the progressive assertion of experiment, in the endless duel between the innovator and tradition. Here the influence was an inheritance from Emerson, Thoreau, and Whitman, subsequently homogenized in the blanket educational reformative attitude of William James and John B. Watson. Classic traditional academic ballet, "artificial" in its graceful historicity, seemed to most American progressive educators, wherever they recognized its fragile presence, not only played out but, worse, immoral. It now even menaced our shores as an alien invasion. The dance critic of *The New York Times*, after viewing Balanchine's debut on Broadway with a provocative repertory, advised him to sail back to Paris as soon as possible.

Sadly, the anxious and disgruntled mother reclaimed her restless hopeful. Unsatisfied, facing dismissal, she thanked Balanchine "for his time," a gesture that was also an accusation against a foreigner's lack of sympathy. Bewildered, but estimating that little enough had been risked or lost, they vanished. Soon came hundreds like them. Meanwhile, Balanchine advanced that moral substructure on which his school's regimen was founded.

II

A lady I've known since childhood, with whom I share interests in "art," but who is moved more by "literature" than listening to music or looking at dancing, asked me, when she heard Balanchine was terminally ill, "Was he, in any sense, 'religious'?" To anyone who had the least contact with him, this seemed less an ignorant than an astonishing question.

Balanchine was in every sense "religious" in its most accepted dictionary definition. His observance of the rites of Russian Orthodoxy was inborn and unswerving. St. Petersburg's ballet school, which was paid from the Tsar's privy purse and which he entered in 1913, had its own chapel and priest (as do West Point, Annapolis, and the Air Force Academy).

As a "liberal" or even "revolutionary" student attracted to progressive expression in music and the plastic arts, in the open atmosphere following Lenin's October victory, he arranged choreography

for the reading of Alexander Blok's poem *The Twelve* by a choir of fifty in 1923. He was enthusiastic about Meyerhold and Mayakovsky, but he had small interest in factional politics of the day. In later life, gross social programs for amelioration of the human condition meant far less to him than specific, minimal benefits. His affecting impersonation onstage as Don Quixote was echoed domestically when he dedicated his company's performances towards Italian earthquake relief, or when he bought bulletproof vests for New York policemen.

For him, Lord God in one big bang "created" the cosmos, which existed before time. After that, everything was discovery or invention. Two epithets he particularly detested, though they were frequently invoked to qualify his "genius," were "creative" and "original." The first, he felt, was the more false; only less offensive was "original," or its twin, "authentic." Any unique human explosion of initiative was usually mutation, but, more often, dilution. As for "genius," the word rarely signified contact with a genie, a spirit released from bottled earth to infinite air, but, rather, a person endowed with given, if extraordinary, powers. Geniuses come in all styles, good or evil, Haydn to Hitler.

In classic academic opera-house dancing, which was his empire, he never claimed to be more than a reassembler, inverter, or extender. This positioning was neither reformation, distortion, nor replacement. His deep and oft-repeated generous obligation and respect for predecessors—Lev Ivanov, Marius Petipa in particular, but also Michel Fokine and Kasyan Goleizovsky—continually surprised commentators, who were quick to flatter Balanchine's surprising movement as "revolutionary." Few of these had been familiar with the late Diaghilev repertory or its St. Petersburg ancestry. Also, they rarely estimated his debt to those heavenly powers which blessed his firmest collaborators, Bach, Gluck, Mozart, Tchaikovsky, and Stravinsky. Balanchine's belief was akin to Søren Kierkegaard's: Morality is not religious life, but only a prelude to it.

III

From his baptism in infancy, Balanchine's sensuous and visual impressions were stimulated by celebration of saints, their feats and festivals. Icons, and the music and incense that wafted about the altar screen,

furnished ideas that still resounded when he came to map movements for theatrical action. His uncle, the Archbishop of Georgian Tbilisi, celebrated the eucharist in vestments of purple and heavy gold. His nephew was given small objects to bless. The boy played at priest, cherishing the precious little relics he'd been handed as sacred toys. The annual remembrance of his own birth and origins, celebrated on the feast day of his patron, St. George of Lydda, were convocations of friends and colleagues, tasting memorable food he cooked, drinking wines he prized. Dependence on hierarchies of protectors—sacred and profane, mythical or historic—was his comfort.

It may be useful to sketch the poetics in theology that irradiated his faith, since these were transmitted to the secular rites he arranged. This is manifest in distinctions between forms of belief in the Christianity of the West, centered on Rome, and that of Eastern, Greek, or subsequently Slavic Orthodoxy, embodied in the Second Rome, Constantine's capital, which had become Byzantium. In A.D. 988, in Kiev, Prince Vladimir, whose name like the title of Christ means "Ruler of the World," had his people baptized; he established the Church and its institutions. Kiev became the fount of that philosophy of imperial angelism which was incarnate in the flesh and motion of Balanchine's invention.

He was something of an amateur theologian, as were his friends Wystan Auden, J. Robert Oppenheimer, and Igor Stravinsky. To Auden, the anatomies of various theologies were his form of chess. To Oppenheimer, as perhaps to Galileo and Newton, theological formulae measured the rhythm of the random. To Balanchine, concepts or images of the Divine, even cant uses of "divine" as a shibboleth of quality ("My dear, she danced *divinely!*"), had their daily resonance. "Divine" is from *divus*, Latin "of, or pertaining to God (or, a god); given by, or proceeding from God; having the sanction of, or inspired by, God."

His most quoted apothegm was: "to make audiences *see* music and *hear* dancing." St. Paul has it: "Eye hath not seen, nor ear heard, neither have entered into the heart of man, the things which God hath prepared for them that love him." Shakespeare has Nick Bottom, the Warwickshire weaver, fondle his born-again ears, no longer those of a fantastical ass, trying to make sense of a midsummer night's dream from which he has emerged as a man, not a beast. The peasant reverses

Gospel: "The eye of man hath not heard, the ear of man hath not seen, man's hand is not able to taste, his tongue to conceive, nor his heart to report, what my dream was."

Balanchine was sometimes amused to contrast notions of good and bad, virtue and vice, grace and sin, distinguishing between his Eastern and our Western orthodoxies. Byzantine icons glossing Holy Script, the mural masters of Hagia Sophia (Holy Wisdom, not St. Sophia), Hosios Lukas (St. Luke in Phocis), and El Greco's Cretan teachers all depict Lucifer—Son of the Morning, Fire-Bringer, soul of free choice and ultimate possibility—not as a fiend but as an angel. In the West, personifications of d'Evil, Father of Lies, Lord of the Flies, Old Nick, Auld Reekie, Foul Fiend, Satan (Shaitan), looked bad and smelled worse. From pre-Christian to late medieval models, devils were imagined as rough humanoid bipeds bestially deformed, horned, with goat's shanks, cloven hooves, spiked tails, and hairy anuses that witches kissed. In contrast, Greek Orthodoxy's knowledge and fear of hell does not argue the simple matter of right and white against black and wrong. So crass an opposition, so low a common denominator, is not existentially exclusive. It is not the deformation or denial of grace that must be considered but the recognition of an equation of right *and* wrong. This is not "either/or," an unenforceable law, but "both/and," a realistic choice. Suffering—education by the consciousness of permanent evil, and of those powers that educate one beyond the capacity of mere self—in the cosmos as in heaven frees the angelic choir.

The Byzantine Lucifer, Prince of Darkness, was to be seen in his glorious mystical uniform identical with his perfect sinless siblings, Gabriel, Michael, Raphael, Uriel, but with one drastic difference. All these last displayed lustrous peacock wings, were robed in gold, haloed in jewels. Fair-haired, brightly complected, the lot. But the hands, face, and feet of the Evil One were black. Transparency blessed the good angels; opacity cursed the bad. All but Satan were clear as crystal. Denied by density, impervious to light, he was deprived of the sun of Godhead. His was permanent denial, negation of Source, of the Logos. Willful incapacity to admit the difference between light and darkness, obsessive preference for personal difference in self-serving isolation, proclaimed the triumph of the self. This dark angel and his myriad progeny set themselves against the Father and his apostolic succession,

removed from any de-selfed communion and, ultimately, in their selfishness, from fruitful service to their fellow men. This angel of night and darkness could not be penetrated by the mercy of grace. But black as he might be, he was still an angel. Today he might stand for the romantically rebellious solipsist, the unreckoning challenger of historicity, prince and demon of every narcissist aesthete, patron of self-devoted artists wherever they flourish.

IV

When Balanchine spoke of angels, as he often did, and of his dancers as angels, he intended confidence in an angelic system that governed the deployment of a *corps de ballet*. As was common gossip, he imagined at one time that in this mortal dispensation, he had actually "married an angel in the flesh" and had set dances on this third consort. All through his long life, he contrived to encounter these supernal beings or, rather, their corporal embodiments, whose habitual flights he made soar into steps less ordinary than heavenly.

Angels were enlisted in a category that commonly registers demons. Intermediate between gods and mortals, they could be hostile or compassionate. There were Egyptian, Assyrian, and Hebrew winged figures long before Christian eras, personifying and revealing multiple aspects of the divine cosmos. Air, wind, thunder, and lightning proclaimed their power. Gentle breezes and stupendous cyclones were their fingers. Hosts of angels chanted music of the spheres. Good and bad angels were protectors, guides, tempters, and betrayers of babes born sinless, but each with a God-granted choice. And there were dangers for the over-innocent in undue emphasis on their assigned dominion.

"Angel" in Hebrew or Greek means "messenger," one sent, and not necessarily with good tidings. In Christian theology, East or West, angels apply to priests, prophets, and messiahs dispatched by the Godhead. They are spiritual essences "created by God before the heavens and all material things." Black angels fell to devildom, since they were made free to indulge in "desire of absolute dominion over created things, in hatred of any rivalry or subjection." Their sin and our curse is not simple vanity but blind pride; in modern dance, this is an incapacity to learn or accept what tradition teaches, the amateur's

boastful proposing of an alternate language that its self delimits, a personal idiom legible for no longer than its inventor's existence.

In the Revelation of St. John the Divine, it is written that he prostrated himself before an angel who'd been sent to humble him. John's automatic reverence showed mindless dependence and lazy irresponsibility. The angel bid him rise: "Seest thou do it not, for I am also thy fellow-servant . . . Adore not me, but God." Balanchine believed that he, as well as his dancers, were in constant service—not to any individual ambition, but to the principle of a general humane alliance and need. He had his demonic advisors who helped him in his service of propelling bipeds forward across the stage floors of the world in a shared conquest of earth and air. In this process, often accompanied by "heavenly" music, dancers appear as messengers of fair weather, occasional safeguards from streets outside swarming with chaos, anarchy, and despair.

V

Balanchine's method of instruction was twofold. First came daily class for his company. This might be called "practice," but in reality it was incessant reiteration towards technical refinement. In this endless process, mind and matter were anatomized. He might allow, in tones of cool disparagement, that the only thing students could learn in seven years of academic training was to recognize the difference between correctness of execution and the intensity achieved by stage performance. The scale of the school's annual workshop demonstration—a program rehearsed during the entire school year in preparation for three open viewings—which marks the advance of students from a lower to a higher division, was tiny, compared to the stress and pressure of working in the company's huge repertory, on a big stage, before a critical public.

Promising aspirants who are marked for eventual soloist standing often disappoint teachers, parents, and, worst of all, themselves. Cute kittens turn into scraggly cats. Children of promise—who had been cushioned by strict repetition under secure conditions, daily, monthly, yearly—when released to the vulnerability of fuller responsibility, may collapse or, more trying, hit a median level of blocked progress with little hope of more capacity. They fade into a dim if useful support,

a modest service, in which a passive or resentful handful may find some satisfaction. The life and schooling of professional dancers have their negative aspects; these Balanchine never concealed. He realized that as much as half the force and efficiency of a supporting corps is fueled as much by resentment as by ambition. Fury at failure to advance or achieve a desired status is not negligible as a source of negative energy. Balanchine calibrated dancers also for their spirit. Some of the lower order of angels are able to accommodate themselves to their assigned rank; some abdicate while still able to perform; others abandon hope at some crisis in a dubious career. Balanchine could be polite enough; he seldom wasted optimal opinion. "Damn braces," said Blake. "Bless relaxes." Willfulness is the curse of children set on stardom.

Modern and now post-modern dancers convince themselves and their annotators that minimal motion is as interesting to watch as to perform, at least to cult or coterie audiences in minimal spaces, clubs for companionship rather than frames for absolute skill. Minimal movement exploits a token idiom of natural motion: walk, turn, hop, run. Also, there is free-fall to the floor plus rolling and writhing. But angels don't jerk or twitch, except as irony or accent: they seem to swim or fly. The domain of ballet dancers is not earth but air. Long, strenuous preparation aims to allow them to defy the pull of floors, releases them from gravity towards the apparently impossible. Academic dancers are trained to leap, as well as to appear to leap, as high as Olympic record breakers. Theirs is an academy of physical, visible magic. Acrobatics are supranormal or maximal. Acrobats are not walkers, joggers, hoppers, or bores. Their effects are not minimal but angelic.

Angels are androgyne, lacking heavy bosoms and buttocks. Portraits of angels in mural or mosaic have slight physiognomical distinction one from another. There is a blessed lack of "personality" in their stance against the skies. But this aerial or ethereal positioning grants them a special grace or magic in accepted service. Ballerinas are kin to those mythic Amazons who sliced off a breast to shoot arrows the more efficiently. The criterion of professional owns not only a particular psychic tempering but also peculiar anatomical configuration. Balanchine's standard controlled his company. The few deliberately outstanding exceptions in height or style proved his general

rule. His corps was and is a band of brothers and sisters; maybe it is no accident that it contains so many twins and siblings. He would say, of those he could or would not accept, "She (or he) doesn't *look* like a dancer."

Those candidates who anatomically and temperamentally possessed the qualities that Balanchine required were ordained by methods that dissidents found demeaning or deforming. These methods could be taken as frustrating adolescents at the very moment of their incipient expansion. But liberal educators seldom realize that "success" or "happiness" lies neither in self-satisfaction, in self-indulgence, nor in that unfocused hedonism which too many young people believe is their franchise, obligation, and destiny. Their precious "personalities" are but a bundle of chance preferences, since as yet they have had only the opportunity, but hardly the ability, to analyze received data, *to think*.

The ballet dancer's mode of existence may seem to outsiders as circumscribed as that of convent or cloister. More than accepting rude discipline, professionals must endure not only unappeasable mental anxiety like everyone else but also, from their bodies, brittleness, strain, and fatigue. The hazards of a snapped Achilles tendon, bad sprains, slipped disks, the anguish and boredom of measureless recuperation, the slow and dubious resumption of practice and performances—these are taxes every good dancer must pay. In this process, by the conscious use and comprehension of suffering, the dancer begins to perceive the essence of the Nature of Existence, of Being, of serving one's art and craft, of one's true nature and destiny. It is a stringent education, but when we see a great dancer onstage, performing with full power, we are inspecting a very developed human being, one who knows more about self than any psychiatrist can suggest. Seamless luck in avoiding injury doesn't exist here any more than in any of the games for which people applaud winners.

Many modern therapies, with current spiritual scenarios, preach condign avoidance of suffering as if it were anathema, the unearned deserts of mindless fate. Mrs. Eddy's Christian Science swears that the existence of suffering is purely imaginary. Placebos for extenuation or avoidance come a dime a dozen, or as bargains for a fifty-minute hour. Since suffering is indeed real and unavoidable, analysts, lay or legitimate, proffer their mesmeric recipes, which have become pandemic

since Freud met Charcot. Balanchine offered no cure but work, in which the self-wounded artist could best cure self. His requirements were really extreme, corresponding to real extremity.

<div align="center">V I</div>

Three musicians whom Balanchine most preferred as partners were, in the familiar sense, profoundly "religious." Each was a communicant Christian according to the frame of his historical perspective. The fabric of their imaginative process was coined from Christian Gospel. The opening *Preghiera* in *Mozartiana*, Tchaikovsky's homage to a predecessor, danced with such total consecration by Suzanne Farrell, is a rescript of Mozart's *Ave Verum Corpus* ("Hail the True Body of Our Lord"). It was Mozart's own *Requiem Mass* which the ballet master ordered for his memorial.

When the Tchaikovsky Festival of 1981 closed with a setting of the fourth movement (*Adagio Lamentoso*) of his Sixth Symphony, the *Pathétique*, which contains a quotation from the Orthodox Service for the Dead, Balanchine made a flock of a dozen angels, their tall, gilt wings, stiff as in an icon, flow onstage. They stood immobile, witnesses giving testimony to a martyrdom. A cruciform composition of prostrate, despairing monks made a great Cross, centering the scene with the breathing metaphor of a magnificent artist's trial and judgment. Condemned by a hypocritical society and its legal cabal, Tchaikovsky, self-slain, had taken his poisoned chalice. At the end of the ballet, a small boy in a white shift, bearing a single lit taper, drew a wide world into the dancers' concentrated space. When he blew the tiny flame out, the real presence of evil burned black. Absolute silence after the curtain fell was instinctive recognition more stunning in its delayed and silent shock than thousands of applauding hands.

For the climactic finale of the Stravinsky Festival of 1972, there was no choice but to crown it with his *Symphony of Psalms*, a sole, appropriate *amen*. But unlike some younger, less aware choreographers, Balanchine was not quick to compete with the choir. Instead, his dancers, in ordinary practice dress, sat at ease on the stage floor, in eager attention, framing the musicians. Now they were "hearing," not "dancing." There was no waste or excess in adorning or "inter-

preting" sonorities which commanded their unique autonomy. This
ballet master knew there is music superior to any visual gloss.

It is often reiterated that Balanchine was an "inspired" maker. He
was indeed infinitely capable of drawing from the traditional lexicon
of steps, as if he breathed or derived from it a fresh range of motion.
It is difficult for many to comprehend the extraordinary richness of
discrete steps in their academic configuration which make up the idiom
which he handled, but the easiest comparison is a parallel in musical
notation, its keys and combinations. Often, a surprising or abrupt
sequence of steps infused his dancers' bodies easily and inevitably as
a refreshment of systole and diastole. This exceptional talent was com-
monly recognized as "God-given," but since the deity granting it was
seldom acknowledged, it was rarely admitted that the artist inspired
thought he owed something to his Creator.

Balanchine reported to W. McNeil Lowry that on his appoint-
ment as the last ballet master to Diaghilev, at the age of twenty, he
was brought to Florence in order to learn to look at pictures. In Russia
there had been little time or opportunity for such instruction. Lowry's
tape recording reads:

I couldn't understand why it [painting] was good at first, but he [Diaghilev]
told me: "Now you stare for hours; we're going to have lunch and when we
come back you'll still be there," in some chapel where Perugino was. So I
stared and stared and stared, and they came back and I said: "No. I don't
know what's good about it." Later on, I went myself a hundred times. Then
I realized how beautiful it is: the sky so pale blue and the way the faces . . .

And from then on I somehow started to see Raphael and how beautiful
it is and then I found Mantegna and then Caravaggio and finally I realized
how beautiful is Piero della Francesca. Also I was probably a lot influenced
by the Church, or *our* [Orthodox] Church, the enormous cathedrals, and by
our clergy, the way they were dressed, you know; and they also have a black
clergy, those important ones that become patriarchs [archimandrites] and wear
black . . .

So that also to me was God. Not that it's "God Invisible." I don't know
what that is. God is this wonderful dress you see. Even now, always, I have
to say I couldn't just think of God in some abstract way, to connect with
Him just by spirit, by mind. You have to be really mystic to sit down and
meditate, to worm down in yourself. But I can't do that. As they say, my

work is with what I see, with moving, with making ballets. So too with God—He is real, before me. Through Christ I know how God looks, I know His face, I know His beard, and I know how He'll talk, and I know that in the end we'll go to God. You see, that's how I believe, and I believe so fantastic.

Name it *God* or *Order*, what conspired to "inspire" Balanchine to construct stage movement, as well as what moves his inheritors, is neither capricious improvisation nor waste motion. It derives from an energetic source that permits it to fulfill circumscribed stage space for more than one "inspired" occasion. He made dance works strong enough to bear repetition, and by performers other than their own inspirers. His inestimable service was an ordering of active behavior as a reflection of overall orderliness, as well as its negative aspect in dislocation and disorder. There are his caustic violations of the traditional canon—inverted feet, angular arms, jagged fingers, "ungraceful" torsion, "ugly" attitudes. His was and is a constant demonstration of outrageous liberties in choice within the large, encompassing lectionary from which he had the wit and skill to draw.

Even today, we have no more viable a word for "divinity" than its opposite in "anarchy" or the eschatological "absurd." Balanchine's catalogue is a book of orderly rites, psalms, hymns. These were confidently conceived and constructed by and to order. Many were produced in answer to current, pressing needs. Mandatory was his supply of "opening," "middle," and "closing" ballets. Rousing applause machines were not to be wasted by being set first on a program; they were to be saved for a culminating finale. Different works, after their introduction, could in time be shifted about; the placement was frequently determined by requirements in setting up complicated scenery, so that intermissions might not seem too long.

Season after season, works were on order, like fresh skirts, shirts, ties, and trousers, to tempt the new, while satisfying old, subscribers, to ensure in advance fiscal security and practical continuity. Ballets were often brought into being by response to immediate popular taste or fashion, with various results as to box-office success or lasting acceptance. A rule of thumb indicated one out of three might remain in the repertory after three seasons; some, failing at first, had more luck in revival. Like seeds of the dandelion, many must be blown

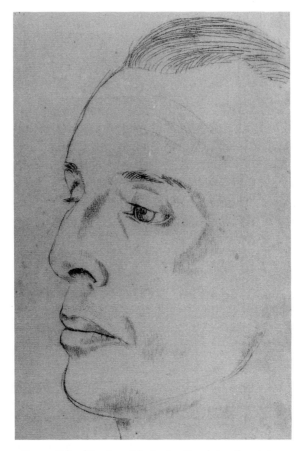

George Balanchine *(1950) by Lucian Freud; pencil on paper*

about to assure a central harvest. It was not only the challenge or curiosity in innovation, or even in the commissioning or resuscitation of powerful or surprising composers: Ives, Webern, Sousa, Hindemith, Gershwin. Balanchine set *"sur mesure et par commande,"* like a master cabinetmaker, tailor, or cook.

　　Although he could recognize his own sins down to their least fraction, he rarely complained of subjective blockage or restraint in energy due to personal dismay or private pain. There were never any arguments over contracts; with his own succession of companies there was hardly even a verbal agreement. Confidence was mutual, confirmed by silence on irrelevant legalities. There were few complaints about funding withheld, few interviews granted to "explain" or justify

his intentions. He made no protests, sent no corrections to critics, staged no tantrum exits. When he quit the Metropolitan Opera, in which his company survived three trying years, it was done over-night, with small explanation. But when he discovered that the or-chestra pit at the New York State Theater in Lincoln Center, ostensibly designed for him, could contain enough musicians of service only to Broadway, he called in jackhammers to carve out a decent space. When he refused to dance in Washington's Kennedy Center for three seasons due to the wretched stage floor, it was eventually repaired.

Picturesque, romantic, marketable narcissism, the whole dead mirror of the manipulative persona, was an identifiable enemy, pet-rified in the star system, the promotion of flashy performers for richer returns to agents and impresarios. Early on, he had estimated the value of critical reportage of dance events. Working journalists pressed by loose thought or the need to put their papers to bed were rarely as assiduous in their observation as sports or science writers. In his early career he had been reviled by the leading critic of Paris for the insolence and degeneracy noted in his choreography for Stravinsky's *Apollon Musagète*, the music of which was equally condemned. Over the years journalists managed to propose both "the Balanchine dancer" and "the Balanchine ballet" without much analysis of the diversity in the choice of his dancers or in the variety of what they danced.

Along with translations of Shakespeare, Dante, Goethe, and Schiller, Pushkin was learned by heart in the Tsar's dancing school, following whole chapters from New and Old Testaments. In 1950, when Balanchine revived *The Prodigal Son*, his last ballet surviving from the Diaghilev repertory (save *Apollon*), produced originally with Prokofiev and Rouault, Wystan Auden was taken backstage at the old City Center of Music and Drama on West Fifty-fifth Street. The poet spoke as a devoted biblical student and professional man of theatre. In the ballet's last scene, the austere father figure, recalling Jehovah as imagined by William Blake, stood stock-still, unbending, impassive. His wayward son, now abject in shame, traversed the wide stage floor on his knees. Dancers who assumed the role padded their knees against splinters. Auden complained that the Father should not have remained rigid but, with Christian compassion, might have advanced at least a step, in some sign of pardon. Auden might have quoted Luke:

I will arise and go to my father, and will say unto him, Father, I have sinned against heaven, and before thee, and am no more worthy to be called thy son: make me as one of thy hired servants. And he arose, and came to his father. But when he was yet a great way off, his father saw him, and had compassion, and ran, and fell on his neck, and kissed him.

The choreographer disagreed. He made his own point, altering Scripture for his own didactic purposes. Christ, first of all, was a Jew, raised on the Pentateuch, which included Deuteronomy and Leviticus. The parable embodied an older Testament's tribal ethic. To be sure, the penitent sinner would be ultimately forgiven; and in the staging the boy climbs up into the father's strong arms. A cape covers the boy's shame, making his vulnerability dramatically clear. And Balanchine slyly justified his tampering with the text. Was not the generous gesture an early patristic interpolation, sweetening the rabbinical rigor in favor of propaganda for the new faith?

What was inferred was an indication of Balanchine's metaphysic. Only through acceptance, realization, and use of the responsible self, even though it might mean a denial of mercy or support, can vain, energetic youth be brought to Abraham's bosom. An Anglican poet spoke by a new, but a Russian Orthodox by an older, wisdom. This was hardly an eye for an eye, a tooth for a tooth, but as ballet master, Balanchine seldom shirked diagnosis. Unaccompanied by any drastic final judgment, his close inspection was, in its immediacy, severe. Only those in whom he had no interest or expectation failed to feel his scalpel.

In promoting dancers from the rank of *corps* member to soloist or principal, sometimes he seemed slow to act. In an elite world of acrobatic virtuosity, pure justice is accompanied by few explanations and no apologies. Following Ring Lardner's omnivorous advice, the choreographer's message often reduced itself to " 'Shut up,' he explained." In the end, there was no mitigation and not much further recourse. Sometimes there were wordless estimations, accompanied by an unmistakable facial or physical expression, which were his analyses of all the factors: corporal, psychological, moral. While he could cherish Suzanne Farrell as "my Stradivarius," such breezy, wholesale, entire-encompassing tolerance was in fact a brutal, unsentimental computerization.

In this conservatively economical survey he remembered the general self-indulgence, lethargy, and irresponsibility which are the inalienable rights of American parents and their spoiled progeny. When one mother asked him, in the tones of a Roman matron, "What are you going to do for my noble boy?" (one already half-castrated), Balanchine answered: "Nothing. Perhaps, only perhaps, he can do some little thing for himself." In morning class, a brilliantly promising male of seventeen, on the verge of entering the company, bit his lip savagely, in evident disgust or despair at his inability to make his muscles obey what his will demanded. His grimace of self-contempt seemed excessive. Temporary failure was inconvenience, not tragedy. Instead of reassurance, Balanchine snapped at the boy: "It's you who chose to be a dancer. I didn't choose for you."

As professor of a highly inflected language, dependent on a pyramidal structure of physical exercises resulting in the subtlest visual refinement, his precise teaching derived from illustration, not with words, but with his own body's continual demonstration. Some of his students would doubt that Balanchine had ever been much of a brilliant performer himself. They spoke of his early tuberculosis and lack of a lung, the time and energy required to compose his constant inventions. He stopped dancing in the early thirties, but photographs from the twenties show him not only as Kastchei, the demon-wizard of *Firebird*, and the Old Showman in *Petrouchka*, but as the Spirit in *Le Spectre de la Rose* and Prince Charming in *Aurora's Wedding* (in which role Diaghilev would never have let him appear, since he would have followed Pierre Vladimiroff, of the great 1921 revival).

Anyone who watched Balanchine give class, whatever his lost physical efficiency may have been in the early eighties, knew they were seeing a kind of analyzed legible movement, as if it were cast in bronze or cut in marble. He had contempt for those retired dancers who taught complacently, even seated in class, with no real talent for the transmission of their language, whatever their past fame in performance, or for those who perfunctorily, dramatizing their own particular style, "talked a good class," showing hungry students what they wished to be told. Speed in footwork, his famous "elephant-trunk" metaphor for *pointe* (supple but strong), steel clarity of profile, perfect balance in partnering, the consideration needed to support another's weight in motion, don't come easily or quickly.

Yet he could, with no trouble, forgive a kind of behavior, apparently disorderly, which hid hints of latent energy. This might well indicate a commitment to the profession stronger than the ordinary. There could be abrupt seizures of demonic hysteria, masking nervous insecurity or fear of failure, actually only symptoms of excess energy. One promising girl, midway in school, in a fit of resentful frustration tossed off all her clothes to parade in the corridor. Of course, she got herself suspended for that term. What else could one do? On the other hand, Balanchine was delighted, since he saw she had the temperament of a first dancer, which she shortly became. Ah, but what if everyone behaved like that? No danger.

And his consistency was inconsistence. In his company there would always be use for those dancers who defied familiar facile formulae that less masterful directors might find basic requirements. Some might, at best, be thought of as mascots or pets; but rather, they were more like exotic flavorings—peppercorns, odd mustards, horseradish, marjoram, pistachio—flavorings that dressed his salad bowls. His choices could seem flagrant eccentricity, the flouting of his own declared criteria. But these were decisions based on long experience in which few others were able to share, and from which there was no recourse.

### VII

In Moscow, between October 16 and 22, 1972, Balanchine was interviewed by "Nedelia," the weekly "cultural" supplement of the newspaper *Izvestia*. Headed "A Conversational Pas de Trois," the interview comprised Balanchine, the choreographer Jerome Robbins, and Yuri Grigorovich, chief ballet master of the Bolshoi Ballet Company since 1964, who was considered a relatively progressive artist. It was the New York City Ballet's second tour of the Soviet Union; Balanchine was now more or less accepted as a returned prodigal son, native, however errant. Grigorovich expressed admiration for the technical or, more honestly, the mechanical virtues of *Concerto Barocco* and Bizet's *Symphony in C*, while regretting the American disdain of narrative mimicry, scenic investiture, the full panoply of ballet tradition in opera houses. To him, and indeed to many of his French and English counterparts, Balanchine seemed puritanical, by rather per-

versely wasting so much in the famous troika of dance, decor, and music, summarily suspending them—and by working in so affluent a nation as the United States. Balanchine consistently reaffirmed the capital autonomy of dance *steps*, the stuff of choreography. The laureate of the Lenin Prize responded:

GRIGOROVICH: Since we are speaking of some kind of affirmation, I affirm the art of representation in its most spectacular brilliance of which theatre is capable. I don't know to what point, personally, I am successful, but I affirm ballet as a great theatrical art, with a complex and active dramatic content, expressed in dance by the accompaniment of painting helping to express this by scenery, with especially commissioned music, and of course with the pantomime of actor-dancers. It is possible to stage a ballet without scenery or costumes by dressing dancers merely in practice clothes, but why limit yourself? It is bad, naturally, if all these theatrical components do not help in expressing the idea which inspires you. But if they do, is it not splendid?
BALANCHINE: What do I affirm or reject? I reject nothing. Why should I? I am not affirming anything either.
"NEDELIA": But you do express yourself?
BALANCHINE: I am not doing anything in particular. I simply dance. Why must everything be defined by words? When you place flowers on a table, are you affirming or denying or disproving anything? You like flowers because they are beautiful. Well, I like flowers, too. I plant them without considering them articulately. I don't have a "logical" mind, just three-dimensional plasticity. I am no physicist, no mathematician, no botanist. I know nothing about anything. I just see and hear.
GRIGOROVICH: A flower *is* beautiful. But it is Nature, not Art. A flower affirms nothing, but the man who plants it affirms both the flower and its beauty. And how about Japanese flower arrangement? Is this not Art?
BALANCHINE: Of course I have a logic. But it is the logic of movement. Something is joined together, something else discarded. I am not trying to prove anything. That is, trying to prove something quite other than the fact of dancing. I only wish to prove the dance by dancing. I want to say: "If you should happen to like it, here they are: dancers dancing. They dance for the pleasure of it, because they wish to." Don't other people dance? All of Georgia [his ancestral home] dances! And these people dance for delight without hoping or wishing to prove anything.
GRIGOROVICH: But there is a difference between "just dancing" and ballet.

Folk and social dancing are primarily for oneself. Ballet is dancing for an audience. Dancing just for fun is an emotion, whereas ballet is an art which transforms emotion into thought and unites them.

BALANCHINE: I believe in the dance as an independent category, as something that really exists in itself and by itself. However, this may be an unreal or inaccurate metaphysical category, something immaterial, perhaps indefinable.

"NEDELIA": But you said yourself [at the start of the interview] that your ballets were not "abstractions," that live people performed them . . .

BALANCHINE: Yes. They convey the sense of the dance to the spectator, but the dance also exists without spectators!

GRIGOROVICH: Pray, in what form?

BALANCHINE: In the form in which it comes to me; in the form in which I set it out.

VIII

The magnificent pictorial tradition of Byzantine-Slavic Orthodoxy is rich in its strongly mysterious treasury of sacred imagery, in mural painting and portable panels. Not long ago, when these votive works began to be collected in the West, at least with examples on a less-than-monumental scale, icons were estimated as hardly more than native artifacts, naïve "folk art." Similarly, African fetish objects and ritual masks, called into being for purely religious use, were set down as evidence of "primitive" superstition, although prized for plastic or aesthetic qualities. Although African, Oceanic, and pre-Columbian art are now widely admired and expensively mounted, hardly a Western museum hangs important images by Greek, Russian, Serbian, or Cretan painters in the line of Andrei Rublev or the School of Vladimir-Suzdal. However, some scholars of broad curiosity are not slow to place such panels alongside the finest temperas of the early Tuscans and Umbrians. We often ignore the fact that these artists were working in the same belief as Giotto, Masaccio, and Fra Angelico.

The anonymous spirit and service of subsequent icon painters required that any individual or idiosyncratic expression of image or idea must be held to a minimum, towards greater emphasis on the glory of God. The Fathers of Byzantine Orthodoxy, defending their art against iconoclast puritans, swore: "We do *not* worship icons; we

know that the veneration accorded the image ascends to the Prototype." It was not the stuff crafted, painted, gilded, armored in precious metals with such devotion which was adored, but rather the incarnate Idea.

Balanchine's ballets can be read as icons for the laity, should we grant dancers attributes of earthly angels. These have sworn to disavow hedonism in a calling which demands transcendence of worldliness and possessiveness, an abjuration and abandonment of elementary self-indulgence. We can even discover in their aura an animal innocence as one aspect of the Lamb of God which takes away the sins of this world, for they sacrifice much enjoyment in ordinary fun and games of their fellows. They are schooled to serve paradigms of order—at least for the temporal duration of their performing—which, if well done, seem momentarily to give their audience something approaching "peace of mind."

Over the last half century, perhaps for the first time since Euripides, theatres, even more than museums of precious artifacts, have taken the place of temples. Ballet, opera, the classic dramatic repertory offer secular rites in which a communion exists between lay hierophants and a congregated public. There is also a vital distinction in the architectural planning of places of worship, West and East. Roman cathedrals descended from basilican law courts of the late Empire. The altar, focus of faith, was always in view. In Eastern Orthodoxy, the icon screen separates the Holy of Holies from the people, who are not seated in pews but always stand. The officiating priest passes in and out of the sacred golden portals, disappearing and reappearing, a sign of that intermittent mystery which clouds any absolute or final answer. We are led to take much faith as fact. More is withheld in our incapacity to encompass a totality of reality.

Our modern theatre assumes the frame for an atmosphere of ritual. We sit in big multibalconied rooms, brightly lit, in expectation of magic. Lights dim in the auditorium and flare in footlights. Silence, then the breath of strings, woodwinds, brass. A curtain rises, launching a celebration. If the measures are properly performed with force and dignity, which is their due, a shard of general order is revealed. A charge of electrified sympathy suffuses a public which becomes less passive. Released applause at the end signals the sight and sound of an angelic order. What has been seen and absorbed is commonly agreed to have been of the "Divine."

# III

# PHOTOGRAPHY AND PAINTING

# Photographs of America:
# Walker Evans

[*Lincoln Kirstein has had a complex relationship with photography, in part perhaps as a result of inherited attitudes. (George Eastman suggested a partnership with Kirstein's father, Louis, but was turned down because Mr. Kirstein saw no future for the cheap camera.) His son has called the medium "a graphic subspecies, like lithography, postcards, or postage-stamps," but he has also been a enthusiastic analyst of the works of individual photographers. Kirstein met Walker Evans in the late twenties while he was at Harvard, and quickly published Evans's studies of nineteenth-century Boston houses in* Hound & Horn. *In 1938 he helped to arrange for the first large exhibition of Evans's photographs to be held at the Museum of Modern Art in New York. This is the Introduction to the catalogue,* Walker Evans: American Photographs *(New York: Museum of Modern Art, 1938).*]

E V E R  S I N C E the practice of photography was invented over a century ago, there has been the question of whether the camera is a technical means or an artistic end in itself. Although fairly early in its history what was at first a labor-saving aid to pictorial reproduction acquired the prestige of an exploitable fine art, the inventors of the process were less pretentious for it than their modern heirs. The artist-photographer, in spite of the development of such amenities as the daguerreotype parlor and the photographic atelier, was not seriously considered the peer of professional painters. Brush, paint, and palette can scarcely be considered a machine—the camera can never have been thought of as anything else.

By 1900, however, mainly through the development of advertising as a "fine" art, the photographer had been forced into a position in which his work was presented—in approach, potentialities, and achievement—as the equal and even the superior of the painter's, to be criticized on the same philosophical basis.

A superficial ease of operation has rendered the camera the dilettante's delight. It is both simpler and cleaner to make bad photographs than it is to make bad paintings. It is not, probably, as difficult to make a good photograph as to paint a good picture. If it were, manufacturers of paints and brushes would be far richer today than the great film and camera monopolies. Sighting familiar objects, scenes, friends, or fun through a little window and clicking a small key are obviously child's play, and the ensuing childish results offer the vastest possibilities for innocent amusement and practical exploitation by advertisers, camera clubs, photographic yearbooks, salons, and prizes.

We need not berate a harmless pastime. But thanks to clever mercantile calculation, anyone using a camera seemed almost to have an inside right to be included in the general fraternity of the graphic artist, for the amateur photographer differs in class but not in kind from the artist-photographer, and he in turn—and not by any means in the field of portraiture alone—approaches the professional painter.

## Early Masters of Photography

Although the camera is a machine and photography a science, a large element of human judgment comes into the process, amounting to creative selection. For lack of a better term we can call this the photographer's eye, his personal vision or unique attitude. The attitude of the early photographic master was a simple but overwhelming interest in the *object* which was set before his machine. His single task was to render the object, face, group, house, or battlefield airlessly clear in the isolation of its accidental circumstances, to record the presence of every fact gathered within the net of rays focused on his lens, to create out of a fragmentary moment its own permanence. The human personality, the incidental individual comment of the photographer, was ignored. His fingerprints were not on the plate or his signature on the print. He was an artisan as anonymous as an Egyptian or Roman portraitist whose work, but not whose name or life, is forever

remembered. In this spirit, photographs were taken which come close to great art on any critical basis. The faces of Bernhardt and Baudelaire, Carlyle and Helmholtz, Abraham Lincoln and Walt Whitman are ours by virtue of the selfless eye of Nadar, Cameron, Hill, Brady, and the nameless artists of their kind. Provincial photographers imitating Continental ateliers abroad and Sarony on lower Fifth Avenue have preserved for us the frank aspect of the men that dominated the age they worked in. These photographers were not much concerned with their theoretical right to claim the prestige of an artist. For them photography was an end in itself whether or not it was a subservient method of isolating the facets of facts or human faces.

Manual dexterity in using a mechanical device from which it is not supremely difficult to obtain an apparent result, coupled with a little nervous energy and some visual memory, produced numerous confusions. The photographers posed models disguised as Van Dyck or Whistler models and fuzzed their focus soft. Or they created with new and original costumings their own new "compositions" for the annual salons. To parallel this corruption, the salon painter, whose sole problem was rendering naturally any image with which his un-imaginative retina was confronted, embraced the camera as an ulti-mate solution. In the swampy margins of the half-arts, the wallowing of painter-photographer and photographer-painter has spawned prob-ably the most odious and humorous objects in the lexicon of our disdain.

As far as photographic technique goes, it is well known that little has been done to excel the work of the first masters of the science, although through constantly improved equipment the range of me-chanical achievement has enormously widened. (This is not true of painting, where methods and materials become yearly more compa-rable to those of the trecento.) In our time, due probably to the search for novelty and a striking approach, the idea of photographing an object has been frequently replaced, at least by the self-styled artist-photographer, with the capturing of indiscriminate surfaces, textures, patterns, and promiscuous abstract or concrete objects. Such photo-graphs only testify to the virtuosity of the camera and have no inde-pendent value either as decoration or as artistic document. They were and are, when they are other than aids to merchandising, semi-official records of competitive manual eyesight.

Always, however, certain photographers with a creative attitude and a clean eye have continued to catalogue the facts of their epoch. Atget is surely the complement of Proust; Brady of Stephen Crane. A large quality of eye and a grand openness of vision are the only signature of great photography and make much of it seem, whatever its date or authorship, the work of the same man done at the same time, or even, perhaps, the creation of the unaided machine.

## The Candid Camera

Recently we have not been greatly troubled by the old-fashioned "artistic" soft-focus photographer. We all agreed to laugh him out of the magazines and exhibitions ten years ago. But new kinds of eye corruptors have arrived. These are not the facile and legitimate photographers of fashions and commodities who have replaced the commercial draftsmen, the technically able workmen who suavely define the ultimate in desirability of chic or convenience. The new confusers are the candid-camera men.

The candid camera is the greatest liar in the photographic family, shaming the patient hand retoucher as an innocent fibber. The candid camera, with its great pretensions to accuracy, its promise of sensational truth, its visions of clipped disaster, presents an inversion of truth, a kind of accidental revelation which does far more to hide the real fact of what is going on than to explode it. It is a good deal easier to look at a picture than to read a paragraph. The American reading public is fast becoming not even a looking public but a glancing or glimpsing public. The candid camera makes up in quantitative shock what it lacks in real testimony. It drugs the eye into believing it has witnessed a significant fact when it has only caught a flicker not clear enough to indicate a *psychological* image, however solid the material one. No one would suffer for a second the slipshod and ill-defined approach of the candid camera if it were transferred to the newsreels. But newsreel camera men are not stamp collectors of unrelated moments. They are sound and usually brilliant technical documentors.

The candid technique has little candor. It sensationalizes movement, distorts gesture, and caricatures emotion. Its only inherent characteristic is the accidental shock that obliterates the essential nature of the event it pretends to discover. It is anarchic, naïve, and superficial.

Eventually it will sober down, forced by the ultimate boredom of a sight-sated public into principles closer to the permanent standards of good photography.

## The Uses of Photography Today

And good photography has an enormous field today. The use of the visual arts to show us our own moral and economic situation has almost completely fallen into the hands of the photographer. After the explosion of Cubism and the breakdown of the School of Paris, with the initiation of our own mural movement our painters have actually gone to the photographers, rather than to other painters or nature, for inspiration. The method of the lens, the availability of classified photographic files have eliminated the necessity of much preliminary sketching and study. Experiments in photographic montage, in the juxtaposition of images, in the play of aerial perspective have unquestionably affected many painters, notably among them Picasso, de Chirico, Dalí, Tchelitchev, and Ben Shahn.

This, however, although it has been one of numerous honest services, does not imply a relegation of the photographer to the painter's use. The real photographer's other services, services which take the greatest advantage of his particular medium and invoke its most powerful effect, are social. The facts of our homes and times, shown surgically, without the intrusion of the poet's or painter's comment or necessary distortion, are the unique contemporary field of the photographer, whether in static print or moving film. It is for him to fix and to show the whole aspect of our society, the sober portrait of its stratifications, their backgrounds and embattled contrasts. It is the camera that today reveals our disasters and our claims to divinity, doing what painting and poetry used to do and, we can only hope, will do again.

## Walker Evans

The photographic eye of Walker Evans represents much that is best in photography's past and in its American present. His eye can be called, with that of his young French colleague Cartier-Bresson, anti-graphic, or at least anti-art-photographic. Photography in itself prob-

ably does not interest him: you do not think of him as a photographer first of all. When you see certain sights, certain relics of American civilization past or present, in the countryside or on a city street, you feel they call for his camera, since he has already uniquely recorded their cognates or parallels. Physically the pictures in this book exist as separate prints. They lack the surface, obvious continuity of the moving picture, which by its physical nature compels the observer to perceive a series of images as parts of a whole. But these photographs, of necessity seen singly, are not conceived as isolated pictures made by the camera turned indiscriminately here or there. In intention and in effect they exist as a collection of statements deriving from and presenting a consistent attitude. Looked at in sequence they are overwhelming in their exhaustiveness of detail, their poetry of contrast, and, for those who wish to see it, their moral implication. Walker Evans is giving us the contemporary civilization of Eastern America and its dependencies as Atget gave us Paris before the war and as Brady gave us the War between the States.

This at first may seem an extravagant claim for a young artist in relation to a subject as vast as contemporary American civilization. But after looking at these pictures with all their clear, hideous, and beautiful detail, their open insanity and pitiful grandeur, compare this vision of a continent as it is, not as it might be or as it was, with any other coherent vision that we have had since the war. What poet has said as much? What painter has shown as much? Only newspapers, the writers of popular music, the technicians of advertising and radio have in their blind energy accidentally, fortuitously, evoked for future historians such a powerful monument to our moment. And Evans's work has, in addition, intention, logic, continuity, climax, sense, and perfection.

Our most distinguished living expatriate, and our greatest living victim of the nineteenth century, said once that the America Whitman hoped for turned out to be the America Henry James realized. The puritanical eye of T. S. Eliot would be sympathetic to the puritanical eye of Walker Evans. Our Middle West has been responsible for the best of our arts since New England lapsed into its long winter sleep. The Middle West combined the principles of Concord and of Cambridge with the energy of a frontier station. Its commercialism was evangelical. The poetic vision which governed its painters and writers,

however provincial, was purer in essence than the decadent European echoes influential on the Atlantic seaboard.

From St. Louis, Eliot went to Harvard and Paris. From St. Louis and Chicago, Evans went to Williams and Paris. The Middle Western amazement and horror, the love and loathing of big-city life and its effect on our comparatively innocent provinces, had its living parallel in the general attitude of the great French realistic poets: the disgust of Baudelaire, Rimbaud's country-boy contempt, the street music of Apollinaire, the boulevard tricks of Cocteau. Like Eliot and others of the next generation, Evans saw Baudelaire through his verse and the photographs of Nadar. He saw Paris through Proust's own photographic style and the great prints of Atget. But Paris was now no second home, no haven for a spiritual exile. To implement his own vision France offered its wonderful analytical method, the classic scalpel of Stendhal and Flaubert, the skimmed eye of Degas and Seurat: so equipped he could turn home to focus on contemporary America the mechanical device of Nicéphore Niépce and Daguerre.

Contemporary America, even America considered in the disintegration of chaos, presents a spectacle differing in kind, in intensity, and in the actual pattern of disaster from the spectacle of Europe in collapse. Some weaker American artists, attracted by the prestige and nostalgia of European culture, have been caught in the tide of its destruction. Some, like James, Eliot, Gertrude Stein, and Pound, have survived and have stayed as Americans on the European earth to create their indictment of it almost as a moral vengeance. But others, like Dos Passos, Hemingway, William Carlos Williams, and Walker Evans, armed with the weapons of their spiritual ancestors, have turned from the breakup on the continent of Europe to attack the subject matter of their own country in their own time.

Walker Evans knew Hart Crane while Crane was at work on *The Bridge*. Crane did not survive: the Middle West, the fierce transplanted puritan pressure, revenged itself on his great talent. But the intensity of method that Europe gave his genius has been transmitted to younger Americans. It is no chance that, after Crane, Walker Evans should have worked with James Agee, the author of *Permit Me Voyage*, whose verse, springing at once from Catholic liturgy, moving pictures, music, and spoken language, is our purest diction since Eliot. Walker Evans's eye is a poet's eye. It finds corroboration in the poet's voice.

But no matter how sensitive an artist's eye may be, it is irrelevant unless fixed on its special subjects. The development of sensibility for its own sake damned the "nineties" as well as the "twenties." Evans's eye is sympathetic to a very special aspect of a very general material. The wavelength of his vision is exactly equaled by the radiation of the images which attract and repel it. The eye of Evans is open to the visible effects, direct and indirect, of the Industrial Revolution in America, the replacement by the machine in all its complexities of the work and art once done by individual hands and hearts, the exploitation of men by machinery and machinery by men. He records alike the vulgarization which inevitably results from the widespread multiplication of goods and services and the naïve creative spirit imperishable and inherent in the ordinary man. It is this spirit which produces sturdy decorative letterings and grave childlike picturings in an epoch so crass and so corrupt that the only purity of the ordinary individual is unconscious.

A sophisticated yet unaffected eye prizes the naïve for the sake of its pure though accidental vision, not for the paucity of its technical means. In our architecture of the mid-nineteenth century our carpenters and builders made a human and widely acceptable familiarization of Gothic and Renaissance models. By way of uncolored engravings, similar in spirit to Evans's hard uncolored prints, we accommodated European stone to the provincial delicacy of our pine and stucco. By 1850 we could afford ourselves the bold appropriation of every past style, spurning the finicking refinement of bourgeois "good taste" that castrated the Georgian into the weakened scale of our post-revolutionary New England and colonial architecture. Later we were given the neo-Gothic Woolworth Tower and the degradation of the collegiate style at New Haven and Princeton, the neo-colonial at Harvard. Only Evans has completely caught the purest examples of this corrupt homage—innocent and touching in its earlier manifestations—which can be taken as the thematic statement in the symphony of our conglomerate taste. His eye is on symbolic fragments of nineteenth-century American taste, crumpled pressed-tin Corinthian capitals, debased Baroque ornament, wooden rustication, and cracked cast-iron molding, survivals of our early imperialistic expansion. He has noted our stubby country courthouse columns, the thin wooden Gothic crenellation on rural churches, images of an unquenchable appetite

for the prestige of the past in a new land. Such ornament, logical for its place and its time, indigenous to Syracuse in Sicily or London in England, was pure fantasy in Syracuse, New York, or New London, Connecticut. Evans has employed a knowing and hence respectful attitude to explore the consecutive tradition of our primitive monuments, an advanced philosophical and ideological technique to record their simplicity.

But our buildings are impressive only in relation to the people who built and use them, and Evans knows this whether he puts people in front to give them scale or not. A photograph of Chartres, the Parthenon, or the Colosseum has no need of the presence of human figures. If people chance to be caught by a camera before them, the grand design in the stone usually obliterates the human factor. In Evans's pictures of temples or shelters, the presence or absence of the people who created them is the most important thing. The structures are social rather than artistic monuments. The photographs are social documents. In choosing as his subject matter disintegration and its contrasts, he has managed to elevate fortuitous accidents of juxtaposition into ordained design. A clumsy FOR SALE sign clamped on a delicate pillar, a junk pile before a splendid gate, are living citations of the Hegelian theory of opposites. Photographic surprises and accidental conjunctions are not merely superficially grotesque. They are serious symbols allied in disparate chaos. Walker Evans, photographing in New England or in Louisiana, watching a Cuban political funeral or a Mississippi flood, waiting patiently for the season of year or time of day for the right sun on weather-beaten boards, stepping cautiously so as to disturb no dust from the normal atmosphere of the average place, can be considered a kind of disembodied burrowing eye, a conspirator against time and its hammers. His work, print after print of it, seems to call to be shown before the decay which it portrays flattens all sagging roof trees and rusts all the twisted automobile chassis. Here are the records of the age before an imminent collapse. His pictures exist to testify to the symptoms of waste and selfishness that caused the ruin and to salvage whatever was splendid for the future reference of the survivors.

Such a photographer as Walker Evans is not in any way a decorative artist. Such photography is not presentable as an accent for a wall: there is hardly ever any purchaser for the unrelieved, bare-faced,

revelatory fact. Neither is his talent an illustrative accompaniment, or rather, it is not merely an illustrative accompaniment, although such a study as *Middletown* might have been even more effective had it also been plotted in visual terms. The pictures in this book indicate his function and what would appear to be his own definition of the direction in which he must continue to work. It would be a logical continuation of what he has begun if Evans were to go into every state of the Union making series of his faces, houses, streets, and rivers. He might, as another example, chronicle in its human aspect the current war against soil erosion, slums, and drought—as Brady chronicled the Civil War. In the same terms he might make pictures of our industrial plants. Most industrial photography sings a Wagnerian hymn to the vision of machines as deities. Evans is less concerned with the majesty of machinery than with the psychology, manners, and looks of the men who make it work.

Most of all it is interesting to speculate about the work that Evans might do in films, and not necessarily "documentary" films, although the films he makes would unquestionably be documents. His special vision has something unique that could be brought to the screen, and in films he would probably achieve his ultimate lyricism. There are very few lyricists in the movies. There are Cocteau and Dalí, who have been deeply moved by photography and have employed a camera eye in films in a free, adaptable, and truly poetic manner. Best of all, of course, there is the stupendous work of Eisenstein–Alexandrov–Tissé in the butchered Mexican film where, as in Evans's work, the facts sang for themselves [see pp. 278 ff.]. Evans's eye and attitude could do the same for America: elevating the casual, the everyday, and the literal into specific, permanent symbols.

The most characteristic single feature of Evans's work is its purity, or even its puritanism. It is "straight" photography not only in technique but in the rigorous directness of its way of looking. All through the pictures in this book you will search in vain for an angle shot. Every object is regarded head-on with the unsparing frankness of a Russian icon or a Flemish portrait. The facts pile up with the prints.

This is neither a baroque nor a decorative, but a purely protestant attitude: meager, stripped, cold, and, on occasion, humorous. It is also the naked, difficult, solitary attitude of a member revolting from his own class, who knows best what in it must be uncovered, cauter-

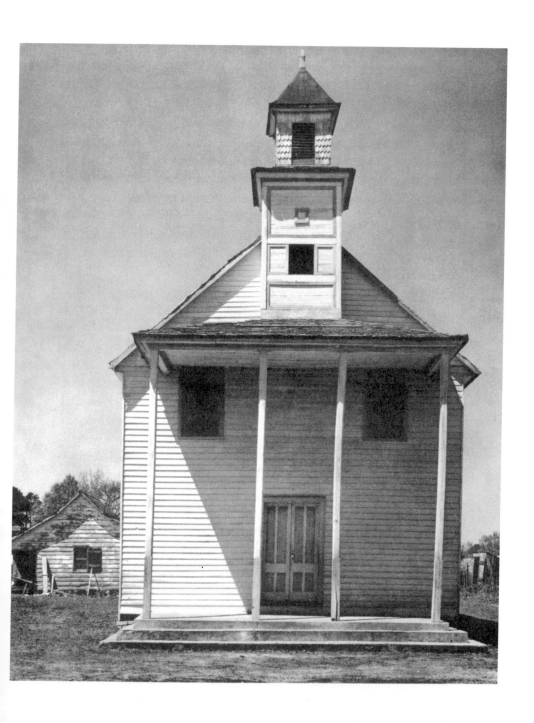

Negro Church, South Carolina *(1936) by Walker Evans*

ized, and why. The view is clinical. Evans is a visual doctor, diag-nostician rather than specialist. But he is also the family physician, quiet and dispassionate, before whom even very old or very sick people are no longer ashamed to reveal themselves.

There has been no need for Evans to dramatize his material with photographic tricks, because the material is already, in itself, intensely dramatic. Even the inanimate things, bureau drawers, pots, tires, bricks, signs, seem waiting in their own patient dignity, posing for their picture. The pictures of men and portraits of houses have only that "expression" which the experience of their society and times has imposed on them. The faces, even those tired, vicious, or content, are past reflecting accidental emotions. They are isolated and essen-tialized. The power of Evans's work lies in the fact that he so details the effect of circumstances on familiar specimens that the single face, the single house, the single street, strike with the strength of over-whelming numbers, the terrible cumulative force of thousands of faces, houses, and streets.

Other photographers have made famous single photographs or are well employed turning out a certain style of photographic product. They work on in a rather ambiguous position, having created a salable commodity which may be useful for a time. But they are always in danger of supercession. A batch of younger photographers, usually their darkroom assistants, is always just around the corner, ready to do the new jobs for less cash. Just as with automobiles, the style turnover is rapid and the old dogs can't seem to learn new tricks. Among the many practitioners, Evans is one of the few who continue to proceed, enlarging not only his technical apparatus but his historian's view of society.

It is nearly impossible to illuminate pictorial art by words with any satisfaction, and one can attempt it here only because so many ideas are present in these pictures. Evans's talent recalls that of others in different fields: the quartz-and-bone cameos of Marianne Moore, the lyrical case book of Dr. William Carlos Williams, the mural histories of Ben Shahn. The sculpture of the New Bedford shipbuilders, the face maps of itinerant portraitists, the fantasy of our popular song-sters and anonymous typefounders continue in his camera. We rec-ognize in his photographs a way of seeing which has appeared persistently throughout the American past.

In the reproductions presented in this book two large divisions have been made. In the first part, which might be labeled "People by Photography," we have an aspect of America for which it would be difficult to claim too much. The photographs are arranged to be seen in their given sequence. They demand and should receive the slight flattery of your closest attention. They are not entirely easy to look at. They repel an easy glance. They are so full of facts they have to be inspected with more care than quickness. The physiognomy of a nation is laid on your table. In the second part will be found the work of Evans which refers to the continuous fact of an indigenous American expression, whatever its source, whatever form it has taken, whether in sculpture, paint, or architecture: that native accent we find again in Kentucky mountain and cowboy ballads, in the compositions Stephen Foster adapted from Irish folk song and in contemporary swing music.

# Siqueiros in Chillán

[Kirstein saw the great Siqueiros murals in Chillán, Chile, in 1942, when he was traveling alone through South America on an art-buying journey for the Museum of Modern Art (see p. xvii). His essay was first published in the Magazine of Art 36.8 (December 1943).]

THE MOST significant event in contemporary Chilean painting was the arrival of the Mexican painter David Alfaro Siqueiros in 1941. This artist, in many ways the most original of all his national contemporaries, had been three years serving as colonel in the Republican Army during the Spanish Civil War, particularly along the Guadarrama front. Returning to Mexico, he was notoriously connected with events leading to the first assault on the exiled revolutionary Leon Trotsky, then occupying a house owned by the painter Diego Rivera, in Coyoacán, a suburb of Mexico City. Imprisoned for his role in this affair, after certain events which remain obscure, Siqueiros left Mexico after Trotsky's ultimate assassination, with which outrage he was never directly implicated. His work, since he has been in Chile, is of the first international importance. It cannot fail to have a profound importance on the future of Chilean and Argentine painting. Already young students are starting to paint walls emulating his own at Chillán, and while there was at first, and in some circles still is, a definite antagonism towards his brash exuberance and conscious violence, he nevertheless commands the respect, and indeed fear, of many local

contemporary academicians, a surprisingly small number of whom have actually taken the trouble to visit the paintings.

Siqueiros is a fighter, and at the present moment he proclaims himself on a personal crusade to destroy easel painting. To hear him talk, the *caballete* (easel) is the fascism of art, this monstrous little square of besmirched canvas, pullulating under the skin of rotting varnish, fit prey for those canny usurers, the speculating picture dealers of the rue de la Boëtie and Fifty-seventh Street. It is not only easel painting against which he fulminates, with its chief function as decorative prestige furniture for a personal and proprietary enjoyment rather than wholesale popular instruction, but also the techniques involving the mediums of oil painting and true fresco as well. He, unlike many painters, is entirely comfortable in our highly industrialized era, deeply involved in the latest developments of chemico-synthetic as opposed to traditional craft methods and materials: the development of plastics, new resins, and cellulose derivatives, the extension of the retina's capacities by camera, still or motion picture, and the projection, or rather the attack, of psychological reference on the human visual apparatus. He paints in duco, or pyroxylin, with airbrush, knife, thumb, or brush, on composition surfaces curved to his own version of the Renaissance "golden section," within walls of which no inch, from floor to ceiling, is free from the assault of his technique and imagination.

If Siqueiros were not so able a craftsman, and if he did not have to his credit nearly three dozen superb easel pictures and three or four surviving murals, he might easily be dismissed as an eccentric, if not a charlatan. His enemies in Mexico claim he is not a serious artist but a braggart or painter-brigand in the line of Benvenuto Cellini, whose style is simply a melodramatic synthesis of Rivera and Orozco. But Siqueiros knows other painters besides his contemporaries—Mantegna, for example, Blake, and Michelangelo. He has gone to the best of the old schools and has had the luck to be raised in almost the best of the new ones.

On the night of January 24, 1939, a terrible earthquake shook the southern provinces of Chile, particularly those of Ñuble and Concepción. In the important rail center and market town of Chillán, birthplace of Chile's Washington—Bernardo O'Higgins—at about ten-thirty in the evening, the shock struck, killing some seven hundred

people in a crowded cinema and more than eight hundred more around the town. It was one of the worst civil disasters in South America within memory. In a country where earthquakes that North America would consider of panic dimensions merit hardly a notice, the tragedy of Chillán was estimated a national disaster.

On March 25, 1942, a trainload of officials rode down from Santiago for the inauguration of Chillán's new primary school, presented by the people of Mexico to the people of Chile. The recent progressive social policies of the two republics have been analogous, and this gesture was a significant one in Latin American politics, particularly if understood against the background of those years in relation to our United States of North America as the invisible catalyst and reagent. For this was also, it must be remembered, the epoch of the Mexican oil expropriations, and our grave difficulties with Chilean mining questions. Chillán has now more than half emerged from its ashes. The school, a sensible cement structure with clean modern lines, is a large building, and it is in the big library on the second floor, directly over the central entrance, where Siqueiros's walls are painted.

If you are not an official bound on a special train, but only an ordinary traveler, you will probably arrive at Chillán around quarter past five of a frequently, in winter at least, very wet morning. There are no hotels, and one hardly feels like breaking into either of the two semiprivate pensions, one Spanish, one German, at such an hour. There is in fact nothing to do but go into the large, hideous, new, naked church, walk to the market, and wait for daylight. In the rambling market are sold many charming objects of popular folk manufacture: the black-surfaced Quinchimali pottery of animals, birds, and guitar players, similar to Oaxaca ware in Mexico; splendid saddlery with fat stirrups richly carved in wood and metal; heavily chased, clean steel spurs with huge rowels, flashed blue over the silver, which sing when twirled.

Due to a gasoline shortage, there are few automobiles in this fairly remote district, and outlying farmers have revived the ancestral calèches and victorias of their fathers' epoch. Rumbling over cobblestones, these coaches give the streets an appearance of a Western movie of twenty years ago, except in place of cowboys, every so often a *huaso*, superbly dressed with his short colored *manta* free to the wind, dashes

past on a sturdy Creole pony. Or there are old men in huge fur pantaloon-like chaps, spurs clanking on the pavement, wearing the same flat felt sombreros one used to see in the south of Spain. And in fact, as Siqueiros remarked, the whole place with its extraordinary natural elegance of the faces and figures of the men, their short jackets and red sashes, is *"muy Andaluz"*—a kind of forgotten provincial Andalusia, with no remote thought of Indians, or even Americans, North or South, transplanted from the middle of a Creole Prosper Merimée's nineteenth century.

The small children in the school of Mexico at Chillán call their library *"La Sala de Gigantes."* They have a rather possessive feeling about this room, which is infrequently open. It is kept locked, and the library is more a town than a school institution. Their eyes have not been sufficiently corrupted to be frightened by the possibilities of aesthetic violence or bad taste. They have not seen much bad art, because they have seen hardly any art at all. But instinctively they realize it is a designed room, not a brace of framed panels. They take it for what it is intended to be, a continuum of narrative statement which endlessly conducts its visual campaign against the ordinary spectator by its dynamic, almost kinetic movement. Children are fond of giants. To them, giants are not monsters but interesting possibilities, big, lumbering, even friendly. They have understood Siqueiros perfectly.

With the acceptance that these paintings are neither wallpaper nor the decorative distribution of applied bric-a-brac to break the casual monotony of a given surface by playful placement of form or color, one enters the room from a central door, advances halfway to the large double-hung windows opposite, and then looks either right, at the wall depicting the symbolic history of Chile, or left, to the symbolic history of Mexico, and then above, at the ceiling, which continuously bridges and welds both walls. The paintings are designed to be observed from a floor track which is the normal traffic of a room, up and down or straight across. As one advances down the axis, towards either wall, one becomes increasingly involved in Siqueiros's confined space. Ideally speaking, perhaps, if the room had been an elliptical sphere, or the interior of an ovoid, rather than an adapted rectangle, and here only, the simulacrum, by force of circumstance, of an ideal sphere— no space would have been free from his paint, not even the floor

underfoot. Actually the walls are painted on Masonite panels attached to balanced armatures, as a box within walls. If they had been painted in true fresco on rigid plaster, the next earthquake could dislodge them. But with Siqueiros's foresight and realism towards survival, they now may oscillate almost elastically to any but the most apocalyptic temblor. Necessity, imposing its rigid conditions on Siqueiros where he has attempted the approximation of a continuous surface without sharp angles, by pinching in the corners of every wall, by swelling and depressing every large surface on a profile section derived from the "golden section," has caused him to risk some of the most valuable and rational experiments in optical illusion since Leonardo da Vinci indicated the camera obscura.

These optical illusions are not entirely apparent in the photographic documentation of Chillán. The camera, with its absolute physiochemical eye, does not produce the same angle of tolerance as our human eye. Hence, he has taken into consideration ocular as well as mental or psychological deformation. The visual "corrections" in Siqueiros's planned design are aimed at the retina with its human variability rather than at mechanical reproduction. A still photograph cannot, although a motion-picture camera possibly could, reproduce the abrupt liberation of Siqueiros's forms in space, the Aztec arrows launched at the fiery Cross, the curve in the accordion-pleated backbend of the Aztec archer, or the bloody cross sections of Galvarino's jewel-like arm stumps, because they exist in the round, in air, independent of flat surfaces. Due to the layers or films of pigment possible to build up, or overlay by airbrush, in his duco-pyroxylin technique, in which the hard outlines may receive knife edges and yet be softened within the area of half a square foot to simulations of soft wool or cotton, Siqueiros has been able to render matter with a kind of mechanized superrealism (though never a bastard realism). In his early work in this medium, his critics accused him of a preference for forms and surfaces resembling automobile fenders; but now he can vary and contrast texture and surface as he wishes.

In the Mexican panel, the steps of the synthetic Aztec pyramid in recessive bands (first used by Siqueiros in Los Angeles at the Plaza Art Center, but here perfected), with absolute, mechanically clean edges, annihilate the arbitrarily established bands and bulges in his wall surface. While the Aztec archer's bow seems to be entirely on a

flat surface, actually half of it is painted on the ceiling at a forty-five-degree angle, above the spectator's head.

This bowman has Siqueiros's own bent eagle's beak. He is a violent and frequently impatient man. He likes to work in duco because it dries quickly and he need not await the inchworm schedule of workers on lime-wet walls in the traditional true-fresco technique. He has come to duco, not by chance, but by trial and error. After Rivera had painted the Paraninfo Bolívar in encaustic, Siqueiros used encaustic, and later fresco, and in the United States, colored cements. But duco most pleases him, and his mastery of delicate psychological delineation is nowhere more secure than in his hewn head of Juárez (far more powerful than his early, more famous, Zapata), or in the section embracing La Adelita, revolutionary Mexico's *soldadera* heroine (actually a portrait of his wife, Angélica), which section was all painted in less than half a day, at the very moment when the special train from Santiago was puffing into Chillán's temporary railroad station, bringing the guests for the school's opening.

The most striking portion of the overwhelming Chilean panel is in the central double-headed giant, Galvarino, the Araucanian grafted onto Bilbao, Chile's great recent popular leader. The identification of the two figures in time and space is a successful extension of Siqueiros's device, formulated in the same medium and now in the collection of the Museum of Modern Art, entitled *The Echo of a Scream*, in which a monstrous baby's yelling mouth holds its own screaming infant image. Siqueiros is not here indulging in any of the naïve pictographic primer walls of so many other early and late Mexican wall painters. He is making an inscription by asserting a reference, not explaining in primitive syllables why and how such and such a fact is true. Similarly, his identification of the Araucanian chief Caupolicán with the labor leader Recabarren is his *statement* and scarcely a polemical illustration. The superb stiff double banner grasped in the strongly enlarged hands of Bernardo O'Higgins, Chillán's most famous son, which streams out in one direction as the original flag of Chilean independence, and in the other as Chile's present standard, coincides with the careful structural deformation of the pinched-in angle of the room's corner, while both converge above the spectator to whip and ripple in the still wind overhead.

A clever Chilean critic wrote at the time of the unveiling: "These

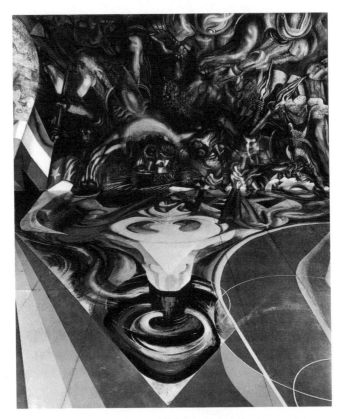

*David Alfaro Siqueiros's mural* Death to the Invader (1941–42) *in the Escuela México, Chillán. The south wall shows the history of Chile, with, in the center, the Araucanian Indian Galvarino, Bilbao, and Caupolicán*

walls scream phonetically." Picasso in his sketches for, if not in the final flat tragic poster of, *Guernica* pioneered in adding an element of aural horror to the nerves of contemporary plastic art. His stricken bullring nags scream with the blood-curdling bleat of beasts whose nature it is to be silent. Siqueiros's big central figures in both panels produce the neural impression of mechanical fingernails scratching a monster blackboard. It is not agreeable, nor can it be ignored. Then also, the forms seem almost to commence to stir in their own atmosphere. Arms and legs loom up and out, enveloped in the fumes of their double or multiple exposure. The great Indians breast their way into the room as through a fog. They do not recede up, out, and away

to let the air through as in the Baroque precipitations of the method of Tintoretto or Tiepolo. Instead, hands clutch out from the wall, released arrows stick up and into air as if quivering in space. A spectator, instead of placidly regarding recessive images, is almost physically involved in a violent emergent combat. The flesh of Galvarino's die-stamped knee crushes the Conquistador's forged steel armor, which in turn has shattered an actual glass mirror inlaid into the curving Masonite wall, which was then glazed with duco. The Spanish conquerors had used mirrors to frighten the Araucanians. Here a particular symbol typifies the subject of the whole space—"Death to the Invader"—while in the actual painting of this single section one nearly *hears* the broken spell of the Castilian yoke in a crash of fractured glass and shattered metal. Only in the face of St. Stephen reflected in the limp olive-green armor of the dead Count of Orgaz may one find an equal technical mastery of materials, surfaces, or psychological association.

Chillán's walls are a satisfactory testimony to Siqueiros's creed of painting, which he wrote as an appreciation of the work of his friend Orozco-Romero in 1939:

Good painting, like all good art, is a synthesis of contradictory elements. Of opposed elements that exclude one another and yet fit together and coordinate themselves. It is the rhythm of syncopation; it is the magical fruit born of a pathetic shock; it is the weaving musical fusion of that which is smooth with that which is rough; it is the straight line that strikes against the curve and then breaks into angles; and it is above all the stimulating and active super-position of the physical world over the metaphysical. Namely, of the internal world with the external, of what we can see and touch with what, though existing, yet does not exist. One might say the coexistence, the simultaneity of metier with mystery.

In Santiago, one may be told these walls are an accident and not in the least Chilean, whatever that may mean. One may search Chile in vain for a specifically Chilean art except among the popular crafts, and these share an Indian origin stretching to Mexico. One may also be told that these paintings are not mural decoration at all, for in them the walls are destroyed, the strain of intention is embarrassing, the color brutal bad taste, and that, most corrupt of all, they are "prop-aganda." All this is more a criticism of contemporary painting in that

country than of Siqueiros. He has indeed violated the surface of the wall, thereby denying the formulae of the debilitated tradition of Renaissance dilutions since Puvis de Chavannes, which are taught in official art schools all over the world. He has gone against every principle of academic French purism, which holds all furniture as decor including painting, and whose single criterion of sensibility had over five years ago become as irresponsible as the French foreign policy. The Mexican's taste is certainly not the comestible *bon goût* of the School of Paris. Politically speaking, however, or from the aspect of "propaganda," the walls are scarcely polemical. Instead, they are rather naïve statements of familiar prototypes, erected into a monument, indeed official in their academic iconography, what with all the familiar heroes—O'Higgins, Balmaceda, Juárez, Hidalgo, and Morelos. The polemic which essentially occupied the artist in this case was propaganda for a technique, and for new ways of rendering and seeing. For here Siqueiros has stated conclusively, though still (due to physical conditions beyond his control) in a manner more primitive than on the walls of the Electrical Union in Mexico City (his work just previous to Chillán), principles of an important new synthesis of plastic elements. In these walls we have none of the complacent generalization of heavy forms and flat surfaces as in the norm of the late Rivera, nor the ecstatic confusion of symbols in whose murky ambiguity Orozco is frequently inspired to his automatic and impressive violence. In Siqueiros, the mastering characteristic is the intelligence. To borrow the categories of constitutional psychology, Rivera is dominantly visceral, Orozco muscular, and Siqueiros cerebral. In him everything is reasoned out, worked at, considered, directed. It is a far cry from the romantic naturalism of the Syndicate of the twenties. In Siqueiros we have instead a new classicism, of emotional and lyric realism, nondecorative, anti-exotic, anti-romantic.

# Henri Cartier-Bresson:
# Documentary Humanist

[*Kirstein's interest in the work of Cartier-Bresson began in 1934, when they were introduced in New York by the composer Nicolas Nabokov. This, the first of two essays on the photographer, was published in* The Photographs of Henri Cartier-Bresson *(New York: Museum of Modern Art, 1947).*]

A NUMBER of contemporary photographers are united towards formulating a new approach to deliberate photography. Perhaps the leading European exponent of this direction is Henri Cartier-Bresson, who, by his denial of the academic "artistic" or salon taste of modern art-photography has taken sequences of pictures which in their freshness, elegance, and truth remain works of art within their own radical aesthetic.

Since the discovery of photography, over a century ago, there has been recurrent confusion as to its function and effect. At first there was the giddy sense, amounting almost to fright, that the camera lens had spoiled any future for representational painting, making any further realistic rendering by the hand and brush useless. At the same time and a little later, certain painters occupied with basic problems in the arrangement of form and light (Corot, Degas, Eakins) employed even the accidents of photography—lack of a sharpened focus, forced perspective—as new pictorial devices. Even the candid composition of the snapshot, with figures cut arbitrarily by the frame, was deftly used by Degas and Toulouse-Lautrec. And yet, historically speaking, it was Manet who had introduced the vision of an instantaneous accident,

borrowed from the strips of Japanese woodcuts, sliced to fit on the slim posts of teahouses.

Afterwards, when it was realized that easel painters had nothing to fear and even much to gain from the camera, and that the prestige of the painter could remain intact, a school of salon photographers attempted to imitate or rival painterly compositions. From the first use of the camera, the line of salon photographers was paralleled by men whose candor of vision accepted the mechanism for its unique services, and created something quite irreplaceable with it. Such were the prints of Nadar and Brady, and many anonymous daguerreotypists. But the salon photographers occupied themselves with "arrangement," "texture," "atmosphere," and "quality." The pictures they posed, however, except possibly for strictly documentary portraits of people or places, did not long satisfy as independent works of art. No matter how sagacious the photographer, the elements of composition, texture, atmosphere, and quality could not be fused into an image with a continuous life of its own, equaling the synthesis made possible by the greatest painting. Photographs even failed to be convincing framed and glazed decorations, and the addition of hand-painted tinting did not help. Photographs were at once postcards and simulacra of paint. Bad taste accompanied the more ambitious, and soon photography as a popular craft was expressed in the promiscuous anonymity of journalism. But in the masses of journalistic shots, every so often a few wonderful human images emerged, and if this was usually accidental, the pictures were nonetheless effective for their unconscious appeal. And these images have never failed to excite and affect present-day easel painters, who, like Vermeer and Manet before them, can always be moved by the miraculous accidents of light and the surprise of suddenly fixed frames.

Then certain artists, primarily interested in the use of the camera, who had been made aware of the naïve, or at least half-consciously formulated journalistic approach, began to use the frank attitude of the reporter-photographer, but now with deliberate design. They began to school the non-selective primitive eye, with all its piquant mishaps, to their own sophisticated program. It is also noteworthy that several of our best documentary humanists were also trained as painters. Cartier-Bresson and the American Walker Evans (who has quite a different style) have both painted, and were considerably influenced by the folk

cultures of Africa, the Caribbean, and Polynesia. The photographer Brassaï is a talented draftsman. These photographers, and others of their school, are as familiar with the creative impulse as painters. They work with a different medium and a more mechanical process.

The decisive part of Cartier-Bresson's particular process takes place not in the mechanism in his hand but in the vision in his head; in that right eye which (he says) looks out onto the exterior world, and that left eye which looks inside to his personal world. The vision fuses on what he sees, where and when, and how he feels about it. His pictures are closer to the news photo of a daily crime or a sporting event than to the naïve perfection of the still-life groups of the great chronicler of Paris in the early 1900s, Eugène Atget. But while a news photo is brutal, factual, and public or official, and the great human interest in Atget is more by implication from inanimate objects, Cartier-Bresson, with means as modest, gives us an intense and questioning image, not stripped of light and air, but close to the figures involved, to their private identities, their social origin and habits, and the local site. And while news photographers specialize in catastrophe, the photo finish, or some aspect of shock, Cartier-Bresson's pictures are seized in the middle norm of a run of action, a specimen slice or symbolic fragment, snapped from a series. His early shot of children playing in ruins of plaster walls whose holes seem torn out of the paper on which they are printed was prophecy of an imminent decade of disaster. No image since has provided such a powerful report of fused innocence and destruction, of fun and fright.

Cartier-Bresson feels that an insistence on the direct and indirect documentation of human behavior by the camera offers an unlimited field of investigation for individual photographers, and of infinite differences of personal comment. There is no reason for anyone else to ape his particular eye or to attempt to recapture his set of lyric values, individually developed over a long time to suit his temperament; it would be possible only as dilution. There was only one Atget, despite the apparent anonymity of his plates, and his countless subsequent and careless imitators. The very real differences between Cartier-Bresson and the other documentary humanists—Brassaï, Bill Brandt, Doisneau, Walker Evans, Helen Levitt, Ben Shahn (as photographer, not painter), and Weegee, for example—show how many strongly personal styles may be developed within their program.

Cartier-Bresson's particular personality is Parisian and Norman. From Paris he gains his easy internationalism, his ability to pass in or out of any milieu however exotic, dangerous, or boring, without wasting his time. He went off for a year in West Africa with no more equipment than a pair of his father's old pants, a new sun helmet, and a thousand-franc note. He embarked for Mexico without troubling to find out on whose responsibility or authority his vague expedition was based and, of course, it blew up. But he got to know Africa and Mexico as no well-outfitted tourist ever could. He never loses himself in mere nostalgic strangeness; the contrasts of new people and far places do not overwhelm him. He accepts whatever part of the exotic is essential in its integrity as another equally interesting phenomenon, but quite without travelogue romance or soft-focus brooding.

From Normandy comes his frugal elegance and peasant shrewdness, an independent chill or candor, and also a transparent dignity and pride in his own brand of technique, which is less a matter of taking pictures than of talking to people and getting along well with them so they will not shrink from him, or "pose" for him. He has an antagonism to gadgetry in his medium; the instruments are for use, like a plane or a square, and his craftsmanship is less specialized than specific for his needs. He does not have much of a feeling for the darkroom. Here he supervises the technician, for, after all, what he has seen is already implicit in what appears in the negative and on the print. He has taken a sequence of trial shots, dancing about his subject on tiptoe, like a boxer or fencer, until he chooses the ultimate frame and instance; then traps it in time. He considers his own assignments and the exploitation of his practical talents (which are considerable) as an ordinary workman does his labor. Should he be occupied with pictorial journalism, very well then, there are the usual conditions of his editors to be satisfied. He is not hampered by them. Peacetime is different from war, but not necessarily easier. The war in Spain is different from the war in France. The parlor of a wine master of the Loire certainly differs from that of Bonnard or Rouault, and wherever he happens to work he spends the time as an agreeable and almost invisible guest.

There is a discreet Parisian lightness as well as a Norman rigor in his personality which he transfers to his prints. His cheeriness, his

dispassionate curiosity, his stubborn attention and self-effacement: how unlike the usual conscientious or case-hardened reporter. He is sympathetic towards his sitters or assignments in the way of a good nurse with a fractious patient. Without allowing them to be aware of it—which might somehow remind them of their condition, or their habitual defenses—he puts them at ease, makes them quite comfortable, allays their vanities, involves them deeply in their own currents of action, takes his pictures, continues the conversation as if nothing had happened, with his follow-through in the entire process never cutting the ordinary flow of atmosphere by a self-conscious or unconscious flirtation with the camera on the part of the sitter or subject.

Sometimes and somehow, almost out of a superior craftsman's good manners, he seems able to leave his lens out of the picture. His portrait subjects are not shot; they get themselves taken at tactful intervals, by eavesdropping or absorption. His pictures are not generally cropped down after printing. He does not have to try to save a composition by eliminating a band or an edge, here or there. His finest shots are discovered rather than contrived, and he does not go in for the systematic disruption or rearrangement of an interior, for example, to render it more "picturesque" or "characteristic." That is why his recent series of eminent French writers and painters is so valuable. By avoiding any factitious formal effects, even those recently developed in the mode of the candid camera, by having an almost tacit understanding between himself and his sitters that they will, together, defeat the clichés of photography, by not attempting the maximum the camera can do with light and lens, by rejecting most of what usually counts for sensitive arrangement and clever illumination, by coming humbly to his subject with the preoccupied intensity of a fisherman playing to land a big catch or a boxer landing a knockout, he achieves his pure biographical accuracy. Perhaps no illustrious group has ever been portrayed with so much penetration and psychological illumination, unless it was by Nadar. Perhaps it is this very intensity, this spasm at the instant of clicking that exhausts his energy and renders Cartier-Bresson relatively indifferent to the subsequent processes necessary for the public to see his pictures. Up to the click, there has been nothing really mechanical; notch by notch the various accidents and incidents group themselves in space and time for the focal second when he

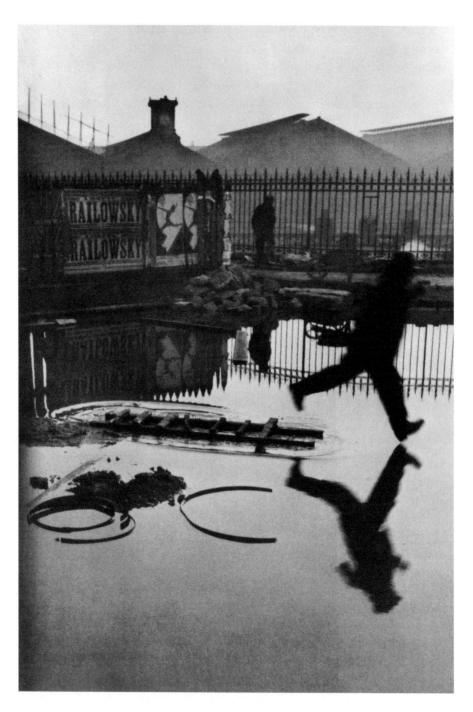

Behind Gare St. Lazare, Paris (1932) *by Henri Cartier-Bresson*

springs his trap. Afterwards, the developing, the printing, and the promulgation require a different sort of energy, and one which he dutifully if indifferently spends.

The series on the painter Bonnard is suffused with that intimate sunny light of French domestic life, that constant reference to the family symbols of the white cloth, the brown loaf and red wine which have made Bonnard so representative of a national habit of life. The face of Paul Claudel, flanked by the peasant's black and silver hearse, is a unique synthetic image of the poet whose incomparable diction has fused medieval homily and baroque splendor into the language of a lively faith. Here too, with equal simplicity and sense, we have the faintly sinister intellectual surliness of Jean-Paul Sartre, the puckered old clown's wisdom of Rouault, and the bold elaboration of Matisse's domestic decor, a combination of an aviary and an Oriental restaurant.

What could be more British than the absurd dignity and shabby tribal complacency of his Coronation series? Cartier-Bresson turns his back on the majesty of the processions, the brilliance of colonial deputations, the ancient London streets, however appealing and pictorial, to devote himself to the fierce loyalties of the rapt mass. Looking at those traditional faces we are all the more conscious of the truth in John Strachey's *mot*: "Remember, gentlemen, when the time comes, it will be *His Majesty's* Communist Government."

Instead of developing an interest in the rendition of surface or tonal values as such, which in some photographers leads them to present human skin as oiled leather, with every pore a pit and every hair a stroke of engraved penmanship, Cartier-Bresson has rather preferred to whet his historical and moral perceptions. With a kind of bland abnegation he manages to avoid the intrusion of idiosyncrasy, of his own accidental personality, of his individual background. But the more he effaces himself, the more he ignores his particular Frenchness or contemporaneity, the more he becomes the crystal eye, the more his pictures sign themselves. For his sight, divested of superficial prejudice or preference, focusing itself on what is most essential in his subject, also reflects what is most essential in himself.

Some of the drama in his still photographs may have come from his experience with films, either assisting Jean Renoir or by himself, as in the documentary covering the Republican hospitals of Madrid, Valencia, and Barcelona during the Spanish Civil War, or recently

in *Le Retour,* made through the United States Office of War Information, but released, unfortunately, only in France.

Cartier-Bresson was captured at the time of the Armistice of 1940 with his photo-unit in the Vosges mountains. He spent thirty-five months in prisoner-of-war camps in Germany, from which he twice attempted to escape but was each time recaptured and sent back to confinement. On his third try, he managed to reach France. Hence it is not surprising that he has known so well how to film some of the most bitterly moving or exhilarating scenes of the war. Many American soldiers recall (how faintly now) that rapture of freedom and friendship in overrunning the prison camps for forced workers, prisoners of war, deportees, and hostages. For a few insanely happy minutes it seemed to all of us that the whole war had been won here and now, with our tangible, ferocious victory; that the men we helped to liberate, who had endured so much for the cause that was then not allied with, but indistinguishable from, our own, were the point of our war, and we had been lucky enough to be in at this ecstatic climax. Cartier-Bresson, who had been one of them, took their pictures and followed them home, all the interminable way, to the huge centers of repatriation in the vast deserted railway sheds, and then finally back to their own farms and foyers. And much of the anguish in this film's almost insupportable emotion is clear in his still photographs of the denunciation of traitors and informers by the released French prisoners.

The camera is still a seductive and ambiguous instrument. If today it seldom suffers from soft-focus sentimentality, it has the even worse disease of being capitalized upon for a kind of false realism, in staged "true-story" treatments, in prearranged publicity stunt shots, in rearrangements towards the purveyance of an artificial truth. It has taken us too long a time to discover that the most impressive and lasting achievements of the camera are in pictures, snapped from impartial history, which could not have been realized in any other medium. Cartier-Bresson's best shots could not have been drawn or painted, but only photographed. Some of these are among the most memorable documentation of our epoch. And in looking over the range of his fifteen years of work, we realize the great service of photography, in hands as responsible as his, and the discoveries from which even painters have profited, new discoveries in the realm of space, the nostalgia of distance, the pathos of empty enclosures prophesied by de

Chirico, and which have had re-echoes of influence in many easel painters. In an age of predominantly decorative or plastic values in painting, it has been the camera, supervised by such eyes as Cartier-Bresson's, which has kept the fascination of independent reality alive for the reinvestigation of the new humanism whose first indications are already felt.

# The Interior Landscapes of Pavel Tchelitchev

[*Pavel Tchelitchev (1898–1957) was a fashionable and at times an influential figure in the art worlds of Paris, London, and New York during the twenties, thirties, and forties. It was Tchelitchev, an erudite, sarcastic, mesmerizing conversationalist, who introduced Kirstein to Balanchine and who supplied them, in Kirstein's words, with the "aura of social cachet without which the classic academic theatrical dance has seldom survived." His setting for* Orfeo ed Eurydice, *produced at the Metropolitan Opera in 1937, was Balanchine's favorite stage design. Tchelitchev's most ambitious painting,* Cache-Cache *(1940–42), a strange dream-amalgam exploring childhood, is in New York's Museum of Modern Art. His vigorously stated anti-Surrealism in Surrealist-filled wartime New York, as well as his work for dress designers and fashion magazines, helped to undermine his reputation as a serious painter. However, Kirstein remained a friend, admirer, and patron. This essay, dating from the period when Kirstein's quarrel with the whole direction of modern art was becoming increasingly public and fierce, was published in the* Magazine of Art *41.2 (February 1948).*]

> It is a byword of the schools that man is a smaller world in whose body may be seen a mixture of the elements and the heavenly spirit, the vegetable soul of plants and the senses of beasts, the mind of angels and the likeness to God.
>
> Pico della Mirandola, *The Dignity of Man*

PAVEL TCHELITCHEV calls the works of his past six years "the interior landscape." At first they may not appear to be landscapes, either in subject or treatment. However, we must recognize that they are, as he clearly states, *interior* landscapes. They are pictures of places, but instead of portraying a field or valley visible in external geography, they depict an inner and generally hidden world, usually invisible, although always to be apprehended, the world of the roots and structures of the human organism.

The basic problem in landscape is a description of space: emptiness filled by natural features; the presence of distance; perhaps the likeness of a particular place or the invention of an imaginary locale by indications of fantastic topography or architecture. The space is cultivated by paint so that air seems to occupy it, with the further particularization of a time of day or year. A landscape is a fragment of a world, realized completely as a world in itself, a kind of framed X, marking the spot where many currents cross, the focus of an eye and an epoch and a place, whether in history or in imagination. Light tailors the arrangements of its forms indicating sharply or loosely the various levels, depths, and accents. This is a world external to us and, while dependent on what we may have seen, or what we can immediately recognize as model or inspiration, is in its ultimate achievement an independent vision.

Before telescope or microscope it was natural that landscapes were painted as little more than gardens, the *hortus inclusus* of Gothic miniature and tapestry, where each flower is a tree and beds of herbs or blossoms are veritable forests. But with the discovery of scientific capacities for measuring space, the description of this measure and the transformation of it visually onto a plane surface, garden paths and brick walls projected themselves into the crags of northern Italy, the fields of Flanders, the ruins of Rome, the wide precipitate skies of Holland, the English countryside, and the high seas. Gradually, through four centuries, important visions of Europe's scene were fixed within the framed windows through which we still see symbols of place and time—views of Venice, Delft, and Toledo, St. Peter's from the Janiculum, Salisbury Cathedral and Étretat. When we now recall the immediate aspect of a spot visited or remembered, it has come to be in the renowned terms of Canaletto, Constable, or Corot.

Landscape became so interesting in itself that painters abandoned

mere background, a backdrop for human figures, or as an arena
... which acts occurred. Its scope was broadened so that the force or
grace of nature dominated, and its scale was indicated in the terms of
a six-foot man; clouds, trees, and buildings were set against the stature
of men as how much more huge. The enormous variety of leaves on
tree trunks, in rocks or water, displaced air in heroic fertility. Forests
and clouds became important personages who stood for their portraits,
and non-human, or man-made but inanimate objects assumed a psy-
chological or sentimental attraction.

Trees are freely developing forms, as are cliffs and hills, serpentine
brooks, ragged waterfalls, the improvised hulk of clouds, the surprising
tack of wind and waves. But each has an underlying logic in design
and an overall structural and geometric control nearly as rigid as the
vanishing point imagined for walls or pavements. The trunk and splay-
ing branches determine the order of the massing foliage; each vein on
every leaf echoes a tree's organic symmetry, just as the roots below
ground mirror the shape of the wood above. Rocks split along their
crystal cleavage, clouds betray wind, heat, and light; all their silhou-
ettes, however untidy or Protean, however each may also assume some
other reminiscent shape, have nevertheless the government of the
central spine upon which they are suspended and about which they
circulate.

With the addition of architecture, elements of an absolute entered
into landscape painting. Profiles were constructed of straight ruled
lines, and blocks of masonry became forms that, even if ruined by
time or interrupted by shadow or light, conveyed insistent geometrical
shapes. Perspective is an intellectual exercise, an invented language
adapted to the photo-mechanism of the Western eye—a basic skeleton
which atmosphere may invest and upon whose diminishing chessboard
individual forms and pieces are set and linked to create arrangements
of spacious illusion.

The spyglass and the telescope brought remote distance close at
hand, provided conventions for representing space, diminished inter-
vening planes, and elided veils of air separating yard from yard and
mile from mile. Artists were able to decompose space and to erect
their system of perspective with mathematical sense. While the mi-
croscope did not exactly reverse the process, the study of the interior
organism of the human body, whose atoms are no less old or complex

than those of trees or stars, has provided another universe for investigation and inspiration.

It is not in the discovery or listing of bones and muscles that Pavel Tchelitchev has chosen to excel. There is no longer necessary any further unfolding of gross anatomy. Long ago, Vesalius, working intimately with his great draftsman John of Calcar, Titian's pupil and Raphael's disciple, made possible the whole descent of Baroque painting and sculpture, providing an academy for the expression of the tragic nude ever since. Tchelitchev is by no means some sort of later-day Vesalius. Vesalius was a scientist, a Columbus in his field; what he did was virtually done for the first time and does not need to be done again. He caused to be demonstrated in almost incontrovertible terms the mosaic architecture of the human body, from its skin coat, through laminations of fat, cartilage, muscle, embedded nerve and vein, down to the hinged bone. Subsequent research only corrected his charts in detail; it enlarged our lens and made us see the parts more closely or more clearly.

Tchelitchev's interior landscapes presuppose a close and very complete anatomical information derived from the heirs of Vesalius. It is a school which he has attended as an eager student, just as contemporary symphonists have mastered the entire system and tradition of Western counterpoint and harmony. But it is a language or vocabulary to be used, rather than a discovery to be demonstrated. Vesalius displayed the given parts in their canonical arrangement; indeed, he practically established the canon. Tchelitchev had no need to be occupied with firsthand dissection, nor with the minute documents of histology. This was all anciently apparent, repeatedly described, and gloriously delineated. Instead, Tchelitchev selected elements from anatomy (Greek: *to cut asunder*), chose his grand features as others choose trees, rocks, or clouds, and composed them into landscapes incorporating the cave of the chest overrun with veins of vines. He illuminates their functioning; he does not catalogue it. His particular exploration and discovery is into the essence of their plastic structure rather than into their variety or order.

Paul Valéry in his subtle *Simple Reflexions upon the Human Body* writes of the nature of "the Three Bodies" combined in our single one. The First is the primary, immediate, personal, and private possession of us all: the My-Body, made up of My-Legs, My-Arms, My-

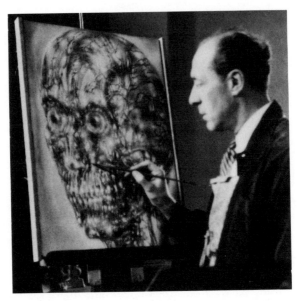

*Pavel Tchelitchev painting one of his "Interior Landscapes." New York, 1947*

Head, and so on, that individual mortal property which we inhabit on earth, by which we move about. The Second Body is that one observed by others, the role we play, the Narcissus-image of mirrors and portraits. The Third Body is the physical, chemical, and biological complex, the mechanical synthesis of tubes and motors which maintain various liquids thin or viscous in the balance of their vital temperatures; the conglomerate mass of sponges, drops, and corpuscles, vessels and articulations, shared in comparative degrees by all animate creatures. This is the body that continues its constant work all but automatically while we walk or make love or sleep or eat, quite independent of our only momentary and usually vague consciousness of it.

We generally recall Our-Body when we bark Our-Shins or have an ache in Our-Head. We know, more or less, how we appear to others, since we have often stared at or surprised ourselves in front of a mirror, or gained some flattering or unflattering hints from portrait painters or photographers. But this Third Body, the internal ambulant symphony in structure, is present to us only at rare intervals; perhaps only when, with clear head and dispassionate curiosity, prompted by

consciousness based on the necessity for physical survival, we are willing to countenance the revelations of science and its explanations.

Tchelitchev's interior landscapes are utterly occupied with the Third Body. However, they have as little to do with particular subjects or individual models as they have with pathology or mortality. Unlike the supreme morbid elegance of the illustrations of Vesalius, they contain nothing of the melodrama of the dissected but resurrected cadaver. Their interiors have not yet been penetrated by the scalpel but by light. The Third Body which they investigate, chart, and illuminate is, after all, our *living* body. The drama in them is that the tubes, sponges, vessels, and processes are not drained away but are active in full force, mobile, dynamic. We know less of the map of the human body than of towns, countries, or the shifting imaginary boundaries of the political world. We may be roughly familiar with our skin and its bumps beneath, our height, weight, and shape, but our mirror, through habit, at once flatters and dulls away real curiosity. The most superficial vanity or fright diminishes our need for much accurate or penetrating self-knowledge. We associate our flayed prime processes with the least noble of their functions, and when we verge on consideration of the sources of the presence of life inside us, it is with an almost superstitious mortal dread.

Tchelitchev seems to have been preparing himself for an investigation of this interior aspect of nature for over twenty-five years. In his early youth, an exhaustive apprenticeship to the academy of Cubism showed him its uses for an analysis and decomposition of absolute form, the methods of arranging shapes in a frame, the abstract anchorage in cone and square and mastery of geometrical principle. He long ago recognized the multiformity of isolated shapes, the presence of every form in every other form, the metamorphosis of meanings that lie in wait in their re-echoing profiles. His single clowns were composed of whole circuses whose small acrobats, animals, and equestriennes supported the equilibrium of a single backbone, head, and human expression. His portraits were compacted of domestic still lifes, the properties of kitchens and studios. His clouds held swimmers and his wintry fields hid great sleepy cats whose tawny stripes fused with the stone wall's vanishing precipitation. He worked with the isolated, free-standing human figure seen head-on, from above and from below

simultaneously in triple diminishment, adding an element of time to the synthesis of the form in its space by the opening and shutting of his accordion-like perspective.

With his large allegorical canvas *Hide-and-Seek* (*Cache-Cache*: 1940–42), now in the permanent collection of the Museum of Modern Art, Tchelitchev combined these successive formal and psychological researches into a single composition, which was at once a comparison of the four natural elements and the seasons of the year, superimposed on a basic theme of the physical, mental, and spiritual world of childhood. A rich, visual punning transparency of lyric imagery saturates its elaborate but orderly design. Every imaginable sort of animal and vegetable conceit nests in the gnarled roots and knotty branches of the huge tree trunk, grown from a human foot into the five wrinkled fingers of a human hand. In the lower right-hand quarter, in that section devoted to winter and fixed in rime-sprayed twiglets, we can uncover a frosty youth in profile whose shadowy vertebrae are X-rayed beneath a mother-of-pearl surface, whose blown-glass columnar bones are translucent through to their icicle articulation.

This was perhaps the germ of the later interior landscapes. Next followed *The Golden Leaf* (1943), a large gouache of a three-quarter-length standing nude, seen through from the back, which promised all the subsequent work. It is a design of arresting skill in its complex separations and superimpositions of the systematic levels in structure. The striking stance, the humanity in the inclination of its quivering silhouette, the solidity inside its complexity fuse in a sense of living completeness within a transparent, fluent luminosity. The profile flickers steadily like an alcohol flame, but the interior also flows with light. The muscular, nervous, and lymphatic systems, woven about lobe and bone, are each apparent at once, but the figure could never be imagined as an *écorché*; its lively presence is no stripped corpse but a revealed and burning existence. The mosaic of structure and function emerges by parts and blends in a whole, its binding element not blood but light. The landscapes which follow *The Golden Leaf* investigate in more detail and even more isolated grandeur each chosen part; but, loose as it is in comparison with those later ones based on eye, nose, or ear, it is perhaps the most humane and touching of an only apparently analytic series.

If we doubt that these pictures are actually landscapes rather than,

let us say, still lifes or fantasies, we must ask ourselves: Are they portraits of places or caprices? They are portraits of places. Sometimes the place is the antrum, the vaults of the sinus, the spiral labyrinth of the inner ear, the corridors of the semicircular canal, the tree of the nervous system, the rivers of lymph, or the pools of glands and vessels. The eye, in a series of *Flowers of Sight* (1944–45), is seen as a vision of the sun it reflects. If we read the lashes like flames, jetting out from a solar mass in a flash of poetic double exposure, we have an image from the microscope superimposed on a sight through a telescope. The human eye itself is only a net through which light braids its beams, outward through timeless interstellar space and inward to the no less vast complex of the human cellular universe. The bony skull is also a sea plant or a fragment of a seascape, with tentacles of hair wreathing the pearly casque. While none of the series of heads or skulls can be thought of as possessing a personality or a definite sentiment, nevertheless each has its expression—a sense of awareness, a consciousness of its components and its place in nature. The wide-open eyes may at first seem staring in awe. But the more one looks, the more the expression is bland, impersonal, *conscious*. They bear the ambiguous, unlaughing smile apparent in both Oriental and Western faces when the artist is dominated by esoteric or philosophical doctrine—whether Gitas or neo-Platonism—when individual personality seems less interesting than the expression of a type that governs idiosyncrasy. It is the expression of Siva, Quetzalcoatl, and the Umbrian angels. In Tchelitchev, it is remarkable that such insistence and dedication to the physical aspects of man should result dialectically in such a strong impression of unearthly, unfleshly, indeed unfleshed perfection.

Each of Tchelitchev's landscapes leads its continuous life within itself, however much an isolated eye or nose or head is dependent on other parts of the body. The parts depicted are seen less as seized out of context, fixed as they are in the dignity of their separate structures. Formally, each landscape has its own organization. The composition, the planning of the maze of nets and channels, sac and sinew, the phosphorescent branching lights following along the pipes for vital liquors all have that unbalanced symmetry inlaid also in the garden patterns of Oriental carpets. In these a baffling intricacy seems identically doubled or quartered, but is upon examination found to be

Interior Landscape *(1948) by Pavel Tchelitchev; oil on canvas*

entirely asymmetrical, no one part corresponding to another in a single detail. The fluent cords and membranes glow, undissolved in aqueous light, so that no portion ever seems at rest. The flow is never haphazard; it conducts the eye along those firm sinuous tubes which in life transmit the blood and lymph.

These visions of an interior world are perhaps something new in contemporary art. They are not only beautiful and skillful in painting, they also point a direction towards another attitude in our aesthetic, not necessarily novel, but more serious than many of those to which we have become accustomed. With Tchelitchev's interior landscapes we find something approaching a new aristocracy of humanism. Highly planned technical dexterity is presupposed, but the measure is again

man. The artist's intention is the expression of a more complete idea of his order.

Valéry said: "We speak of the [three parts of the] body as of a thing which belongs to us; but it is not so simple, for the body belongs to us a little less than we belong to it." In the Renaissance, for the first time, artist-scientists opened dead bodies to discover how we were made. Now, after five hundred years of investigation not only in gross anatomy but also in cellular structure, in psychology and in the formal development of plastic expression in paint, we come to observe interior man as living symbol. He no longer needs to be thought of as dead to be understood; the secrets of interior man are living secrets, and Pavel Tchelitchev may have given us a key into their mysterious countries.

# Paul Cadmus's
# Seven Deadly Sins

[*Kirstein met Paul Cadmus in the early thirties, and he has been an admirer of Cadmus's bizarre and meticulous art ever since. In 1941, he married the painter Fidelma Cadmus, Paul's sister. First published as part of* Paul Cadmus *(New York: Imago, 1984).*]

THE SEVEN DEADLY SINS, a sequence of egg-tempera panels, is in concept and achievement a capstone of Cadmus's career. Riveting in their diabolical repulsiveness, imagined with an awareness of essential morality, their precision of imagery and intense realization in form and color present a universalized iconography of evil unique in our time.

Roman Catholic theology distinguishes between capital or cardinal, as against mortal or deadly, sin. Cardinal sins include those most common and apparent; mortal sins lead inevitably to damnation and the soul's eternal death. Dante in his cosmology set no capital sin in the Inferno, but only in Purgatory's limbo. This does not imply damnation; through sincere penance and the Blessed Sacraments salvation is still possible, even inevitable through the love of God, the mercy of Christ, and the grace of the Holy Spirit. Canonical mortal sin, compelled by disregard for the Mosaic Decalogue, is fault with no possibility of redemption. In medieval art, the seven sins were monitory, didactic exemplars, shown often in retable or choir stall as vice against virtue, good struggling with evil.

In Madrid's Prado, Cadmus might have noticed Hieronymus

Bosch's *Seven Deadly Sins* painted as a tabletop, probably for use devotional meditation. Once it hung in Philip II's Escorial bedchamber. A central rondel, about which its septad turns, shows the God who sees all earthly evil as the Single Eye on every human heart and mind. The motto below reads: "Beware. God sees." Each of Bosch's illustrations is an anecdote. Pride is a woman admiring a new hat in a mirror held by a demon. Sloth is a man warming himself at his hearth, ignoring his wife's plea for him to rouse himself.

The most legible and formidable nomenclature in the hierarchy of sin is fixed in Roman Catholic doctrine, and perhaps only a fantasy developed within its purview could have conceived vice in such specificity. It has been said that Michelangelo's *Last Judgment* was one stupendous pretext to exploit the male nude on a heroic scale. The same subject depicted by earlier medieval painters proclaimed a more domestic intimacy in the certainty of personal punishment, into which the artist might be plunged, if he did not take proper heed. But later, and perhaps greater, painters so magnified human scale that the Herculean forms had less connection to those norms which bind ordinary suffering.

Charles Baudelaire, a good and bad Catholic, wrote that the Devil's first trick was to make one believe he did not exist. Cadmus's ferocious insistence on personalization and particularization of evil, its negation of positive energy, its power as an immediate presence, the incapacity to love beyond the limits of the self, shows that sin is to be acknowledged in our own flesh—hence, the power in this incarnation of its reality and essence.

Notions of sin, descending from Yahwistic definition (the fall of Lucifer, the expulsion from Eden, the crime of Cain), are basic in concept, promulgated and developed from Judaism through Islam, but in the Christian Church are increasingly subtle and complex. The ascetic Origen (A.D. 184–254), one of the Church fathers, adumbrated ideas upon which further instruction and warning would be based. John Cassian of Marseilles (c. 360–435), a Scythian monk who borrowed Eastern monasticism for Western practice, established the canonical categories. Evagrius, a fifth-century follower of Origen, classified the root sins as eight: Gluttony, Fornication (Lust), Avarice, Envy, Dejection (or Sadness), Anger, Sloth (Weariness), Pride (or Vainglory). Dejection, or lack of pleasure, a common fault of monks

and nuns, was fused with Sloth; Vainglory with Pride. Great saints, Ambrose, Bernard, Augustine, Aquinas, and Ignatius Loyola, continued to demonstrate how evil can be recognized and abjured. Chaucer's pilgrim parson on his way to Canterbury sermonized concerning the seven: "They are all leashed together, trunk of the tree from which all others branch."

Cadmus makes no reference to the neurotic hysteria that victimized the cloisters, which modern behaviorists forgive as a prior conditioned weakness of the traumatized will. This artist sees sin as timeless and ubiquitous. Yet despite his declared agnosticism, he seems to inherit Christian hermeneutics even in his idiosyncratic iconology; he places each of the seven as a mirror of itself, each stares back at us, reflecting and exposing our own filthiest secrets. He has confessed that he himself posed for every one. In this he might have had Augustine of Hippo (*Confessions*: III, 8) as his authority:

But how can vicious sin touch you, Lord, since you can't be hurt by anyone? How can violence harm you since nothing can move you? Your chastisement is for sins which men transgress against themselves, because though they sin against you, they wound their own souls and their harm is to themselves.

We discover Cadmus's personifications are not implausible grotesques, rather they follow Pope Gregory the Great's proviso: "They are able to serve as the soul's normal perils under life's ordinary conditions." Their order of importance, established by him in the thirteenth century, is no longer random or accidental. His sequence is that followed by Dante and Chaucer. Pride commands, infecting the next half dozen—Envy, Anger, Sloth, Avarice, Gluttony, and Lust, the last and perhaps the least. A more modern Jesuit reassignment retains Pride in first place, then Avarice, Lust, Anger, Gluttony, Envy, and Sloth. The positions of Envy and Anger are sometimes interchanged. Recently, due to a preoccupation with post-Freudian emphasis on sex, there is some tendency to elevate Lust from least important (though lust and sex are not exactly synonymous).

A Franciscan contemporary of Pope Gregory, one Berthold of Regensburg (c. 1220–72), in missionary homilies on sin and its relevance to the Ten Commandments, opposes to it seven virtues which clarify by contrast. Against Pride stands Humility; Avarice, Generosity

(almsgiving); Lust, Chastity; Gluttony, Temperance; Envy (and Hatred), Love; Anger, Prudence (or Patience); Sloth, Diligence. After Cadmus had completed his series, W. H. Auden suggested he engage upon a second, of the Christian virtues. However, the painter felt that the static or passive factors visible in each did not lend themselves to any vivid or dynamic representation.

Disclaimers may be made for Cadmus's cursory denomination of his seven as *moral.* Canonically, this may be a misnomer; actually, he painted the venial, or lesser, sins. If any sort of believer, Cadmus is a lapsed Catholic; it would be easy to assume that his morality stems from Saint Paul's incontrovertible principle: "What does not come from faith is sin." Sin as Pride is man's refusal to recognize God as God. As in Greek hubris, man tends constantly to deify himself, to make the self absolute, despite obvious psychological limits. In self-sufficiency, self-indulgence, and egotism are denied both cosmic or divine order and love (or at least charity) for others. Venial sin, though it may lead to those which are deadly, and is the greatest evil save mortal sin itself, still does not annihilate the soul's contact with God. Venial sin, said Origen, is morality's infirmity or disease, not its sickness unto death. Grace still abounds and by it a soul can be repaired.

With the Jews, sin was communal, lodged in and borne by tribe or nation. With the Christian dispensation, sin became personal. Holy Church never sinned; individual men did. The word "sin" comes from a Sanskrit root meaning "to miss the mark." When inadequate energy or will is directed towards a goal of perfection, the degree of failure measures the hazard of doom. In the early Church councils, the deadly sins were Idolatry, Murder, and Adultery. The first, which of course encompassed Pride, or self-love, being the worst. Cadmus depicts the proliferation of vice leading to and from each of these, which proceeds to excommunication (denial of sacraments) and damnation (Hell). For Idolatry is worse than simple vanity; it cancels the notion of the interrelation with and responsibility for others. Anger leads to murder, Lust to adultery, but, as an artist, Cadmus fixes no focused image of killing or concupiscence as did Bosch in the Prado tabletop. To Cadmus, each sin is a more personal extremity of imbalance or impotence rather than blind aggressive negation. Indications are even towards suicide, but there is also present the burden of grief. His ambivalent or questioning attitude towards orthodox dogma is reflected in spe-

cifics. As for idolatry, his *Pride* shows no capricious worship of another devil or deity, but an idiotic adoration of the preposterous self-impersonation. *Anger* is not depicted as leading to a brother's murder, but only to one's own damage. *Lust* typifies postcoital, morbidly priapic dejection, and manic-depressive engorgement, not the rape of another person.

In the Cadmus series, *Pride* is self-love, the fault of insensate singularity, individual obsession, or rebellion against limited possibility in ordained creation or cosmic order. Its quick virus infects Envy when we assume we deserve more than we've been given, or wish we were other than we are, merely from supposed need or accidental desire. Pride poisons Anger through impatience, followed by neurotic dissatisfaction, culminating in hysteria and mayhem. Pride in Avarice loosens us to boundless greed or locks us in a surfeit of its own frustration. Pride in Gluttony repletes without stint appetites that swell to bursting, while starving us for the savor of natural provender. Pride in Sloth reduces energy to sluggish dreams and conceits of nihilism, emasculating the will. Pride in Lust cancels companionship in affection, exhausting psyche and physique in the expense and waste of transient excitement.

In Cadmus's painting, *Pride* is actually depicted as *Vanitas*, an inflated androgyne (all seven sins are double-sexed). Its body is a plastic balloon with armored fists tensely clutching bulging breasts, adorned by a peacock's plume and a military order. It grins with the smirk of a fashionable matron or hairdresser's dummy with spray-lacquered, self-conscious, gilt curls. Its frozen mask is veneered in cosmetics. Thin skin, a synthetic integument swollen by gas, is pierced by a spike from mineral depths. Its blistered iridescent gut all but reeks of escaping fetor. Cadmus's image suggests a social snobbery that in self-satisfaction or arrogance condemns the rest of the world as unequal or inferior. As with envy and anger, its energy springs from love's negation, the empty stance of self-assigned worth, diverted or perverted from natural instinct, warped away from self-respect or self-preservation. Pride is grateful for nothing.

*Envy* is seen as a reptilian mendicant stalking a liverish landscape sewn with needles, which pierce feet withered from lack of flesh and blood. Crowned by a nest of vipers, its mean, pinched grin is a rictus of discontent and its body is clad in the endless cast of a snake's

Pride (1945) *from* The Seven Deadly Sins *by Paul Cadmus; egg
tempera on pressed wood panel*

*Detail:* Anger (1947) *from* The Seven Deadly Sins *by Paul Cadmus;*
*egg tempera on pressed wood panel*

exhausted skin. From its chest swarm venomous worms, while fin-
gernails terminate in fanged jaws. Traditionally thin-lipped and slit-
eyed, the envious were seen by Dante as lacing their eyelids with iron
threads. They could not bear to look upon the sun's promiscuous light
or the chance luck of others. Envy is without gratitude for what it has
or may be given.

   *Anger* resembles a science-fiction cartooned superman, screaming
in feckless wrath, enraged by the self-heated furnace of an iron breast.
Shoulders bristle with hardened thorns, pectorals spout iron spikes,
pig eyes glare in aimless fury. Cadmus's ingenious and spectacular
invention depicts rampant, uncontrolled hate, for the demon has just
smashed the glass glazing its own portrait. Jagged fragments slice its
inflamed flesh, spurting hot gore against the splinters. With the familiar
shibboleth "It's good to get it off your chest," we express and pardon

our rage through behaviorist therapy. But irascible self-indulgence scorches the spirit, most of all wounding its reason. Anger is not identical with hatred, but is a torch to it. Berthold of Regensburg preached that wrath is bred of impatience, grows by self-induced agitation, and launches hysteria leading to murder.

*Sloth* is an elephantine, miasmal android whose lower limbs founder in primordial dankness, whose glaucous, idiot eyes lift sadly in the glazed vacancy of a dream. Though the creature is fouled in sticky layers of its own detritus, we can, if we search, discern a single feeble manifestation of residual energy—a useless, pitiful knot of waste filament which somehow it has managed, however lumberingly, to tie. In crippled lethargy, the monstrous sluggard is overwhelmed by both muscular and moral torpor. A spineless, irksome mass of involuntary ennui, this behemoth is a crusted amphibian whose eternal suspension in tepid swamps encrusts its leprous scabs with bloodless gangrene. Barely sensitized, energy is at so low an ebb that it is almost impossible to separate animal from vegetable matter, but neither holds the chance for growth. Sloth has not the strength to thank or praise.

*Avarice* in orthodox theology is "inordinate love of material goods." In Cadmus's personification, a spidery, taloned oldster, based perhaps on a world-famous, dime-donating philanthropist, its cheeks skinned to skull, rib cage flayed to bare bone, hauls a backbreaking sack of rubbish, which adheres as a cancerous lump. Its claws snatch at falling nuggets of fool's gold, which turn to lead in the clefts and breakage of a sunless, exhausted mine shaft. No meat sticks to those tendons hairy with arthritic ague. Miserliness clamped in vulturine anxiety is latched on metal, worthless for exchange or use, its fictive rarity or rigged price its sole value.

*Gluttony* is a horror so revolting in its gross visceral deformation that it is often dismissed as too disgusting to scan. A thing composed entirely of intestines, its greasy fatness boasts no absorbed nourishment but gut function only, the dulled automatism of digestion and excretion. Wormy spaghetti filters down into its slack, gaping maw, fumbled by flabby stumps of paws too blunt for any articulation. Belly, crammed to bursting, has already exploded, only to be slovenly resewn with bits of food that stuff it. Out of its dugs spurt waste. The undigestible swill of its incorrigible hunger cannot be evacuated, since its bloat and

ferment, sagging to overflow, are tightly tied at the vent. Accumulation of unneeded food ingested in mindless appetite is the waste of necessary sustenance.

*Lust* in its arresting indecency is the single panel which, set beside the other six, has often rendered all seven unacceptable to shy museum officials or a horrified public. Instead of proposing a naïvely porno-graphic image of sexual arousal, Cadmus's smiling obelisk erects itself as both repulsive and menacing. Double-sexed, its anthropomorphic shaft embodies a gigantic penis sheathed in a huge drugstore condom. Facial expression is evenly balanced, the left morbidly sad, the right hysterically glad. Thumbs mutate into swollen male members; hairy armpits are also orifices; the navel is an anus. Here sexuality admits no gratitude for tenderness; its lonely heat is a vain attempt at self-gratification. The loveless slave of abuse or rape, it exposes itself in a flasher's shameless pride—rampant, unpurged, unsatisfied, and drunk on guilt.

Originally *Luxuria* was called *Concupiscentia*, signifying selfish desire, and was only in the strictest sense sexually focused. Lust as legal adultery followed the Mosaic commandment. Cadmus's most flagrant and easily legible personification reflects a current ambivalence towards the quality and gravity of guilt and responsibility burdening the individual conscience, in the light of our psychological apologetics and the present confusion in academic philosophy.

# IV

# FILM,

# LITERATURE,

# THEATRE

# James Cagney
# and the American Hero

[*First published in* Hound & Horn 5.3 (*April/June 1932*). *See also p. 44.*]

EACH MOVIE TYPE has several faces. There is a hero who has been a nice-looking juvenile from Wallace Reid to Douglas Fairbanks, Jr.; he has two or three dialects of action from fresh, rough-and-ready to wistful and sappy. He has had his attendant heroines from the Gish girls to Janet Gaynor. Then there are the types of villainesses, or heavies, from the vamp who was Theda Bara to the anomalous villainess-heroine of Greta–Dietrich. And they have had their corresponding villains. There are a few other masks—the comedians, for example, each with a little more solid differentiation due to a technical development.

Every so often in this carefully bred descent of types there is a line of sports, of powerful exceptions. For example, figures arise, not with "sex-*appeal*," as Gilbert Seldes pointed out, but with "sex-*menace*"—which is something else again. Rudolph Valentino had sex menace; so has Clark Gable. It is silent, imperious, will not be denied. Valentino was exotic, foreign, scarcely American. Gable is hardly exotic; he is as American as Eugene O'Neill. He is a strong silent man, or he is the 1931–32, maybe –33, model of a strong silent man.

The strong silent man is the heir of the American pioneer, the brother of Daniel Boone, whom James Fenimore Cooper immortalized as the American type for Europe. The strong silent man has been a trapper, a cowboy, a miner, a railroad man, a soldier, a sailor, a U.S.

Marine. He has become, now a surgeon, an architect—even a movie director. The strong silent man means America, just as a hunting squire means England, a man in a silk hat and waxed mustache means France, and a bullfighter Spain. He is more American than Uncle Sam, and now he's a gangster—or was. The public is supposed to be fed up with gangster films, so he talks tough guy and is a taxi driver or an automobile racer. The origin of the lean, shrewd, lantern-jawed, slow-voiced, rangy, blond American pioneer was in the New England adventurer in the West. The type has become a short, red-headed Irishman, quick to wrath, humorous, articulate in anger, representing not a minority in action but the action of the American majority—the semiliterate lower middle class.

James Cagney, while he is neither typically strong nor silent, does excellently as the latest titleholder of a movie type which either has become or is derived from a national type. Cagney, in a way, creates his own type. After the creation we can put it in its proper niche in the Hall of Fame of our folk legends. Cagney is mick-Irish. He was trained as a tap dancer. He has had a small experience as a "legitimate" actor. He is the first definitely metropolitan figure to become national, as opposed to the suburban national figure of a few years ago, or of the farmer before that. He is, or has been, quick-shooting, while old Bill Hart was straight-shooting. He snarls, "If I taut yuh meant dat, why I'd . . ." instead of "When you say that, pardner, smile." He twists a grapefruit in his lady's face, which is the reverse and equivalent courtesy of the older "ladies first" school of etiquette. It delights and shocks us because it is based on the reverse of chivalry. Cagney may be a dirty little lowlife rat, a hoodlum, a small-time racketeer, but when his riddled body is propped up against his mother's door, mummied in bandages and flecked with blood, there is a catch in our throats and we realize that this is a hero's death.

Cagney, in spite of the coincidence of his character with the American tough guy, whether it's a racketeer or taxi driver, is an independent actor in his own right and as finished and flexible an artist as there is in the talkies today. He has resisted every attempt to exhaust him by having him act the same character in every play. Few new actors ever can survive the prestige of their first success. Cagney has an inspired sense of timing, an arrogant style, a pride in the control of his body, and a conviction and lack of self-consciousness that are

unique in the deserts of the American screen. We may think of the stock gestures of an Elizabethan bravo, slapping the rapier into scabbard, cocking his hat, or leaping to his horse, as typical active Elizabethan. In America there are men and boys lounging in front of drugstores, easing down off trucks, lifting up the hoods of their engines, sighting for a cue on a billiard table, tossing down their little pony of raw whiskey, or even shooting through the pocket of their double-breasted tuxedos. When Cagney gets down off a truck, or deals a hand at cards, or curses, or slaps his girl, or even when he affords himself and her the mockery of sweetness, he is, for the time being, the American hero whom ordinary men and boys recognize as themselves and women consider "cute." It is impossible to tell at once whether his handshake is cordial or threatening. He is "cute"—the way Abraham Lincoln said a certain trapper was "cute"; that is, quick, candid, and ambiguous. Cagney is not a man yet, but neither is he a juvenile. He has not allowed himself to rely too much on the good stories and brilliant dialogue that he has been given. In his next picture we will see him as an automobile racer; after that as a prizefighter. No one expresses more clearly in terms of pictorial action the delights of violence, the overtones of a semi-conscious sadism, the tendency towards destruction, towards anarchy, which is the basis of American sex appeal.

# Eisenstein:
# ¡Que Viva México!

[*Between December 1930 and January 1932, Sergei Eisenstein, on leave from his duties in the Soviet Union and with backing from the novelist Upton Sinclair, shot a massive quantity of footage for a panoramic history of Mexican civilization, to be called* ¡Que Viva México! *Through a combination of politics, quarrels, soaring costs, and ballooning schedules, the project fell apart in public during early 1932. Eisenstein desperately tried to retain control of his film, and in April 1932, en route to the Soviet Union, he stopped in New York to try to edit the rushes. Kirstein, who had been introduced to the director by the art historians Alfred Barr and Jere Abbott, showed him the city's high, and low, life. To Eisenstein's intense disappointment,* ¡Que Viva México! *was eventually broken down and rearranged into several smaller, less ambitious films, including* Thunder Over Mexico *and* Death Day. *When a preview of* Thunder Over Mexico *was shown at the New School in 1933, Lincoln Kirstein rose to make a speech of protest and was thrown out. This essay was first published in* Arts Weekly *1.8 (April 30, 1932).*]

IN A VERY brilliant Commentary in the April 1932 issue of *The Criterion*, T. S. Eliot analyzes the present attitude towards social ideas in general, and Communism in particular, on the part of the young intelligentsia, in a way which no person, even vaguely interested, can possibly ignore. Not the least interesting implications are in relation to the power of the individual artist under Communism.

One great test of a society is the kind of art it produces. Art in its highest development, both in Europe and in Asia, can hardly exist without a sense of individuality, a sense of tragedy, for which Communism does not seem to leave room. There must be many people like myself who can be more quickly and completely convinced of the justification of Communism, or of any new form of society, when we are convinced by art instead of philosophizing. It is perhaps premature to judge of Russia until a generation has grown to maturity which has never known any condition but settled Bolshevism. I am, unfortunately, incapable of being convinced by the arts of the cinema; though I am willing to admit that a comparison of Russian films with American films somewhat favors the former.

Fortunately, I am capable of being convinced by the arts of the cinema, and I think that had Mr. Eliot the extraordinary good luck of myself in the last ten days, he also would have been convinced. Sergei Eisenstein, the director of *Battleship Potemkin, Ten Days That Shook the World*, and *The Old and the New*, has been in Mexico for the last eighteen months and, with his two remarkable colleagues, Alexandrov and Tissé, has filmed a picture which will be called, if and when cut, *¡Que Viva México!* I saw only about thirty reels of over two hundred that were taken. These "rush" shots were shown in the sequence in which they happened to be filmed; that is, in no regular order. Sometimes the same scene appeared four or five times in succession, each time altered and improved as the direction demanded. Personally speaking, to sit in the small projection room with Mr. Eisenstein scratching down notations in Russian as each reel flashed by, with the cameraman on the one hand and the director on the other, all faced with footage which they had not seen since the moment it was taken over a year ago, and commenting on the sequences, was a very absorbing experience. More critically, I am sure that anyone would agree with me in thinking I had seen perhaps the richest material, both from a human and an artistic point of view, that ever was the potential substance of a film.

This tentative superlative is justified. Standards of movie criticism which have been erected in this country to apply to the mass of Hollywood movies, or even occasional foreign ones, so rarely apply to an independent excellence that every time an unusual event occurs the critic has almost to apologize for his failure to pigeonhole it. This new

Eisenstein film is not one story but four separate novels recording the social history, the essential geographical and spiritual quality, and the very human heritage of a nation. It is not an "epic" in the American sense of *The Birth of a Nation,* but in the international sense of *War and Peace,* or *Battleship Potemkin.*

The first section will be called *Xandunga.* It is the name of a native dance of the Indians of the Isthmus of Tehuantepec. In it the origins and sources of the Aztec, Toltec, and Maya cultures are not reproduced but created in their existent entity. The profile of a living Indian, his face cut out of his obsidian mask of flesh, stands under the cut-stone mask of a bare-fanged deity thrust out from the walls of Chichén Itzá. The correspondence of face type, bone structure, skin texture, pride, and dispassionate nobility is staggering. The whole section will be extravagantly full of the tropical breath of the indigenous background—the swung tails of bearded apes clawing at toucans, the huge round crockery jars with huge round hats of sleeping Indians beneath, basking under a sun so bright as to be black—the compulsion of the rhythms of the Xandunga itself, tossing the heavy headgear and swing-flashing skirts of the dipping dancers revolving in a precision of consecutive motion—bound together by a simple story of a direct tenderness which is perfect for the purpose.

The second novel is called *Maguey.* This colossal, smooth-leafed, branching cactus, from which the national drink of pulque is drawn, is its recurrent symbol of peonage, the feudal oppression by the owners of great farms or haciendas. The maguey plant fills the screen; then we see the cheek of a peon pressed against the fat cheek of a calabash drawing up, through its trunk-like tube, the liquor from the cactus heart. The hacienda itself is a huge walled citadel under the shadow of whose stones the sorely oppressed peons brood on revolt, steal rifles from under the shadow of Díaz's preposterous portrait, set off a bull of fireworks in a corridor of streaming shadow, attack—and fail. The final terrific tragedy of the stamping out of the peon's brains by a battalion of stallions under the spurs of the Spanish heirs is of such proportionate intensity as to make it forever a part of the personal experience of the spectator.

Each section, each novel, has a different and particular treatment, an individual idiom which suits it like a frame. The third, *Fiesta,* represents the Mexico of before the revolution; the effete bourgeoisie

of Spanish corruption, the glorification of the bullfighter, the laziness of the urban bureaucracy of Church and State. Eisenstein, with his unfailing sense of fitness, has filmed the sequence, in part, in the style of popular cheap postcards—the wax-mustached parlor caballero strumming his guitar at the feet of a mantillaed tart, whose lavish grin has the background of the floating pleasure gardens of Xochimilco. A short résumé such as this has only the value of an advance notice; one cannot possibly describe moving pictures if one has volumes of blank paper—only the scenes themselves are their own definition: the matadors, somber and swift in their dusky splendor of heavy fighting clothes, kneeling for a moment under the feet of a fine Spanish Christ, before the glare and dripping horse guts of the arena.

The fourth section has to do with industrial Mexico. The pyramids of Montezuma's people are superimposed upon the pyramids of factories; but the identical aspiring shape maintains. The Maya priests mount the steps of the Temple of the Thousand Columns, and their pure descendants advance towards the grain elevator with their fathers' faces towards the future. A fifth section of the actual revolution was proposed but failed of accomplishment. But the film as it will stand is an architectural whole, amazingly rich in cross-correspondence, in inscribed comparisons, in that devastating irony and surpassing beauty which Eisenstein controls.

The photography of the film has a clear-edged intensity of differential color values that makes everything but our occasional newsreel look like fogged glasses. The opposition of breathing skin to polished leaf, to the undyed warp of a serape, to the air of clouds and dust of earth, has a feel of visual reality which is entirely tactile.

The use of actual "types," acting as themselves, or seduced by Eisenstein into behaving as their prototypes, which they unconsciously do, gives a pulse of reality, of entire conviction that is so tremendously appealing as to exhaust, on the one hand, and spoil one's eye for anything else, on the other.

Eisenstein is that, in our times, so much sought-after and denied human being—a genius. The word still holds. It is compact of energy, direction, and the capability of seeing through to every implication of object used as his material. His social attitude is the only possible one for an artist courageous enough to employ the full exhaustion of his potential, in this time.

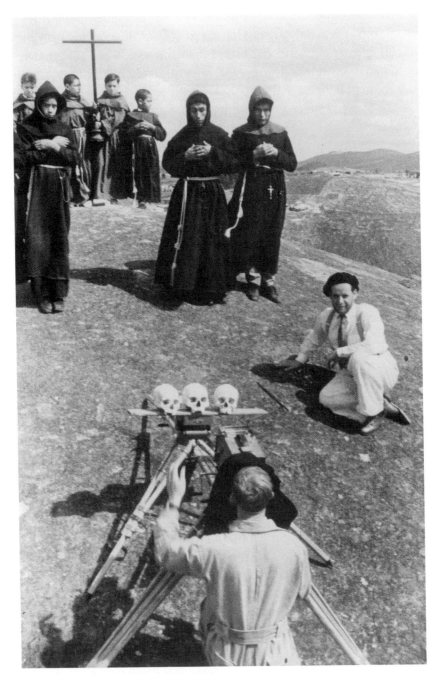

*Sergei Eisenstein (right), in Mexico in 1931, organizing a shot during filming of* ¡Que Viva México!

If anything should happen to *¡Que Viva México!* between now and the time it is cut and shown to rob it of Eisenstein's final fingering, it would be a loss of staggering dimensions. There are no catalogues of the Alexandrian Library which Caesar's fire ignited, and we have only the Rubens copy to show us what Leonardo's *Battle of Anghiari* may have been. For us their loss would have been less crippling than this film of the heart of a consciousness, this testimony of extreme distinction.

# Hemingway's
# Canon of Death

[A *review of* Death in the Afternoon *(1932)*, *first published in* Hound & Horn 6.2 *(January/March 1933)*.]

''THE PRESENT volume, *Death in the Afternoon*, is not intended to be either historical or exhaustive. It is intended as an introduction to the modern Spanish bullfight and attempts to explain that spectacle both emotionally and practically.'' *Death in the Afternoon* is more than an introduction to bullfighting. It is also a spiritual autobiography, a study of manners in the Iberian peninsula, and a book, which, though not fictional, concerns the craft of fiction. It also defines in a way which has perhaps never before been attempted, at least in the English language, the ecstasy in valor.

A book about bullfights, it is in more ways than one a book like a bullfight. Mr. Hemingway commences his apologia with a defense and a justification for the disemboweling of horses. To many of his readers *Death in the Afternoon* is a revolting book, not alone because of his descriptions of corporeal decay, nor from his free speech. Indeed, there are qualities in the book which are so hateful that, like the horses, they are best suffered first.

*Death in the Afternoon* is, of all personal books, the most personal. The quality of its author's character is imprinted in the ink of the type on every page. The one thing Mr. Hemingway prizes above all others is that kind of valor which is the "strength of mind in resisting fear

and braving danger; bravery; especially, courage and skill in fighting."
There may be other kinds of courage but it is with physical courage
alone he is occupied. His approach to physicality is immediate and
tactile. He can only describe what he has seen with his eyes, touched
with his hands. Not only does he distrust any other perception, he
virtually denies its possibility. He divides most males, and this also is
a book of "Men Without Women," into two classes, those with balls
and those without. He allocates his maleness according to his preju-
dices and has always in mind his two categories. It is for them he does
his writing, or at least for and in praise of those that have; in spite of
and against those that haven't. Those that have balls are certain bull-
fighters who are unimaginative enough to be incapable of fearing the
intense danger to which they are constantly exposed, or those who,
imagining it, can transcend it, "Goya" and "William Faulkner." Those
who have not are certain cowardly toreros who fake courage without
achieving it, upper-middle-class American snobs, "those who suck
after intellectuals and marry money," magazine owners, "well-fed,
skull and bones-ed, Porcellian-ed, beach-tanned, flannelled, Panama-
hatted, sports-shod men, 'Radiguet' and 'El Greco.' "* This distinction
may be infantile, naïve and limited, but it means a great deal to Mr.
Hemingway and it is the source of his limits. In the terms of his limits
he can best be explained.

At the present, physical courage is scarcely a necessity, at least
among people who are not professional sportsmen, workers with treach-
erous machines, soldiers, steeplejacks, or the like. Chivalric valor lurks
in the Boy Scout manuals and is presupposed in sport, but one scarcely
ever thinks of one's friends as brave or cowardly in terms of their
bodies. Mr. Hemingway very much does. For him, valor is almost
the ability to die well, and his contempt for his fellows who accept an

---

* Hemingway accuses Meier-Graefe of going to Spain to see its paintings "in order to
have publishable ecstasies about them." That he went to see bullfights for the same reason would
be as true. Hemingway's opinion of Greco is his own and will no doubt influence the same
people who think *The Sun Also Rises* is a great work. From what we know of Greco, he did *not*
"believe in the Holy Ghost, in the communion and fellowship of saints . . . and in fairies." He
was had up by the Inquisition for heterodoxy, his library contained more classical than Christian
writers, he was suspected of being a heretic; he was surely a supreme satirist, as anyone who
looks at *The Burial of Count Orgaz* simply knows. The documents of his domestic life would
confuse Mr. Hemingway if he read them. There is no trace of viciousness at all.

unheroic end is close to the snobbish contempt of a bully, without kindness, sympathy, or the profounder comprehension of the chemical roots of cowardice.

The presence of physical bravery, that is, on its most elemental plane, the plane of a child's courage, is a personal attribute not unlike physical beauty, as disparate, and for most purposes as irrelevant. Rank cowardice can be as sickening as a ghastly scar, when it is not psychopathic. The balance between action against odds and inaction may be a moral balance, but a nerveless bravery without thought of reverse possibility, however fair to see, is hardly the subject for praise or blame. Mr. Hemingway believes in the courage of immediate physical action above all other. It is an implicit belief in the innocence of animals, in the purity of uncorrupted flesh; its godlike thoughtlessness. He is not busied with the courage of the mind, the energy of a moral activity restless in its penetration to the heart of truth, unflinching at any self-imposed limits. He does not recognize that valor above the quickened pulse and caught breath, the valor necessary to ignore one's own hard-erected categories, to exceed the limits that might endanger one's position as a finished technician on a certain plane of development. He does not admit the simple bravery of a man doomed to an exploitation of every possibility of human morality, for whom physical death, however superbly received, is no release.

Ernest Hemingway, more deliberately and consciously than any American writer of fiction since Henry James, has occupied himself with his education as a man of letters. Like every new artist of power he has the conviction that no one before him ever achieved the razor truth of indestructible accuracy in rendering emotion. So he went to Spain, where, since the wars were over, such a simple thing as physical death could be anatomized down to its last ritualized detail. He occupied himself first with death, since it is less complex than life—perhaps because the terrible unreality of war had rendered his perceptions anemic, and he could bear the simplicity of orderly death, the real limits of synthesized bloodletting, feeling here was life in its essential microcosm. One can hardly pass any judgment on this attitude in *Death in the Afternoon* until the appearance of its author's subsequent work. Then one can see whether or not an education in mortality has had the desired effect.

*Death in the Afternoon* has been called a classic of presentation.

It commences with mentioning the unmentionable, the visceral comedies of a horse's ripped belly; take it or leave it. Shortly an old lady is introduced, a fiendish beldam of gracious cruelty and kindly spite, who speaks in the formal diction of an excellent translation of Cervantes. The old lady at first seems Hemingway's compacted adversaries—those who are bored by bullfights, those who think he should stick to writing conversation, which he, at least, does well. She voices the reader's own unvoiced objections before he thinks of them, to allow the author to settle the score before he is sure it is this or that to which his enemy really objects. She is a device of genius, and in his dialogue with her it is at once apparent in its finished state what has been felt before in approximation—that Hemingway's talk is more dramatic than his situations, and he is admirably fitted as a writer of plays.

OLD LADY: Well, sir, since we have stopped early today why do you not tell me a story?

About what, Madame?

OLD LADY: Anything you like, sir, except I would not like another one about the dead. I am a little tired of the dead.

Ah, Madame, the dead are tired too.

One would think from this notice that the mention of bullfighting in *Death in the Afternoon* was secondary to various ideas of living and dying. But if Hemingway is forgotten as a novelist and as an influence, his book on bulls will be read always as the most complete definition of the decadence of that phenomenon. It gives one the very rare illusion, after having completed it, that one knows all about—that there is literally nothing more to learn of—a single segment at least of human experience. His technical descriptions are also for laymen, and with the wonderful photographs a completely legible and absorbing guide. He has a visual memory which creates in one his two kinds of travel books, a true promise of Spain before you've been there and a living reconstruction after you've come away.

Some artists have a superb overflow, an extra exuberance of creative energy which splashes all over the formal structure of their work. One thinks of Melville's chapter on the "Whiteness of the Whale," of Byron's bad rhymes. In Hemingway the overflow is there too; of a different sort, to be sure, but in the same relation. With him it is his

personal sneers, his irritable cheapness, his disposal of men he dislikes as fairies with the same lazy bravado of Marxians dismissing the petit bourgeoisie. It is his insistence on including private references to shock, and to give trouble to the collators of his posthumous editions. It is his bullying and his adolescent apology for the expression of any overt feeling, which fortunately by no means hinders him from its accurate and splendid analysis, and it is the other meanness and lack of grace which is only socially embarrassing, and which he so relentlessly scorns in others.

But however irritating, this overflow is separate and meaningless. The sum of the book stands head and shoulders above his worst self; it is his best self. That it is as good as it is and no better is perhaps a severe judgment upon the whole nature of our literature. That the discipline to which its author subjected himself in order to write it was deliberate and possibly artificial, that the choice of the subject matter itself is remote from the majority of his countrymen's interest, and of a decadent form of entertainment in a decadent period, is all true enough, and on account of that fact the book's importance is enormous as a definition of the state of affairs in which artists find themselves today. Hemingway, whether he likes it or not, is at once a reformer of literature and a violent reactionary. He has made it almost impossible for anyone to write loosely of a certain portion of physical experience again. His conviction that nothing is really like what most writers think it is, of the almost complete inexpressibility of the essence of anything, may cloud his own expression with a petulant impatience, but it is a sovereign warning for anyone who attempts less. *Death in the Afternoon* is an exhilarating, exhausting, and thorough monument in spite of its author and its time, a tragic masterpiece whose tragedy is also implicit in the character of its author, of his time, and of his work.

Hemingway's eloquence concerning the delights of dealing death is the climax and point to this book. Just as completely as he has shown us the minute shifts of wrist, sucked-in belly, and the profiled thrust; just as he has taken us to bull testings, to the cafés where the hangers-on sit with the promoters over the food they eat, the talk they talk; just as he has smelled for us the exact taste of courage in the throat, "the smell of smoked leather or the smell of a frozen road," so has he unalterably demonstrated the transports of a matador, as he plays the whole crowd through the bull "and being moved as it responds in a

growing ecstasy of ordered, formal, passionate, increasing disregard for death that leaves you, when it is over, and the death administered to the animal that has made it possible, as empty, as changed and as sad as any major emotion will leave you." Hemingway knows how separate and inert our contemporary existences are from the elements of living, from a more primitive and unconditional sensibility, and he has almost erected a canon of death to restore to us the capacity for life. "Once you accept the rule of death 'Thou shalt not kill' is an easily and a naturally obeyed commandment. But when a man is still in rebellion against death he has pleasure in taking to himself one of the god-like attributes; that of giving it."

He has penetrated further into the anatomy of a kind of bravery and cowardice than perhaps any living writer except T. E. Lawrence. The author of *The Seven Pillars of Wisdom* could afford to presuppose his courage, which Hemingway cannot, but he was writing about pure action engaging masses of men in actual carnage. "Blood was always on our hands: we were licensed to it." The bullfighters are more priests than warriors. The blood on their hands is almost sacrificial, and it was Hemingway's misfortune that the war failed to teach him how men died, so he had to investigate the artifice of how men have continued to kill and not be killed. Only the behavior of a man in the face of sure death seems to convince him of his ability to live. More insistent on a unique aspect of humanity than D. H. Lawrence, Conrad, or Stephen Crane, he achieves by this concentration a greater intensity, if a slighter reference. Hemingway is an incomplete tragic artist whose willful limits, as yet, exclude him from the company of creators of living character. He has, to be sure, given us characters, but they have the signature of his choice attached, and he has personally endowed them with their characteristics. They do not exist in their own air, independent of his approval, as do Anna Karenina, Starbuck, or Leopold Bloom. Convinced and a master of a physical world as he now is, can he dare to acquire a knowledge of the others? No one, at least in this country, knows how much there is to be known for the purposes which he has so far proudly professed.

# On Producing
# A Midsummer Night's Dream

[*The American Shakespeare Festival Theatre Academy, founded in 1955 and with which Kirstein was associated until the early sixties, held a season every summer in a large wooden theatre in Stratford, Connecticut. The aim was to create, within striking distance of New York and using American actors, a national repertory company capable of mounting serious Shakespearean productions. The participants included Katharine Hepburn, John Houseman, and Morris Carnovsky. This essay was published in* A Midsummer Night's Dream, *ed. Charles Jasper Sisson (New York: Dell, 1960).*]

## I  The Aim of the Production

THIS ESSAY was prompted by a production at the American Shakespeare Festival in Stratford, Connecticut, in 1958. The production was directed by Jack Landau, with settings by David Hays, costumes by Thea Neu, music by Marc Blitzstein, and dances arranged by George Balanchine. The essential aim was to follow Shakespeare's original intention as closely as possible.

*A Midsummer Night's Dream* was probably devised originally as part of the entertainment at a noble marriage. The marriage itself would have taken place in broad daylight, "after the toune be rysen with honours and reverence," and the play would have been performed that night at the wedding feast. Noble weddings were splendid enough to cause the early Puritans to rail at their vain shows. Several such

weddings have been suggested as the occasion of the play, the most probable being that of Elizabeth Carey and Thomas Berkeley in 1596. Many masques and entertainments for weddings survive, and splendid weddings are sometimes called for in plays of the period.

That any play can be visualized in a variety of styles goes without saying. If A *Midsummer Night's Dream* was first offered as part of a wedding celebration, it was surely enacted later on the London stage, with appropriate alterations. The play as we have it can be thought of as having an ending for production in a private house, with Puck sweeping the hall before bedtime, and another ending for the play-house: a final dance. In the 1958 Connecticut production there was a synthesis of the two endings. The aim was not antiquarian accuracy but an imaginative re-creation of an entertainment composed by a great poet for a splendid occasion.

Productions of this play in the last century suffered from too much spectacle, but our younger and more analytical directors turn increasingly to the text itself. There is more wizardry in the spoken verse, if said with conviction, care, and charm, than any painted canvas or miraculous dressmaking can manufacture. And so, for this production, we cleaved to the word as written, and tried to echo the author's intention.

## II  Architecture and Setting

The play takes place in the palace of the Duke of Athens, in a workmen's room or shop, and in a nearby forest. The original performing area was probably the Great Hall of a manor house. Such a house was large enough to accommodate Queen Elizabeth when she was the guest of one of her great nobles on one of her summer "progresses." With its barns and dependencies, the house might have had to care for three hundred bag-and-baggage carts, a huge staff of domestics (besides the regular house servants), and the court guests, horses, grooms, and retainers.

This manor house is no fortress. We are no longer in the medieval world of heavy masonry-bearing walls, slit windows, and surrounding moats. Society is reflected in the play. Egeus is the conventional squire, the father of a country family. Theseus is more justice of the peace than great captain: magistrate, not tyrant. His soldiers are gentlemen

armed for the hunt rather than a fight. His realm is not a castle but a country house. Charlecote, the home of Sir Thomas Lucy, connected by tradition with Shakespeare's youthful poaching imbroglio, would be an excellent model.

The structure of a Great Hall in a country house in which a queen could have been welcomed, or a duchess married, determines the style and often the movement of the play. The scene is not changed by complete changes of setting but by means of simple visual props or descriptions in the verse. The actors perform, not within a square proscenium, curtained and footlit, but at the far end of a huge oak-beamed room, whose heavy slate roof is supported by massy timbers, and through whose high, lead-paned lights we can see the surrounding trees. The movement passes up and down, in front of and behind a splendid ornamented staircase which has two symmetrical flights of steps, each leading by at least one turn to the gallery above, which gives off to the upper bedrooms. One can imagine, outside, formal knot gardens of box or yew, with topiary birds and sculptured hedges. Beyond is the deer park, which merges imperceptibly into Oberon's oak wood.

In Stratford, Connecticut, the theatre is built, inside and out, of a silvery brown, tobacco-colored South American teak. No curtain separates the spacious apron of the raked stage from the auditorium. When the audience has assembled, lights dim in the hall and rise on the stage, to mark the start of a play. For this particular play, we first see the far end of an Elizabethan Great Hall. Broad twin steps turn up towards a balcony, fronted by a pierced foliate grille. High above hangs a large verdure tapestry, a greeny-blue forest of thin-trunked trees, recalling the background of the great series of Unicorn tapestries in the Cloisters Museum. Their style is medieval rather than Renaissance, like the rest of the play, as if these hangings had been part of inherited house furnishings, in the owner's family for generations.

The action of this production started in dumbshow, with the company of mechanicals, each in character, as house servants preparing the hall for the marriage festivities. Hence it was clear from the first that they were members of a Warwickshire estate's staff, not Athenian workmen. They raised to the rafters great cut-out initials, a double monogram, T and H, in late Tudor script, for Duke Theseus and his Hippolyta. Having made the hall ready, the mechanicals with-

*June Havoc as Titania, Richard Waring as Oberon, and Richard Easton as Puck in the 1958 American Shakespeare Festival production of* A Midsummer Night's Dream

drew, taking much care to behave silently and properly. The master of ceremonies of the ducal household then prepared the way, and Theseus, a lordly but faintly comic figure, made his entrance and began his speech which opens the play.

The verdure tapestry suspended above the gallery was a device of focal importance. In the transformation of the timbered hall into the forest, outdoors, the figured stuff of the tapestry magically divides. It then spreads to thrice its size and surrounds the entire acting area with shimmering leafage. At the end of the play it shrinks, to become woven tapestry again. There is a final glint of starlight through its texture, to reflect fading embers from an unseen fireplace, which Puck sweeps tidy just at cockcrow.

### III  Music

The treasure of sung, danced, and partly instrumental music descending to us from Shakespeare's time is incalculably rich. One may find in it a dazzling, indeed confusing wealth of material with which to adorn the plays.

European travelers in Elizabeth's time often remarked that the English were a nation of musicians. Paul Hentzer, a German visitor in 1598, wrote:

The English excel in dancing and music, for they are active and lively. . . . They are fond of great noises that fill the air, such as the firing of cannon, drums and the ringing of bells. . . . Actors represent almost every day comedies and tragedies to very numerous audiences; these are concluded by a variety of dances accompanied by excellent music and the excessive applause of all those that are present.

The source of musical life, no longer the Church, was rather the court, and later the town. The rising merchant class took over the taste of the court for musically based shows.

Shakespeare's plays abound in references to music, and the lilt of clear song or plucked strings is interwoven in the whole texture of *Dream*. As for specific music to accompany the various parts of the play, there are as many possibilities as there are directors.

For our production, the music was specially composed by Marc Blitzstein, an experienced theatre musician. He was inspired by antique precedent, but made music for his own time. Since the company enjoyed the services of Russell Oberlin, whose voice is one of the most beautiful countertenors now singing, much floating, liquid melody with words, and even in simple vocalization in extended cantilena, was given to his pure, soaring notes. The instrumental accompaniments were discreet, except for the ruder and more percussive dance portions and the underscoring for the play of Pyramus and Thisbe.

### IV  The Dances

In Shakespeare's time social dancing on the aristocratic level approached theatrical spectacle in its calculated ostentation. Folk dancing

of country or townspeople continued a medieval tradition, including the morris and other seasonal festival dances derived from Italy, France, and Spain. All of these dances were embroidered with flashier steps and figures for theatrical use.

It was customary to end the plays with a dance, as in *A Midsummer Night's Dream* and *Much Ado about Nothing*. A Swiss traveler in 1599 saw *Julius Caesar* (probably Shakespeare's, at the Globe), and reported: "At the end, as is their custom, they danced, two in men's and two in women's clothes, wonderfully well together." A month later he saw another play, and again, "They performed the English and Irish dances." The Irish dance was possibly a jig, a comic danced ballad, accompanied by pipe and tabor.

In *Dream*, dances of various kinds are called for on different occasions. If the play has any connection with a public festival, it would be May Day, which the atmosphere and action sometimes suggest. On May Day there were elaborate dances and celebrations. In the city of London midnight fires were lit to celebrate the passage of the sun through the zodiac's highest arc, and boys leapt over the fires, for good luck, and to cleanse their souls. The play, however, is not specifically connected with the festival of a particular date. Rather, it is set in a countryside where all the folk celebrations were familiar, and it was common knowledge, for instance, that fairies dance in rounds or fairy circles. There were at least two kinds of fairy rings, a green circle surrounded by a bare brown circumference made by bad fairies, and a brilliant green in the midst of a lush meadow, caused either by good fairies or by a fungus.

Titania and Oberon often refer to the fairy lore of the time. Titania (Act II, Scene 2) calls, "Come, now a roundel and a fairy song." A roundel (or roundelay) was a round dance to the accompaniment of the dancers' singing. In Act II, Scene 1, the First Fairy (who is traditionally both the first dancer and a singing soloist) explains:

> *And I serve the fairy queen,*
> *To dew her orbs upon the green.*

That means that the fairies must refresh the bruised grass of the fairy rings, which have been crushed in the tramp of the fairy measures.

Titania's hint (Act II, Scene 1) enables us to imagine the floor plan of the fairies' dances as somewhat complicated:

> *The nine men's morris is fill'd up with mud,*
> *And the quaint mazes in the wanton green,*
> *For lack of tread are undistinguishable.*

The nine-men's morris is a game of Midland shepherds, something like a game of checkers cut in deep turf. "The quaint mazes" may refer to traces of a child's game, or, more probably, to tracks left by rural sports and dances on the village green. In any case, in a contemporary production of the play, it would be wise to combine a bit of art with a bit of folk dance, just as Shakespeare mixed in his verses to be sung the old folk song and the new art song. The publications of the English Folk Dance Society, while they generally apply to social rather than theatrical forms, provide a mass of basic material.

Towards the end of the play (Act V, Scene 1) Duke Theseus asks:

> *Come now; what masques, what dances shall we have,*
> *To wear away this long age of three hours,*
> *Between our after-supper and bed-time?*

The after-supper was dessert, with sweetmeats. Philostrate offers a rich list of entertainments, all derived from Italian models: the kind of pompous shows which European princes from Parma to Paris published, in splendid editions, to impress their peers, wherever policy demanded. Philostrate suggests a battle of centaurs, to be sung (accompanied, we can imagine, by a choreographed scene) by an Athenian eunuch, to the harp. Inappropriate for a marriage, the Duke will have none of that. Well then, "The riot of the tipsy Bacchanals,/ Tearing the Thracian singer in their rage," that is, the story of Orpheus. But Theseus chooses the "tedious brief scene" of Pyramus and Thisbe, and after that maladroit amusement is over, Bottom asks:

Will it please you to see the epilogue, or to hear a Bergomask dance between two of our company?

Theseus disdains the epilogue, and the First Folio says (V. i, 345) A *Dance of Clowns*. Bottom was correct when he said *"hear a Ber-gamask dance,"* for the *Bergamasco* was a sung dance. It derived, however remotely, from a dance of the Italian peasants of Bergamo. The Italian buffoons used to imitate the rustic Bergamaschi, and their *commedia dell'arte* was popular all over Europe. There is, however, no real reason to introduce the characters of the *commedia* into this play, though their familiar figures have been used as decorative features in many recent productions. John Playford, whose *English Dancing Master* (1650) is a source book of folk music, described the country dance as calling for "kissing, shaking hands, clapping, stamping, snap-ping the fingers, peeping, wiping the eyes." The handkerchief, to hold and to wave, was an important accessory.

Actors are not necessarily trained dancers, and in the Bergamask dance they can be as rude and hearty as possible. Mistakes are only the funnier if the simple pattern be performed with rustic energy. In the Connecticut production, George Balanchine made a fairly elab-orate transition from the comic play to the finale. The *Bergamasco* started with Nick Bottom and Robin Starveling, then Peter Quince, Tom Snout, and Snug the joiner joined in. It was a five-handed country dance that could have been called by any square-dance caller; but then, imperceptibly, the gentry were invited to join the mechan-icals. Hermia and Helena, followed by Hippolyta (who in her wedding dress looked like a portrait by Zuccaro of Elizabeth herself), were swung into the pattern. But the weight of their skirts, as well as the grandeur of their status, slowed the dance down and brought heels back to the floor. The clowns respectfully made their bows and mod-estly withdrew, while their places were taken by the noble guests Ly-sander and Demetrius, and finally the Duke himself. The music changed from rough and quick to slow and stately; the dance became a version of pavane, an Italian figure supposedly inspired by the spread-ing peacock (*pavone*), in which the robes and skirts of the nobility could be displayed to the greatest advantage. Balanchine's steps were very simple, but the style of the actors' execution of them, the light and atmosphere of the long day ending, the formal exchange of the mixed partners, who after all the adventures had regained their loving opposites, the twin stairs to be gained for beds above, provided a touching and beautiful climax to the poetry of the occasion.

Our ballet has not had a good effect on recent productions of Shakespeare, for the dexterity of trained dancers seems to accentuate the limited range of actors, and make it seem awkwardness. If actors can be taught the traditional court bow and curtsy, and perform them with formal elegance and simplicity, that is enough. To learn to bow and curtsy is harder than one might imagine. Americans have not the habit of saluting, or even recognizing status: we have no Court of St. James's as model for ballroom behavior. In America the most beautiful public reverences are seen in the opera house and concert hall, in recognition of the audience's acclamation. There are infinite varieties of meaning—gratitude, modest mastery, consideration, exact judgment of partner or public—which may be expressed and made legible in the simple inclination of the neck and head, the bend of the knee, the management of the skirts. But this requires study and practice. In this play the most important element in performing the dances is not virtuosity but neatness. The stage represents, essentially, a ballroom, and the dances are more analytically social than brilliantly theatrical.

In our theatre, this play could suitably end with a masque of fairies, in which Oberon and Titania recapitulate their quarrel over the Indian boy, leaving Puck to sweep the place clean of evil and ill luck. There is danger that such a dance might develop into a divertissement, delaying the final lines, which are, after all, the key to the play. But there is ample precedent for elaboration. In Connecticut, the wealth of stairs and traps on the stage encouraged a magical ending molded into the movement of the actors. Morning was not far off; the fire from the great imaginary chimney had burned to dozing embers. Stars glittered like hundreds of sequins through the translucent green verdure of the tapestries. Only a few graceful steps, turns, and exchanges were needed to make all creatures vanish, and leave Puck his epilogue. With a puff of smoke he blew out his cheeks and the whole hall vanished. The applause he had begged for overwhelmed him.

## V  A *Footnote on the Fairies*

Who were the fairies; what did they look like? Well before 1400 the Wife of Bath, on her way to Canterbury, said that they were even then hard to come by:

*Tholde dayes of the Kyng Arthour,*
*Of which the Britons speken greet honour,*
*Al was this land fulfild of faierye.*
*The elf queene with hir joly compaignye*
*Daunced ful ofte in manye a grene mede;*
*This was the olde opinion, as I rede.*
*I speke of manye hundred yeres ago;*
*But now kan no man se none elves mo.*

The point is often made, just before and after Shakespeare's time, in ballad and broadside, that fairy folk are little, visible by mortals mainly between midnight and dawn. Reginald Scott in his *The Discouverie of Witchcraft* (1571) compounds confusion. All the types he mentions have appeared, at one time or another, in the court masques derived from the Italian models:

. . . In our childhood our mothers maides have so terrified us with . . . bull beggars, spirits, witches, urchens, elves, hags, fairies, satyrs, pans, faunes, sylens, kit with the cansticke, tritons, centaurs, dwarfes, giants, imps, calcars, conjurors, nymphes, changelings, Incubus, Robin goodfellow, the spoorne, the mare, the man in the oke, the hellwaine, the fierdrake, the puckle, Tom thombe, hob goblin, Tom tumbler, boneless and such other bugs, that we are afraid of our own shadowes.

How Pan, Silenus, fauns, tritons, and centaurs, creatures with an ancestry from Ovid, got mixed up with purely English, Scotch, and Irish countryside figures is a grateful topic for the learned. But it seems to have been conceded that although early fairies were taller than humans, Elizabethan fairies were small, not evil, while elves were mischievous but not lethal.

*The Mad Pranks and Merry Jests of Robin Goodfellow* (printed in 1628, but thought to have been circulated as early as 1588, and perhaps consulted by Shakespeare) is filled with suggestions for modern designers:

. . . There were with King Obreon a many fayries, all attyred in greene silke: all these with King Obreon, did welcome Robin Goodfellow into their company. Obreon took Robin by the hand and led him in a dance: their musicians

were little Tom Thumb; for hee had an excellent bag-pipe made of a wren's quill, and the skin of a Greenland louse; this pipe was so shrill, and so sweete, that a Scottish pipe compared to it, it would no more come neere it, than a Jewes-trump doth it to an Irish harpe.

It seems that fairies were, by and large, green more than any other color, probably grasshopper- or grass-green; by extension, iridescent, with insectile antennae and froggy dapplings. In *The Merry Wives of Windsor* (Act IV, Scene 4) the fairies are described as black, white, gray, and green. *The Fairy Tradition of Britain*, by Lewis Spence, may be consulted for microscopic particulars. He instances variants from the canonical green.

As for more or less modern fairies, the residual figures of an ancient tradition, perhaps the best models are Arthur Rackham's beautiful watercolors in his gift edition of the play. It is unfortunately out of print, but available in libraries. He more than any other artist illustrated the spirit of the Song of Robin Goodfellow:

> . . . *Round about, little ones, quick and nimble,*
> *In and out wheele about, run, hop or amble.*
> *Joyne your hands lovingly: well done, musition!*
> *Mirth keepeth man in health like a phisition . . .*
> *Make a ring on the grasse with your quick measures,*
> *Tom shall play, and Ile sing for all your pleasures. . . .*

# Marilyn Monroe: 1926–62

*[Although Kirstein's aesthetic requires an appearance of perfect finish and grace—the "neoclassic rigors," as he calls them—his writing has never underestimated the indifference with which the performing artist must contend nor minimized the personal costs of such virtuosity. Throughout his work there are sympathetic references to the long list of America's broken and failed performers. First published in* The Nation *195.4 (August 25, 1962).]*

THE DEATH of someone who has given you intense pleasure, even if you never met, amounts almost to the death of a personal friend. Having heard the news on the radio and knowing how I felt about Marilyn Monroe, an artist friend wrote me from Indonesia: "I liked everything about her; mainly her power that outwitted the hungry weak for so long."

Extravagant claims need not be made for her capacities as the complete actress; she never had the chance to develop them. But as a classic comedienne of grace, delicacy, and happy wonder, she certainly has had no peer since Billie Burke or Ina Claire. The lightness, justness, and rhythm in her clowning often held hints of something more penetrating. Her comic tone was sometimes disturbingly ironic; her personal style was more lyric than naturalistic. Irony and lyricism are two prime components of the grand manner. Whether or not she could have succeeded as Lady Macbeth, which she solemnly said she wanted to play one day, after what she had done to herself with the aid and abetment of most of us, we cannot know. But it is possible

that her gifts were far more in the scale of the proscenium frame than the camera frame.

Imagination boggles at the overtime that would have been loaded onto the rehearsal schedule of any Shakespearean repertory company placed at her tender mercies. But her notorious tardiness or procrastination (it never bankrupted anybody except herself), which so irritated the manipulators for whom she grossed only forty-three million dollars—not, alas, the two hundred million that was first reported—may not have been merely compulsive behavior. Does it never occur to the producer, director, and investor that a performing artist at the peak of her craft may always want to give a peak performance; and that often, for reasons physical as well as psychological, she may not feel up to the peak she knows she can attain? In the theatre, a star is prepared by weeks of New York rehearsals, months of provincial tours, before settling into the final pattern of the Broadway run. Some seductive movie directors manage to get peak performances out of their stars faster or oftener than average, but by and large the American film industry rarely provides working conditions comparable to the comfort of a successful run in our commercial theatre (and we cannot even make comparison with what prevails in more cultivated countries, able to afford institutional theatre: the theatre of Stanislavsky, of Brecht, of Barrault or Olivier). Everything shot in Hollywood, or planned there, is geared for hysteria and the bet on lucky, improvised takes and type casting.

So Marilyn Monroe paralyzed production by demanding retakes; maybe she took sixty of a single scene and had them all printed. Maybe the sixtieth wasn't as good as the third. And maybe, at the same time, she had a conscience about the cash she was costing her partners and manipulators. She knew what money was about, since she was born with none, died with little, and valued it chiefly for the pleasure of giving it to people poorer than herself.

Perhaps such things qualified her art—nothing qualifies her life as the material of tragedy. It has been hard for novelists or dramatists to canonize performing artists. Sarah Bernhardt inspired Proust and Henry James; Colette drew on her own fascinating life; Sartre worked hard at Kean. But whatever these triumphs were between covers, they have never given great actresses great roles. The performing artist is a complex mechanism, and in the most powerful of them the urge for

self-exposure, the shame of an inadequate performance—even the continual racking desire to be rid, once and for all, of the very desire to risk such hazard—often exist in an almost intolerable balance. Marilyn Monroe was used in her own lifetime as the basis of a shoddy commercial film which failed, among other reasons, for its superficiality. The resemblance was duly publicized but no one really believed it or cared. *The Goddess*, cheap as it was in conception and execution, may well become a monument of taste and talent compared to the doubtless inevitable *Marilyn Monroe Story*, starring some as yet unborn replica of the best features of Jeanne Eagels, Jean Harlow, Carole Lombard, Bette Davis, and Greta Garbo, with a supporting cast of Joe DiMaggio, Jr., when he gets out of the Marines, and Clark Gable, Jr., when he gets out of the cradle.

But let us assume that one day Marilyn Monroe's story will find that poetic dramatist who can capture its tragedy—not as Norma Jean Mortenson turned into Marilyn Monroe, not as M.M., but rather as the Performing Artist in our country, in our time. Such a dramatist, reading Maurice Zolotow's admirable biography, will see that the denouement is indicated from the first chapter. Zolotow's study, which comes up to *The Misfits* and her death, is courteous, humane, and extremely perceptive. In it, only Monroe's wisecracks are funny. It is a book that can serve someone as North's *Plutarch* served Shakespeare: everything is there save the choice of scene and the grandeur of words.

Lacking a Shakespeare, who often breathed immortality into far less absorbing originals, we shall look long for someone to encompass her griefs. Her playwright husband gave her her most serious script, and if it was a flawed masterpiece, it is still a masterpiece. But *The Misfits*, unlike her other films, is not essentially about her performance, or about an artist performing. It is about the almost pornographic horror of a famous man who is actually dying and a famous woman who is having a nervous breakdown. Arthur Miller knew her as no one else: "If she was simple it would have been easy to help her. She could have made it with a little luck. She needed a blessing." Had she enjoyed that blessing, she certainly could have played magnificently Doll Tearsheet, Katharina the Shrew, Mistress Page, Portia. And if she had been granted another chance, in another life, in another society or culture, she could have played Cleopatra—not Shaw's kitten-queen, but the Alexandrian princess, the serpent of old Nile. Yet, in

our time, who could have encompassed her character? Tennessee Williams naturally springs to mind, since he knows our movie industry well and has what passes for passion and compassion; but judging by his last two and possibly best plays, his largest gifts are for comedy. He writes comedies of manners, more mannerist than tragic. Brecht might have made a cartoon, but Monroe was not grim; O'Neill was almost humorless; neither had the innocence and gaiety which assert Monroe's aura.

However, there is one playwright, and evidence has just come to light that he is far more "modern" than many now living in the flesh. Oscar Wilde might have triumphed with Marilyn Monroe's material, since it was so much like his own. When the thousand and more pages of his collected letters appear here in the fall, so magnificently presented and annotated by Mr. Rupert Hart-Davis, we shall enjoy not only one of the greatest of English autobiographies; we shall also learn to know, for the first time, a marvelously funny, generous, profoundly decent man, who in his whole short life (he died at forty-six) never harmed a living soul, save himself, the wife he adored, and the two very young children who meant more to him than anything in the world. His personal tragedy is certainly one of the most terrible and moving about which we have absolutely complete information. And he was a performing artist in his public as well as in his private life.

Monroe was a woman of considerable importance, and Wilde would have known, as few others, just wherein her importance lay. She belongs in the fairly large company of tragedians in life who also performed for money in a broader theatre. Not all of them were stage actors, and in the cases of Oscar Wilde and Marilyn Monroe, some of their greatest scenes were not played onstage. Like Wilde, she often reserved her talent for her art and her genius for her life.

The essence of the star performer's individual contribution is the development of a tone, style, and rhythm which make legible his private morality. The intensity of the distillation has an inflammatory effect on the whole world, highbrow, lowbrow, and middlebrow, because it seems a revelation, at least in part, of their own divine or monstrous qualities. The genius-performer, whose compelling, or "compulsive," problem is the editing of a private identity into an intoxicating icon, has a long line of saints and martyrs: Beckford, Byron, Kean, Baudelaire, Booth, Rimbaud, van Gogh, T. E. Law-

rence, Nijinsky, Dylan Thomas, James Dean, Jean Harlow, and her legitimate daughter, Marilyn Monroe. The stupendous question: "Who am I, really?"—unless it is answered to one's own satisfaction at about the age when one achieves an end of technical apprenticeship—generates an endless seesaw energy of frustration disguised as brilliant nervous energy, which is no less predictably fatal than cancer. By no means all great performers are martyrs, though some approach the saintly. Many of the best have had the power to solve their own questions of identity, and have heard the lovely music at the end. One thinks of Garrick at home; Walt Whitman, the arch-impersonator, receiving Oscar Wilde in Camden; Sir Henry Irving and Ellen Terry; Victor Hugo, Duse, Pavlova, and Cocteau himself, who has played the various disguises of Harlequin for seventy years, surviving all the spiritual and physical exercises that are credited with killing so many of his juniors.

The "healthy," the "wholesome" performers, as opposed to the "compulsive" ones, have been able to balance or employ their compelling behavior in public, usually supported by a technique and a tradition of craft. And in the old days, no matter how horrifying their infancies or adolescences, performers could almost call their souls their own. Edmund Kean, the greatest Shakespearean of his time, had no easier a human apprenticeship than Marilyn Monroe; psychic shocks from his youth certainly killed him sooner than if he had been a nobleman and rich (in which case he could not have been an actor at all). But Kean, in spite of his hysterical behavior, had the final satisfaction of appearing in a great repertory. He himself controlled every element of its production, presentation as well as exploitation. His reputation and body belonged to himself to do with as he pleased, and he pleased to drink. However, he was not both president and partner of Edmund Kean Productions, Inc., a corporation manipulated by a cartel of hopeful wolves, who were treacherous always, and who could yet howl about their property's final, desperate treachery. There was publicity-seeking in Kean's day and probably in Shakespeare's too. But in Shakespeare's time, repertory troupes were protected by royal patent or noble patrons, and the actors wore their responsible masters' livery. Now we have no repertory companies, except in a few interstitial or putative institutions, and it is highly unlikely that they will ever again dominate our theatre. Our only true repertory houses are

the chains of small art-film houses, where *Bus Stop, The Blood of the Poet, Ten Days That Shook the World, Some Like It Hot,* and *The Misfits* will be shown for generations.

Certainly Marilyn Monroe was victimized, but one must study Maurice Zolotow's book to understand the crafty uses she made of her own adversity, and the legends she helped augment as weapon, protection, and blackmail. We all know how juvenile delinquents feed back quite adequately Freudian jargon to their interrogators, who then check off the predictable causes: guilt, rejection, alienation, insecurity, etc. Lacking a Shakespeare, it would take a Bernard Shaw—who understood T. E. Lawrence as Private Shaw, Ross, the Bastard, the Poet, the Adventurer, the Failure, the Success—to utilize all of Monroe's maniacal procrastination, her treacheries to those who "helped" her—that wolf pack and rat pack, agents and instructors, who of course expected only a kind word for their investment.

Dance and song, unlike the spoken word or the use of classic diction, have absolute techniques. Virtuosity is the salvation of the singer and dancer; the actor has no such luck. Of course it is true that Nijinsky went mad, that Callas behaves badly (or astutely), and that Dylan Thomas wrote very good verse, read it very well, and drank too much. But the greatest performers of institutional theatre, singers, dancers, and those actor-managers of the last century, by and large provide a picture of almost bourgeois domestic simplicity. That is also true of many excellent film actors who have come to their own satisfaction with a becoming modesty: James Cagney, Gary Cooper, Burt Lancaster, Katharine Hepburn, and many others. But these are fine character actors, which is different from a blazing star: a Garbo, who does not die, except to the screen; a Marilyn Monroe.

Hollywood has always been a supermarket of personality. As in most supermarkets, the comestibles come packed with additives, preservatives, detergents; and while not immediately lethal, such nourishment hasn't the savor that nature intended. Very little has issued from Hollywood that has any claim on the most transient memory. Naturally there is in Hollywood no museum devoted to the motion picture; it is a phenomenon without a real history, in which only the freaks, the exceptions, the tragedies are memorable. The one academy it ever sanctioned is suitably enough an annual racket. It is a climate providing less chance for healthy work than even downtown Los An-

geles, for all its smog. But it's not the only villain; Hollywood has its conscious and unconscious accomplices.

It doesn't help the performing arts much that Harvard University, having some decades ago exiled George Pierce Baker to teach at Yale, finally erected a fantastically equipped theatre with the proviso that acting is not to be instructed for credit, and that there be no graduate school of drama. The Loeb Theatre is thus only a clean playpen for the young gentlemen. It helps less to have Congress grant a land site for a national cultural center with the proviso that the nation never be called upon either to erect the building or maintain it. It helps least of all that the Kennedy Administration, after a canny survey, has discovered no political mileage in culture, and is cloaking that bit of intelligence with tasteful interest in interior decoration, good cooking, and polite literary conversation. Sure, lots of culture centers are going up all over the country. If one wants a fair idea of what happens when they are built, regard the situation in Seattle, which thanks to the planners of a successful World's Fair has an excellent facility. There is a dog fight as to how the buildings will be used; and there is no plan for any future use, except the pious promise that expensive cultural events should be prudently pruned.

Marilyn Monroe was supposed to be the Sex Goddess, but somehow no one, including, or indeed, first of all, herself, ever believed it. Rather, she was a comedienne *impersonating* the American idea of the Sex Goddess, just as she impersonated Hildegarde, the "chantoosie," in *Bus Stop*. When people paid their forty million to see Monroe, it was for an aesthetic performance, not a simple provocation. And she, perhaps even consciously, exemplified a philosophy which had come to her pragmatically, and which a lot of American women don't like very much—a philosophy at once hedonistic, full of uncommon common sense, and even to some intellectuals deeply disturbing. Her performances indicated that while sex is certainly fun, and often funny, it is only one of many games. Others include the use of the intelligence. Sex has a certain importance, indubitably, but the messianic role which has been assigned it in the first half of the twentieth century may have been overplayed, just as it was underplayed in the second half of the nineteenth century. It seems to have been played about right in Greece, Rome, Japan, and eighteenth-century France. Marilyn Monroe just played right around it. Her act was

fantastic, uproarious, and daft. Not the least ironic part of a life so crammed with irony was that someone made so dependent on the shaky therapies of contemporary post-Freudian philosophy should have portrayed to the public the very picture of bumptious sexual normalcy.

A Hollywood gossip columnist, who should know if anyone does, said that Marilyn Monroe's life was an absolute waste; one wonders what he, in the brief watches of the night, thinks of what he does with his time. Radio Vatican proclaimed that a person should have the courage to face life without turning to the easy way out of suicide. It seems to have been a relatively difficult way for a woman who tried it some half-dozen times without success. Marilyn Monroe turned to Christian Science and let herself, as a good daughter-in-law, be instructed in the Reformed Jewish faith. There is evidence that she believed in Divine Providence, but its councilors on earth have not proceeded far enough in the ecumenical movement to help miserable performing artists whose God-given talents bring them more burdens than their God-given flesh can bear. More than predictably, the filthiest footnote appeared in *Time*'s anonymity. Recapping every detail which could exude a faintly pornographic whiff, its final diapason rolled: "All the same she was a star; it hardly matters she never quite became an actress." Get that "*quite.*" Marilyn Monroe's life was not a waste. She gave delight. She was a criterion of the comic in a rather sad world. Her films will continue to give delight, and it is blasphemy to say she had no use. Her example, our waste of her, has the use of a redemption in artists yet untrained and unborn.

# W. H. Auden—
# Uncle Wiz

[*Kirstein met W. H. Auden shortly after the English poet arrived in New York in 1939. Although Auden was not interested in the ballet (he once called it "a very minor art"), he and Kirstein soon struck up a close and enduring friendship, one that was terminated only by Auden's death in 1973. The* Shield of Achilles (1955) *is dedicated to Lincoln Kirstein and his wife, Fidelma. This review of Humphrey Carpenter's* W. H. Auden: A Biography *was published in* The New York Review of Books, *December 17, 1981.*]

THIS CAPACIOUS, cautious, splendid biography commences with its author's caveat: "It is not a book of literary criticism." It ably shows how certain writings developed from instances of a lifetime. "I hope I have also managed to convey my own huge enthusiasm for his poetry." Here Carpenter triumphs where others have been so drawn to anecdote or exegesis that poetry (and, importantly, prose) seems diminished. What he has not touched, Edward Mendelson's *Early Auden* fully provides.

Carpenter's is the first biography to enjoy free access to a wide range of personal correspondence, unpublished manuscripts, family and personal memoirs. His accomplishment is awesome in accounting for the breath and breadth of an important contemporary poet. Prior attention has been useful for explication or useless as random gossip. Here we have days and nights spent in their inspiriting diversity and complexity. All that is perhaps lacking is a sense of fun and games which infused the speaking maker. Auden's irony and sympathy, his

magical influence over a band of adoring and admonished subalterns are well shown, but his mortal tone is impossible to recover.

Auden was one of the few influential intellectuals of his day who did not try to elevate his errors into some sort of philosophical system. He is to be read, like most energetic thinkers at their different moments, as inconsistent, with the proviso that every apparent mutation was prefaced by scrupulous self-questioning in which ambiguity in each step was expunged. As his lifetime friend Professor E. R. Dodds explained:

The ruthless treatment of his own past work which recent critics have observed and deplored was no new thing in Wystan; it is the price his readers have to pay for the companionship of a receptive mind that perpetually rejudged the past in the changing light of the present. *

Auden's early repudiation of political flirtation and of a dazzling idiosyncratic rhetoric which he felt had become formularized, and the shifts in his world-view, which abrasion by experience of the world as it is came to seem to him naïve, were not exactly ambiguous. Ultimately, his attitudes became unequivocal and unwavering, as self-discipline and self-awareness led to exile, alienation, and discovery—which few other of our artists had the wit, courage, or extremity to risk. His apologia was not couched in terms of the heroic, self-sorrowful confessional:

> *I can't think what my It had on Its mind*
> *To give me flat feet and a big behind.†*

And the frowned-on changes, those metamorphoses which led Early to Middle to Late Auden, transforming helmeted airman to comfy Austrian Householder, is what Humphrey Carpenter clearly details. This speaks volumes for the personal responsibility of a modern biographer; Auden's friends and lovers have felt free to confide in

---

* *Missing Persons: An Autobiography* (Oxford University Press, 1977), p. 123.
† *Letters from Iceland* (Faber and Faber, 1937), p. 202.

Carpenter, most of them without let or hindrance, and he responded with a generosity sparing nothing save grossness. Auden the man, in his appetites, needs, satisfactions, or lack of them, is here, and from such just and vivid documentation of tastes and talents we comprehend the poetry from its wellsprings as never before. This book does not aim to, nor can it "tell everything," but each and everything related in depth and dignity may go far to convince those who misprize Auden's homogeneity in its largest sense to extend the accidental limits of their partial information. It has been suggested that, if Auden had been mainly heterosexual, Carpenter would not have made so much of his particular behavior. Auden himself was scrupulous about the avoidance of personal gender in every one of his lyrics.

Auden's reputation has survived the fever chart of early renown and posthumous abeyance. Prematurely and imprecisely hailed as paladin of a greedy "left," he discovered for himself in Spanish and Chinese civil warfare how the epigones of Marx and Trotsky could be culpable like everyone else. Thus, when he left Britain, he would be accused of double infamy, as lapsed comrade of a "working class" and as traitor to his native hearth. It is conveniently ignored that as early as *Paid on Both Sides* (1928), or *The Ascent of F6* (1936), with their clinical diagnosis of England in decline, he laid bare to an avid elite of "liberal" readers that his homeland in its accelerating lack of genuine possibility was no home for him. By 1937 he had sensed the situation which Mrs. Thatcher now superintends.

The hero of *F6*, named Ransom, was drawn from the exploitable theatricality of Lawrence of Arabia and George Mallory, the intrepid climber who vanished on Everest. "Mr. and Mrs. A," Auden's tragic chorus, at the end of the first act proclaim a starved nation's alarmed insistence:

MRS. A: I have dreamed of a threadbare barnstorming actor, and he was a national symbol.
MR. A: England's honour is covered with rust.
MRS. A: Ransom must beat them! He must! He must!
MR. A: Or England falls. She has had her hour. And now must decline to a second-class power.

In his *gran rifiuto*,* his relinquishment of Yorkshire and Cumberland, from his de-self-centered exile, he composed a *paysage moralisé* from Manhattan to the Mezzogiorno to rural Austria. The farther the exile, the greater his communion. In an excellent essay on Auden and Louis MacNeice's *Letters from Iceland* (1937), the poet Tom Paulin analyzes a view of great nature in contrast to Wordsworth's romantic landscape.

Parnassus must be colonised and tamed deliberately changing it from a grim empty peak above a lake to the public park with fountains, cafés and ice-cream vans. The dominating mountain must be dominated and made social, humanist and democratic. †

It is the various attitudes towards domination, colonization, democratization that two generations of critics, commencing with F. R. Leavis, have found inconsistent or repellent. This was aroused by the lapidary firmness of Auden's compact judgment, early and late, which had the weight and eloquence to nominate a year, a season, an age, as if by some future unborn historian. What one may question in Carpenter's superlative biography is a slighting of two prime factors in the poet's range and practice, discussed in Professor Mendelson's *Early Auden*: intellectual energy and curiosity, together with an insistent morality. Auden's omnivorous, attentive prowling in language, science, philosophy, public affairs, literature, and music surpass any other poet's of his epoch. To be sure, there are academicians everywhere who seize on the suburbs of the imagination to make them their own, and in so doing contribute worthy books. But flipping through catalogues of university presses in their dissertational overkill of Shakespeare, Melville, Henry James, one finds little to compare with Auden's chilling conclusions on Iago in "The Dyer's Hand" or Prospero in "The Sea and the Mirror," or with the capital elegies on Melville, Yeats, Freud, and James.

As for morality, its inference, or practice, Carpenter spends little scrutiny on Auden's ideas other than on him as aphorist. But everything

---

* *Inferno*, III, 60.
† *The Nineteen Thirties: A Challenge to Orthodoxy*, edited by John Lucas (Barnes & Noble, 1978).

Auden wrote, taught, or preached was within the frame of a rigorous morality. That is, in every facet of his unlimited working he considered the obligation of the self in action relative to the fair or ugly behavior of others—in society, its history, climate—towards individual artists and as a whole. No stranger to the singular or fanciful, he included in his prayers for romanticizing poets a remission of sins for those whose gifts withered from the anemia of obsessive self-preoccupation. And it was the novelist's craft and power that he praised above the versifier:

> *Encased in talent like a uniform,*
> *The rank of every poet is well known;*
> *They can amaze us like a thunderstorm,*
> *Or die so young, or live for years alone . . .*

But the deviser of fictions must be otherwise:

> *For, to achieve his lightest wish, he must*
> *Become the whole of boredom, subject to*
> *Vulgar complaints like love, among the Just*
>
> *Be just, among the Filthy filthy too,*
> *And in his own weak person, if he can,*
> *Dully put up with all the wrongs of Man.*
> ["The Novelist," 1938]

Auden's activated conscience concerning itself and his neighbors' was as adept and energetic as formal prosody; it is consciousness of self as an *other* which gravely informs his verse—light, dramatic, trivial, ironic, importunate, or lyrical.

> *Blessed be all metrical rules that forbid automatic responses,*
> *force us to have second thoughts, free from the fetters of Self.*
> [1969]

Who was the last English professional poet with Auden's scope, verbal control, or luxury in quotable phrases, the mastery in an apostolic succession of popular poetics? Answer is easy: a master of tech-

nics—mechanical, material, and metrical; a seer of international apprehension; scholar of Bible and hymnal, one also who used much personal suffering to "in the prison of his days / Teach the free man how to praise." Who he? Rudyard Kipling.

With him, Auden shared a vital historicity which enabled both to endow an immediate present with the enriching reference of the past. In a sense, everything has already happened in time past, but the ever-ready poet spotlights those distinctions whose linkage intensifies surprising difference. Auden said that to the ignorant the past is simultaneous. Disdain of the past as mere repetition or binding irrelevance is one of the worst side effects of "modern" culture.

What is it that makes Kipling so extraordinary? Is it not that while virtually every other European writer since the fall of the Roman Empire has felt that the dangers threatening civilization came from *inside* that civilization (or from inside the individual consciousness), Kipling is obsessed by a sense of dangers threatening from *outside*?

Others have been concerned with the corruptions of the big city, the *ennui* of the cultured mind; some sought a remedy in a return to Nature, to childhood, to Classical Antiquity; others looked forward to a brighter future of liberty, equality, and fraternity: they called on the powers of the subconscious, or prayed for the grace of God to inrupt and save their souls; they called on the oppressed to arise and save the world. In Kipling there is none of this, no nostalgia for a Golden Age, no belief in Progress. For him civilization (and consciousness) is a little citadel of light surrounded by a great darkness full of malignant forces and only maintained through the centuries by everlasting vigilance, will-power, and self-sacrifice.*

Auden's attitude towards the treasure in history invested his accomplishments in metric; there was hardly an antique measure which he did not use, alter, or extend with virtuosity. The more difficult the game of counting syllables or scanning stress, the more amusing the play of words. In our colleges, courses in modern poetry generally disdain sportive verse in favor of trying to extract something lived and hence presumably unique or "creative" from wholly undeveloped or

---

* "The Poet of the Encirclement," *Forewords and Afterwords* (Random House, 1973), p. 352.

prematurely locked personalities. Individual and accidental sensibility substitutes for experience; what by chance has happened to me is my total gift. Ignorance of prosodic possibility, which for many centuries empowered English verse, over the last fifty years has caused the identical deterioration of music without melody, painting without portraiture, and architecture without ornament.

When verse is "free," when a line is terminated by the typewriter's signal, a criterion of spontaneity proliferates into the helplessly prolix. With meter, as with rhyme, when handled by genial masters like Milton, Hopkins, Hardy, Kipling, and Auden, currents of sonorous energy swell the conduits of echoing utterance. Then words avoid a blur, and even when read rather than spoken, there is a residue of incandescent speech. Here are examples of anti-solipsist verse in which personal accents are fired by dramatic objectivity:

> *Lord, Thou has made this world*
> > *below the shadow of a dream*
> *An' taught by time, I tak' it so—*
> > *exceptin' always Steam.*
> *From coupler-flange to spindle-*
> > *guide I see Thy Hand, O God—*
> *Predestination in the stride o' yon*
> > *connectin'-rod.*
> *John Calvin might ha' forged the*
> > *same—enorrmous, certain,*
> > *slow—*
> *Ay, wrought it in the furnace-*
> > *flame—my "Institutio."*
> ["McAndrew's Hymn," Kipling, 1893]

> *Yes, these are the dog-days, Fortunatus:*

> *The heather lies limp and dead*
> *On the mountain, the baltering torrent*
> *Shrunk to a soodling\* thread;*

---

\* Auden never "invented" words. From the OED: *Baltering*: to wallow, welter, tumble. *Soodling*: to walk slow in a leisurely manner; to stroll; saunter.

> *Rusty the spears of the legion, unshaven its captain,*
>    *Vacant the scholar's brain*
>    *Under his great hat,*
>    *Drug though She may, the Sybil utters*
>    *A gush of table-chat.*
>
> *And you yourself with a head-cold and upset stomach,*
>    *Lying in bed till noon,*
>      *Your bills unpaid, your much advertised*
>      *Epic not yet begun,*
> *Are a sufferer too. All day, you tell us, you wish*
>    *Some earthquake would astonish,*
>    *Or the wind of the Comforter's wing*
> *Unlock the prisons and translate*
>    *The slipshod gathering . . .*
>
>                     ["Under Sirius," Auden, 1949]

If, or when, such models may be recommended to tutees in modern poetry, professor must explain that John Calvin (1509–64) was a Swiss reforming priest whose *Institutes of the Christian Religion* (1536) are a keystone of Protestant hermeneutics, rock of the Church of Scotland, on whose craggy faith Kipling's ship's engineer was anchored, justifying divinity and dynamo. Venantius Fortunatus (ca. A.D. 530–600) was Roman Gaul's last Latin poet, "a charming *bon viveur* and writer of occasional verse, who took holy orders in later life," as John Fuller's invaluable *Reader's Guide to W. H. Auden* (1970) tells us. A tone of cheerful self-questioning holds forth, under Sirius the Dog Star, at once on a slackening of poetry, the decline of Rome, and our own postwar Western world. Ransacking word books, Auden manufactured no Jabberwocky. He did not intend to preside over the dissolution of the English vocabulary, but his odd findings were appropriate in sonority and sense.

In 1949, Professor Dodds was teaching in California, and on his way back to the Regius chair at Oxford he paid

a happy visit to Wystan Auden in his ramshackle down-town flat in New York where I met his American friends and began to understand better the

complex influences which seemed so sharply to separate the new Wystan from the old, yet without obliterating their unique and endearing identity.

Auden's affirmation by settling in Manhattan was neither abdication nor flight; he refused to become the bard a nation needed. Kipling evaded knighthood and the laureate's post; he accepted the Order of Merit, as had Henry James in his rejection of American citizenship when he condemned Woodrow Wilson for being "too proud to fight." Kipling in his obscured maturity exiled himself to Tudor Sussex and in ballads glorified the whole myth of England. Auden accepted the King's Medal for Poetry and left for the United States, free of cliques that claimed him for the forced feeding of a personality cult. Benjamin Britten, returning from Long Island to Aldeburgh, fulfilled the role circumstance demanded, achieving a national reputation along with Gustav Holst, Frederick Delius, and Ralph Vaughan Williams. Auden, liberated from parochial applause, made what questions in Parliament proposed was a coward's choice. With William Hogarth as his monitory daemon, he flew above early borders and, for an unlimited international standard repertory, followed *The Rake's Progress* with Igor Stravinsky.*

Auden was one of the few English poets since the Elizabethans who enjoyed collaboration. He worked brilliantly and continually with Chester Kallman; this partnership was real, by no means as one-sided as many assumed. He worked closely with Isherwood, Bertolt Brecht, Louis MacNeice, James Stern, and with the musicians Stravinsky, Britten, Hans Werner Henze, Nicolas Nabokov, and Noah Greenberg. He thought that dual authorship produced a third partner. Like Stravinsky, he loved to be handed tight conditions of tone and format for paid jobs. In the broadest terms, he professed letters, and it was characteristic of him that, of all his writing, he was proudest of the Jacobean prose in Caliban's extended address to the audience in "The Sea and the Mirror" (*For the Time Being*, 1944). And as a professional, he had great respect for the expertise of others. His obiter dicta may be read as litigation against guardians of Eng. Lit.:

* In 1978–79, *The Rake's Progress* was in repertory in England, France, Germany, Sweden, South Africa, and the United States.

When I find myself in the company of scientists, I feel like a shabby curate who has strayed by mistake into a drawing room full of dukes . . .

["The Poet and the City," *The Dyer's Hand*, 1962]

How happy the lot of the mathematician! He is judged solely by his peers, and the standard is so high that no colleague or rival can ever win a reputation he does not deserve.

["Writing," *The Dyer's Hand*]

In 1947 Auden lectured on Cervantes, causing raised eyebrows at Harvard when he confessed he couldn't claim to have read every page of *Don Quixote*. However, he emphasized a single incident seldom noted by commentators. In its final chapters, the man from La Mancha recaptures sanity, but none of his neighbors wants him sane. He should stay crazy, to provide them with more amusement. They beg him to become once again the mad simpleton—*for their sake*. But, as a Christian knight, he knows that he diminishes the rabble by serving their sport. Truths he tells, having passed from delusion to reality, are more beneficial than his extravagances. A poet knew exactly how the don felt. English (and some Americans) complain that an early rocket fizzled in something approaching senility. They are loath to realize that latterly he was offering, if they troubled to read, speech deeper, wiser, finally even more memorable, than much from his winning and unreckoning youth. Under the deliberately disquieting mask of comfyness and coziness, there is the unfashionable repudiation of rhetorical hedonism, an affirmation of solitary consolation with no self-pity, the conscience of self-sufficiency.

The Cervantes lecture was by way of a test towards nomination to an eminent series endowed as the Charles Eliot Norton Chair of Poetry, filled by T. S. Eliot, Stravinsky, e. e. cummings, Ben Shahn, and others. In 1946 Auden had been commissioned by Harvard's chapter of Phi Beta Kappa to indite "Under Which Lyre" (A *Reactionary Tract for the Times*). Herein he proffered an "Hermetic decalogue," admonishing ex-GIs of their paramilitary moral futures. His First Commandment:

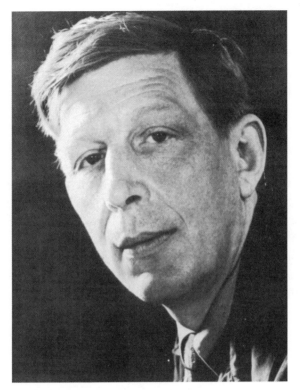

*W. H. Auden in U.S. Air Force uniform, 1945*

*Thou shalt not do as the dean pleases,*
*Thou shalt not write thy doctor's thesis*
  *On education,*
*Thou shalt not worship projects nor*
*Shalt thou or thine bow down before*
  *Administration.*

Harvard rarely fails to save itself from hazard and is expert in post-humous amends. Fifteen years later, Auden was invited to perform the Norton lectures; he was otherwise occupied. The academic estab-lishment was ever chary of Auden's capacity to arouse students over the heads of tenured masters. Wrath is still vouchsafed at his position of popularity. This is often launched against his "ideas," his lack of logic, change of mind, political ineptitude, his status as a cult figure.

He is blamed as *thinker,* a man of faulty opinions; the poet is minor. Yet these envious and disgruntled sages, stewards of passive youth, extol or forgive the years Yeats spent on astrology or psychic research, Pound's manic obscenities, and Stevens's mandarin self-satisfaction. University occupants in their eunuch rivalries are economical in their attention to tutelage. But Auden's employment was not for the undertakings of proprietary professors, but for those inquisitive pupils who were worried or wearied by the somnolent formulae of their expensive mentors.

Auden was, and is, a wizard teacher for those whose curiosity and energy open themselves to quaint method. Carpenter deftly describes his practice in suggestive dislocation of received ideas which teased students into thinking instead of allowing them to doze through an even flow of comestible opinion. Nervousness about cash and growing prestige lodged him in a dozen schools; apprehensive faculties audited his whimsical collocations and mandatory cocktails. He was not one to subside in tenure but grabbed short jobs as much to observe new places and people as to harangue complacent post-adolescents. Yet recipes for the apprenticeship of aspirant poets, compact in *The Dyer's Hand,* and embedded in the totality of his several didactic anthologies and critical prose, can serve as among the fullest, most empirical guides to a younger generation. Some among it may find themselves the heirs of luck, alive and kicking at a moment of historical release. The more than half-a-century hiatus in the reversal of traditional practice in music, architecture, and dance begins to be terminated. Solipsism in the arts fades in its minimality, and if so far we have been startled by few flaming demonstrations, the decks, at least, are being cleared. In this puzzling and disturbing process two colleagues, Auden and Stravinsky, showed how a present usage of the past, quite apart from idiosyncrasy, added to standard repertories wherein most recent pioneers have conspicuously failed.

Often we seem too much in a hurry to adopt pervading eschatology as an evasion from the resolution of a workable optimism. If there seemed next to no real possibility for the expansion of the imaginative potential in Europe, Auden embraced the "ragbag" of American democracy as the only available choice. It was neither easily faced nor accepted, but with sobering admonition:

. . . the greater the equality of opportunity in a society becomes, the more obvious becomes the inequality of the talent and character among individuals, and the more bitter and personal it must be to fail, particularly for those who have some talent but not enough to win them second or third place.*

Auden's impatience with self-indulgence, either lyric or behavioral, which in his personal idiom was "naughtiness," was a crushing put-down, mildly but heavily cruel, unkindly to be kind. His irritation at suicide, salvation by failure, was not compassionately accepted as the solipsist's triumphant blackmail. Humphrey Carpenter was perhaps overly polite in omitting Auden's epitaph on the impetuous exit of one of his most exacerbated critics. Randall Jarrell, he said, "might, at least, have thought of the truck driver."

Auden's self-confidence, his constant calibration of the quality of his own gift, was certainly, as he believed, God-given. He might have become a mining engineer or an Anglican bishop. At the age of fifteen he voluntarily joined his school's Officer Training Corps. At the time, a young friend, by chance, suggested a true vocation:

> *Kicking a little stone, he turned to me*
> *And said, "Tell me, do you write poetry?"*
> *I never had, and said so, but I knew*
> *That very moment what I wished to do.†*

Hopkins, the secret Jesuit innovator of sprung rhythm, wrote his confidant, Robert Bridges, the laureate:

What are works of art for? to educate, to be standards . . . We must try then to be known, aim at it, take means to it. And this without puffing in the process or pride in the success . . . Besides, we are Englishmen. A great work by an Englishman is like a great battle won by England.‡

* "Interlude: [Nathanael] West's Disease," *The Dyer's Hand*, p. 245.
† "Letter to Lord Byron," Part IV, September 1936.
‡ *Letters to Robert Bridges*, CXXXVI (1888).

In the winter of 1964, Auden summarized his reply to a symposium devoted to various interpretations of his poem "A Change of Air" which was conducted by *The Kenyon Review*:

Whatever else it may or may not be, I want every poem I write to be a hymn in praise of the English language: hence my fascination with certain speech rhythms which can only occur in an uninflected language rich in monosyllables, my fondness for peculiar words with no equivalents in other tongues, and my deliberate avoidance of that kind of visual imagery which has no basis in verbal experience and can therefore be translated without loss.

Wondrous and beautiful it is that now, hardly a decade after death, the audience he hoped for has found him; that careful young critics like Carpenter and Mendelson have mapped what he was and meant. Carpenter quotes an early unpublished poem, written before Auden left Gresham's School, which can be read as alternative to the black and gold marble script in Poet's Corner, Westminster Abbey:

> *That as thou goest through life*
> *Tired men may hear thy words*
> *And find strength in them.*

# V

# INDIVIDUALS

# T. E. "Lawrence"

*[Like most of his generation, Lincoln Kirstein was—and still is—a passionate admirer of T. E. Lawrence, the man whom Auden called "our nearest approach to a synthesis of feeling and reason, act and thought . . . the most relevant accusation and hope." During 1933 Kirstein, who wanted to write Lawrence's biography, just missed him several times in London (see p. 144–57). This review of* Colonel Lawrence: The Man Behind the Legend *(1934) by B. H. Liddell Hart was published in* The New Republic *78.1011 (April 18, 1934). Because Lawrence liked the notice, they began to correspond, and he invited Kirstein to visit him in England. They were never to meet: in 1935 Lawrence was thrown from his motorcycle and killed.]*

THE WORLD WAR, our time's dreariest triumph, has little in the way of heroism elevated to legend, or of human nobility that defies recent researches of the ironic historian. A big markdown sale of death where mortal merchandise was thrown away on extreme largesse, it seems now unreal in its memory, as it was in its immediacy, pointless, impersonal, appreciable only in its tentacle effects. It is common to say in its despite that the last war fought for principle was the American Civil War.

The last great war fought for principle was waged by Lawrence, an Englishman, towards the possibility of a United States of Islam. The story of his campaigns waged on a small quantitative scale in comparison with the morass of blood along French rivers is packed with economies of swift action, quick effect, which are unlike histories

of any other theatre of conflict, still relevant and legible to us, taking on yearly the classic aura of magnificence shared by the captains of Cannae, Crécy, and Cold Harbor.

Lawrence increasingly rises as a unique figure of the twentieth century in the Western world who, in relation to his personal qualities as manifest in his life, commands our acute attention for his practical relevance. Heretofore obscured by a superficial legend, he is revealed to us in Captain Liddell Hart's superb new book; now we can know as much about him as we need to test opinion. For, in Lawrence, as in no other living Westerner, meet the most pertinent moral conflicts of the century, the relationship of the East to the West, and of the common man or mass of men to the individual.

The Ageyl, on an order, moved out to right and left as wings. A patter of drums, and the poet of the right wing burst into song, of Feisal and the delights he would afford them in Wejh. The right wing took up the refrain. A few moments later the poet of the left wing retorted with a similar extempore verse, and then the whole bodyguard burst into their marching song.

A subaltern on indefinite leave, an ex-archaeologist, Lawrence was alien and yet master. An energy of ferocious excess accompanied this march into deserts at the moment when the only songs on the Somme were the mechanical noises of huger murder. Yet in spite of Elizabethan parallels, Lawrence was an Englishman of his day. The war he waged was modern warfare, utilizing explosive and airplane, even though the terrain was sand and his troops Oriental.

Captain Liddell Hart makes quite clear the significance of the Arab revolt as useful to the grand plans of the Allies and, clearer than that, Lawrence's consummate skill as a technician in war. When his accomplishment is divested of its mystery and each small step is displayed in particular logic, there is no dulling the edge of glamour. The feats of Lawrence glow brighter when one considers the backgrounds of information—no Arab, yet a master of dialects; no soldier, luckily, but acquainted with all classical exemplars of battle art. As general, Lawrence's greatness lay in his reduction of the element of accident to the minimum; unlike other generals, he was avaricious of the lives of his companions. "My personal duty was command, and I began to unravel command and analyze it, both from the point of

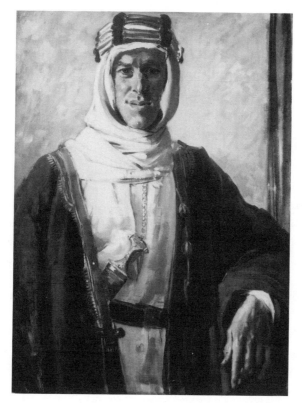

Colonel T. E. Lawrence (1919) *by Augustus John; oil on canvas*

view of strategy, the aim of war, the synoptic regard which sees every-
thing by the standard of the whole; and from the point of view called
tactics, the means towards the strategic end, the steps of its staircase."
Lawrence has the flexible attention of a craftsman always, whether he
is tabulating principles for handling Arab manners, calculating max-
imum destruction of a charge of TNT, weaving the double-barreled
diplomacy of super-Oriental duplicity, now for use against English
superiors, then against Arab allies, or reviving the Homeric diction
into iron English. Aircraftsman now, the carriage of planes and mo-
torboats receives the cool affection of his easy interest, which by its
very thoroughness has seemed so magical to a world whose only idea
of craft is dilettantism or treachery.

It is not so impressive any longer that, small and blond, he could
so powerfully affect the tribes. It is the Briton's imperial gift to pass in

deserts. Burton, Doughty, Gertrude Bell, Wilfred Blunt, and Bertram Thomas have also absorbed the basic principles of Islam, its complete practicalities of cause and effect. The Koran is no Bible book; it is a way of life mastered. As literature it is only decoration to such travelers. Lawrence, not without accident, came to Arabia. "Of course the mere wishing to be an Arabian betrays the roots of a quirk—one will fix latitudes, the silly things, another collect plants or insects (not to eat, but to bring home), a third make war, which is coals to Newcastle. We fritter our allegiances and our loyalties." What Lawrence accomplished was not due to an empire builder's single purpose over disparate people. If it had been a like occasion in South Africa, Asia, the point of this story would not have been very different. Yet in Arabia, as an artist, he gives his signature to names of towns and desert tracks. There is that railroad siding where, tormented by most serious doubts, he withdrew from the feast of his own men and arranged all night the anguished corpses of his recent enemies into repose. There is Dera, where he suffered torture which is not unthinkable only because he described it; Damascus, where in the moment of victory, in the pesthouse, his face was smacked with such an amazing destitution of irony; and near Azraq, the site of a campfire where he addressed the uncertain Serahin:

We put it to them, not abstractly, but concretely, for their case, how life in mass was sensual only, to be lived and loved in its extremity. There could be no resthouses for revolt, no dividend of joy paid out. Its spirit was accretive, to endure as far as the senses would endure, and to use each such advance as base for further adventure, deeper privation, sharper pain.

As a boy of twenty-six he intended to be a general and knighted at thirty. In four years he underwent illuminations that no contemporary and few saints have enjoyed. With his unkept promises to his bloody brothers-in-arms, notions of temporal power seemed waste. Lawrence's vanity, his self-love or self-respect, or more exactly the occupation with his essence as opposed to other men's, was not diminished by worldly failure. It was canonized. He was free to investigate real objects of his interest, obscured till now by his impetus and by that quality which he later said he hated next only to being physically touched: animal spirits. He who had known how to make the strength

of the Turks their weakness, the weakness of the Arabs their triumph, now turned to investigating his universe in his solitude.

With crippling modesty, before which ordinary pride is bad manners, he has a way of diminishing every one of his great acts to the level of a personal excuse. His observations on average men as he has lived with them in monasteries of air force and tank corps should give the new messiahs pause. For he is compassionate in his information, yet realistic in his wisdom. He has accepted the religion of personal responsibility exhausted to the limits of his organism. "In each I found the same elements, one algebraical, one biological, a third psychological." In his life he has the shifty equilibrium of the intellectual, the physical, the emotional. A tripartite welding has developed a consciousness which would be fearful to imagine had he chosen other action. As he is, the residual consciousness is visible in his art, in *The Seven Pillars of Wisdom*, the greatest book written by a man of action who is also an artist, and in that other unpublished book in whose frightful pages there is a new revelation of hope and hell. In his note on Homer he wrote: "Though a stickler for the prides of poets and a man who never misses the chance to cocker up their standing, yet he must be (like writers two thousand years after him) the associate of menials, making himself their friend and defender by understanding."

# The New Augustan Age

[*Published in* The Nation 192.5 *(February 4, 1961).*]

Washington, D.C.

Now hear this, men! Now hear this:

DURING OUR FORTHCOMING ADMINISTRATION
WE HOPE TO EFFECT A PRODUCTIVE RELATION-
SHIP WITH OUR WRITERS, ARTISTS, COM-
POSERS, PHILOSOPHERS, SCIENTISTS AND
HEADS OF CULTURAL INSTITUTIONS. AS A
BEGINNING, IN RECOGNITION OF THEIR IM-
PORTANCE, MAY WE EXTEND YOU OUR MOST
CORDIAL INVITATION TO ATTEND THE INAU-
GURATION CEREMONIES IN WASHINGTON ON
JANUARY 19 AND 20. RESERVATIONS FOR IN-
AUGURAL CONCERT, PARADE, BALL ARE HELD
FOR YOU. ROOM ACCOMMODATIONS AND HOS-
PITALITY WILL BE ARRANGED FOR YOU BY A
SPECIAL SUBCOMMITTEE. RSVP WHICH EVENTS
DESIRED AND WHAT ACCOMMODATIONS NEEDED
BY TELEGRAPHING K. HALLE, 3001 DENT
PLACE, N.W., WASHINGTON.

SINCERELY,

PRESIDENT ELECT AND MRS. KENNEDY

I WAS AWAKENED at dawn, Monday, January 16, 1961, when this command was delivered, as it was to some 140 other artists, musicians, writers, scientists, educators, and theologians, including Igor Stravinsky, Roger Sessions, Arthur Miller, Samuel Barber, Mark Rothko, Franz Kline, Tennessee Williams, Paul Tillich, Reinhold Niebuhr, John Steinbeck, John Hersey, Robert Lowell. Hemingway couldn't make it; Stravinsky was in Hollywood. Auden called me; he always knows in advance who gets what. The railroad strike was threatening to spread to the Pennsylvania. I asked him if he wanted to go under any conditions. He said this was not an invitation but a command; if they had made the effort, we should. If we couldn't get alternate bus or plane transportation, we would drive. Snow had been promised a year ahead, in the *Farmer's Almanac*. We would leave at 6 a.m.

The last time we had had to drive together was in May 1944. He had, as my sergeant described him, "the stimulated rank of major," and was in Munich to interrogate Pastor Niemöller as to whether the German people minded more being bombed by the Americans or the British. Today, we took a train. In Georgetown, the street where we were going was cut off by television trucks and cops. Mr. Kennedy was visiting a friend, Mr. William Walton, a young painter (some years earlier, he quit as a foreign correspondent of *Time* from chagrin at the editing of his copy) who had done much to organize the campaign in New York. It was beginning to snow, and hard. Tickets had to be picked up from Miss Kay Halle, a beautiful and distinguished Democratic lady who has long lived in Washington. She it was who, a month earlier, had the original notion of inviting the intellectuals to the inauguration, but it had taken until now to reach the proper echelons of party organization. The euphoric telegrams were issued by a local impresario, Mr. Robert Richman, who, from his business of arranging lecture dates for intellectuals, knew one and all.

Mr. John Hersey looked a bit dashed when he picked up his tickets for the concert and found that they cost $50. It was lucky he had fifty bucks on him; he and his wife had driven down, leaving a new baby with a babysitter. With the concert tickets (benefit of the Democratic National Committee's deficit), one drew excellent grandstand seats for the inaugural parade, and a pale blue, square lapel card which guaranteed "Preferred Standing Room" for the inauguration ceremony itself. There was a bit of confusion about the inaugural ball.

Replicas of the official engraved invitation had been issued to loyal party workers in some numbers; these, thinking no ill, assumed they had been given bona fide invitations and responded in hordes. So there was not one but five separate and distinct inaugural balls for the Kennedys to attend.

The Walter Lippmanns decided that, since the artists, scientists, and theologians had been asked, it would be nice if somebody did something about them in a human way; so on short notice, in the midst of a busy life, they threw an extremely pleasant cocktail party with warm fires and warm drink. People arrived in bursts. Washington was beginning to be demoralized by the conjunction of snow and inauguration; few had snow tires or chains; traffic was congealing. Mrs. Steinbeck said she was going to *everything*; to hell with the snow. Steinbeck looked sleek and purring. Arthur Miller towered benignly over all. He had made, at a book-and-author luncheon a few days before in New York, some nice noises about the invitation to the intellectuals. "It seems we will now be looking at, or at the least glancing towards, our poets, writers, and men-of-the-mind for more than a laugh." However, he was not sent an invitation. It eventually arrived through the intercession of Cartier-Bresson, the photographer. Miller talked about the weather. "When *All My Sons* opened in Boston, it had snowed two days before. I wasn't known then. On the opening night, the theatre was about a quarter full. But the box office guys told me we were in."

Time to prepare for the concert. Everyone had been told to be there by 8:15 or they would not be seated. We started from Georgetown with chains on at 7:15. The traffic was almost impenetrable, but profiting from the knowledge of Washington's streets possessed by John Thatcher, director of Dumbarton Oaks, we made a U-turn under the K Street viaduct and escaped onto the parkway. The snow was almost too heavy to drive. Five blocks from Constitution Hall the battery of the station wagon conked out; we walked. The decor was good for D. W. Griffiths's *Way Down East*. Mr. and Mrs. Kennedy had not been able to get transportation from Georgetown; at the last moment the President-elect called the White House. A limousine was sent. The Kennedys arrived ahead of everyone, around 8:00. Howard Mitchell, conductor of the National Symphony, arrived a few minutes later;

it was reported they chatted gaily until the concert, naturally delayed, started. Mr. Mitchell told Mrs. Kennedy it took eighty-five years to make a musician (conductor). And then maybe not everyone. Constitution Hall, a vast hideous barn which seats some 3,400 persons, was innocent of bunting, flowers, or any trace of gala welcoming. Maybe 340 persons were in the hall when we got into our seats.

When the Kennedys entered the hall, to sit alone at the far left of the stage, everyone rose and tried to make up in enthusiasm what they lacked in numbers. Mrs. Kennedy appeared a princess in a magnificent white dress (Oleg Cassini) with long sleeves. With them was Mr. Walton. A little off sat a security officer, but the three young people seemed vulnerable and detached. The Howard University Choir, which was to share the honors with the Georgetown University Choir, never arrived. Neither did Mischa Elman, who was to have played the Vivaldi Concerto in G Minor. The strings and woodwinds had suffered casualties from the storm. Still and all, the concert proper began with a *pièce d'occasion*; Mr. John La Montaine had made it, or rather, had it made, with his overture, "From Sea to Shining Sea," a piece of alarming mediocrity whose thematic materials, if any, were based on "America the Beautiful." Then Mr. Mitchell, not himself among the first rank of American conductors, led half the chorus in a horrendous rendition of Randall Thompson's grisly *Testament of Freedom*, a work not in the first category of American compositions. At that very moment, at the Frank Sinatra–Peter Lawford Hollywood Ratpack Gala to raise real dough for the Democratic deficit, Leonard Bernstein, a first-rate American conductor, was conducting a first-rate American composition: John Philip Sousa's "Stars and Stripes Forever."

*The New York Times* reported next day that when someone asked Kennedy if he was "excited," he replied: "No. Interested." During the concert, the President-elect appeared interested, but since the four parts of *Testament of Freedom* seemed to last four hours, it must have been tough. "And *who* is William Walton?" asked Auden, during the intermission. "Any relation to Willie?" Sir William (Willie) Walton had written *Façades* in his youth for Edith Sitwell, and the march "Crown Imperial" for the coronation of Elizabeth II. No relation. "The least they could have done was to ask Stravinsky to write a twelve-tone fanfare; his late pieces are so nice and short." No Stravinsky, and

no Aaron Copland, or Virgil Thomson, or Roger Sessions, or Sam Barber or Charles Ives. Just John La Montaine and Randall, the wrong T. The Kennedys left for the gala; by now the hall was almost a third full and everyone rose and applauded. Few remained to hear Mr. Howard Mitchell render the fantasy overture *Romeo and Juliet* (Tchaikovsky), or Mr. Earl Wild's well-worn overhauling of *Rhapsody in Blue* (Gershwin).

We managed to corrupt a Virginia taxi, operating unlawfully in Washington; it took two and a half hours to arrive in Georgetown. During the journey Roger Sessions talked dispassionately about official art. It's not that, in itself, it is wicked; it all depends upon the officials commanding; one can get Giotto, Palestrina, the Place de la Concorde. Mrs. Kennedy had said she was going to redecorate the White House, and every abstract expressionist in America had had palpitations. Subsequently, however, and here one felt a historical analyst at work, it seemed she had decided that since the house was largely eighteenth-century in concept and nineteenth-century in style, it would be best to keep the public rooms as they were.

Snow sifted in fat drifts. Towards dawn it stopped. I caught a bus at Wisconsin Avenue in an attempt to trace the abandoned station wagon. The day was diamond-studded, crystalline: the sun of Wagram and Austerlitz.

On the bus, into Washington city, sixteen white policemen and a very black Negro one. "Hey, Chalky: come over here, Chalky; you been up all night, Chalky." Complete integration. The station wagon seemed to have been hauled off by the police. At the Union Terminal, where I went to ask for news about the Pennsylvania strike and to secure transportation home, a distinguished young Negro with a powerful profile stood just ahead in the line. The ticket seller said evenly and kindly: "Sir, I cannot sell you a Pullman, only a ticket. The reason I cannot sell you any Pullman space is because there is none left. I hope you believe me." Sidney Poitier, who had come down for the Sinatra gala, replied: "Yes, I believe you."

The small square card entitling intellectuals to Preferred Standing Room (House Side) worked like magic. I found myself, with a bottle of brandy, in the midst of a vast clutter of convent students with their priests. The teenagers said they bet Jackie would wear the same robin's-egg-blue wool coat she wore for the christening. One girl, with a mirror

periscope, said, "This is like old history days, like Herodotus." "Like Thucydides, dope," said her girl friend. For a few seconds there seemed to be a danger of panic—some boys smashed their way through the dense crowd as if they were being chased. Finally, one could see the central stands fill, and the ceremony began.

Those who watched the inaugural ceremony on television had a much clearer idea of what went on than most of us in the crowd in front of the national capitol. They saw the Diplomatic Corps form in the rotunda, the Justices gather, and Mr. Kennedy scratch Ike's back when he couldn't reach where it itched. A cabdriver had said that Jack had completely won the old general over: "No one had told me what a fine young chap Jack is." But standing in the crowd, what one did see was intensely impressive; what one heard was mightily moving. The dignity of the event was on the level of its importance to the world. They "nothing common did or mean / Upon that memorable scene." Mr. Kennedy has the public magic of inbred but detached authority; when was it last seen in America on such a scale of physical attraction? Not since the Duke of Windsor was Prince of Wales; or better, as Joseph Alsop said, not since the first Roosevelt, whom the new President resembles in physique and philosophy.

The inaugural ceremony is essentially a religious one. Richard Cardinal Cushing led off the prayers. He did go on a bit, but reflect, fellow citizens, that Cushing is the Bishop of Boston, Mr. Kennedy's hometown, and that he is neither Francis Cardinal Spellman, who is also a Bostonian, nor Fulton J. Sheen. Archbishop Iakovos, of the Greek Orthodox Church of North and South America, prayed most beautifully in the slight trace of accent; Byzantine richness and brevity. Marian Anderson sang two verses of "The Star-Spangled Banner." Her lapidary diction made the verse sound like poetry; her mahogany voice was never strained.

Robert Frost tried to deliver some doggerel, grateful and decent, but doggerel. However, Apollo, Sun God and Leader of the Muses, shone his great disk full in the bard's face; bade him desist. But when Frost turned to poetry and spoke the good words he had written, the god smiled, hid his awful rays, and our American laureate declaimed with steady resonance. The Monday following the inauguration, Frost told the President: "Be more Irish than Harvard. Poetry and power is

the formula for another Augustan Age, and don't be afraid of power."

The Reverend Dr. John Barclay, Pastor of the Central Christian Church, Austin, Texas, in the heart of Lady-Bird-land, sounded a bit dim in the company of the dynastic descent from Rome and Byzantium. Rabbi Nelson Glueck, president of the Hebrew Union College, Cincinnati, added to his calm benediction the actual Hebrew words: *Adonai Eloheinu, Adonai Echod.* Kennedy may be a "bad" Catholic but he had one more piece of luck on his inaugural. He drew the fire of the American primate on the parochial-school issue. Standing among convent students, one imagined Kennedy knows what prayer is about, what extreme danger and illness are, physical and moral, and the consolation of faith in something greater than self. Anyone who heard him say, from the steps of the capitol, "I do not shrink from this responsibility—I welcome it," prayed for him. The crowd responded to his statement as if following a teacher. When was the last time one thought: I would do anything this man asked me to do?

Then the parade. The concert tickets entitled me to a seat directly opposite the White House. Walking back fast from the capitol, since there were no cabs, I arrived just as the first motorcycle police squadrons swept by. My only friend there seemed to be Henry Allen Moe, the sage and generous director of the Guggenheim Foundation, whose help to artists, poets, scientists, and theologians over the long years has certainly staffed the New Frontier. Alfred Barr, Director of Collections of the Museum of Modern Art, and a passionate birdwatcher, had the fortune to see a female cardinal perch on the stands above his head. He reported this two days later in Fort Worth, where we were inaugurating the Amon Carter Museum of Western Art; a Texas lady, a trace high, said, "Those Kennedys will stop at *nothin'*."

There was a splendid spectacle of the service academies in full battalions and, most appealing, the Virginia Military Institute in their early-nineteenth-century uniforms with gray-red-and-white capes. Mr. Kennedy appeared with his tall father, now out of seclusion for the first time, in the big presidential box just 100 feet across the street. The Philippine house servants attached to the White House staff mess, run by the Navy, gave everyone hot tea. Mrs. Kennedy, changed into gray, stayed for a bit and left. Lyndon Johnson enthusiastically greeted the most charming sight in the parade: a buckskinned Texan riding a

buffalo; the beast had snow in its beard, curvetted about like a kitten, and knelt to Kennedy.

No: the concert wasn't much, but doubtless as good in the ears of God as music at the Coolidge, Harding, or Truman inaugural. And what would we have got from Dick and Pat? Listen: we wouldn't have been there. So after the PT boat float, and all of the President's plumper buddies had disappeared past the old State, War, and Navy buildings, darkness came down. All along the block of stands, one heard, as the President of the United States turned to enter the White House: "Good night, Jack," "Good night, Jack." "Jack, good night."

# Star, Bar & Stripe

FOR CHARLES SHANNON

[*Kirstein took part in the civil rights marches in Alabama in 1965. This is from* The Poems of Lincoln Kirstein *(New York: Atheneum, 1987).*]

## I

Montgomery motel, "by dawn's early light." TV trucks track in.
    Six o'clock—
"so proudly hailed." Yup . . . Let's eat. A cop's gizzard grin,
    redneck crock
croaks: "You-all, dam' Yankeh agitatohs . . ." A waitress, she's
    stiff as steel,
Southernness, hatin' us: "Fray'd aigs? Sunneh-saide-up?" Yes, please.
    Cautious meal.

Green-casqued State Troopers stand guard, on whose house or what
    home?
    Above the
Alabama State Capitol's high classic dome
    snappily
flaps Stars & Bars. Third Army's brass cools, colonels in jeeps.
    Clear skies wipe
gleaming dawn. Nowhere flown by these drear Ku Klux creeps
    star nor stripe.

Churchyard: marshaling area (like Normandy, '44).
　　　We may boast,
marking time, Invasion's finally launched. This means War!
　　　Well, almost.
Our big gang's reinforced, by sore locals all ignored—
　　　this deep breach:
police guesstimate, ten, twelve? More. Thirty, thousands. A horde
　　　(Omaha Beach).

What holds us back? Something wrong? Here they come, straight
　　　ahead!
　　　　Flashing vest;
Selma boys slogged fifty miles corseleted in Day-Glo red
　　　six abreast.
Churchyard's full. Snail's pace first. Trot a bit. Now run, man! Run!
　　　Three miles on
our team hand-in-hand, priest, nun, kids having fun. We've won!
　　　But file on.

Banners blow: M.I.T., U.C.L.A., YALE. It's slow,
　　　packed, fierce, strained,
trudging through centuries. For one glorious day? Who'll know
　　　what's been gained?
Who wins, white or black, slave or free? Hymn's full swell: "We shall
　　　overcome
someday." Not today? No. Then when? Well—still and all,
　　　shout: "*Freedom!*"

Schoolkids cram windows barred, salute this funny parade,
　　　jovial din.
We bid them join. They wave us: "We can't." It seems they're betrayed.
　　　They're locked in
by teachers outside. Teachers? Keepers, learned in old lores
　　　from white folks
whose slogans scream: "Them priests, them nuns. They is whores!"
　　　Dirty jokes.

Their yell: "You doan live heah! This ain' yoh faight!" Whose is it?
     We've no right.
Forget the whole deal after one day's thrilling visit.
     Not our fight . . .
So let them be as they've been. Why should we be involved?
     O'er that dome
floats their flag in habit and health. They've got this thing solved.
     Best go home.

"Mine eyes have seen the glory . . ." Ancient chant, battle hymn,
     organ verse.
Hoist cute kids pickaback; from the curb, ugly louts, grim;
     hear 'em curse:
"Them's yoh pappy's black bastids?" Cops, side-armed, just in case.
     Third Army,
wary troops hug side streets, saving whose hooded face?
     'Tis of thee.

A long day. We're tired. Disperse us in peace. Day gets night.
     We are gone.
Who's won? Who's lost? Miles beyond—black boy, a woman, white,
     drive straight on.
Their car's hounded by hunters. Target: two sitting ducks.
     "Stop that car!"
Bull's-eye blast. You-all kin caount on ah ole Ku Klux:
     civil war.

Civil state. States of grace. Misunited states of mind.
     North again,
safe and sound, our selves saved. Same old self, deaf, dumb, or blind,
     in no pain.
There, waydown South stays dismayed at time's lag. We're aware
     of somewhere
dawn drags, clocks stop, blood boils. Here, back home, we try to care
     or not care.

II

"Magnificent distance"—Washington, D.C.—L'Enfant's scheme—
        architect
echoed Versailles' grandiose clear imperious dream—
        vast project—
mudhole for years—Brasília, Canberra, New Delhi, the same.
        Nonetheless,
war, peace, they stand, built stating each their politic claim
        to impress.

Capitol Hill, "magnificent distance"—six miles from that dome:
        Arlington.
Here, Robert E. Lee, his wife (née Custis), kept home-sweet-home.
        War's begun,
April, 1861. Civil War. Now Lee must decide
        in one night,—
(veteran West Pointer; he'd hung John Brown), on which side
        will he fight.

Doric colonnade, freeman's mansion, no single slave.
        Lee shall choose
in agonized hours futures for whites, blacks, craven, brave.
        All will lose.
Christian Virginian, aristocrat, his strategy's fate
        petrified:
Lincoln vs. northern Virginia,—Lee's sovereign state.
        When Lee died

Arlington, Virginia, national boneyard became,—
        fair estate,
headstones aligned. Here's a couple carved KENNEDY. Famed name,
        recent date.
Last year, past Lincoln's column-clad fane, imperial seat,
        marble throne,
I scanned bivouacked battalions, our immortal elite
        stunned in stone.

In prayer Lee paced his portico, his sacred place.
     He refused
Lincoln's offer of armies, clamped to earth, clan, class, race.
     He confused
Virginia with set states of mind, staunch, stubborn, untamed,
     and ingrained.
Stern corps of stiff markers blur thousands, nameless or named.
     Foreordained?

Magnificent distance: Washington, Lincoln, and Lee;
     Kennedy.
Marines halt, this graveyard's permanent burial party.
     O we see
to one side by noon's level light, what's final though fair.
     Black and white
boys present arms to a crate whose corpse serviced its share,
     wrong or right.

One veteran black chose this site as his destined spot;
     many could.
A mess sergeant, World War II, loads a private plot
     as he should.
Burial detail; captain in dress blues, shavetails proud
     fire three blanks.
Over raw soil, fold, for a wife, Stars & Stripes, a shroud;
     her mute thanks
gagged by grief, yet death doth endow what life hath him robbed;
     seemly sight.
Three shots. Honors. Kennedys killed, half a world sobbed
     half a night.

"Someday!" in clay we'll all lie with sergeant, Lincoln, Lee,
     timelessly;
no need to march or muse, dream or doze. Sly enemy—
     apathy.
Today, a delay. Selma to Montgomery: O say
     can you see

by what dawn's murky light who wins where? And this is a
    rich country.

Arlington, by shrapnel unscarred, hosts bones of the lost.
    History
congeals in cut script. Interred as spent dust, count the cost
    thriftlessly.
Magnificent distance; in victories won or failed,
    famous dates
adorn large design. Here, O what was so proudly hailed,
    half-thanked, waits.

# Robert Gould Shaw

[On his first day at Harvard, Kirstein agreed to take lodgings with the boy standing next to him in line for a medical examination. His name, it turned out, was Francis Cabot Lowell, and he quickly led his roommate into the core of old Boston society. The people that Kirstein met there were "historical objects; and they fascinated me because they behaved exactly as their parents and grandparents behaved." His obsession with the city's aristocratic inhabitants and, through them, with the founding and preservation of the Republic gave him reference points against which the present could be judged (see also p. 22). From Lay This Laurel: An Album on the Saint-Gaudens Memorial on Boston Common (New York: Eakins Press Foundation, 1973).]

I

ON THE 18TH of April 1861, Robert Shaw, a twenty-three-year-old proper Bostonian who had recently volunteered in the Seventh New York National Guard Regiment, wrote his family:

The Massachusetts men passed through New York this morning. We start tomorrow [Friday] at 3 P.M.

Won't it be grand to meet the men from all the States, East and West down there [Washington], ready to fight for the country as the old fellows did in the Revolution?

On that identical afternoon, Gus Saint-Gaudens, a redheaded lad of thirteen, was driving a foot lathe, polishing miniature cameo brooches, near one of twin windows in a tiny shop kept by a fine French craftsman. This strict master operated his own lathe facing the other window. The Seventh Massachusetts Regiment was marching to the Battery on its way to Annapolis and Washington. There was fear that the national capital was menaced by Confederate troops. In the street below the room where young Saint-Gaudens was reluctantly bound to his lathe, the sidewalks were packed. The day before, in Baltimore, a riot had occurred in which four Massachusetts soldiers of another regiment had been killed, bringing the threat of worse civil strife. Although the apprentice cameo cutter was not allowed to rush downstairs to join the throngs, he saw through his window, above the heads of the crowd, the slanting glint of sunlight on newly issued Springfield rifles. He could not have known it, but in the mass of soldiers, as flank man in a platoon, was Private Robert Gould Shaw, who had quit the Harvard Class of 1856 after his junior year.

It was hardly by accident that Thomas Wentworth Higginson and Shaw, who were to become the two most famous commanders of black troops in the Civil War, both came from Unitarian Boston. "The Athens of America," "Hub of the Universe," "The Brahmin's Rome," as Boston's best described their citadel, with less smugness than irony, was supported by traditions which Harvard College had defined for two hundred years, partly as transcendental ethics, and even more significantly as active political morality.

Shaw's mother was a Sturgis, his father a committed antislavery activist. As a sophomore at Harvard, Shaw had had doubts about the wisdom of trying to enforce an arbitrary union of the American states against a powerful and disruptive Southern separatist policy, but after Abraham Lincoln's election, though it hardly granted any clear mandate, Shaw in his junior year became a staunch and vocal Unionist.

In Washington in April 1861, Shaw decided to stay in the army although he had signed on for only thirty days, as was current custom. On May 2 he was commissioned second lieutenant in the Second Massachusetts Regiment. In this regiment, enlistment was for three years or for the duration of the rebellion. The first battle of Bull Run and other initial disasters had not yet been visited upon a hopelessly divided nation.

On the 18th of July 1862, a few days before the Second Bull
Run, the Massachusetts Second was in Harper's Ferry, where Lieu-
tenant Shaw carefully inspected the bullet-torn federal arsenal which
old John Brown had converted to his private fortress two years before.
To the son of an ardent abolitionist, John Brown was a hero-martyr,
who had shouted: "We have given the sword to the white man: the
time has come to give it to the black!"

After the disaster and panic following the first Bull Run, the
extremity of danger posed by Confederate armed forces was clearly
revealed. Union defenses were on the verge of chaos. Additional reg-
iments, well trained and battle-ready, were sorely needed. Robert Shaw
wrote a friend working on the influential *New York Daily Tribune*:

Isn't it extraordinary that the Government won't make use of the instrument
that would finish the war sooner than anything else, *viz.* the slaves? I have
no doubt that they could give more information about the enemy than anyone
else, and that there would be nothing easier than to have a line of spies right
back into their camp. What a lick it would be to them, to call all the blacks
in the country to come and enlist in our army! They would probably make
a fine army after a little drill, and could certainly be kept under better discipline
than our independent Yankees.

Frederick Douglass, one of the key moral forces of the epoch,
had for some time been of the same opinion. Son of a white father
and a slave mother, who was a woman of extraordinary intelligence,
Douglass was himself an escaped slave. His legal freedom had been
purchased by popular subscription. Since 1847, he had edited and
published an important antislavery journal from Rochester, New York.
He had schooled himself to become a skilled orator and appeared
widely at abolitionist rallies throughout the nation. He had toured
Great Britain, lecturing to unfriendly audiences, making allies for his
crusade, which was thoroughly unpopular, especially among the
cotton-mill owners of Manchester and the industrial Midlands, despite
the fact that England had moved against the literal legality of slavery
even before the American Revolution. In his magnificent autobiog-
raphy he would write:

From the first I reproached the North that they fought the rebels with only one hand, when they might strike effectively with two,—that they fought with their soft white hand, while they kept their black iron hand chained and helpless behind them—that they fought the effect, while they protected the cause, and that the Union Cause would never prosper till the war assumed an antislavery attitude, and the Negro was enlisted on the loyal side.

In Douglass's *Monthly* for July 1862, he reported from Rochester:

General Hunter is said to have organized a black brigade in South Carolina, but this terrible iron arm, more dreaded by the rebels than ten thousand men of any other color, is said to be disbanded by order from Washington just at the moment when the blow was most needed, and when it was about to be struck. Though thus repelled, and insulted, the Negro persists in his devotion to the Government, and will serve it with a pickaxe if he cannot with a pistol, a spade if he cannot with a sword.

For many months even after the Civil War began, Abraham Lincoln had hesitated to act on this issue, though his aim since 1837 had been ultimate emancipation. Fearful of alienating political forces in those border states whose aid was currently essential to an eventual victory for the North, Lincoln moved cautiously, patiently, ambiguously, balancing between political perils, until the moment seemed ripe. After what seemed to many abolitionists an interminable vacillation, in July 1862 Congress at last authorized the President to raise black troops and arm them for combat. By that November, Colonel Thomas Wentworth Higginson, an ardent backer of John Brown and a Unitarian who had lost his pulpit by delivering from it incendiary sermons against slavery, mustered a regiment of blacks, the First South Carolina Volunteers, near Beaufort, South Carolina. In his memoirs, Higginson wrote that had he received an invitation to command a regiment of Kalmuck Tartars, he could not have been more surprised. Soon, in Louisiana and Tennessee, four other wholly black "contraband" units were under arms. Though the ex-slaves had been persuaded to join by promises of pay and conditions equal to those of white soldiers, their actual conditions of fighting and dying were determined by harsh and unjust treatment. Indeed, further recruiting

became very unpromising; yet it was soon to be proved that ex-slaves could become excellent fighting men. Colonel Higginson wrote:

In noticing the squad-drills I perceive that the men learn less laboriously than whites that "double, double, toil and trouble," which is the elementary vexation of the drill-master,—that they more rarely mistake their left for their right,—and are more grave and sedate under instruction. The extremes of jollity and sobriety, being greater with them, are less liable to be intermingled. These companies can be driven with a looser rein than my former [white] one, for they restrain themselves; but the moment they are dismissed from drill every tongue is relaxed and every ivory tooth visible.

On the first day of January 1863, Lincoln issued his Emancipation Proclamation. In Massachusetts, Governor John Albion Andrew, the most energetic of Northern executives dedicated to the cause of black freedom, became the moving force in forming a regiment of volunteer black soldiers from his state. During the first six weeks of recruitment, Massachusetts, with its comparatively small black population, managed to sign up about one hundred men. Governor Andrew turned for help to his friend George L. Stearns, a leading Republican politico who had been an ardent backer of John Brown, and put him in full charge. Stearns promptly raised five thousand dollars and opened offices from Boston to St. Louis. In February he went to Rochester, where Douglass became a chief supporter and issued his famous appeal "Men of Color, To Arms!" which was widely circulated in the national press as well as by broadside and pamphlet, becoming perhaps the single most persuasive instrument in gaining black recruits. Douglass required his own agents to write to Stearns every night, summarizing the day's work. The fact that the officers in the volunteer regiments would be white was recognized immediately as an injustice and doubtless kept many able young men from volunteering, but by April the ranks of the Fifty-fourth Regiment of Massachusetts Volunteers were filled, and plans for the Fifty-fifth begun.

Robert Shaw was then still stationed in the South, serving in the Second Massachusetts. Although he had enlisted in April 1861, it was not until October 22 that Shaw's regiment took part in a major engagement, at Ball's Bluff. The Fifteenth and Twentieth Massachusetts were badly ravaged. Young Lieutenant Shaw found himself kneeling

beside a wounded man with one bullet through a leg and another
through a lung. This was none other than Oliver Wendell Holmes,
Jr., who, recovered from such trials, decades later became a legend
on the Supreme Court. Since April, Shaw had grown increasingly
frustrated. Close friends were killed and hurt; others sought their release
from the infantry to join a far more glamorous cavalry; all of which
did little to relieve his impatience. One might have supposed that
Shaw also would have joined the horse soldiers. But his preoccupation
aimed him elsewhere. During the many months sanguinary warfare
eluded him, politics had become more tautly polarized between "rad-
ical" Republicans and hesitant "liberals." On March 13, 1862, an act
sponsored by a New England antislavery coalition in the Congress was
passed prohibiting the return of fugitive slaves. On May 18, Shaw
wrote his father:

You will be surprised to see that I am in Washington. I came down with
Major Copeland to see if I could assist him at all, in a plan he has made for
getting up a black regiment. He says, very justly, that it would be much wiser
to enlist men in the North, who have had the courage to run away, and
already have suffered for their freedom, than to take them all from contra-
bands. . . . Copeland wants me to take hold of the black regiment with him,
if he can get permission to raise it, and offers me a major's commission in
it. . . . Copeland thinks that the raising of black regiments will be the greatest
thing that has ever been done for the negro race.

On May 25, 1862, in Winchester, Virginia, Shaw took part in
an engagement with units of Jackson's forces whose guns were aimed
and fired by old men and young girls. He was hit by a minié ball but
it was deflected by a gold watch which he wore over his heart. Soon
he was appointed to the staff of his commander, General Gordon,
originally colonel of the Second Massachusetts, now a brigadier.

September 15 found Shaw and his men as part of McClellan's
force by Antietam Creek, facing Jackson and Lee. Through gross errors
of judgment, overestimation of enemy strength, and exacerbated tem-
peramental indecision, McClellan let absolute victory evade him.
Shaw survived Antietam, the bloodiest engagement of the war so far
fought, with nothing worse than a spent bullet grazing his neck. Lee
withdrew, neither routed nor discouraged. But in Lee's withdrawal,

Lincoln saw the chance for which he had long waited. Now he could present his Cabinet with a first draft of a preliminary Emancipation Proclamation. McClellan, his commander in the field, had flubbed a major opportunity. The Commander in Chief would seize the political initiative. Emancipation would launch the Union cause as an international moral crusade. England, with all the world watching, would be hard put to recognize the Confederacy, however much inclined the mill owners of Manchester and a majority of upper-class Britons were.

The Proclamation, when at last enunciated, was scarcely greeted with unmixed joy, even in the North. Legalization of servile rebellion in its horrid potential of urging blacks to shoot their former masters was feared by many Unionists, who thought Jefferson Davis might use it as an excellent excuse to jettison every rule of Christian warfare. Extreme retaliation was indeed promptly proposed in Richmond. However, there was to be no formal legislation except as it applied to white officers or their black soldiers under arms. Shaw voiced a common apprehension: "Jeff Davis will soon issue a proclamation threatening to hang every prisoner they take, and will make this a war of extermination."

Governor Andrew, seeking to find the right leader, offered Robert Shaw the colonelcy of the Fifty-fourth Regiment of Massachusetts Volunteers, the first such unit to be raised within the free states of the Northeast. At first Shaw hesitated. As the philosopher William James recalled years later in his oration at the unveiling of Saint-Gaudens's *Memorial*:

In this new negro-soldier venture, loneliness was certain, ridicule inevitable, failure possible; and Shaw was only twenty-five; and although he had stood among the bullets at Cedar Mountain and Antietam, he till then had been walking socially on the sunny side of life. . . . [But Shaw] . . . inclined naturally towards difficult resolves.

Even within the lower ranks of the Union Army, there was deep prejudice against the use of black troops. At first Shaw flatly refused, pleading incompetence, which enormously discouraged his rather neurotic mother, who blamed it harshly on her husband's constitutional

self-doubt, which their only son seemed to have inherited. But on February 5, Shaw telegraphed his father to cancel his letter of refusal sent the day before and to inform Governor Andrew that he would accept the command. Overjoyed, his mother wrote: "Now I feel ready to die, for I see you are willing to give your support to the cause of truth that is lying crushed and bleeding."

On May 1, 1863, the Confederate Congress passed a resolution firmly lodged against white officers commanding black troops. Such would be treated as inciters of servile rebellion and would be, if captured, "put to death, or otherwise punished." No Unionist could hold any illusion about what quarter to expect in the event of being taken prisoner. Shaw's soldier friends regarded his appointment with satisfaction, since they knew he was in no degree fanatic. It was thought best for a variety of reasons, political as well as military, to commence Massachusetts enlistments in Boston. A committee was formed to raise funds, mainly of those long identified with the abolitionist cause, many of whom had housed and financed John Brown. The volunteers were promised thirteen dollars a month (since no federal funds were as yet available) with a hundred dollars bounty at the expiration of service. Wendell Phillips, the great orator, addressing a rally at the Joy Street Church, faced the injustice:

Now they offer you a musket and say, "Come and help us." The question is, will you of Massachusetts take hold? I hear there is some reluctance because you are not to have officers of your own color. This may be wrong, for I think you have as much right to the first commission in a brigade as a white man. No regiment should be without a mixture of the races. But if you cannot have a whole loaf, will you not take a slice?

Difficulties in raising the regiment were not slight. Some early work had been done successfully within, and in secret outside, Massachusetts. Men offering themselves were training at Readville, near Boston. Only a small proportion had been slaves; a large number were light-complexioned compared with personnel forming Southern contraband units. The State Surgeon General himself gave rigorous physical examinations; only a third volunteering were accepted. This meant

slow work in filling the roster. However, Shaw insisted on severe standards, since he realized the symbolic status of his regiment would necessarily attract universal scrutiny. Frederick Douglass's two sons, Charles and Lewis, joined. Fugitive slaves in Canada found themselves willing to return; others were attracted from as far west as Missouri, Illinois, and Michigan. While at the outset the men were supposedly to derive mainly from Massachusetts, it soon became common knowledge that the effort was far wider. A columnist in *The National Intelligencer* derided the operation: ". . . [Governor Andrew's] crimping sergeants will shortly turn up in Egypt, competing with Napoleon for the next cargo of Nubians."

Meanwhile, Shaw drilled his men at Readville, attended by gloomy prognostications. It had been assumed that blacks would never make fighting men. How could anyone expect ex-slaves to fight knowing that, if made prisoners, they would be returned to slavery, or worse? There were also false accusations that Shaw abused his volunteers. He wrote indignantly to his mother that he dealt with his men less harshly than his former commands. By March there were some four hundred in camp, with the number growing weekly. Recruiting in Canada and farther afield was reduced. By May 14 his ranks were full; he was informed by telegraph that there were two hundred additional men north of the border who would presently be available for a Fifty-fifth volunteer regiment. Robertson James, a younger brother of the novelist Henry James, enlisted under Shaw at the age of seventeen: later he would serve as a lieutenant in the Fifty-fifth. Skeptics who came to observe Readville were astonished both by the superiority of the recruits and the excellence of training. Henry James, Jr., exempted from the war by some unnamed disability and feeling guilty at this exemption, visited his younger brother Garth Wilkinson James, who also served with his brother Robertson in Shaw's regiment.

Robert Shaw was now married; he had courted a New York girl since before his first enlistment and arranged to marry before his regiment left for the front. His ranks being filled by the middle of May, on May 18 there took place the ceremonial presentation of battle flags. Frederick Douglass, William Lloyd Garrison, veteran editor of *The Liberator*, and the orator Wendell Phillips spoke to some three thousand friends and families. Then Governor Andrew, turning to Shaw, said:

I know not, Sir, when in all human history, to any given thousands of men in arms, there has been committed a work at once so proud, so precious, so full of hope and glory, as the work committed to you.

Shaw thanked the governor for the embroidered silken banners. He said in part:

May we have an opportunity to show you that you have not made a mistake in intrusting the honour of the State to a coloured regiment,—the first State that has ever sent one to war.

Henry James, in one of those lucubrations quivering between agonizingly circuitous elegance and a determination to fix what he honestly felt, wrote in *Notes of a Son and Brother*:

That second aspect of the weeks of preparation before the departure of the regiment can not at all have suggested a frolic, though at the time I don't remember it as grim, and can only gather that, as the other impression had been of something luminous and beautiful, so this was vaguely sinister and sad—perhaps simply through the fact that, though our sympathies, our own as a family's, were, in the current phrase, all enlisted on behalf of a race that had sat in bondage, it was impossible for the mustered presence of more specimens of it, and of a stranger, than I had ever seen together, not to make the young men who were about to lead them appear sacrificed to the general tragic need in a degree beyond that of their more orthodox appearances.

The Fifty-fourth was scheduled to march to Battery Wharf and there embark for the Sea Islands off Charleston, South Carolina. A parade was deemed appropriate. On May 28 one hundred policemen kept order while another brigade was kept in covert reserve; it was not known how the crowd might receive blacks bearing arms in their own regiment. As Shaw rode at the head of his men through Essex Street, he passed the home of Wendell Phillips, where, on its balcony, stood Garrison, tears in his eyes and his hand on a bust of John Brown, to receive the colonel's salute. In the front ranks marched Lewis Douglass as sergeant major. The regiment passed by the spot on King Street where Crispus Attucks, a runaway mulatto slave, had been shot during the so-called Boston Massacre of 1770. His was symbolic as the first

death in the struggle with Britain; colonials considered it noteworthy for one not so free as they to fight and fall. In 1854 over the same State Street cobblestones, an escort of two thousand soldiers had secured the escaped "slave-preacher" Anthony Burns's return by ship to his Virginia master, after another minister, Thomas Wentworth Higginson, had failed in an attack on the prison. When the Fifty-fourth Regiment reached the wharf, Irish laborers attempted to create a riot; otherwise the parade passed without incident. At the very spot where, thirty-four years later almost to the day, Saint-Gaudens's monument would be unveiled, Shaw paused to raise his sword to Governor Andrew, standing with his staff on the State House steps. Then he passed down Beacon Street, where, from the balcony of the beautiful Sturgis home at No. 44, Shaw's sister Ellen watched:

I was not quite eighteen when the regiment sailed. My mother, Rob's wife, my sisters and I were on the balcony to see the regiment go by, and when Rob, riding at its head, looked up and kissed his sword, his face was as the face of an angel and I felt perfectly sure he would never come back.

Among many watching was the abolitionist Quaker poet John Greenleaf Whittier. Before this occasion he had refused even to look at an armed man. Now, although much moved, he could not bring himself to further expression in verse or prose, since he felt that whatever he wrote might lead, however indirectly, "to some further impulse of slaughter," but later he wrote:

The only regiment I ever looked upon during the war was the 54th Massachusetts on its departure for the South. I can never forget the scene as Colonel Shaw rode at the head of his men. The very flower of grace and chivalry, he seemed to me beautiful and awful, as an angel of God come down to lead the host of freedom to victory.

As the regiment marched away, the band played "John Brown's Body," and while the words of Julia Ward Howe's battle hymn were not sounded, many remembered her second verse:

*I have read a fiery gospel, writ in rows of burnished steel:*
*"As ye deal with My contemners, so with you My grace shall deal;*

*Let the Hero, born of woman, crush the serpent with his heel,*
*Since God is marching on."*

And it would be Robert Shaw at the head of the first volunteer regiment of blacks, as his sister and the two poets visualized him and the spirit of the event, that Augustus Saint-Gaudens, sculptor, would fix in bronze, three decades and a half later, when the great rebellion and these heroes were already half forgotten.

## II

The heroic story of the fate of Robert Gould Shaw and the men of the Fifty-fourth Regiment has been admirably told in two authoritative books. Captain Luis F. Emilio was the author of the official *History of the Fifty-fourth Regiment of Massachusetts Volunteer Infantry, 1863–1865* (first issued in 1894 and reprinted in 1968). The second, more recent book on the subject is *One Gallant Rush: Robert Gould Shaw & His Brave Black Regiment*, by Peter Burchard (1965). Captain Emilio was with the regiment and fought when it was massacred at Fort Wagner, a scant two months after it sailed from Boston; on him fell the burden of command when nearly every one of his superiors was slain in the assault. His book is a veteran's stoic, unvarnished, but authentic record; it contains photographs of many black soldiers that reinforce the author's honest discretion and solid memory. Peter Burchard's vivid, sensible, and sensitive researches are full revivals for our time of Shaw's world, the regiment's martyrdom, and its great accomplishment.

In a time when military heroism is suspect and a thousand images of melodramatic violence have polluted the subject, to adequately recount the actual battle at Fort Wagner, where Shaw and almost half the regiment were killed, wounded, or missing, would call for the exaltation of an ancient Greek or Welsh bard.

During the first weeks after arriving in South Carolina, the regiment assisted in taking and sacking the undefended Confederate town of Darien, Georgia, an action Shaw objected to as unworthy of their abilities and damaging to the cause they represented. However, they soon had their baptism by fire, taking part in attempts to capture James and Morris Islands, strategic land areas leading to and protecting Fort

Wagner, the heavily bastioned Confederate stronghold on the tip of Morris Island, which guarded the main ship channel to Charleston, less than six miles away.

During the second week of July, the Fifty-fourth fought in early efforts to capture the islands and distinguished itself, rescuing the Tenth Connecticut Regiment from defeat and massacre. A war correspondent from New England reported in a newspaper dispatch:

The boys of the Tenth Connecticut could not help loving the men who saved them from destruction. . . . The dark-skinned heroes fought the good fight and covered with their own brave hearts the retreat of brothers, sons and fathers of Connecticut.

Lacking food and rest, after a two-night march through pelting rain and shifting sand, having received no proper rations for fifty hours, the Fifty-fourth was offered the chance to lead an attack almost certainly doomed in advance to defeat: a direct and major assault on Fort Wagner itself.

On behalf of the regiment, Robert Shaw accepted the assignment when it was offered. General Strong, who had participated a week before in an earlier but weaker attempt on Wagner and who was to lose his own life in the second assault, told Colonel Shaw of the decision again to storm the fort.

"You may lead the column if you say yes," Strong said. "Your men, I know, are worn out, but do as you choose." Shaw accepted, though he must have known the risk involved.

The attack was scheduled to take place on July 18. During that day a bombardment of the fort of unprecedented force was made by the Union flotilla of battleships and other craft to support the land operations against Wagner and other forts protecting Charleston Harbor. The Union commander of the entire effort was Brigadier General Quincy Adams Gilmore, the most efficient artillery commander the war had produced thus far. He ordered the land attack to take place immediately after dark so that the assault regiments would not be visible to the fort's defenders. He estimated that the tremendous naval barrage would have sufficiently disabled and demoralized the Confederate forces. In this as in other calculations he was in grave error, though the taking of Fort Wagner seemed a necessary and logical step in the

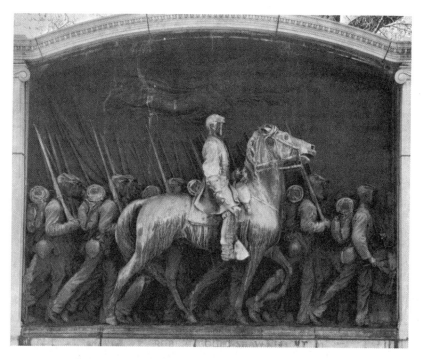

The Robert Gould Shaw Monument (1884–97) *by Augustus Saint-Gaudens, Boston Common; bronze*

attempt to capture Charleston, which the fort on Morris Island over-looked. Charleston, a lovely old town, was also "the cradle of secession" and one of the two principal ports of entry through which arms and supplies from abroad could reach the almost totally blockaded Confederacy.

Shaw had accepted the assignment despite the risk and the ex-traordinary sacrifice involved. The men of the Fifty-fourth had fought valiantly on James Island only two days before. With no rest and hardly any food, with many sick in camp, others weakened by fatigue and guard detail, the regiment advanced by forced march to Morris Island. And it was the day after, July 18, having but six hundred men in line instead of full regimental strength of almost a thousand, that it undertook to lead the attack on Fort Wagner.

At around six o'clock in the evening, General Strong, mounted and in parade dress and attended by two aides and two orderlies, appeared before the assembled troops and asked Shaw's men if they

would head the army in leading the assault. Voices roared and Strong, seizing the regimental flags from their color sergeants, held them high. After this burst of enthusiasm they had an hour's rest before moving into the lead position.

One officer later recalled that Shaw looked extremely pale: "A slight twitching at the corners of his mouth plainly showed that the whole cost was counted." Darkness was beginning to fall as the men moved into position. According to Peter Burchard:

There had always been a touch of austerity in Shaw's relations with his men. Now, one remembered, he spoke to them warmly, with evident affection. "I want you to prove yourselves," he told them. "The eyes of thousands will look on what you do tonight."

At 7:45 he strode briskly along the line to stand in its center, urging every man to see that his bayonet was securely fixed. His men stood up; he called: "Move in quick-time until within a hundred yards of the fort; then double-quick and charge!" He paused briefly, drew his sword, and commenced the march up the slope to the parapets of the fort, all eyes straining to make out their destination in the deepening darkness.

Inside the fort the Confederate forces, not seriously impaired by the day's bombardment, were ready; when the Fifty-fourth arrived at a point two hundred yards from the top of the ramparts, they opened murderous fire. The Massachusetts Regiment climbed unflagging as men fell everywhere. Shaw, leading, was among the first to die. He was observed to fall the moment he arrived at the top, pitching forward, sword upraised, a bullet through his heart. Though the troops behind him did not falter in their advance, they endured massacre, and those few who managed to win their way into the fort engaged in hand-to-hand fighting and were killed, wounded, or captured. Negroes and whites were strewn together along the sands for three-quarters of a mile.

Lewis Douglass later wrote his father: "I had my sword-sheath blown away while on the parapet . . . swept down like chaff, still our men went on and on."

Color Sergeant William H. Carney, Company C, who had carried the regimental flag to the top of the fort, managed, although seriously

wounded, to hold on to the standard and to make his way back to a
field hospital.

A Confederate lieutenant, Iredell Jones, who visited the ground
next morning, reported:

The dead and wounded were piled up in a ditch together sometimes fifteen
in a heap, and they were strewn all over the plain for a distance of three-
fourths of a mile. . . . One pile of negroes numbered thirty. Numbers of
both white and black were killed on top of our breastworks as well as inside.
The negroes fought gallantly, and were headed by as brave a colonel as ever
lived. He mounted the breastworks waving his sword, and at the head of his
regiment, and he and an orderly sergeant fell dead over the inner crest of the
works. The negroes were as fine-looking a set as I ever saw,—large, strong,
muscular fellows.

Later, Shaw's corpse was stripped of its uniform, tossed to the
bottom of a ditch, and covered with the bodies of his men. Express
ignominy was intended, since this treatment was accorded no other
white officer, and many had been slain. Brigadier General Hagood,
commander of the Confederate forces of the fort, supposedly said
(although denying it later):

I knew Colonel Shaw before the war, and then esteemed him. Had he been
in command of white troops, I should have given him an honorable burial;
,as it is, I shall bury him in the common trench with the negroes that fell
with him.

In the accounts of what happened at Fort Wagner reported in the
Northern press, this statement became "He is buried with his niggers."
Outrage at the implications of this attributed remark added to the
impact of the tragedy. Enlistments in regiments manned by blacks
increased tenfold; many black regiments were formed in the North,
and Shaw and the men who died with him became martyrs whose
fate made them heroes famous throughout the nation. Meanwhile,
the members of the Fifty-fourth who had fought their way into Fort
Wagner and were captured or wounded were sent by the Confederate
forces to hospitals and prisons in and around Charleston, where they
received special mistreatment in recognition of their special courage.

In the aftermath of the holocaust at Fort Wagner, as well as in the years since, there has been much recrimination among those who have studied the event. To some it appears that Shaw's command was committed against such impossible odds that the tragedy developed from an almost criminal lack of care and lack of planning, and that Shaw was foolish in allowing his regiment to take the lead when it was exhausted and depleted from previous engagement. Some Union brigade commanders were outspoken against the assault, but the commander, General Trueman Seymour, made the decision. As one dissenting colonel said: "I did not think we could take the fort so: but Seymour overruled me. Seymour is a devil of a fellow for a dash."

That men actually breached the bastion was the result of a superhuman determination. The regiment sustained 42 percent of its committed strength in casualties; two-thirds of the officers and nearly half of the enlisted men were killed, wounded, or missing. There were 1,515 casualties in the attack on the Union side, while the Confederate casualties amounted to 181. In a contemporary investigation of what amounted to a massacre, the *New York Tribune* reported testimony from a special correspondent who was present when the two officers in command, General Gilmore and General Seymour, discussed the proposed assault. The correspondent quoted General Seymour, who was later known to be an ardent admirer of black troops, as making derogatory and anti-Negro remarks about the Fifty-fourth Regiment, suggesting that General Strong's and Colonel Shaw's troops might lead in order to be sacrificed.

Other observers and scholars who have studied the attack take another view and defend the validity of the action. In addition to prior planning there had, in fact, been a previous attack made on Fort Wagner a week before, an attack mounted by white officers and carried forward by white troops, many of whom fought again on July 18, and some of whom were killed or captured. Peter Burchard points out that Shaw had written to General Strong urging him to include the Fifty-fourth, and states that, bitter statements of black leaders and white crusaders notwithstanding, he has found no facts to support the thesis that the blacks were sent into battle instead of white soldiers because they were thought of as expendable. Almost any battle of the Civil War, particularly most before 1863, he concludes, might be seen as a hopeless, bumbling sacrifice of men.

Fort Wagner was not taken by Union forces until September 6, a little more than two months after Gettysburg. Soon after its recapture, Francis George Shaw wrote to the Commander of the Department of the South:

I take the liberty to address you because I am informed that efforts are to be made to recover the body of my son, Colonel Robert Shaw of the Fifty-fourth Massachusetts Regiment, which was buried at Fort Wagner. My object in writing is to say that such efforts are not authorized by me or any of my family, and they are not approved by us. We hold that a soldier's most appropriate burial-place is on the field where he has fallen. I shall therefore be much obliged, General, if in case this matter is brought to your cognizance, you will forbid the desecration of my son's grave, and prevent the disturbance of his remains or those buried with him.

Another view of the sacrifice can be found expressed in one of the multitude of letters written to Lincoln when Congress finally, on June 15, 1864, granted equal pay to black soldiers, a letter signed with the name of James Henry Gooding:

When the arms of the Union were beaten, in the first year of the war, and the executive called for more food for its ravaging maw, again the black man begged the privilege of aiding his country in her need, to be again refused.

And now he is in the war, and how has he conducted himself? Let their dusky forms rise up out of the mires of James Island and give the answer. Let the rich mold around Wagner's parapets be upturned, and there will be eloquent answer. Obedient and patient and solid as well are they. All we lack is a paler hue and a better acquaintance with the alphabet.

At the end of the Civil War, black soldiers constituted some 10 percent of the Union armies. Lincoln on more than one occasion credited these troops with possibly tipping the balance that made Union victory possible. The deprivations, unfair treatment received, and single-minded persistent devotion of heroism of these soldiers would be difficult to exaggerate. It is certain that the heroism of Robert Gould Shaw and the enlisted men of the Fifty-fourth Regiment was the

principal rallying point for black participation in the war as free men fighting slavery. The subsequent history of the Fifty-fourth Regiment, fighting on through the war, and the contribution of other black regiments in a national history often dominated by shameful event form an episode that gives cause for pride.

# Marian Hooper Adams

[*Two of Kirstein's enduring interests—Augustus Saint-Gaudens and Henry Adams—came together in his bleak study of Adams's marriage to Marian Sturgis Hooper and the Saint-Gaudens memorial to her, commissioned after her death by the desolate husband. From* Memorial to a Marriage: An Album on the Saint-Gaudens Memorial in Rock Creek Cemetery *by Lincoln Kirstein and Jerry L. Thompson (New York: Metropolitan Museum of Art, 1989).*]

I

MARIAN STURGIS HOOPER, known as Clover from childhood, was born in 1843, a thrice-proper Bostonian. Her father, Robert William Hooper, was an eminent ophthalmologist rich enough to evade formal practice. The family was one of the most ancient and honorable clans of New England landed oligarchy—Sturgis, Cabot, Shaw, Lowell, Bancroft, all in the solid intermarried lineage of patrician liberalism. Robert Gould Shaw, colonel of the celebrated regiment of black volunteers massacred at Fort Wagner in 1863 and immortalized by Saint-Gaudens's great high relief on Boston Common, was her second cousin. Her mother died when she was five, precipitating a fervent attachment to her father that survived marriage as the virtual core of her existence.

When she was fourteen, she was enrolled in Elizabeth Agassiz's progressive classes for young girls, which not long afterwards developed into an academic annex to Harvard College and in 1894 achieved official incorporation as Radcliffe. As with the offspring of many abolitionist Bostonians, pursuits of the mind were not only permitted but, within limits of gender, even encouraged. Latin, Greek, German, classical and modern literature, music, art were obligatory diversion and adornment, accompanied by daily fluctuating reports from the battlefields of Virginia and Tennessee. In motherless adolescence, one of her strongest influences was her aunt Caroline Tappan, a close follower of the transcendentalist coterie, a prolific poet, and a feminist ahead of her time. A poem of hers, titled "Disenfranchised," is a wistful statement of her views.

> *Standing like statues, ever in one place,*
> *When every man a citizen shall be,*
> *But I and all my sisters long must wait,*
> *Enforced obedience our childish fate.*

Clover Hooper was hardly a banner-bearing activist, but privately she too subscribed to women's causes, though certainly in girlhood, and well into marriage, she had no reason to feel less than free to think and act as she fancied. If she was not permitted to attend classes alongside her brother at Harvard, she was quite as well-read and informed. If she was unable to vote for Andrew Johnson or Ulysses S. Grant, it was no great deprivation. Throughout the Civil War, she served faithfully with her cousins and friends in the Sanitary Commission's female auxiliary, rolling bandages while *Vanity Fair* was read aloud to those platoons of patriotic virgins. Immediately after the grave news from Gettysburg, Dr. Hooper issued from retirement and volunteered for the field. Edward (Ned) Hooper, Clover's brother, together with Charles Francis Adams, Henry's censorious and more aggressive brother, was at Port Royal, detailed to the propaganda project of educating the blacks of the offshore Carolina islands.

Following Appomattox, Clover, with stubborn dash and ingenuity, managed to land herself in Washington in the company of other

unmarried debutantes to witness two days of parading by the victorious Grand Army of the Republic. She was seated in the grandstand directly opposite President Johnson, General Grant, and General William Tecumseh Sherman. Herself an accomplished equestrienne, she was greatly impressed by the manège of Colonel George Custer (later of the Little Bighorn) as he gentled a fractious steed. With her companions she inspected the tiny room in which Abraham Lincoln died, chilled by the sight of bloody pillows on an unchanged bed. Attending the military tribunal that tried the conspirators, she observed the facial expressions of the assassins as the key to their guilt. Mrs. Surratt was veiled. She would hang with other guests of her rooming house, though some thought that as a woman she was less culpable.

<center>III</center>

The normal flow of Beacon Hill nuptials, interrupted by war, now resumed. Ellen Hooper, Clover's adored sister, married Ephraim Gurney, a worthy fellow who, like Emerson, forsook the pulpit. Gurney became dean of the faculty by which Charles William Eliot transformed Harvard College into its new magnitude as a great university. When Clover was twenty-two, Dr. Hooper, released from the army, took her to Europe. On May 16, 1866, they dined at the American Embassy in London, where Minister Charles Francis Adams had as his private secretary his son Henry Brooks Adams, aged twenty-eight. In Henry's daybook, cramped in copperplate script at the tail of a guest list, one reads "Dr. & Miss Hooper." The encounter was perfunctory.

On June 5, 1863, young Adams, feeling guilty at staying the war out, scarless, had written his brother Charles Francis that he was bored in London and longed "to go home and take a commission in a negro regiment." That was the Fifty-fourth Massachusetts Volunteer Infantry, under Colonel Robert Gould Shaw, which was massacred five weeks later. Charles Francis boasted that he'd napped through cannonades at Gettysburg and Antietam. Supercilious, begrudging, yet in early years affectionate, he told Henry he was more useful in London as his father's aide and confidant than he would be as one more body in uniform. It was touch and go until three-quarters through the war whether or not Queen Victoria's government would recognize the Confederacy. Britain had forsworn slavery early in the century. Now,

Manchester's mill owners, hard-pressed by the North's naval blockade, lacked cotton to spin or sell. England's Midlands starved. Because of the redoubtable skill, tact, and forbearance of Minister Adams, a frail neutrality triumphed in the face of disastrously provocative incidents that otherwise might have led to intervention first by Britain and then by other European nations. Henry would recall that he had been "private secretary in the morning, son in the afternoon and man about town in the evening." He would confess that though he was schooled at Harvard, his true education had begun in London. In England, two of his lifelong friendships were forged. The packed files of his correspondence with Charles Milnes Gaskell and Sir Robert Cunliffe are almost as important to the reconstruction of his career as is his autobiography.

Henry Adams was born in 1838. His mother's father, Peter Chardon Brooks, was the richest merchant in New England, hence the grandson would always be more than comfortably well-off. His great-grandfather was John Adams, part author of the Declaration of Independence and Washington's successor in the presidency. His grandfather was John Quincy Adams, diplomat at twenty-six, then Secretary of State, finally sixth President. It was confidently expected that his father, the senior Charles Francis Adams, would also come to inhabit the White House. The expectation was almost realized. In little Henry's turn, an Irish gardener at the ancestral Quincy home said: "An' you'll be thinkin' you'll be President, too!"

Henry called his best-known book an "education." One way or another, he fulfilled the role of virtuoso instructor for the rest of his days, whether his students were Harvard collegians, his wife, his brothers, his friends, or, at the end, a mesmerized cluster of nieces and near-nieces. His oeuvre—an enormous number of books, articles, and reviews, derived from firsthand experience or from research in American history, Gothic architecture, philosophical speculation on the measure of human events and the nature of man—establishes a formidable reputation. From birth he was at home in the highest reaches of political and intellectual action. Observing as a youth in Britain the diplomatic negotiations that had preserved his country's sovereignty lent him profound insight into the manipulation of power in which ultimately, despite ambition and aptitude, he had not enough hardihood to participate. In his *Education*, he wrote of himself in 1861, at

the beginning of his service to his father: "As for the private secretary
. . . he was, like all Bostonians, instinctively English"; in 1866, the
year of his first encounter with his wife, he described himself "dragged
on one side into English dilettantism, which of all dilettantism he held
the most futile; and, on the other, into American antiquarianism,
which of all antiquarianism, he held the most foolish." That was, of
course, a less than half-true deprecation adorning considerable human
experience. He was already recognized for his merits, but modesty was
a stylistic affectation that gave a wry charm to his artificed writing.

IV

In July 1868, the Adamses, father and son, landed in Manhattan,
relieved of diplomatic duties. What lay ahead? They'd been seven
years away from home. Diplomacy was no longer an option without
lifetime commitment. Both had already had quite enough. Henry
Adams wished to become a writer. But what sort? How to proceed?
In Washington, he was offered a desk in the Attorney General's office.
He had no legal training. The lack was crucial. However, he managed
to write an extensive analysis of the current congressional scene, which
the Democratic National Committee printed and circulated four years
later, during the presidential campaign against Ulysses S. Grant.

In November 1868, Adams wrote to his friend Ralph Palmer, a
British barrister:

Your list of engagements shows that somehow or other the aristocracy means
in both sexes to copulate according to law, both civil and canonical. This is
better than to do it illegally; at least in my opinion; though hitherto I have
proceeded on the latter theory. I wish someone would take the trouble to
marry me out-of-hand. I've asked my mother and all my aunts to undertake
the negotiation, promising to accept anyone they selected. . . . All the women
acknowledge that no man is fit to choose himself a wife, and yet they all
ridicule the idea of doing it for him.

Any forced or quick decision about his future was averted when
he was called to Italy by his sister Louisa's illness and subsequent
death. When he returned to Quincy, President Eliot of Harvard per-
suaded him to become an assistant professor of history. In the next

seven years, with one sabbatical break, Adams taught European history from the year A.D. 989, medieval history and institutions, English constitutional history and law, American colonial and early federal history, and a graduate seminar in Anglo-Saxon law. He demanded from the outset absolute academic freedom, and won it. He had no prior experience in teaching, but he exactly suited those principles that Eliot promoted. He was a memorable instructor who numbered among his students Albert Bushnell Hart and Henry Osborn Taylor, leading professional historians of their generation, and Henry Cabot Lodge, later an influential Massachusetts senator and Woodrow Wilson's nemesis, who was awarded Harvard's first Ph.D. degree in history.

Adams also became editor of *North American Review*, a learned quarterly devoted to political reform and contemporary science. In the spring of 1872, he was offered a position on the *New York Tribune*. Given his name, erudition, and financial independence, it could have led to a career as a political pundit, but, familiar with the uses of the press and with journalists' often corrupt reaction to political pressure, he chose to remain teaching as editor and historian. There were other commanding factors. He enjoyed the comfortable life of Quincy and Harvard, and he was engaged to be married.

In a letter he wrote that year, Adams depicted himself as a social butterfly suffering from "a contemptible weakness for women's society." He blushed at the follies he was committing: "In this Arcadian society sexual passions seem to be abolished. Whether it is so or not, I can't say, but I suspect both men and women are cold, and love only with great refinement. How they ever reconcile themselves to the brutalities of marriage, I don't know."

In Boston, Clover kept house for her father with charm and efficiency, the complacent habit of her high-minded Sturgis, Shaw, Higginson, Cabot, Brooks, and Bancroft cousinage. She took long conversational walks with young Oliver Wendell Holmes, who did most of the talking. She was acquainted with the junior Henry James, then at Harvard, who admired her spirited qualities and unabashedly borrowed them for the heroines of some of his books, including *Daisy Miller*, which Clover defended when Daisy was attacked as unfeminine by outraged readers and reviewers. His friendship would continue to the end of her life. As for Henry Adams, in the small world of patrician Boston to which he and she both belonged, they inevitably met again.

They continued to see each other. Their friendship ripened into court-
ship, and they quietly became engaged.

In view of the epoch's overmastering shyness in demonstrating
personal affection, it is difficult to reconstruct how they ever entered
into a covenant as binding as marriage. Clover hinted broadly that if
the brother of a friend had not departed early from tea *à trois*, leaving
Adams to stay on longer, nothing at all might have transpired between
them. There may be clues to their courtship in *Esther*, Adams's roman
à clef, published pseudonymously (as by Frances Snow Compton), in
which the Clover character sends out echoes of faint but honorably
agonized doubt: to her lover's passionate outburst "I love you! I adore
you! I will never let you go!" she replies, "You must . . . ! I am not
good enough for you. You must love someone who has her heart in
your work. . . . I shall ruin your life! I shall never satisfy you!"

On March 3, 1872, Adams wrote to his younger brother Brooks:

On coming to know Clover Hooper, I found her so far away superior to any
woman I had ever met, that I did not think it worth while to resist. I threw
myself head over heels into the pursuit and succeeded in conducting the
affair so quietly that this last week we became engaged without a single soul
outside her immediate family suspecting it.

As much as one can reach to estimate the truth in Adams's heart, in
this passage he certainly sounds like a man in love, as he did on other
occasions. Yet he also felt free to analyze his intended in a letter to
Charles Milnes Gaskell, his closest English confidant: "She talks gar-
rulously, but on the whole pretty sensibly. She is very open to instruc-
tion. *We* shall improve her. She dresses badly. She decidedly has
humor and will appreciate *our* wit." He admitted that Clover was
"certainly not handsome," but added, "She reads German—also
Latin—also, I fear, a little Greek." (He *feared*?)

Clover was far more open in admitting her vulnerability. As she
expressed it to her sister, whose marriage had given Ellen a sense of
liberated fulfillment and who therefore encouraged Clover's expecta-
tions of happiness:

This winter when the very cold weather came the sun began to warm me
but I snapped my fingers at it & I tried to ignore it. By & by it got so warm

that I tried to move & couldn't & then last Tuesday at about sunset the sun blinded me so that in real terror I put my hands up to my face to keep it away & when I took them away there sat Henry Adams holding them & the ice has all melted away & I am going to sit in the sun as long as it shines.

Clover was well aware of the horrors of emotional illness. Dr. Hooper, though not in regular practice, treated patients at the Worcester Asylum for the Insane and often took Clover with him on his visits. In view of the closeness between father and daughter, he must have discussed his more interesting cases with her. Her reactions were vivid. To her, becoming a burden to others or ending up in an asylum was much worse than dying; a quick end was infinitely preferable to a lingering illness. She criticized the Episcopalian practice of praying to be delivered from sudden death, as if the burden of an asylum was not worse. It is often forgotten that throughout the last century mental disorders were no less common or incurable than diphtheria, yellow fever, or tuberculosis. Rarely was even a famous family untouched: Hawthorne, Poe, Melville, the wife of Abraham Lincoln, the brothers of Emerson and Walt Whitman, all suffered the ravages of psychological collapse. The three children of Robert and Ellen Hooper would be suicides. Clover's father favored her engagement to Henry Adams, whose difficult brother Charles Francis, remarking that "all the Hoopers were crazy as coots," warned that Clover would probably kill herself. Henry remained imperturbable: "I know better than anyone the risks I run. But I have weighed them carefully and accept them," he said. The Adamses themselves were not immune to the nineteenth-century syndrome of emotional illness. Henry's brother Brooks, who confessed to his fiancée that he was "eccentric almost to the point of madness," would later have problems of his own with mental imbalance. And intermittent euphoric and schizoid fantasies were not entirely absent from Henry's mind.

In that election year of 1872, a fair possibility obtained that Henry's father would be nominated for the presidency by the Republican Party. Grant's first administration was mired in scandal, though whether or not he was culpable was not known. The senior Adams had served in Congress, was a seasoned diplomat, and, as an example of the ancient probity and uncommon common sense possessed by the Founding Fathers, was an appealing figure. But quite in keeping

with the arrogance of his clan, he refused to campaign for his party's nomination and went off to Geneva without apology. Grant was re-elected by a million votes.

On June 27, Henry Adams married Marian Hooper at her father's house in Beverly Farms, on Boston's North Shore. He had lived with Dr. Hooper for some weeks before the wedding. The ceremony, which the couple designed for and by themselves, took two minutes. Dr. Hooper lent them a nearby cottage for a fortnight's honeymoon. The bemused groom justified his insistence on seclusion to Gaskell in England: "We must be allowed to do what we think best. From having no mother to take responsibility off her shoulders, [my young woman] has grown up to look after herself and has a certain vein of personality which approaches eccentricity. This is very attractive to me but then I am absurdly in love."

One may assume that young Mr. and Mrs. Adams were reasonably happy at once and for at least a dozen years. Their childlessness has been the subject of fruitless speculation, imputed equally to physical or psychological causes. The genetic strain of mental imbalance, marked on the Sturgis side and not entirely absent from the Adams family, could have been worrisome. Their lack of children did not seem to bother either of them unduly at first. Apart from her social talents and her skill at managing what would become an elaborate household, Clover was occupied as her husband's research assistant, copyist, and strategic aide, especially gifted in gaining access to archives guarded by crusty, possessive custodians.

V

Two weeks after their wedding, the Adamses sailed for London, the start of a trip that would keep them abroad for a year. Their first stop was at Wenlock Abbey in Shropshire, a renovated Gothic ruin occupied by Adams's boon companion Charles Milnes Gaskell. Both guests photographed the abbey with delight, and Clover reported to her father in Boston that Gaskell was most cordial; his home, a marvel.

Such an ideal place as this is! The ruins of an immense abbey, ivy-covered. . . . The garden . . . is full of roses, white lilies and ferns, with close-shaven lawn. . . . The drawing-room where I am now sitting [is] long, 35 feet high,

with an elaborate ceiling of oak beams, black with age, polished oak floor, jet black, with an immense Persian rug. . . . I feel as if I were a 15th-century dame and newspapers, reform, and bustle were nowhere.

On her honeymoon, she began the custom of writing weekly letters to her father. Until his death, she abandoned it only on the rare occasion of ungovernable mental stress.

In London, the young couple hunted furniture for a future home. Clover reported to her father that drawings by Rembrandt, Van Dyck, and Hogarth were expensive; fourteen by Blake, though very curious, were a bit much at one hundred pounds. The portrait of Whistler's mother at the Royal Academy was interesting but affected. In Paris, Clover was taken to the designer Worth by Mrs. Jack Gardner, Boston's queen of collectors, whose eccentricity exceeded all. After ordering a gown, the duplicate of one done for the Grand Duchess of Württemberg, the Adamses departed for the Low Countries and then went to Geneva for an Adams family reunion. Clover had left her wedding dress in London; dinner for thirty seemed crowded. From Dresden, she begged Dr. Hooper to send a bright red maple leaf to remind her of New England's autumn. In Berlin, she and Henry met her cousin George Bancroft, the American minister and noted historian. The meeting was awkward: Henry had criticized one of Bancroft's books for its peculiarities of style. She was homesick, longing desperately for her father. (It is doubtful that she had ever left him emotionally.) At the American Embassy, they dined with Theodor Mommsen, whose history of Rome she knew well. Another guest was a son of one of the brothers Grimm. Adams was impressed by German archival methods, which were very advanced. As the couple prepared for a trip up the Nile, a letter from Clover's brother, who was an astute man of business, came with news of the great Boston fire of 1872, which had leveled the business district. Harvard president Eliot and his treasurer had managed to scoop up two and a half million dollars from the university strongbox in State Street; Ned reported that Henry and Clover had themselves suffered a ten-thousand-dollar loss. Clover pondered the consequences: "Is it a dead loss? We've no right to growl when we've enough to eat, but I'd rather have money run away with than burnt up, 'cos then someone enjoys it. I'm going to buy a big Japanese teapot and put everything in it—a fireproof one."

The Nile adventure promised well. Clover wrote home that Henry was utterly devoted and tender. Mosques were splendid, howling dervishes picturesque. Ralph Waldo Emerson, not quite right in the head, was also in Egypt, his Concord home having burned. A worldwide campaign for funds, swollen by generous contributions from Aunt Caroline Tappan and the Bancrofts, had paid for his trip. Bancroft had taken charge of the travel arrangements for the Nile journey, but Emerson considered the adventure "a perpetual humiliation, satirizing and whipping our ignorance. . . . The sphinxes scorn dunces; the obelisks, the temple walls, defy us with their histories which we cannot spell."

The Adamses spent three long months in the *Isis*, a luxurious lateen-rigged river yacht. Besides Emerson and Bancroft, several other Bostonians were also on the Nile, soaking up the glories of the pharaohs. Nevertheless, it was hardly home. In spite of Clover's apparent interest in Egyptian architectural splendors, in the peculiarities of the people, in the monstrous magnificence of Abu Simbel, it must have become evident to her husband that she was putting on a brave show. Writing from Thebes, she said, "I must confess I hate the process of seeing things which I am hopelessly ignorant of, and am disgusted at my want of curiosity. . . . But I shall leave this [letter] open for a day or two and perhaps launch forth into glowing and poetical disquisitions on Karnak."

At Karnak, her malaise, either unacknowledged loneliness or nervous anxiety, turned into what reads like depression approaching breakdown. Naturally, it was not reported as such, but there is sufficient evidence to determine its gravity. Clover's letters to her father stopped unaccountably for two weeks. In time to come, when the problem resurfaced, the crisis on the Nile came to mind as an ominous precedent. As for Emerson, then at Thebes, he seems to have summoned courage by desperation to head for home. Clover, resuming her correspondence with her father, duly recorded his departure:

[Mr. Emerson] was not interested in Egyptian antiquities, which for a philosopher is quite shocking. I confess that temples do begin to pall—but that is an aside—so much the worse for me! How true it is that the mind sees what it has means of seeing. I get so little, while the others about me are so intelligent and cultivated that everything appeals to them.

In Cairo, she bought a Bible and pasted in the back a photograph of Henry, head bowed, ensconced in his cabin among palm fronds arranged for a Christmas celebration. The mahogany paneling and the gilded mirror document the uneasy luxury of the *Isis*. She also initialed in the back verses that seemed appropriate to her, sketching near the chapter numerals a small tau cross, Greek, with equal arms.

Nevertheless, she was soon able to declare their winter in Egypt a great success. Her complaints would always be few. Naples, Pompeii, and Amalfi revived her spirits. In Rome, there was dear Henry James, who was in town for the season to gather background for *Roderick Hudson*, a book in progress, and who also had the painful commission for a respectful biography of William Wetmore Story. Story was a tiresome sculptor, though his studio was the center of American society. Clover, calling on him with James, was not deceived: "And oh! how he does spoil nice blocks of white marble. Nothing but Sibyls on all sides, sitting, standing, legs crossed, legs uncrossed, and all with the same expression as if they smelt something wrong. . . . Mrs. Story is very stout and tells lies." James referred to his friends as "the Clover Adams." Later, he would call Clover "a perfect Voltaire in petticoats." Because of her own intransigence and her distance from an organized church, she preferred to name herself "a Buddhist or a Mormon."

VI

Once back in America, the Adamses settled into a house on Marlborough Street, on landfill recently reclaimed from Boston's Back Bay. Furniture and cartons of objects and pictures were unpacked. Dr. Hooper dwelt around the corner; there was no longer need for Clover's weekly chronicles. Adams resumed his fastidious instruction in Anglo-Saxon law to a classroom of young bachelors. Much of what Harvard had previously offered as courses was a series of simple reading programs, which students were expected to absorb more or less by rote. Adams proclaimed loud distrust of received ideas and unquestioned fact. When one youth idly asked the meaning of transubstantiation, he snapped, "Oh, go look it up." A kind of radically conservative gadfly, he grew in reputation. His methods, at least as accepted by the brighter students, heightened speculative thinking; he would later be thanked for his breezy, illuminating lectures.

In the summer of 1874, which he spent preparing a new series on American politics in the colonial period (when Great-grandfather John had emerged from his Quincy farm), Henry Adams feared he was growing blind. He reduced his reading and writing to a minimum. Clover read aloud to him and answered his letters. When he recovered his eyesight, she resumed her study of Greek. Churlishly, he commented that that was now quite the thing to do—for a young woman. He himself knew no Greek, and would "have to keep her in check with medieval Latin." In some exasperation, he wrote to Gaskell:

Our young women are haunted by the idea that they ought to read, to draw, or to labor in some way, not for any such frivolous object as making themselves agreeable to society, not for simple amusement, but to "improve" their minds. They are utterly unconscious of the pathetic impossibility of improving those poor little hard, thin, wiry, one-stringed instruments which they call their minds, and which haven't range enough to master one big emotion much less to express it in words or figures.

Adams suffered from permanent ambivalence in his ratiocinations on women. There had been strong females in his lineage, from his great-grandmother the remarkable Abigail, wife of the earlier John, to Our Lady of Chartres, whom he would claim as his personal intercessor at pilgrimage end. In 1876, he was invited to give the Lowell lectures at Harvard, a heavily endowed series of great local prestige. He chose as his subject "The Primitive Rights of Women." John Lowell, the original benefactor, had specified in his will that the auditors (who were admitted gratis to the series) be "neatly dressed and of orderly behavior." No vagrants or unwashed would drowse in the lecture hall. His stipulation virtually restricted the audience to family and friends, but the lectures gave Adams the opportunity to put his ideas in order on a topic that would occupy his mind for years to come.

In Adams's day, it was widely believed that the women of primitive, pre-Christian tribes were mere objects to be traded or sold into slavery. But Adams propounded that the women of Teutonic forest peoples had enjoyed equal standing with the men. In the Germanic legends, he discovered the birth of representative government, and there he traced the genesis of independent rights for women. In the last quarter of the nineteenth century, it was something approaching

*lèse-majesté* to suggest that there was an old and valid precedent for female equality relative to politics and property. In American Indian tribes, which Adams equated with those of ancient Germany, a bride was neither slave nor property for barter but remained what she had been before. As described by Adams, that was, for the most part, "a member of her own family and clan; her children followed her line of descent, and the husband belonged to her as much as she belonged to the husband. . . . In most cases she was the head of the family; her husband usually came to live with her, not she with him, and her children belonged to her clan, not to their father's." Adams reinforced his argument with further evidence. Egyptian queens were enthroned next to their royal husbands, often their brothers; Greek wives were free women; Norse wives were equally liberated. He quoted an apt passage written by Margaret Fuller in 1845: "Women could take part in the processions, the songs, the dances, or old religions; no one fancied their delicacy was impaired by appearing in public for such a cause."

What, then, asked Adams rhetorically, had happened to make women hoopskirted, corseted, secondary citizens without political voice or professional status? His answer: "The Church!"

The Church felt with reason that society should be taught to obey; and of all classes of society, the women . . . were obliged to learn [obedience] most thoroughly. The Church established a new ideal of feminine character, thenceforward not the proud, self-confident, vindictive woman of German tradition received the admiration and commanded the service of law and society. . . . In reprobation of these the Church raised up, with the willing cooperation of the men, the modern type of Griselda—the meek and patient, the silent and tender sufferer, the pale reflection of the Mater Dolorosa, submissive to every torture her husband could invent.

His formidable ancestor would have defied the Church's archaic strictures. In 1777, Abigail Adams wrote to her husband:

I long to hear that you have declared an independency—and by the way in the new Code of Laws which I suppose it will be necessary for you to make I desire you would Remember the Ladies, and be more generous and fa-vourable to them than your ancestors. Do not put such unlimited power into

the hands of the Husbands. Remember all Men would be tyrants if they could. If particular care and attention is not paid to the Ladies we are determined to foment a Rebellion, and will not hold ourselves bound by any Laws in which we have no voice, or Representation.

Whatever his great gifts as teacher and historian, Adams never became the politico or the man of force he was perhaps intended to be. He was first and foremost an aesthete. It would be years before he clarified his sentiments towards the Virgin celebrated as the Gothic Mother of God. When he did, he would find that his ideas on her were in psychological and theological imbalance and in opposition to his concept of her as a force comparable to the dynamo, in 1892 the key symbol of scientific industrial progress displayed at the Chicago World's Fair and in 1900 the exhibit that drew him again and again to the Paris Exposition. W. H. Auden defined Adams's conflicting views:

Henry Adams thought that Venus and the Virgin of Chartres were the same persons. Actually, Venus is the Dynamo in disguise, a symbol for an impersonal natural force, and Adams' nostalgic preference for Chartres to Chicago was nothing but aestheticism; he thought the disguise was prettier than the reality, but it was the Dynamo he worshiped, not the Virgin.

### VII

The Lowell lectures completed, Adams wrote Gaskell early in 1877: "I regard my university work as essentially done. All the influence I can exercise has been exercised. The end of it is mere railing at the idiocies of a university education."

An old family friend was now Secretary of State. William Evarts (an early patron of the young Augustus Saint-Gaudens) made available to Adams a desk in the State Department and the freedom to search diplomatic archives. Adams had a congenial commission from the son of Albert Gallatin to edit the correspondence of his father, who had been minister to Great Britain under John Quincy Adams. Henry had always been drawn to Washington, which, however tiny as an urban center, was a hive of political activity. Compared with Paris, London, or Berlin, it appeared as a splendidly planned but less than half-built

promise of national grandeur. However, in its concentration of power, local and international, and in the vitality of its maneuverings, it had more life than a hundred Harvards or a thousand Bostons. It was wide open, crammed with every possibility, and though he was never to play the great role he felt befitted his talents and his inheritance, he was close to every level of the game there.

In all this, Clover reveled. She and Henry rented a big house and filled it with loot from their travels. They were comfortably rich and could entertain in a ritualized reciprocity of breakfasts, teas, and dinners. The house was less than two blocks away from that White House which Henry, as a boy, had half thought he owned and one day would inhabit.

Rutherford B. Hayes was a mediocre President. At the end of November 1877, Clover condescended to be received "very simply and graciously" by Mrs. Hayes, who permitted no hard liquor in the presidential mansion. Adams found the temperature of Washington society cool but comfortable. He and Clover attracted a large circle of friends, including the ambassadors of England, Germany, China, Turkey, and Japan. It was noted that Mrs. Adams's salons were as much to keep people out as in. The Adamses dined with General Sherman, who gave Clover what she referred to as "a little talk about (American) Indians." Carl Schurz, former general and Lincoln's minister to Spain, "played Chopin as [she] had never heard it before."

The term "snob" hardly fits Clover, since the naïveté of its regard implies a blind, prejudiced sense of innate superiority. Her snobbism was a matter of delicately adjusted nuance. She kept clear of huge official dinners, whether given by the White House or by senators or congressmen. "I have instituted 5 o'clk tea every day, thereby escaping morning visitors & it's very cosy," she wrote to her father. Her gossipy letters to him were feline: A governor of Maryland lived "mainly on opium"; she was in a pet when a congressman's consort forced on her an introduction "to a certain Miss Edes whose sole distinction I was told was a flirtation with Vice P. Wilson of blessed memory. I made an arctic bow and walked off." She justified such rudeness as "strong but necessary," and added, "We are not official and have a right to choose our friends and associates."

Isabel Archer, in *The Portrait of a Lady*, is another of Henry James's heroines who share some of Clover's characteristics. Of Isabel,

James wrote: "Her sentiments were worthy of a radical newspaper or a Unitarian preacher. . . . Her notion of the aristocratic life was simply the union of great knowledge with great liberty; the knowledge would give one a sense of duty and the liberty a sense of enjoyment." Clover reported to her father that the novelist had written her on returning to England:

He wished, he said, his last farewell to be said to me as I seemed to him "the incarnation of my native land"—a most equivocal compliment coming from him. Am I then vulgar, dreary and impossible to live with? That's the only obvious interpretation, however self-love might look for a gentler one.

So admired, so apparently self-confident, how could she have misinterpreted what was surely intended as a sincere tribute? What insecurities, what inner turmoil did she hide behind her mask of urbanity? One senses that beneath her natural warmth, charm, and wit lay a resentment towards a society that assigned women formal courtesy while holding them firmly in bondage. She helped Adams edit the Gallatin papers, but it was hardly a full-time occupation for her. They toured historic sites of colonial and revolutionary interest; they went to Niagara Falls on the railroad president's private Pullman car. She loved long walks by the dense overgrowth near the Potomac. Mornings, she rode through Rock Creek Park with Adams on Daisy, her bay mare. Lunch, at home, was early, so Henry could leave for the State Department and the Gallatin files. He returned for tea at six. They had two male and two female servants, two dogs, two horses, and no children.

The five children of John Adams, the second President, provided him with seventeen grandchildren. The senior Charles Francis Adams's two elder sons had eleven children; his two daughters, three; his two younger sons, none. As if an explanation were somehow obligatory, Henry Adams wrote to Gaskell: "I have myself never cared enough about children to be unhappy either at having them or not having them, and if it were not that half the world will never let the other half in peace, I should never think about the subject."

Clover's mother, dead at thirty-six, had had three children and was herself one of six; Clover's father was one of nine. Clover is reported once to have exploded to her cousin Anne Lathrop, "*All* women want

children." Perhaps partly consoling himself, Adams wrote Gaskell: "One consequence of having no children is that husband and wife become very dependent on each other and live very much together. This is my case."

One might deduce from letters and hearsay that Clover was a hypochondriac, but there is little to suggest that she was any more so than most women of her time. A feminist might inquire why infertility was always held to be the woman's fault. In 1879, Clover learned that one of Dr. Hooper's friends, overcome by the sensation that he merited, and was enduring, eternal damnation, had committed himself to the Somerville Asylum, near Boston. She wryly commented that such a place seemed to be "the goal of every good and conscientious Bostonian, babies and insanity the two leading topics. So and So has a baby. She becomes insane and goes to Somerville, baby grows up and promptly retires to Somerville." To Clover, it was "all nonsense."

### VIII

The political and, to only a lesser degree, literary salon maintained by the Adamses from 1879 to 1885 was a sophisticated paradigm of what had been spoken, argued, and defined during the ferment of transcendentalism and abolitionism. Far more than simply social in character, it was in the real sense educational, since its atmosphere fostered an exchange of ideas and information among the best minds then serving the national destiny. Both Adamses demonstrated the Emersonian principle of "unconscious radiation of virtue" on old friends and new acquaintances alike. Their effort was more conscious than not, for both saw themselves not just in a social and political service but also as the center of a didactic reformation of taste. With the ready examples of the pictures and objects they owned, they could demonstrate the excellence of past craft from Europe (since they noticed little enough of native American) and from the Orient as well, for they collected Chinese bronzes and porcelain and Japanese kakemonos and woodblock prints.

After completing his task of editing the Gallatin correspondence, Adams began to plan a monumental *History of the United States of America during the Administrations of Jefferson and Madison*, which

would fill nine volumes. Research for that gigantic task, which he designed in not unjustified terms of Gibbon and Mommsen, sent him to closed archives in England and France, opened to him (though with some difficulty) through his diplomatic connections, and in Spain, to which Clover's charm and fluency in Spanish gained him access. To John Hay, who with George Nicolay had served as private secretary to Abraham Lincoln and who was then preparing with Nicolay a ten-volume biography of the Liberator, Adams wrote: "I make it a rule to strike out ruthlessly in my writings whatever my wife criticises on the theory that she is the average reader, and that her decisions are in fact if not in reason absolute."

Hay, whom Adams had met briefly in 1861, when Hay had come to Washington with Lincoln from Springfield, Illinois, had returned to the capital in 1879 as assistant secretary of state in the Hayes Administration. It was then that he and Adams developed a friendship that would only be strengthened by passing years and private adversity until Hay died in 1905. Adams wrote of him to Sir Robert Cunliffe:

I never knew more than two or three men from west of the Alleghenies who knew the difference between a gentleman and a swindler. This curious obliquity makes [Hay] a particularly charming companion to me, as he knows intimately scores of men whom I would not touch with a pole, but who are more amusing than my own crowd.

When many persons suggested that Adams's political novel *Democracy*—more of a transposed memoir than a work of fiction and published anonymously—was by *Mrs.* Henry Adams, Adams objected testily to Hay, "My wife never wrote for publication in her life and could not write if she tried." His irritation was not the expression of a total lack of generosity but rather of his belief that after long observation and analysis he knew woman's capacity, and it did not include much exercise of the mind. He liked women. He was almost obsessed with them on an ideal level, but on closer acquaintance they usually turned out to be a divinity newly married or a charming girl. As far as a clever woman (Clover) went, he wrote to Gaskell: "Her mind only fed on itself and was neither happy nor altogether free from morbid self-reflections which always come from isolation in society, as I know to my cost."

In the face of that self-satisfied complacency, with her husband enjoying his compulsive labors, how should a wife occupy herself? Clover took up Portuguese. Her sister was then helping to turn the Harvard Annex into Radcliffe College, and Clover sent cash and moral support. She was instrumental in founding in Charleston, South Carolina, cradle of the Confederacy, an art school "to help educate and cultivate a vanquished foe." And there were letters to Father, constant entertaining, supervising a household, and acquiring pictures, mostly watercolors and drawings by Mantegna, Rembrandt, Rubens, Blake, and Bonington. She dared to purchase two small portraits by Sir Joshua Reynolds, although Adams loathed all "face-painting." Clover's response: "Henry can look the other way."

A considerable infusion of warmth came from a little club called the Five of Hearts, which met at the Adamses' house. Clover had her notepaper engraved at the top with a tiny playing card. The club's sole members were the two Adamses, the two Hays, and Clarence King. King, a geologist and a promoter of mining development, was a fascinating man and a true eccentric who, Hay said, had profound sympathy for "the most wretched derelicts of civilization," American Indians and Southern blacks in particular; he had a clandestine, common-law marriage with a black woman. Except for Hay and Gaskell, he was Adams's closest friend. He was extremely fond of Clover and understood her apparent strangeness.

In 1881, Clover's sister-in-law Fanny, having given birth to five daughters in seven years, became seriously ill and died. Clover had wished to nurse her. Because the family wanted to spare Clover upset, they managed to keep her from the funeral by informing her of Fanny's death by slow mail instead of by telegram. At around the same time, Adeline Bigelow, a cousin with whom Clover had made two trips to Europe, suffered a bad nervous breakdown, a peril she herself had guessed at. Clover wrote: "I cannot bear to think that what she most feared has come to pass—for such sweet cheery creatures it seems a cruel fate. . . . I wish it might have been Worcester [the asylum with which Dr. Hooper was connected] instead of Somerville which is such a smelly hideous place."

By 1882, Adams, surrounded by hints and threats of mortality, was recording an endemic decline among his peers:

Hay had heart palpitations; King suffered from an old rupture; Richardson had "Bright's disease" [and would soon die]; Wendell Holmes was "very weary" [and would live for decades]; Louis Agassiz, "another invalid"; not to mention the state of my brother Brooks [who was suffering from writer's block]. . . . These are the jewels of my generation, all the friends I have that count in life.

Amasa Stone, Clara Hay's father, a prosperous railroad builder, made a decision in constructing a bridge that resulted in its collapse, carrying a trainload of people to their deaths. Under the strain of the charges against him, his health was destroyed and in 1883 he ended his own life.

The ethics of suicide, with its questionable license, had long been a subject of discussion among prickly, hyperconscious New England-ers, who from Cotton Mather through Emerson to the senior Henry James steadfastly verbalized their intellectual, personal, epistemolog-ical, theological beliefs in the permanent dissatisfaction that was their torment and triumph.

Around 1867, Alice James, maiden daughter of Henry the phi-losopher and sister of Henry the novelist, had begun to show manic-depressive and hysterical symptoms that could grow into certifiable insanity. She was victimized by fantasies—herself "knocking off the head of the benignant Pater, as he sat with his silver locks, writing." Self-slaughter was also in mind as an increasingly magnetic option. Was suicide a sin? Was it right? Was it wrong? Pray, Papa, tell me. After due consideration, he judged it was indeed permissible for her to choose to end her existence, if it was with a view to break bonds or to assert her freedom, and as long as she could arrange it in a perfectly gentle way in order not to distress her friends. Nevertheless, though Alice could perceive it to be her right to dispose of her own body when life had become intolerable, she could never do it. Instead, for the rest of her years she took refuge in a series of imaginary illnesses.

In Adams's book *Democracy*, the character Madeleine Lee, based on Clover, is self-doomed and patently suicidal. To avoid any proximity to facts too close to the bone, Adams portrayed her as losing her husband and, within a week, her only child. A friend of Madeleine's describes her reaction: "She was wild with despair . . . almost insane.

Indeed I have always thought she was quite insane for a time. I knew she was excessively violent and wanted to kill herself, and I never heard anyone rave as she did about religion and resignation and God."

Mental illness hovered like an ominous mist. On July 2, 1881, President James A. Garfield was shot in the back by Charles Julius Guiteau, a member of the Oneida Community, a religious society established in central New York in 1848 by John Humphrey Noyes. The assassin had felt inspired by the Deity to remove Garfield. His defense would be palpable insanity, substantiated by a long prior list of litigations, protests, and general depravity. A few liberal neurologists, not yet able to arm their defense by psychiatric precedents, pointed to Guiteau's deformed skull and genetic history. Adams was much involved with the nature of heredity; a part of the continuing process of his "education."

To an American in search of a father, it mattered nothing whether the father breathed through lungs, or walked on fins, or on feet. Evolution of mind was altogether another matter and belonged to another science, but whether one traced descent from the shark or the wolf was immaterial even in morals. This matter had been discussed for ages without scientific result. La Fontaine and other fabulists maintained that the wolf, even in morals, stood higher than man; and in view of the late civil war, Adams had doubts of his own on the facts of moral evolution.

Guiteau needed an eye examination and the oculist, a Dr. Folsom, invited Adams and Clover to accompany him to the prison. Clover did not recognize the man who, mistaking Adams for the doctor, rose from his chair. Thinking he was a jailer, she shook the murderer's hand. She wrote her father: "I don't wish to have it repeated that I shook hands with the accursed beast, without the context being given. Someone would write that they 'were sorry to hear that I had asked Guiteau to tea.' "

Henry Adams had his own insights on insanity. After observing Guiteau's trial for some days, he wrote to Wayne MacVeagh, who, in his post as Attorney General in Garfield's Cabinet, had secured the indictment of the President's assassin:

Why is the District Attorney so eager to prove Guiteau sane? You can't hang him. Your only chance for shutting him up for life is to prove him *not* sane. More than this, the assertion that Guiteau is sane is a gross insult to the whole American people. . . . The peculiarity of insanity is the lack of relation between cause and effect. . . . That he is rational proves nothing. We are all more or less rational; it is an almost invariable sign of insanity.

Guiteau went to the gallows swearing it had been God's act, not his. During his trial, in which he insisted on defending himself, he behaved as wildly as possible. That struck many as a determined effort to prove his madness, inherited or not. Clover, who had attended the trial, reported to Dr. Hooper: "The assassin was in front of me, so I could only get his profile—a large strong nose, a high straight forehead. . . . He bullied and badgered everyone; banged his fist on the table. . . . The beast's sallies are more than unjudicial muscles can stand. . . . Every word that Guiteau says tightens his noose now."

Adams's analytical intelligence might have admitted the possibility of a genetic lapse, but Clover was a good Emersonian. If there was no free will, no choice among the multitude of options, where did that leave her? Indeed, where did that leave anyone? On the last day of Guiteau's trial, she wrote her father: "The witnesses that day smashed the hereditary insanity theory pretty thoroughly." Nevertheless, it is interesting to note that Guiteau's mother had died of "brain fever" when Guiteau was seven, and that his whole youth was marked by obstreperous nervousness. Noyes, the head of the Oneida Community, considered him insane, as did his own father.

IX

Both Clover and Adams indulged in photography from early days. On their Nile journey, they carried an elaborate, unwieldy mechanism; each took pictures of the sights and of one another. In those days, technical procedures were so experimental that to distinguish between the professionals and those who used cameras for fun was difficult. The photographic process required a fiendishly painstaking attention and called for as much mechanical and chemical expertness as visual. A freshly washed glass plate brushed evenly with collodion and with a mixture of guncotton dissolved in ether and alcohol produced a

gluelike surface, which, when soaked in silver nitrate, received the image from the lens. The wet glass was slid into a sealed shield and inserted into the camera. The subject, properly set, posed, and warned, could not budge for a count of light-determined seconds. Then the plate went back to the darkroom to be developed: dipped first in a bath of acid; next in a fixing agent—Clover used potassium cyanide—then in clear running water. As often as not, the final image could be blanked or blurred by the capricious sun.

Photography had developed into a universally popular service. Congress began to support Mathew Brady's Gallery of Illustrious Americans by 1850. For forty years, before the Civil War and after, Brady's labors and those of his colleagues contributed unforgettable visual reminders of their era. Clover joined a photographic society and trained herself to be more than a capable amateur. In 1883, she sent her father a review of an exhibition in which portraits she had shown were classed as "very skillful." By that December, she was so busy developing recent work that her weekly chronicle to her father was late:

It was science plain & simple which took up all my morning on Sunday & left me sleepy in the p.m. A wonderful process of printing from negatives has been perfected lately & the man who owns the patent gave an exhibition of the process at the photographic rooms in the National Museum on Sunday. Mr. C. Richardson very kindly smuggled me in as the only woman—we were three hours there though the process is really very rapid. I shall buy of Siebert the right to use his patent for a trifle and will send you a proof.

Perhaps at last Clover had found a device for competing with her husband on his own terms: as a historian, taking pictures of the principal personages of her time, providing an exact and living record. She was close to a broad range of illustrious friends and relatives. From her capturings of the architect Henry Hobson Richardson, the painter John La Farge, Oliver Wendell Holmes as a young jurist, the historians Francis Parkman and George Bancroft, we derive a fresh, sensitive approximation of their appearance as their contemporaries saw them. Accompanied by her husband, she took her paraphernalia to C Street to photograph Senator Lucius Q. C. Lamar.

The Adams Memorial *(1886–91) by Augustus Saint-Gaudens, Rock Creek Cemetery, Washington; bronze*

Printed photos for nearly two hours—seizing a bright sun which is rare of late—then H & I drove to Senator Lamar's rooms . . . to take his photo. L. brushed his long hair to the regulation smoothness & then I refused to take his likeness until he had rumpled it all up. I took two shots of him & one of Gordon [a general from Georgia] who has a deep hole from Antietam in his left cheek as you'll see next summer.

The war was a living memory. She photographed the endless ranks of small, identical marble headstones in the Arlington National Cemetery: "We rode to Arlington Friday P.M. and it was lovely with its fifteen thousand quiet sleepers; no unsightly iron flummery and granite lies there, there's no lovelier place in the world as I know it than Arlington with a sunset behind it and a view in front."

In Clover's last seven months of existence, there was an almost

feverish urgency in taking and developing the glass plates. She kept careful notes, not just of subjects, but of lengths of exposure, weather conditions, and reasons for success or failure: "Francis Parkman in front of Rocks at Beverly Farms, large stop, 2 seconds. . . . Jan. 18, 1884. H. H. Richardson in Henry Adams' study, large stop, 10 seconds—good." Henry Adams was caught in sharp profile, seated on steps, holding Marquis, a big Skye terrier who, along with Possum and Boojum, was a family retainer. Unrelaxed, one hand under the dog's chin, Adams offers nothing of a full face; his mute stare declares ungraciousness. And there is Dr. Hooper, neat in his derby hat, seated on his buckboard drawn by Kitty the mare. Turned three-quarters towards Clover's camera, as she probably placed him, he is casually comfortable.

Among her portraits, particularly evocative are those of George and Elizabeth Bancroft. Clover admitted that while she considered them technically acceptable, they were, perhaps, "not pleasant likenesses." Her historian cousin, seated, quill in hand, annotates from an open volume. There are two of Mrs. Bancroft, a formidable old lady and a Sturgis connection. In one, she is in half-shadowed full face; in the other, she is seen in urgent profile (her photographer was reminded of a marble bust of Judge Davis in the gallery of the Boston Athenaeum). The print of Bancroft impressed John Hay so much that he urged Richard Watson Gilder, editor of *The Century*, a magazine of wide circulation, to use it and to ask Adams to write a short accompanying article. Reproduction might have led to other commissions and something approaching a professional career. Adams forbade it. As he put it in a letter to Hay: "We have declined Mr. Gilder's pleasing offer. You know our modesty. . . . As for flaunting our photographs in *The Century*, we should expect to experience the curses of all our unphotographed friends."

In the lonely months to come, Adams may have had occasion to feel a twinge of remorse over his automatic denial of her opportunity. His excuse was nonsense. Bancroft was forty years older than he and a well-known historian. Clover reported the incident to Dr. Hooper without a trace of chagrin:

Yesterday I was amused to get a letter from R. W. Gilder, the editor of *The Century* magazine, asking if I would let him have a photo of Mr. Bancroft.

Someone had spoken to him of it with a view to its reproduction in the magazine & writing Henry to write an article on Papa Bancroft of 7 or 8 pages to go with it. I've just written to decline & telling him Mr. Adams does not fancy the prevailing literary vivisection. The way in which Howells butters Henry James, & Henry James, Daudet, & Daudet someone else is not pleasant. The mutual admiration game is about played out or ought to be.

Adams had toyed with photography, but had small use for the medium as anything approaching an art form. When Ralph Waldo Emerson confessed that camera work gave him more pleasure than hand-painted pictures, Adams reproved him for demonstrating either "extreme sublimation or tenuity of intelligence." After Clover's death, he avowed: "I hate photographs abstractly because they have given me more ideas perversely and immovably wrong, than I should ever get by imagination."

If indeed Adams harbored some skulking envy of his wife's brave efforts towards a measure of independence, it would hardly have been the sole factor in his putative guilt. After she died, he burned every single letter Dr. Hooper had written her over the years. How could Adams ignore the indissoluble link with her father? In *Esther*, the novel he published pseudonymously a year before their deaths, his fictional characters behaved as their prototypes may well have done in reality. The father-in-law wishes the young husband dead. When he does die, Esther, in despair, wants "to escape, to turn away, to get out of life itself rather than suffer such pain, such terror, such misery of helplessness."

Whatever bearing Clover's reading of Schopenhauer may have had on her, the author, a man whose father had killed himself, could at least determine despair in a manner she could comprehend.

Hope is the confusion of the desire for a thing with its probability. . . . He who is without hope is also without fear: this is the meaning of the expression "desperate." For it is natural to man to believe true what he desires to be true, and to believe it because he desires it; if this salutary and soothing quality in his nature is obliterated by repeated ill-fortune, and he is even brought to the point of believing that what he does not desire must happen and what he desires to happen can never happen simply because he desires it, then this is the condition called despair.

X

Around Christmastime 1883, the Adamses decided to build a house of their own, a permanent, luxurious establishment to replace their usual rentals. There was a large, empty lot on the corner of 11th and 16th streets, directly facing the White House across Lafayette Park. John Hay, who had come into money, was happy to join them in plans for a large double mansion to be designed by Richardson, great architect and reviver of the Romanesque, who had known Adams since college. Trinity Church in Boston, its portal echoing that of St. Trophîme in Arles, was Richardson's masterpiece. During its construction, young Augustus Saint-Gaudens assisted in the mural decorations, painting the figures of the saints Paul and James, and Sir Edward Burne-Jones and John La Farge designed stained-glass windows. On a visit to New York earlier in 1883, Clover visited Saint-Gaudens's studio. He happened to be absent, but she saw work-in-progress on the memorial to her cousin Robert Gould Shaw. That was fourteen years before the great bronze relief was unveiled and during a period of labor so prolonged that the sculptor all but lost the commission. She was delighted that the contract had not gone to William Wetmore Story, as Senator Charles Sumner had first proposed.

The joined houses resembled something of a domestic fortress, vaguely Romanesque in the architect's revived, transformed manner. Richardson had already built a stone summer house at Prides Crossing for Clover's sister. Although extremely busy with important buildings under construction, notably the monumental Allegheny County Courthouse in Pittsburgh, and with his design for All Saints Cathedral in Albany, he eventually arrived in Washington and cast a cool eye on Adams's own inch-to-the-foot-scale drawings of what he thought he wanted. Richardson suffered from nephritis, which would soon carry him off. Clover's photograph of the architect suggests Adams's description of him as a "man-mountain [Gargantua]." (On another occasion, he called him "an ogre [who] devours men crude, and shows the effect of inevitable indigestion in his size.") Richardson's extravagant use of fine materials was no secret. The luxury he loved lent itself to detailed, elaborate stone, executed with careful craftsmanship. Clover was concerned about costs.

We think that as we know just what we want and don't want in the new house that Richardson will consider our wishes. Our present furniture and fittings pitch the key note beforehand. We cannot have a mahogany dining room with our present black walnut and cherry furniture nor can we go in for carving without making what we have seem *mesquin*.

*Mesquin?* There would be nothing shabby or niggardly about the palatial joint residence, with its ground floor seemingly designed more for show than for living. The last months of Clover's life held an acceleration of omens. A large section of the parlor ceiling of the Adamses' rented house fell one morning, just before breakfast. She wrote: "If we had been early risers we should have been corpses inevitably." That event added impetus to their prolonged impatience at the architect's constant procrastination.

Their own house, compared with Hay's adjoining, was relatively simple, according to Adams's taste, and lacked the turrets and gables of what Clover termed Richardson's "agnostic" style. After rejecting any use of hand-cut stone, changing basic materials from sandstone to brick, she allowed for a bit of sculptured detail, "as the devout do in their churches." It must have been something of a foregone conclusion that when the house was finished Adams would complain that he felt Hay's home to be the more successful of the two. He was answered with the professional's eternal justification: "Your liking Hay's house better than your own is accounted for easily I think by the fact that in designing the former I was left entirely untrammelled by restrictions wise or otherwise." While the Adamses waited for final plans and for contracts to be signed, their own establishment had to be run; with constant arrival and departure of guests, it resembled a family hotel. In what time was left, there was always Clover's photography.

In the windy sleet and rain of March 1885, news came that Clover's father was stricken with angina, a condition then ominous in a man of seventy-four. Adams, in *Esther*, which in so many details cannot help but seem prophetic, describes his heroine's apprehension:

She knew that there was no hope and that her father himself was only anxious for the end, yet to see him suffer and slowly fade out was terrible. . . . Esther

had been told she must not give way to agitation, under the risk of killing her father, who lay dozing, half-conscious, with his face turned towards her. Whenever his eyes opened they rested on hers.

Clover left for Cambridge at once, and for the next month shared sickroom service with her sister's and brother-in-law's family. In thirteen years of marriage, she and Henry had never been separated. Though he wrote nearly every day, his letters were awkwardly apologetic in tone. He commenced painfully, or pitifully, with an inverted courtesy that might have caused her dismay if she had been less preoccupied.

Madam: As it is now thirteen years since my last letter to you, you may have forgotten my name. If so try to recall it. For a time we were somewhat intimate. . . . There remains at the bottom of the page just a little crumb of love for you, but you must not eat it all at once. The dogs need some.

Certainly, it was meant well. In his way, he loved her. As her absence extended, his artificial chill warmed. He was busying himself over finishing the new house. He had searched the Smithsonian's mineral collection for the perfect porphyry for facing the living-room fireplace. As for her own bathroom: if a good wall yellow was not available, how about red? An elevator, a safe, and a burglar alarm were installed. Stairs were in work. Only after Clover's urging did he finally consent to attend one of President Cleveland's dinners, taking Richardson along with him. Rose Cleveland, the President's daughter, received them. As Adams related in a letter to Clover, she then

. . . took us into the red room where we found the president seated in a melancholy way. . . . We must admit that, like Abraham Lincoln, the Lord made a mighty common-looking man in him. . . . Miss Cleveland carries an atmosphere of female college about her, thicker than the snow storm outside my window. She listens seriously and asks serious questions. . . . I have seldom been more amused than in thus meeting a sister professor in "the first lady of the land." I liked her. . . . I explained why you were not with me, and she cordially asked me to bring you over in the evening.

Dutifully, Adams visited Cambridge, staying as few hours as possible, returning to devoted dogs. He finally managed to admit that Clover was missed, and by him as well. How, he asked, had he "ever managed to hit on the only woman in the world who fits my cravings and never sounds hollow anywhere?" He added, with customary austerity, that he did not expect to have to wait long alone. Nor did he. Dr. Hooper died three days later, on April 13. Clover wrote John Hay's wife: "His humor and courage lasted till unconsciousness came and he went to sleep like a tired traveler."

On her father's desk, Clover found a fragment that he'd kept, perhaps salvaged from the memoirs of an aristocrat of *l'ancien régime*, one who had survived the Terror: "In that time, one knew how to live and die; one didn't have the excuse of inconvenient illnesses. If one caught gout, one nevertheless walked on without making a face; one concealed suffering under a good education."

After her deathwatch and return to Washington, Adams noticed that she seemed tired, but contrary to what might have been feared, her spirits appeared to be improving. She wisely resolved not to spend the summer at Beverly Farms. For her, New England was now a dead land. Inquiries were made about the recently opened Yellowstone National Park and about the possibility of spending six weeks camping out in the Rockies. However, early summer was blackfly season, so, with their two horses, Adams and Clover drove to the huge old resort hotel at Sweet Springs, West Virginia. Though it was capable of hosting nearly a thousand guests, they found it on opening day all but empty. Adams wrote to Gaskell:

A country less known to Bostonians could not be found. . . . On our first ride we nearly fell off our horses at seeing hillsides sprinkled with flaming yellow, orange and red azaelias, all mixed together, and masses of white and pink laurel. . . . On our second ride, we got a long way into the mountains by a rough path, and the groves of huge rhododendrons were so gloomy and shook their dark fingers so threateningly over our heads, that we turned about and fled for fear night should catch us, and we should never be seen any more by our dear enemies.

By July, the blackflies were gone, and they planned to entrain for Yellowstone with luxurious baggage and equipment, twelve pack

animals, and a cook. But, Adams now confided to Gaskell, "we [*sic*] broke down"; his wife had been out-of-sorts, and "until she gets quite well again, [we] can do nothing." So, ill-advisedly, they went to Beverly Farms.

On their return to Washington, Clover, in the absence of any effective therapy, was locked in a wall of ice, condemned to loneliness and lassitude. She tried to endure her obsessive fantasies of guilt—of what she had done, of what she had failed to do. But she felt she was more Stoic than Christian and must support her failings without a word. She clung to her sister, who recalled: "She was so tender and humble—and appealing when no human help could do anything—sorry for every reckless word or act, wholly forgotten by all save her. Her constant cry was 'Ellen I'm not real—oh make me real— You all of you—are real!' "

There was a disturbing incident concerning Richardson's placement of a block of freshly carved sandstone plumb between the two arches that formed the entrance to the new houses. The carving was of an Assyrian lion backed by a tau cross, perhaps recalling the ensign of the Venetian Republic's *extremissima* serenity. Adams was furious; he wanted the workmen to cease and desist. Hay was not troubled; he felt the carving to be magnificently successful. Adams replied that he began to "turn red, blue and green of nights thinking about it and hiding my head under my pillow. . . . I wish the Assyrian animal would walk off and carry the cross back to the British Museum." He begged Richardson to have the monster removed. He was flatly refused. He sulked in silence, consoling himself that the decoration was in the worst of all possible taste, *really!* That it could have been proposed as a lucky sign of faith by someone near and dear to him never suggested itself. Why the architect felt free to go against his client's express command, why Hay claimed wholehearted approval, remains a mystery. Recently, it has been suggested that the traditional symbol of Saint Mark was a private gesture of Clover's confided to two of her most understanding friends.

Clover spent waking hours and sleepless nights in her prison of apology and guilt. In her tenuous faith there was little consolation. A neighbor knocked daily to offer the placebo of gossip, trying to pull a distraught, mourning woman out of the depths. Charles Francis Adams recalled that his last encounter with his sister-in-law had been painful

to a degree. He had never cared for her. His early warnings concerning her sanity had been ignored. At the start of December, she appeared to improve; a few friends thought there was a good change. On December 6, a Sunday, the day she had once written her weekly reports to her father, Clover and Henry breakfasted together. He had toothache and went for a dentist. At the door, he encountered a woman caller and he returned to see if Clover wished to receive her. She did not, and he went out. Clover started a letter to her sister: "If I had one single point of character or goodness I would stand on that and grow back to life. Henry is more patient and loving than words can express. God might envy him—he bears and hopes and despairs hour after hour. . . . Henry is beyond all words tenderer and better than all of you even."

The letter stayed unfinished. Clover went into her darkroom and took the bottle of potassium cyanide. Less than an hour later, Henry found her, still warm, in front of her fireplace. He carried her to a chaise longue and ran for a doctor. Her body was contorted, and the room had the cloying odor of bitter almonds.

# EPILOGUE

# Domes

I. M.: WILLIAM F. LYNCH, S.J.

[*From* The Poems of Lincoln Kirstein *(New York: Atheneum, 1987).*]

I

In awe of order, drawn nigh to wrought portals
    of Zion's late home—
gilt-mosaic, good taste of proud Hebrew mortals,
    high resonant dome,
one lays at the faldstool of Yahveh, our jealous god,
    a weak caitiff's rage
at self, injustice: this world—its scourge, its rod
    on fretful spent age.

He weeps. Shoulders shake. Tears moisten tense fingers.
    Neurosis or grief?
No. Terror of order. God's orders. Fright lingers
    in guilt's lame relief.
Unfocused sobs in loose order throb sadness.
    A mind starts to spin
on waste panic. Hysteria; not madness
    the state he is in.

So here comes the rabbi to bolster his pew;
    meaning well; nice man.

Pats a paw on shook shoulders: "Man, may I do
    for you what one can?"
Thanks. But is ours any mendable trouble?
    Tears? Sure—mainly nerves
but pain leaks from that single or double
    sense which, when sound, serves

order. So rabbi notes he's not nuts, although
    nervous. Hence, in reply
risks his avid grief: "I'm married. Unhappy. So
    I've a mistress. I
love her. She—me. My wife doesn't know. Must we tell?"
    Hates to hurt her. "D'you
think we should?" Woe melts on a comrade in hell
    kept by God, a Jew.

<div align="center">II</div>

I may cite Priest Gen-do in Nan-zen-ji's shrine
    to God-Goddess Mercy.
Helping Gen deck Kan-non with quince, plum bud, rock pine
    friends were made, barely.
Crushed stone, plush moss, clear stream, his paths raked,
    begs downtown each morn.
By hope unpossessed, all possessiveness slaked,
    thanked his gods he'd been born.

Rabbi, hypertense theologian, concedes:
    "Ah, yes. I can see
East and West create each their creeds, but . . ." He reads
    Kipling: "*Never the
twain shall meet.*" "Their Buddha? That image; it's fat.
    Our life-style's dynamic.
He's passive. We can't then live like that
    since we're both manic

*and* depressed." Hey! Wild yelps! The pew, right ahead:
    a sincere drama:

loud, plump brat, spoiled on lox, chicken fat, rye bread,
    cushioned by Momma.
Irving howls, throws a fit. *Frecheit!* Grab him. She spanks.
    He slaps her straight back.
Rabbi flies to succor the scene. His due thanks—
    a Bronx boy's prompt whack.

In no time, Irving, his permissive mother
    quit their holy place.
Rabbi recaps a loss which shrinks to small bother.
    We both feel we've lost face.

### III

I'd cited Kyoto, Japan—miles, years gone.
    It's not simply Zen.
Zen? For us? No. Fair practice, yet scarcely one
    for quick Western men.
Gen-do grinned. Grace held no threat. Shut, lonely, strong,
    his stone lamp shone bright.
Its wick repaid need without greed. He's all wrong?
    For him it burned right—
which one strained to explain, but a Lord God of Hosts
    in synagogue rich
warned us both: "Requite thine own Pentateuch ghosts!"
    Poor son of a bitch;

poor mistress; poor wife; poor us. Rabbi's sad, soft sigh:
    "An eye for an eye."
Blame smells sweeter than bless. What gods, blinding us, lie?
    Adore that old lie.
Lord-Lady Kan-non, thy mercy; Gen's firm chants,
    stone lantern's lean fire
glow in ease—yet they fade, for some postulants
    hear another choir.

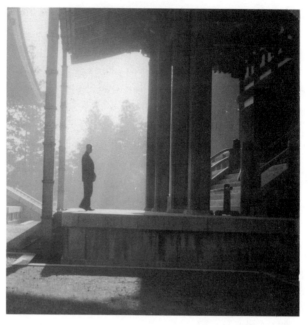

*Lincoln Kirstein at the Shingon temple, Koyosan, Japan, 1962*

I V

Islam's scimitar script, credo to behold—
    our West may forget
marble marvels, pale tulip domes in clear gold:
    mosque, mihrab, minaret—
iron prose of their prophet, Apostle of God;
    Buraq, his winged steed.
We recall how millions deem none of this odd,
    a norm for a need.

Nearby—to that Farthest Rock, back, in free flight,
    far more than a myth,
spanning star-dome to hell and back in a night
    won Prophet the pith
of his proof. Five times a day, strangers in ranks
    share the muezzin's call.

For domes geometrics, all our earthly thanks
      for a Taj Mahal.

V

Is one blind to lapis blue, deaf to psalms sung?
      Ribbed vault frames stained glass.
Lo, there on crossed oak a nailed corpse heavy hung:
      monad of the Mass:
this One, this Other, of God and Man, a son.
      In blood, wine, and bread—
fount, flow, source, ever three, yet always One:
      heart, belly, and head.

Whatever's besought, wherever its shrine,—goddess or god,
      does not all depend
on when and where is first found seed in our sod
      however we end.
In a furnace of fact, singed by metaphor's flames,
      true gods never burn,
To Yahveh, Kan-non, Muhammad, Christ—domed names
      towards order we turn.

Thus, three-quarters along our God-given span
      tired men can turn home
to supper set out for those jaded by man—
      'neath any old dome,
shrine or sky. Wafer crackles its echoing crunch.
      Gods, in deeds, exist,
and, after all, many wean on one heavenly hunch,
      The Eucharist.

# Photograph Credits

*Frontispiece: photo by Jerry L. Thompson, courtesy of James Kirkman, Ltd, London; page 5: copy print made by Jerry L. Thompson; page 15 (left): photo by Martin Mower; page 24: copy print made by Jerry L. Thompson; page 33: photo by Carl Van Vechten, copyright The Estate of Carl Van Vechten; page 36: The Art Institute of Chicago. Photo: © 1991, The Art Institute of Chicago, all rights reserved; page 49: copyright The Estate of George Platt Lynes; page 58: copyright The Estate of Walker Evans, copy print made by Jerry L. Thompson; page 81: copyright The Estate of George Platt Lynes; page 90: photo by Kent Bailly; page 105: photographer unknown, copyright: Dance Collection, The New York Public Library at Lincoln Center; page 120: Press photo, copy print made by Jerry L. Thompson; page 157: photographer unknown, copyright: Dance Collection, The New York Public Library at Lincoln Center; page 163: photo by George Platt Lynes, copyright The Estate of George Platt Lynes; page 173: copyright Henri Cartier-Bresson/Magnum Photos; page 190: photo by Imperial Japanese Household Staff; page 195: copyright The Estate of George Platt Lynes; page 212: photo by Jerry L. Thompson; page 233: copyright The Estate of Walker Evans; page 250: copyright: Henri Cartier-Bresson/Magnum Photos; page 258: copy print made by Jerry L. Thompson; page 262: photo by Jerry L. Thompson; page 269: photo by Geoffrey Clements; page 270: photo by Geoffrey Clements; page 282: courtesy of The Museum of Modern Art, New York/ Film Stills Archive; page 293: photo by Friedman-Abeles Photos, courtesy of The Performing Arts Research Center, The New York Public Library at Lincoln Center; page 319: courtesy of Robert A. Wilson; page 327: photo by John Webb, courtesy of Tate Gallery, London/Art Resource, New York; page 357: photo by Richard Benson, courtesy of Eakins Press Foundation; page 387: photo by Jerry L. Thompson; page 402: photo by Donald Ritchie.*

# INDEX